PROGRAMMING BELIEVABLE

CHARACTERS

FOR COMPUTER GAMES

PROGRAMMING BELIEVABLE CHARACTERS FOR COMPUTER GAMES

PENNY BAILLIE-DE BYL

CHARLES RIVER MEDIA, INC.
Hingham, Massachusetts

Publisher: Jenifer Niles
Production: Eric Lengyel
Cover Design: The Printed Image

CHARLES RIVER MEDIA, INC.
10 Downer Avenue
Hingham, Massachusetts 02043
781-740-0400
781-740-8816 (FAX)
info@charlesriver.com
www.charlesriver.com

This book is printed on acid-free paper.

Penny Baillie-de Byl. *Programming Believable Characters for Computer Games.*
ISBN: 1-58450-323-8

Microsoft product screen shot(s) reprinted with permission from Microsoft Corporation.
The Sims, Ultima, Underworld, SimCity and ORIGIN are trademarks or registered trademarks of Electronic Arts Inc. in the U.S. and/or other countries.

All brand names and product names mentioned in this book are trademarks or service marks of their respective companies. Any omission or misuse (of any kind) of service marks or trademarks should not be regarded as intent to infringe on the property of others. The publisher recognizes and respects all marks used by companies, manufacturers, and developers as a means to distinguish their products.

Library of Congress Cataloging-in-Publication Data
Baillie-de Byl, Penny.
 Programming believable characters for computer games / Penny Baillie-de Byl.
 p. cm.
 ISBN 1-58450-323-8 (pbk. with cd-rom : alk. paper)
 1. Computer games—Design. 2. Computer games—Programming. I. Title.
 QA76.76.C672B34 2004
 794.8'1536—dc22
 2004005214

Printed in the United States of America
04 7 6 5 4 3 2 First Edition

CHARLES RIVER MEDIA titles are available for site license or bulk purchase by institutions, user groups, corporations, etc. For additional information, please contact the Special Sales Department at 781-740-0400.

Requests for replacement of a defective CD-ROM must be accompanied by the original disc, your mailing address, telephone number, date of purchase and purchase price. Please state the nature of the problem, and send the information to CHARLES RIVER MEDIA, INC., 10 Downer Avenue, Hingham, Massachusetts 02043. CRM's sole obligation to the purchaser is to replace the disc, based on defective materials or faulty workmanship, but not on the operation or functionality of the product.

Contents

Acknowledgments

First I would like to show my appreciation toward my publisher Jenifer Niles, who believed in this project from the start. It has been an absolute pleasure working with you. I would also like to thank the various contributors to this work, including Pior Oberson, Steven Bender, Conor O'Kane, and Timothy Evison, who have donated their excellent 3D character models for use throughout this book; Ron Ward, Walter Spunde, Sian Carylon, Edel Chadwick, Bronwyn Dye, Richard (Old Dik) Bennett, Dickson Lukose, and John Laird for their inspirational reviews of the contents; and especially to Leonardo Boselli for his excellent open source 3D Games Engine: Apocalyx. In addition, much credit should go to the many novice, research, and professional games programmers who every day flood the Internet with tutorials and commentaries on games programming and who have inspired the content herein.

Finally, I would like to express my deepest gratitude to my family for their unwavering support and confidence in my abilities, and especially to my beloved husband, Daniel, who assures me daily of my superwoman abilities and how much I am loved. And to my unborn baby (a.k.a The Bean), thank you for the miracle of life, the bounces of encouragement, and the motivation to get this book finished before you decided to come out!

Preface

Computer games have evolved from small programs developed by individuals and novice programmers to major commercial projects produced by teams of 20 or more people working, in some cases, for years on a particular product. It is a rapidly growing industry, employing large numbers of people. As the complexity of games has increased, development roles have become more defined, and games developers now have clearly marked areas of specialized knowledge and skills. Games programmers are often busy programming well-founded, solid Artificial Intelligence (AI) constructs such as low-level pathfinding and have little time to learn about new research in AI, let alone work out new programming constructs to integrate the ideas. The International Games Developers Association's AI Interface Standards Committee believes the next "qualitative jump for artificial intelligence techniques in games" will be the development of middleware that releases the programmer from mundane AI tasks and allows him to focus on "higher-level creative AI tasks" such as believable and intelligent computerized characters with emotions and complex behaviors, such as learning and interaction.

Programming Believable Characters for Computer Games brings the current research and tools for creating believable characters into the hands of programmers and students in a practical, tutorial-based approach. It provides both the experienced and inexperienced game programmer with an in-depth look at the modeling and AI tasks for developing artificial gaming companions and opponents with humanlike, complex behaviors. It also provides practical tools to assist programmers in integrating these concepts into their games with the objective of enhancing suspension of disbelief in virtual gaming environments. In addition, information on AI and intelligent-agent architectures, their design, and programming is included, along with practical C/C++ techniques.

WHY THIS BOOK?

Much AI development takes place in research environments and is written up in academic papers and journals. This information is often not available to the novice game programmer, and if it is, is likely to be written in a format indecipherable to this audience. This text takes current research in artificial intelligence and computer

games and presents both the concepts and architectures, together with practical programming examples. The content covers areas of particular interest to the International Game Developers Association such as pathfinding, decision trees, finite-state machines, rule-based systems, and goal-oriented action planning. In particular, the focus is on the development of higher-level AI, such as believable and interesting non-player characters (NPCs) that learn and express emotions with complex reasoning and interaction skills. Each topic is covered, with a history of the concepts in the area, an overview of its relevance to computer games, and a practical study application.

KEY FEATURES

This book contains the following key features:

- Practical instructions, software, and source code for the development of a fully functioning non-player character in a 3D environment
- Coverage of all major areas of non-player character development, including meshes and skins, inverse kinematics, human interaction, and traditional and experimental AI procedures
- New behavioral aspects of non-player characters, including the psychological aspects of games theory, emotional computing, and agent architectures
- A CD-ROM (Windows-compatible) with a fully functioning 3D Games Engine (Apocalyx), source code, models, skins, and code for creating character models and programming complex AI routines. (See Appendix A for more information.)

INTENDED AUDIENCE

This book has been written to appeal to a wide audience in the gaming community, including professional, hobbyist, and student programmers. Although designers, animators, and other creative occupations within the gaming industry may find tidbits of new information and derive inspiration from the content, the book is written primarily for those with programming experience. It does not, however, assume the audience has had experience programming believable artificial gaming characters.

THE CONTENT

The content of the book pursues the step-by-step creation of a 3D animated autonomous character, written in a tutorial style. Each chapter covers aspects and techniques applicable to creating such a character followed by practical hands-on exercises, drawing examples from real-life games and the academic research community. The facets covered include issues from psychology, economics, animation, physics, and AI. The book follows the creation of a *bot* from the design, modeling, and animation phase to the development of its artificial brain, which includes techniques for learning, socializing, communicating, navigating, and adapting to its environment. Because each chapter builds upon the previous, you should read this book from cover to cover so that important elements and concepts used later on are not missed. Having said this, for those readers who just want to get their hands dirty, there is enough information in each of the practical "Day of Reckoning" sections to create fully functioning bots in a 3D gaming environment without having to read the additional theoretical content.

1 An Overview of Non-Player Characters in Games

In This Chapter

- A history of NPCs and their uses
- The structure of a game and NPC program
- Tools for NPC creation
- The use of AI techniques in game creation
- Getting started in games programming with a 3D game engine

1.1 INTRODUCTION

We've all seen them; many of us have pondered over their plausibility and existence; some of us dream of creating them. But can we really say we have *experienced* them as truly alive, believable artificial beings—ones that can think like we do, behave like we do, and feel like we do? Artificial intelligences, such as Arthur C. Clarke's HAL and Terry Nation's ORAC, or the embodiment of such beings in Isaac Asimov's robot, R. Daneel Olivaw, and *Star Trek®*'s Lieutenant Commander Data have seen a natural evolution of artificial beings in the minds of science fiction writers. They may reveal a secret arrogant motivation in man to create something in his own image or just provide inspiration for researchers to "boldly go where no man has gone before." This is all well and true for writers but quite another thing for programmers attempting to bring to life such fantastic creations using programming code.

As computer-gaming technology advances, players are demanding more from computerized characters. Some of the essential characteristics for successfully created characters are that they need to act like humans (use natural language, reason, and discuss events); have knowledge about their world and memories of personal history; and exhibit emotions and personalities that fuel their motivations and de-

sires. The need for quality, autonomous artificial characters capable of behaving intelligently and adapting to their ever-changing virtual environment is paramount. Artificial companions and opponents must be able to suspend players' disbelief that their interaction with the character is anything but unreal. The aim of this book is to put into the hands of programmers the knowledge required to develop such believable artificial characters only dreamed of by science fiction writers.

1.2 WHAT DO PLAYERS REALLY WANT?

If you could build the ultimate gaming environment, what would it be? One of the most popular artificial environments dreamed of for the purpose of entertainment is *Star Trek*'s Holodeck. In the Holodeck, human participants are fully immersed in their surroundings and provided with photo- and tactile-realistic NPCs that they can interact with during real-time story creation [Stern99].

Unfortunately, an environment such as the Holodeck is currently beyond the state of technology; however, other immersive game-playing environments do exist, not in the sense that players can exist inside the environment but that they can interact with it. Whether a complex virtual-reality environment in which the player dons a sophisticated sensor suit for tactile feedback or a simple online multiplayer gaming environment, each type of gaming media provides the player with the same primal psychological needs.

Researchers have found that computer users use their machines to work through identity issues centered around their own mastery and control of the environment [Turkle94]. A computer game environment is no exception. In a game players can explore their own inner personality, something they may not be comfortable expressing in the real world. A game provides more room for players to develop a greater capacity for collaboration and other social interaction while maintaining anonymity. In other words, players can become masters of their own universes. This role is popular with game players and evident in the success of games such as *Black & White*, in which the player is the omnipotent creator of the environment, and in *SimCity*, in which the player acts as the all-controlling city mayor. During game play players can escape from their everyday world and take on fantastic roles that may fill the void of any inhibitions that restrict them from acting in the same way in the real world. For collaboration and social interactions to exist in the fantasy environment of a game, players must believe in the validity of the other players within the environment, whether human or NPC. Players are more satisfied with their gaming experience if they can believe their opponents are human rather than computer controlled.

The biggest allure of multiplayer games is not in the skill level or intelligence of the other players but the essence of fun in beating another emotional creature and imagining the opponent agonizing over the loss [Zubek02]. In their research, Zubek and Khoo found that human game players tolerate other human players with lower game skills, and even beginning players, as long as they know their opponent is human. Zubek and Khoo summarize that it is difficult for a human player to gain a sense of satisfaction in a victory over a soulless entity, such as an NPC driven purely by programming code with no emotional attachments to its wins or losses.

On surveying a group of 81 third-year university students (average age of 22.35) on their opinions of human- and computer-controlled opponents in computer games, Sweetser et. al. [Sweetser03] collected comments about human opponents suggesting that human players were:

- more intelligent;
- cunning, flexible, and unpredictable;
- able to adapt their strategies to the current state of play;
- able to reason about their actions;
- able to use differing strategies each time they play.

Computer opponents were seen as:

- predictable;
- easy to defeat;
- boring to play against.

The participants in the survey felt that playing against a human opponent made the game more meaningful by providing comradeship, social interaction, and the satisfaction of beating an opponent who is real.

There is no doubt through research and observation that game players want to interact with something that is truly alive [West98]. But does this mean that we must discard the use of NPCs in favor of human players to enhance the game-playing experience, or does it mean that as game developers we must lift our game, rise to the challenge, and create artificial beings that can delude the human players into thinking they are playing against something that is really alive?

Schreiner [Schreiner03] provides a number of reasons for why we cannot do away with NPCs. First, because players all want to be the masters of their universes, they are not satisfied playing a utility role. In multiplayer first-person shooter (FPS) games such as *Quake* and *Unreal*, all players are on an even par and all have the same role: shoot as many of the other players as possible. Therefore, all players in a FPS game can be deluded into thinking that they are the master of the universe and

they can prove it through combat. However, consider a game such as *Splinter Cell* in which there is a single main character (Sam Fisher). In this game, it is the main character's job to infiltrate terrorist organizations by navigating through environments, shooting the bad guys, saving the good guys, and retrieving sensitive information. Although *Splinter Cell* is a single-person game, imagine if each character within the game were controlled by a human player. Would you want to play the security guard that monotonously stands in front of CIA headquarters, occasionally scratching his butt? Utility roles or minor character roles in most games would not be the choice of character to be played by any human player.

Second, not only the lower-level characters should be played by NPCs; upper-level positions of characters that possess a lot of strength and control over the environment should also be NPCs. Hold on—didn't we just say that players want to be masters of their universes? This is fine if the game is a single-player game; however, imagine playing the part of a lower character in a multiplayer game where someone else gets to be bigger and stronger and has more environmental control than you do—not much allure to play in this game. This is precisely why *Black & White* and *SimCity* work as single-player games and not multiplayer games where only one person would get to play god or mayor and everyone else would get to play the subjects or city residents. *Black & White* and *SimCity* would work as a multiplayer game if each player could be a god or mayor of an adjacent city. If you could deal with the fact that someone got to be more powerful than you in a game, how would you handle any abuse of that power?

Finally, in games where the story line is critical, NPCs are needed to maintain the integrity of the game and keep it moving forward. Arena games, in which the objective is to shoot at everybody until you are the last man standing, have no story line. In adventure games that have the players move forward through the story by getting hints from the characters, it would be almost impossible to ensure that the story would move forward if each character were played by a human. Making these games suitable for multiple players would require scripts for each player and a method for ensuring they stuck to the script. There would be no room for forgetting lines or acting out of sequence.

In conclusion, games work best when the human players possess roles of equal caliber and NPCs are used to fill in other character roles to keep the game moving forward and fair. The dilemma that now presents itself is that human players prefer to play against other human players; however, it is still necessary to have NPCs. The only option from here is to attempt to create NPCs that can fool the human player into believing the characters are under the control of another human, when in fact they are not.

In considering what a human player wants in an opponent, we conclude that the ultimate objective in developing a realistic and believable NPC is to create an intelligent and freely acting artificial being capable of perceiving its environment

and adapting to changes in that environment through behaviors that appear rational, yet emotionally driven. Each chapter of this book examines different aspects of programming believable NPCs, with a full academic elucidation of the creation of believable NPCs featured in Chapter 7.

In the next section we examine how the concept of NPCs has evolved from humble beginnings into the characters we see every day in popular computer games.

1.3 A BRIEF HISTORY OF NON-PLAYER CHARACTERS IN GAMES

The word *game* has a long and inexhaustible history. The oldest origins of the word come from the Old English *gamen* and the Old High German *gaman*, both of which were taken to mean *joy* and *glee*. The meaning of *game*, as we now know it, also stems from the Old Norse *gaman*, meaning *sport* and *merriment*, and the Gothic *gamen*, meaning *participation* and *communion* [Luther02].

All of these definitions of *game* explain the motivations that cause a player to play. Not only do people play games for enjoyment but games involving other players and characters provide a sense of communion and participation. Because competition is the main characteristic of game play, the player needs to be provided with an opponent. In the absence of another human player, the next best thing is an NPC. A brief history follows of NPCs created throughout the computer games timeline. As you can see, as games advanced, so did the NPCs' representations and abilities.

> **1974**—*Shark Jaws* by Atari (arcade videogame): *Shark Jaws* is the first known game to include an animated computer opponent. Not exactly what we would class as AI in this day and age, the shark is a predator opponent within the game environment that pursues the player (represented by a scuba diver) as he moves around the screen. The original flyer for *Shark Jaws* is shown in Figure 1.1.

> **1975**—*Gun Fight* by Taito/Midway (arcade videogame): *Gun Fight* was the first arcade game to implement a microprocessor. This advancement allowed for more varied and randomized game play than had been seen previously. The game consists of two gunfighters (one controlled by the player, the other by the computer) in a game of quick draw across a road, cacti, and a covered wagon. The programming of the computer player enables it to move more unpredictably and, thus, enhances game play.

> **1985**—*Little Computer People* by Activision Publishing, Inc.: Widely regarded as the first virtual pet game, *Little Computer People* is a game in which the

player acts as the caretaker of a group of computer-controlled characters by providing food, shelter, entertainment, and education. Unlike subsequent artificial-life (A-Life) games, *Little Computer People* allows the player to be a part of the little people's lives. The player can talk to them by typing phrases into text boxes, play games with them such as poker, and give them rewards by supplying them with records and books or by simply patting them on the head. The little people are also capable of expressing emotional states—for example, if they become disgusted with the actions of the player they can refuse to interact with him. The game cover image and a screen capture are shown in Figure 1.2.

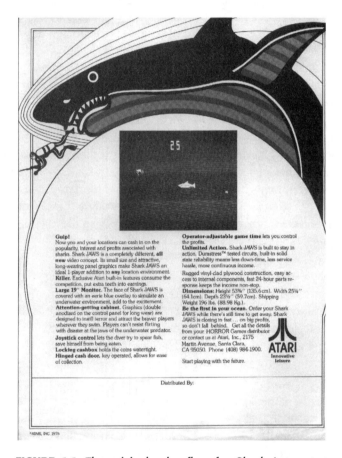

FIGURE 1.1 The original sales flyer for *Shark Jaws*. *Shark Jaws*™ graphic courtesy of Atari Interactive, Inc. © 2004 Atari Interactive, Inc. All rights reserved. Used with permission.

FIGURE 1.2 Game cover image and screen capture insert from *Little Computer People.* Courtesy of Activision.

1992—*Ultima Underworld: The Stygian Abyss* by Blue Sky Productions (published by Electronic Arts, Inc.): This game set new standards in role-playing games by creating a believable and highly interactive 3D environment. The objective of the game is to explore a series of dungeonlike caves called the Stygian Abyss to find Baron Almric's daughter who the player has been accused of kidnapping. The Abyss is populated by a great assortment of NPCs with whom the player can talk and trade. The NPCs greatly enhance the game's atmosphere and unpredictability, and not all characters are hostile. However, a friendly character, if provoked, can become troublesome and give the player a lot of grief.

1995—*Dogz* by PF Magic, Inc. (produced by Virgin Interactive Entertainment): *Dogz* was created to provide players with an interactive virtual dog that behaves like a real pet dog without all the mess. The product attempts to recreate realistic, believable doglike behaviors in the computer-controlled dog that appears in

its own environment on the player's computer screen. Players can interact with the dog by patting, stroking, or disciplining it with their pointer (which takes on the form of a hand when in the environment). Players can also place toys into the environment for the dog to play with and can train the dog to perform tasks such as tricks through positive and negative reinforcement of its actions. The dog is programmed with a simple adaptive AI system, which pays attention to the player's actions and determines how much or how little the player seems to like it.

1996—*Tamagotchi* by Bandai America, Inc.: Not exactly a game, the *Tamagotchis* are virtual-reality creatures that exist within a small handheld device. The objective for owners of a *Tamagotchi* is to care for it in the same way as they would a real pet. The *Tamagotchi* requires feeding and social interaction to grow up. With excellent care the *Tamagotchi* grows up to be a healthy and beautiful creature; with neglect it can become mean and ugly, and even die. The *Tamagotchi* represents one of the first commercial uses of A-Life technology.

1996—*Creatures* by Cyberlife Technology, Ltd. (produced by Millennium Interactive): *Creatures* is another virtual-pet-type game in which the player takes on the role of Scrubby the Fairy, a parental-type entity who has the responsibility of raising creatures called Norns. The game won awards for its advanced AI features that give the Norns personality and allows them to control their own behaviors. The game is the first to include A-Life concepts by incorporating *digital DNA* into the program for each Norn. The game developers' goal was to have the Norns simulate organic life. To achieve this goal, they implemented a series of AI technologies, including genetic algorithms and neural networks.

1997—*The Last Express* by Smoking Car Productions (produced by Broderbund): This game has been described as an interactive movie with a little problem solving thrown in. The objective of the game is to discover what is going on aboard the *Orient Express* on its journey from Paris to Constantinople. The player's character must investigate the situation by interacting with the NPCs aboard the train. Interaction can take place by eavesdropping, interrupting conversations, initiating conversation, and examining a character's personal items and other environmental objects.

2000—*The Sims* (published by Electronic Arts, Inc.): Taking a leap forward from *Little Computer People*, *The Sims* is an environment of computer-controlled characters living as a family in a house that is part of a larger neighborhood of families. Unlike in *Little Computer People*, the player cannot interact as another character within the game. *The Sims* was one of the finest examples of A-Life and the use of fuzzy logic embedded in finite state machines at its release date. Each sim is created with a personality type and a variety of attributes, such as visual appearance and gender. Although each sim is capable of

surviving within its environment by performing behaviors consistent with its desires, to become more prosperous some intervention on the part of the player is often needed.

2001—*Black & White* by Lionhead Studios, Ltd. (published by Electronic Arts, Inc.): *Black & White* is a fully realized fantasy world in which the player is an omnipotent god overseeing villages of subjects. The player's objective is flexible in that he keeps his villages happy (or unhappy if he is a vengeful god) and provides them with food, shelter, and protection from other gods. The player's godlike power and ability to perform miracles is derived from the subjects' worshipping. The player also has a pet creature, which embodies the first truly lifelike artificial intelligence to be found in a game. Throughout the game the creature evolves through interaction with its environment and the player and can be trained to perform tasks through player feedback about its actions (the player can smack it around or pet it), by mimicking the player's actions, and by obeying the player's commands. The lifelike attraction of the creature, which had not been seen in games until *Black & White*'s release, was that it was plausible, impressionable, lovable, and useful to the player in his quests.

The preceding list of NPC use in games is not a complete inventory of all programmed NPCs to date. Its objective is to present the most noticeable use of NPCs and their development throughout the years. Each game in the list marks a significant moment in the timeline where developers dared to step outside the square and create something that had not been seen before.

In the next section we introduce the way in which NPCs are programmed and where their code fits in and interacts with the game's code. The section provides a programming basis that is used throughout the book to create believable NPCs.

1.4 A CRASH COURSE IN GAME AND NON-PLAYER CHARACTER PROGRAMMING

A couple of years ago, finding any information or tutorials on implementing AI techniques in computer games was almost impossible. Sure, many, many academic texts on formal AI, full of complex mathematical equations and algorithms, have been written, but they included very little information on how these techniques could be used in game programming. Now a plethora of material is available to get the novice game developer up and running with AI. However, because many tutorials become bogged down in complex mathematics, the common phrase "this is beyond the technical level of this article" crops up and the tutorial ends just as it is starting to get interesting. There is no denying that mathematics is a quintessential

element of AI programming; while writing this book we also found the level of the explained mathematical concepts lacking when it came to delving deeper into the techniques explained in this book. Where the mathematical explanations begin to get complex, however, we have in some cases provided the solutions up front, avoiding long drawn-out theorems and derivations. Instead we direct you to other materials in which you can brush up on further mathematical concepts. Having said all this, after a game's graphics and sound components have been completed, there is usually on average only 10 percent of memory and CPU time available for AI processing. This means that whatever AI, if any, implemented within a game must be as efficient as possible. As you will see in later chapters, AI techniques such as neural networks, genetic algorithms, and Bayesian networks increase the required processing time exponentially as they increase in size. Therefore, until recently these advanced AI techniques, due to the lack of computer power, have been avoided. We are confident that with future advances in microprocessors and gaming consoles, more space will be available in a game for AI and the concepts taught in this book will not only be relevant but also necessary for successful games programmers.

Because the game itself revolves around the graphics and user interface, not the AI, a gaming program is written as a loop dedicated to updating the interface and capturing the users' commands. This loop is referred to as the main game loop. Each time the program loops, the state of the game is updated. The pseudo code for a simple game is shown in Listing 1.1.

LISTING 1.1 Pseudo code for a simple game

```
int main()
{
    initializeEnvironment();
    displayEnvironment();

    while(player isn't bored)
    {
        getSystemMessages();
        processSystemMessages();
        mainGameLogic();
        redisplayEnvironment();
    }
    finalizeEnvironment();
}
```

After the program initializes the environment—handling memory management, recognizing input (joysticks and controllers) and output devices (LCD com-

puter monitor, television, and so on)—the game environment is loaded and displayed. The program then enters the main game loop, which iterates until the game is exited. When the game is exited, a final method is called to release any devices or memory that the game was using. Within the main game loop the program gets any messages from the user or operating system, such as mouse movements or keyboard strokes, and processes them. The main game logic processes most elements of the game, such as the graphics rendering, environmental physics, and AI. A simple game architecture is shown in Figure 1.3.

As you can see in Figure 1.3, two areas in the game exist where AI techniques are processed. The first is the game AI. This AI takes care of the environmental physics (such as collision detection and how characters can move and interact with objects), how the environmental states are updated and which states should follow

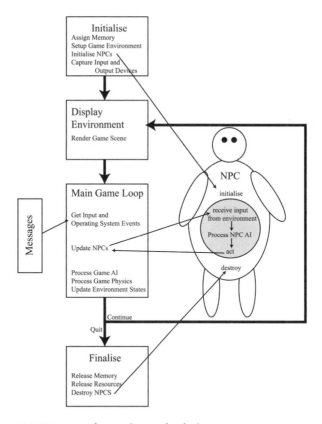

FIGURE 1.3 The main methods in a computer game program with an integrated NPC.

(for example, what the environment will look like after a fire), and general game logic. The second lot of AI processes that exist in a game are contained within an NPC.

An NPC usually exists within a game as a separate object (especially in object-oriented programming languages) defined by a specific class. Using this method a programmer can create as many instantiations of the class as needed to create many NPCs. By programming an NPC with many variables that can change its personality and behavior, a programmer need only modify the variable values at runtime to create a plethora of different characters while using the one NPC class. An NPC is programmed like a miniature game. It should have an initialization method, some main logic code, and a finalize method that destroys the NPC. The initialization of the game environment includes the initialization of any NPCs, which may include loading files with saved NPC parameters. For example, if an NPC has existed within the game for some time, it may have learned things that must be recalled the next time the game is run. The NPC is updated in the main game loop. This update controls how the NPC senses the state of its environment and how the state affects the actions taken by the NPC during game play. The actions of the NPC are determined by the AI processes contained in the parameters. These processes can be as simple as reactive responses to some environmental change or as complex as emotional decision making. When the user exits the game, the NPC is destroyed, but not before its states and any relevant variable values are saved to ensure the NPC's consistent and continued behavior when the game is next run.

Many established AI techniques are available for controlling the environment of a game and even administering the story line. However, because NPCs are the subject of this book, the general game AI will not be examined. Instead the following chapters focus on the creation of an NPC and the many and varied AI techniques available for processing input to the NPC and generating behaviors during game play.

The next section discusses the use of NPCs with respect to different game genres.

1.5 THE ROLE OF NON-PLAYER CHARACTERS IN DIFFERENT GAME GENRES

When most people think of NPCs, they immediately think of games in 3D environments in which the NPC is racing around, attempting to attack the player and other NPCs such as the bots—short for software robots—in *Quake III Arena* or *Unreal Tournament*. However, NPCs can provide a heightened game-playing experience in many game genres, including:

Action Games: These games immerse the player into a fantasy environment—though environments in most types of games are usually fantasy—where the goal is to jump, run, climb, or leap to the next level while avoiding all types of baddies to achieve some kind of heroic gesture, such as slaying a dragon to rescue a princess. NPCs in action games can act as the baddies, attempting to thwart the player's success, or as helpful companions. Games such as *Wolfenstein* contain many NPCs acting as Nazi soldiers who are highly motivated to shoot the player on sight. On the other hand, heroes such as Mario from *Super Mario 64* have their trusty sidekicks, like Yoshi, faithfully with them throughout the game.

Role-Playing Games: These games, fondly known as RPGs, require the player to take on the role of some main character or group. RPGs are best associated with dungeon-and-dragon-type games with swords and magic; however, they can take place in any setting. The objective of these games is to send the player on a fantastical journey during which he interacts with many characters and can acquire new skills for helping him continue through the game. NPCs in RPGs act as both good and evil characters. Often it is not clear to the player what side the NPC is on until the player has interacted with it. Sometimes it is the way in which the player chooses to interact that can determine how friendly or unfriendly an NPC is. In *Eye of the Beholder* (a dungeons-and-dragons type game), the player takes on the role of a band of four explorers, all of which can be controlled individually. During their treks through forests and dungeons the band encounters many NPCs with which to interact. Depending on how the player decides to interact with an NPC determines the band's fate. Whereas a friendly NPC will help the band on its quest, an unfriendly NPC may cast an evil spell on it.

Simulation Games: A simulation game, or sim, places the player in the driver's seat of the replication of a real-life or near-real-life situation. A sim player may be required to oversee the performance of any task, from piloting a plane to building a civilization. An excellent example of a sim is *SimCity*, in which the player, as the mayor of a new urban settlement, must manage the city's budget, land zoning, transportation, ordinances, and public services (to name a few), all while keeping the population happy. NPCs in these types of games are not usually present or complex. "Now wait a minute," we hear you cry. "What about *The Sims* or *Dogz*?" You do have a valid point; however, these types of simulation belong in a special category all their own and are discussed in the A-Life section. Although *SimCity* does animate small characters walking around the streets, driving cars, and constructing buildings, these characters are purely animations and are not programmed as individual NPCs.

Fighting Games: In a fighting game the player is set in opposition to one or more players in an arena. The goal is to survive by beating the other characters senseless in hand-to-hand combat. Examples of such games include *Mortal Combat* and *Street Fighter*. The NPCs in fighting games can act as players on the same team as the human player or as competitors.

Sports Games: These games allow the player to participate in a large range of competitive professional sports, such as soccer, football, basketball, and golf. Similar to RPGs, the player jumps back and forth and controls any characters on his team. When the player is not in control of a character the computer is; therefore, the player's teammates are essentially NPCs. Examples of sports games include *NHL Hockey*, *FIFA International Soccer*, and *Tennis Arena*. These types of games require the NPCs to exhibit crowd and flocking behaviors as well as team coordination skills.

Interactive Fiction: Once known as adventure games, interactive fiction takes the player on a mystical journey through fantastic lands where he must gather inventory items, unlock secret chests and hidden doors, solve puzzles, and accumulate weapons to uncover more of the environment. Often it is difficult to separate interactive fiction from RPG and action games because the boundaries are quite blurred. However, although RPG and action games do have a story line, interactive fiction attempts to immerse the player into the fictitious environment with a robust and plausible story line in which the player can believe he is part of a movie. NPCs in interactive fiction can be friendly or unfriendly and often hold secrets that must be extracted through interrogation to allow the player to proceed in the game. Other NPCs attempt to slow the player's progress by attacking or providing red herrings. Interactive fiction games include *Zork*, *Myst*, and *Discworld*.

Strategy: A strategy game requires the player to take on the leadership role of a divine being or master and commander of an armed force. Strategy games take place on a map where the player must produce resources such as fighting squads and strategically place them on the surface of the map to counteract movements made by an enemy force intent on wiping out the player's army or taking over his land. An NPC in a strategy game can act as an individual character within a squad or as the commander of the opposing force. In the latter case, the NPC should have a good knowledge of the game's strategies and, in some cases, be able to anticipate the player's next move. Some examples of strategy games include *Dark Reign*, *Warlords*, and *StarCraft*.

Board Games: Board games are familiar to most people because before they made it onto the computer screen, they were physically played with wooden or plastic pieces on a game board. Such games include *Monopoly*, *Scrabble*, and *Chess*. The most famous NPC programs, although not strictly characters but

rather opponents, were the AI chess-playing programs Belle, which was rated at master level in 1983; Deep Thought, which in 1989 achieved a United States Chess Federation rating of 2500 (near grandmaster level); and Deep Blue, which in 1997 won a six-game match against world champion Gary Kasparov.

A-Life: Artificial Life, or A-Life, is a field of academic research that attempts to model live biological systems and beings through complex algorithms. Researchers use the models to experiment with the numerous behaviors of living systems. The mid-1990s saw a number of gaming-type applications developed in which the player could act as the master or omnipotent entity in control of one or more characters. Unlike contemporary simulations, which are based on the mechanical principles of systems (such as flight simulators), A-Life programs provide personality-rich NPCs with complex goals and behaviors and the ability to be trained and socially interact. The behavior of such NPCs evolves from the use of A-Life–specific areas of AI, such as genetic algorithms and neural networks, which attempt to simulate lifelike performances by digitally replicating elements of human biology. Games that fall into this genre are *The Sims*, *Dogz*, and *Creatures*.

Although the A-Life genre makes extensive use of complex AI technology to produce intelligent and believable NPCs, any of the game genres can integrate NPCs with the same abilities. Game genres are also not mutually exclusive. For example, *Black & White* could be classified as an interactive fiction integrated with a RPG and A-Life game.

Whatever genre is chosen for a game, the design, modeling, and programming process for an NPC is primarily the same. In the next section we examine some useful tools that are used in the practical sections of this book for NPC creation.

1.6 TOOLS FOR CREATING AN NPC

Once upon a time creating a game was as simple as plugging some BASIC code into your 64KB microprocessor and typing run. Nowadays game creation is far more complex, requiring the game developer to be a graphic artist, animator, modeler, programmer, sound engineer, music composer, architect, physics professor, and more. No wonder more than 20 names are on the credits for most games. Unfortunately, if you are a lone programmer with dreams of grandeur, creating a game that can compete with those produced by Id Software (creators of *Wolfenstein*, *Doom*, and *Quake*) or Lionhead Studios (creators of *Black & White*) can be an extremely daunting task. Fortunately, some talented and generous individuals from around

the world have created some excellent tools and open source code to get you started.

The primary tool used throughout this book for most practical exercises is the Apocalyx 3D game engine. This engine, created by Leonardo Boselli, is written in C/C++ and is freely available and open source. Because we want to examine in detail the construction of NPCs—in particular, their minds—it would be impractical to start examining and illustrating the programming of the graphics, sound, and user interface for a game environment. Luckily, Apocalyx takes care of all of these things so we can concentrate on the NPC's code.

The second-most useful tool is Milkshape, a 3D drawing and animation package available as shareware and registrable for a small fee. (And we do mean small: around $25. We highly recommend that you register the software as soon as possible so you can continue with its use past the 30-day trial.) Milkshape allows you to create the embodiments for your NPCs. Although we don't place as much emphasis on the physical characteristics of the NPC as we do on the AI, a later chapter is dedicated to building a simple NPC model and animating it in Milkshape before importing it into Apocalyx.

ON THE CD
The previously mentioned software tools and a number of other useful programs that are used throughout this book are available in the Software folder on the CD-ROM.

The next section is the first of many practical exercises included in this book. Each practical exercise is structured in the same format, where you are directed to the necessary software and installation instructions on the CD-ROM. For your convenience, initial C/C++ project code is included with each exercise.

1.7 DAY OF RECKONING: CREATING A GAME ENVIRONMENT

Once you set up the Apocalyx programming environment, creating your own NPCs and inserting them into a game is quite simple. However, to get Apocalyx to compile requires a few steps, which are covered in the following sections. For all programming exercises in this book we use Microsoft® Visual Studio® .NET (MVSN) and the accompanying C/C++ compiler. The following steps will get a simple Apocalyx game environment up and running.

1.7.1 Step One: Installing the Apocalyx Source Code

The first step, besides installing a C/C++ compiler, is to copy the Apocalyx source code onto your own computer.

ON THE CD
The Apocalyx source code is provided in the Apocalyx folder. Open Windows Explorer and drag the Apocalyx folder to any desired location on your hard drive.

1.7.2 Step Two: Creating a Win32 Console Project with Microsoft Visual Studio .NET

When you first open MVSN, a list of any previous projects on which you have worked appears as well as a New Project button. When you click this button, the window shown in Figure 1.4 opens.

FIGURE 1.4 The New Project window in MVSN.

When the New Project window opens, select Visual C++ Projects as the Project Type and Win32 Project as the Template. Name the project and create a new folder on your hard drive in which to store it. When you have completed filling out the essential information for creating the project, click OK.

MVSN now opens a Wizard to help configure your new project. The window is similar to that shown in Figure 1.5. On the Application Settings tab select Windows Application as the Application Type and check Empty Project. Leave all other options blank. Click Finish to continue.

MVSN now opens the new empty project. The structure of the project is the main project name with included subfolders, displayed to the right of the main programming interface window, as shown in Figure 1.6.

FIGURE 1.5 The MVSN New Project wizard.

FIGURE 1.6 The MVSN C/C++ programming interface.

1.7.3 Step Three: Creating a Simple Program Linked to the Apocalyx Game Engine

To create a game with the Apocalyx engine you must link all the applicable files to your project. Click Project > Add Existing Item from the main menu. A new window opens, prompting for the names of the files to be added to the project. Locate the folder containing the copied Apocalyx source code and display it in the Look In text box in the upper portion of the window. When you select the correct folder, all the Apocalyx files are displayed in the window. Hold down the Shift key to select all the files, as shown in Figure 1.7.

Click Open to add all the selected files to your project. When you return to the programming interface, the files are displayed under the Source and Header subfolders in the right panel. This structure can become inconvenient when you want to find your own code among all these files. Therefore, you should move them into another project subfolder. Click Project > Add Folder from the main menu. A new folder is created in the lower portion of the right panel. Rename this folder Apocalyx. With the new folder selected right-click the folder and click Add > New Folder from the shortcut menu. Create two new subfolders inside the Apocalyx folder—Source and Headers, as shown in Figure 1.8.

Select all the .cpp files in the Source Files subfolder and drag these files into the Apocalyx/Source subfolder. Do the same with the .h files in Header Files. Drag these into the Apocalyx/Headers subfolder.

FIGURE 1.7 The Add Existing Item window.

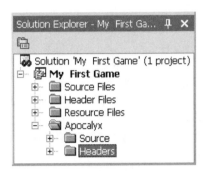

FIGURE 1.8 Adding new project subfolders.

 Several files included with Apocalyx are not needed for our project. To remove them, right-click the file in the Source or Headers subfolder of the Apocalyx folder and click Remove. The files are: phmachinery.cpp, phcloth.cpp, phairplane.cpp, phsimulator.cpp, slcomiler.cpp, slcore.cpp, slengine.cpp, slinterpreter.cpp, slmath.cpp, and their associated .h files.

You must also add some library files to the project for it to compile correctly. To do this click Project > Add Existing Item and add the files *jpegD.lib*, *pngD.lib*, and *zlibD.lib* to the project. Ensure that you have the root folder for the project selected in the right panel; otherwise, the files are added into the selected subfolder. These .lib files can be found in their relative folders under Apocalyx/dev/lib.

 *When adding a .lib file in MVSN, the Add Existing Item window automatically filters the files in the folder being viewed. If you cannot see for example, pngD.lib in Apocalyx/dev/lib, make sure you have the filter in the text box Files of Type at the bottom of the Add Existing Item window set to *.*.*

Next we must set the working directory for the project. Click Project > Properties from the main menu and select Debugging under Configuration Properties. In the right panel, locate the text box for Working Directory and type the directory you want to be the default directory for your project, as shown in Figure 1.9. This directory is the one that MVSN looks in first when searching for files to use in your program.

While this window is open, set up the linker dependencies for the project. In this case we want to link with the OpenGL library files *opengl32.lib* and *glu32.lib*. If you are using Windows XP, these file should already exist on your computer. If you do not have the files, you can download them from *www.opengl.org*. To link to these files, select Linker and Input from the Configuration Properties and type `opengl32.lib` and `glu32.lib` in the Additional Dependencies text box, as shown in Figure 1.10.

21

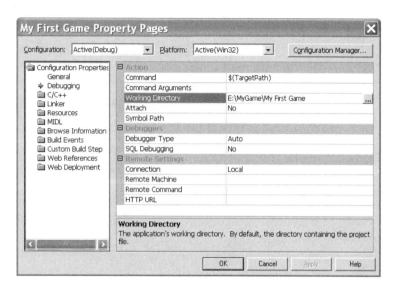

FIGURE 1.9 Setting the default working directory for a project.

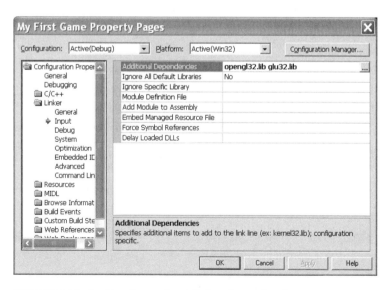

FIGURE 1.10 Setting the projects linker dependencies.

Make one final setting change in the properties window: change the setting of Enable Run Time Type Info in the C/C++ > Language configuration folder to Yes. When you finish, click Apply, then OK to close the window.

You are now ready to write the code for your game that will link with the Apocalyx game engine. Start by creating a new text file in your project. To do this, right-click the Source Files subfolder for the Project in the right panel of the programming interface and click Add > Add New Item from the shortcut menu. A window opens, as shown in Figure 1.11, prompting for the type of file to be created and the name of the file. Ensure the file is a .cpp file and call it *My First Game.cpp*.

After you create the file, a new tab in the programming interface appears on the left, above the large text box named after your file. When you select this tab, the code in your file is displayed in the large text box. If this file is new, the text box appears to be empty. Figure 1.11 shows the file after some code has been entered.

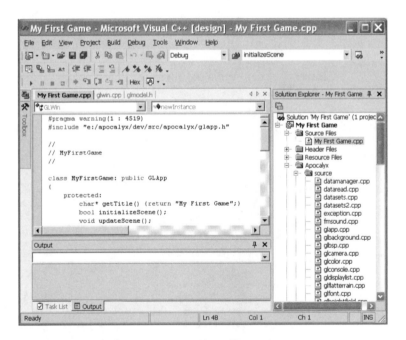

FIGURE 1.11 Creating a new text file in the project.

The code that you write for your game will be unlike the code you are used to if you haven't used a games engine before. The biggest difference you will find is that there is no main() function. The main() function resides in the *glwin.cpp* file, which belongs to Apocalyx. The main objective of the code is the same as that outlined in Listing 1.1. If you are unfamiliar with Windows programming, this code may ap-

pear a little strange. Novice programmers are encouraged to find and read a good introduction to Windows programming such as that contained in *Tricks of the Windows Game Programming Gurus* [Lamothe99].

An outline of the basic code (contained in Apocalyx/dev/src/glwin.cpp) follows:

```
int WINAPI WinMain()
{
    //create a pointer to the game window
    GLWin* glWin;
    //gather resources for the new window
    glWin = GLWin::newInstance(lpCmdLine);
    //create the new window
    glWin->createWindow();

    //while the game window is still open
    //begin main game loop
    while(glWin->isRunning())
    {
        //process and translate messages
        if(PeekMessage(&msg,NULL,0,0,PM_REMOVE))
        {
            //if user wants to quit finish loop
            if(msg.message == WM_QUIT)
            {
                break;
            }
            else
            {
                TranslateMessage(&msg);
                DispatchMessage(&msg);
            }
        }
        else
        {
            //update main game logic
            glWin->updateScene();
            //update graphics rendering
            glWin->executeRendering();
        }
    }

    //destroy game window
    glWin->destroyWindow();
    //release resources
```

```
        delete glWin;
        return 0;
}
```

If this is the main game code, how does it connect to your program? The linkage begins with the first line in the preceding code: glWin = GLWin::newInstance(lpCmdLine). The code for the newInstance() method resides in your game code in the *My First Game.cpp* file. This line kicks off the whole program and puts your game code in charge (well, almost) of the game environment. The bare minimum amount of code needed in *My First Game.cpp* to load the Apocalyx games engine is shown in Listing 1.2.

LISTING 1.2 Initial code for *My First Game.cpp*

```
#pragma warning(1 : 4519)
//NOTE: change the paths for the following to the location
//of your apocalyx files
#include "e:/apocalyx/dev/src/apocalyx/glapp.h"
#include "e:/apocalyx/dev/src/apocalyx/glbsp.h"
#include "e:/apocalyx/dev/src/apocalyx/glmodel.h"
#include "e:/apocalyx/dev/src/apocalyx/phsimulator.cpp"
//
// MyFirstGame
//

class MyFirstGame: public GLApp
{
    protected:
        char* getTitle() {return "My First Game";}
        bool initializeScene();
        void updateScene();
        void finalizeScene();
    public:
        MyFirstGame();
};

//
// MyFirstGame
//

MyFirstGame::MyFirstGame() {}

//called from createWindow() via WinMain() in glwin.cpp
bool MyFirstGame::initializeScene()
```

```
    {
        return true;
    }

    //called from WinMain() in glwin.cpp
    void MyFirstGame::updateScene()
    {
    }

    //called from destroyWindow() via WinMain() in glwin.cpp
    void MyFirstGame::finalizeScene()
    {
        //destroy game environment
        finalizeCurrent();
    }

    //called from WinMain() in glwin.cpp
    GLWin* GLWin::newInstance(char* initStr) throw(Exception)
    {
        return new MyFirstGame();
    }
```

Each of the methods in Listing 1.2 are called from within the WinMain() func-
tion in *glwin.cpp*. initializeScene() is called from the createWindow() method,
which is called in WinMain() before the main game loop. Inside the main game loop
updateScene(), is called. After the main game loop finalizeScene() is called via the
destroyWindow() method.

Type the code from Listing 1.2 into the new *My First Game.cpp* window, then
save, compile, and run it. The Apocalyx game engine opens with a configuration
window, as shown in Figure 1.12. Select the screen setting you want to use and click
OK. When the Settings window closes, you see a black window with a menu option
in the lower-left corner. Press F1 to open and close this help menu.

1.7.4 Step Four: Rendering a 3D Game Environment and Navigation

The concepts required to load a game environment in which to walk around are
beyond the scope of this chapter. However, to give you a taste of things to come, we
now load a *Quake*-like map into our game and create a simple navigation method
to allow you to fly around the environment using the mouse and keyboard.

The file format used for storing environment maps read in by Apocalyx is that
of binary space partitioning (BSP). BSP files, which are also used by *Quake*, and are
easy to create with the right editing tools. We are not creating a map here, but a

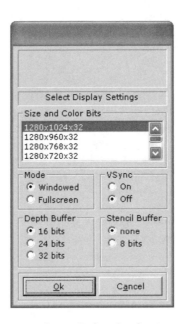

FIGURE 1.12 Startup settings window for the Apocalyx game engine.

primer on creating a 3D game map complete with textures and lights can be found in Appendix B. Instead we use an existing BSP file.

ON THE CD

In the Chapter One/practicals folder on the CD-ROM, you can find a file called *myfirstgame.pk3*. This file contains the BSP map and textures for the environment to be rendered in this practical exercise.

The first step in loading a BSP map into the game is to create a pointer to a map object. To do this include `GLBsp* bsp;` as a public property of the `MyFirstGame` class as follows:

```
class MyFirstGame: public GLApp
{
    public:
        GLBsp* bsp;
    protected:
        char* getTitle() {return "My First Game";}
        bool initializeScene();
        void updateScene();
        void finalizeScene();
    public:
        MyFirstGame();
};
```

Next, fill in the `initializeScene()` method with the following code:

```
setHelpMode(GLWin::REDUCED_HELP);
getCamera().setOrtho();
try
{
    setPerspective(60,0.1f*30,400*30);
    getWorld().setAmbient(0.2f,0.2f,0.2f);

    //open the pak file
    DRZipFile pak("myfirstgame.pk3");

    //extract the BSP map from the pak file
    bsp = pak.getLevel("maps/largemap.bsp",2.5f);
    bsp->setShowUnturedMeshes(true);
    bsp->setShowUnturedPatches(true);
    bsp->setVisible(true);
    getWorld().setScenery(bsp);
}
catch(Exception& e)
{
    return false;
}
return true;
```

The code for the `initialize()` method locates the BSP map and renders it as the game environment.

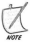

Most of the code that you see in this section is based on the graphics rendering of OpenGL and is not discussed here. It is not essential that you know OpenGL to complete all the exercises in this book because most of the graphics rendering is handled by the Apocalyx engine and the code included in the practical exercises. Having said this, navigation in a 3D environment requires a sound knowledge of vector mathematics, which is covered in Chapter 2.

To move around inside the map, the player must be able to change his point of view. This means moving a camera around the map and taking snapshots at different locations as the player seemingly moves. In this practical exercise we allow the player to move around the map using the mouse to change direction, the up arrow key to move forward, and the down arrow key to move backward. Recall that the graphics rendering is updated within the main game loop of the program. The only part of our program that gets called within the loop is `updateScene()`. Therefore, the following code to move the player and change his point of view should go in there:

```
GLCamera& camera = getCamera();
float timeStep = GLWin::getTimeStep();

//speed at which to rotate players view if they turn
const float rotAngle = 0.15f*timeStep;

//if the up or down arrow keys are pressed
if(isKeyPressed(VK_UP) >> isKeyPressed(VK_DOWN))
{
    BSPVector pos(camera.getPositionX(),
        camera.getPositionY(), camera.getPositionZ());
    BSPVector vel(0,0,0);
    const float moveSpeed = 10*30;

    //positive movement for up arrow
    //negative movement for down arrow
    const float k = timeStep*(isKeyPressed(VK_UP)?
        moveSpeed: —moveSpeed);
    vel.set(
        camera.getViewDirectionX()*k,
        camera.getViewDirectionY()*k,
        camera.getViewDirectionZ()*k
    );
    camera.setPosition(pos.x + vel.x, pos.y + vel.y, pos.z + vel.z);
}

//observe changes in the x and y movements of the mouse
const int dx = getMouseDX();
const int dy = getMouseDY();
if(dx != 0) camera.rotateStanding(—dx*rotAngle);
if(dy != 0) camera.pitch(—dy*rotAngle);
```

This code acts by assuming the player's view of the environment is seen through a camera that takes snapshots and places them on the computer screen. Therefore, when the player wishes to move, the camera moves appropriately.

Save, compile, and run your new code. The program loads the BSP file from *myfirstgame.pk3* and renders it on the screen. If your program cannot find the .pk3 file, check that you have the working directory for your project set correctly. (See "Step Three: Creating a Simple Program Linked to the Apocalyx Game Engine.") You can fly around within the map using the mouse and keyboard to change direction. When rendered, your game environment will look like that shown in Figure 1.13.

FIGURE 1.13 A BSP map rendered by the Apocalyx game engine.

Although you haven't created an actual game during this practical exercise, you are now equipped with the knowledge to write a program that uses the Apocalyx engine. In the following chapters the Apocalyx engine is used to test AI code to control the behaviors of your own bots. The techniques that you can expect to use in later practical exercises are described in the next section.

1.8 THE USE OF AI IN CHARACTER PROGRAMMING

Most of the convincing performances given by NPCs in games come not only from their outward appearances and animations but also from the programming that drives their behavior. As we have already discussed, game players want the NPCs to act more intelligently and unpredictably and to appear as though they understand what is going on in their environment and can adapt to changes in game play. This type of behavior in a real-time game is beyond the capabilities of precreated animations, prerecorded conversations, and prewritten story scripts. A dynamic environment requires on-the-fly decisions to be made by the NPC on how to react and plan for changing game environment futures. To create such capabilities in NPCs, game programmers turn to the field of AI.

To create such capabilities in NPCs, game programmers turn to the field of AI. In the academic sense, mainstream AI covers a plethora of techniques used to emulate the intelligent nature of human cognition and behavior for a variety of applications, from air-traffic controlling and landing a space shuttle to predicting the weather and approving loan applications. Many of the techniques employed have been found useful in improving the believability of NPCs. In this section, we elucidate a number of the techniques currently in use, give some examples (taken from [Woodcock03]) of where they have been implemented in games, and provide pointers to where they are discussed and used in this book.

Rule-Based Systems: These systems, the simplest form of AI, consist of a set of facts that represent the state of the system, a set of rules that specify the actions that should be taken when the system reaches certain states, and a set of conditions that determine how the facts and rules are used. The most basic form of a rule-based system is a set of IF THEN statements, such as those you would program in C/C++ and other programming languages. For example, an NPC might be programmed with a series of rules that determines how it should dress given the weather. These rules might include "if it is raining take an umbrella" and "if it is snowing wear a coat." For these rules to be applied, the NPC must notice facts about its environment that make the IF part of the rule true. When a rule is found to be true it is fired and the appropriate action taken. In this example, if the NPC notices that it is raining, then the appropriate action will be to take an umbrella. Games that use rule-based AI include *Baldur's Gate*, *FX Fighter*, and *Terra Nova*. Rules and their logic are discussed in Chapter 4.

Fuzzy Logic: This system attempts to model the decision-making process that humans use when faced with vague information. Terms such as *hot* or *very hot* are dealt with instead of the discrete values of 1 and 0. The fuzzy values dealt with are represented on a sliding scale and, depending on the decision being made and the input data, can produce differing values each time they are used. For example, describing the weather as hot and describing a fire as hot infer different values for hot in each case, even though the same terminology is used. Soldiers in the game *Close Combat 2* are programmed to make a decision on what action to perform by feeding hundreds of environment variables through a fuzzy logic system. Fuzzy logic is examined in detail in Chapter 4.

State Machines: State machines—in particular, finite state machines—are a tried and true AI method implemented in many games. In brief, a finite state machine represents each of an NPC's possible states in a graph that dictates how the NPC can move from one state to another. For example, let's say the NPC is in the state *hungry*, and it wants to get to the state *full*. In our own experience we know that to stop being hungry we need to eat something. In a finite state machine for this NPC, the states *hungry* and *full* exist along with the

definition of a *state transition function* called *eat* that dictates to the NPC how it can stop being hungry. Most state transitions are also directed, which means they do not work in reverse order. For example, an NPC cannot go from being full to being hungry by eating. Other state machines that extend and enhance the functions of finite state machines include fuzzy state machines, probabilistic state machines, and hierarchical state machines. State machines are implemented in games such as *Age of Empires*, *Half-Life*, *The Sims*, and *Enemy Nations*. State machines are introduced in Chapter 5.

Decision Trees: Decision trees represent a series of complex IF THEN rules structured into a treelike graph. The graph begins at a single root node and branches into child nodes that represent different decision paths. A particular path through the tree is followed according to input values. When a followed path ends, the terminal node represents the decision made. Decision trees are used in the game *Black & White* to control the actions and emotions of one of the main characters, the creature. Decision trees are further examined in Chapter 5.

Evolutionary Computing: This field of AI explores the use of biologically inspired concepts in the creation of algorithms in an attempt to build programs that can learn and breed better and improved programs. Research areas within this field include A-Life and genetic algorithms. In the game *Nooks and Crannies* A-Life technology is implemented in the life-forms a player finds on a desolate planet. The player can breed new life-forms from the existing ones. As in real life, the child life-forms inherit certain characteristics and behaviors from both parents. Genetic algorithms are implemented in *Return Fire II* to improve the performance of the NPCs' fighting strategies. The final NPCs present in the game are the product of the analysis of thousands of games that provide them with abilities worthy of a human opponent. A-Life techniques are discussed throughout the book with respect to creating believable characters; genetic algorithms are examined in detail in Chapter 5.

Neural Networks: These learning systems are based on the structure of the human brain. They consist of a series of neurons with interconnecting pathways. Input fed into the neural network is manipulated by the neurons and a result is given. The neural network is trained using known input and output. These values are repeatedly fed through the network and the paths and neurons adjusted so the required output is achieved. The network can then be used to assess the output for new and previously unknown input data. Virtually every NPC in *Battlecruiser: 3000 AD* is controlled by a neural network. The neural network controls their behavior with respect to navigation, negotiations, trading, and combat. Neural network theory is discussed in Chapter 5 and used in an application for generating synthetic emotions in Chapter 7.

Natural Language Processing: This technique uses a spoken language such as English to communicate with a computer. Natural language can be given as verbal input and passed through a speech-recognition algorithm before being processed or it can be input as text. Natural language can also be used by the computer to communicate with the user. This type of communication allows for a greater degree of natural interaction between a human and an NPC. Natural language processing is implemented in *The Chronicles of Januu Tenk* to allow the player to speak with his virtual pet/AI companion. Natural language learning was planned to be a part of *Black & White* to enhance the NPCs; however, developmental time restrictions required it to be omitted. This topic is discussed in Chapter 7.

Extensible AI Scripting: This method is employed by a number of games engines including *Quake* and *Unreal*, which give the player the ability to design and customize the behavior of the NPCs in the game. The technique involves the creation of a text file containing simplified code that calls methods from the main game engine. The code is usually in the form of a restricted syntactical set of a particular programming language such as C/C++. Scripting allows the player to override the default behavior of an NPC by rewriting parts of the original AI code. For example, an NPC might be programmed to immediately attack the player upon seeing him. If this is not the desired behavior for the NPC, the player can rewrite the code that may make the NPC freeze in place rather than attack upon sight of the player. As scripting is more of a reprogramming technique than an AI domain and is specific to the game engine for which it is being written, it is not explicitly covered in this book. Having said this, there is no reason why the techniques explored in this book cannot be used to reprogram a *Quake* or *Unreal* bot.

1.9 THE STRUCTURE OF THIS BOOK

We have attempted, in this book, to broadly cover most issues related to the creation and programming of believable NPCs. Although a thorough examination of all issues is not possible, we have endeavored to provide you with enough background knowledge in all topics to make this book a diving board from which to jump into particular areas of interest. In brief, this book covers believability programming with respect to the NPCs' appearance, competitive behavior, humanlike reasoning and learning abilities, goal-setting, communication, and emotions.

We have begun this book by examining the nature of NPCs and how they are used in games. This chapter has examined a brief history of the use of NPCs to enhance game play and how an NPC's code is integrated with the game program. To

give you a crash course in games programming, a practical exercise was included to explain the nature of the Apocalyx 3D game engine.

In Chapter 2, we cover the embodiment of NPCs from the perspective of modeling human figures with information about body proportions and the physics of movement necessary for the creation of a believable being. We also examine how the NPC's animation is best used for interaction with the game player. The practical exercises covered in Chapter 2 introduce you to hands-on 3D modeling using Milkshape and the creation of an NPC for importing into the Apocalyx game engine to be used as a bot.

Chapter 3 covers the topic of games theory. Games theory has been an area of interest in mathematics, psychology, economics, and many other domains since the 1930s. The mathematical theorems used in games theory explain the way in which people behave in competitive situations. Understanding how humans behave in competitive situations is imperative in emulating the same behaviors in a believable artificial being. This chapter covers a wide spectrum of topics under the games theory umbrella and instructs you in analyzing competitive situations to determine the best player moves. The chapter concludes by examining the use of games theory in creating competitive NPCs with balanced skill sets.

The main topic of Chapter 4 is knowledge representation. In this chapter you learn how an NPC can be programmed to store its beliefs and information gathered from its environment in a structured and logical manner. The information contained within the NPC's knowledge base is paramount in its attempt to exhibit believable behaviors, in that it is used in the processes of learning, goal setting, planning, and memory management, to name a few. This chapter covers propositional logic, first-order logic, temporal logic, and probability theory. The AI programming language PROLOG is used in practical exercises to explore the creation of a knowledge base and reasoning techniques that can be used by the NPC for making deductions. The chapter concludes by taking a look at the more complex reasoning techniques of Bayesian networks, and fuzzy logic, which attempt to model humanlike reasoning.

Chapter 5 begins by examining some traditional AI techniques used in games from state machines to searching algorithms used for navigation. Following this, more complex AI techniques used for learning and adaptation, including decision trees, genetic algorithms, and artificial neural networks, are examined. The chapter also provides practical exercises for building and experimenting with these techniques.

In Chapter 6 we examine the architectures of autonomous artificial beings, known in the AI realm as agents. Varying agent architectures from the very simple to the highly complex are examined. In the discussion we also illustrate some existing agent architectures that have been modified to be used as NPCs in games. During the chapter you encounter practical exercises focused on the creation of each

type of agent and how these agents can be used as NPCs in the Apocalyx environment to imitate humanlike behavior.

Finally, Chapter 7 steps away from the hard-core AI of agents to consider the necessary elements of a believable agent. It discusses how the perceived intelligence of such an agent is more important than the clinical AI definition of intelligence. The issue and importance of social interaction is reviewed and practical exercises in the synthesis of emotions and generation of natural language in NPCs are examined.

1.10 SUMMARY

With the massive skill set required to be a games programmer, the task is usually assigned to a group of programmers with varying skills to cover the essential areas. However, it is often necessary for each programmer to have an overview of all concepts and techniques in use to help fuse the development team and provide the opportunity for group discussion on the project at hand. This book endeavors to give you a thorough overview of the issues involved in developing believable non-player characters for games.

The NPC has evolved over the years from a simple, reactive object in the game environment to a sophisticated digital entity capable of goal-orientated planning, believable user interaction, and expression of emotion. With the overwhelmingly fast growth in the technology involving graphics and sound in games and with the advent of dedicated gaming machines, players are beginning to demand more believable and intelligent NPCs in the games to enhance their playing experience. Although AI in games has lagged behind graphics and sound in the past, we are now at the beginning of a new frontier where academic expertise in AI and the sharing of research between game developers and academics is providing much thrust for the realization of more complex and believable NPCs.

REFERENCES

[Lamothe99] Lamothe, A., 1999, *Tricks of the Windows Game Programming Gurus*, SAMS, Indiana.

[Luther02] Luther, J., 2002, *What's in a Game? A Linguistic History of "Video Game,"* available online at *http://www.gamesfirst.com/articles/jluther/etymology/etymology.htm*, September 2003.

[Schreiner03] Schreiner, T., 2003, *Artificial Intelligence in Game Design*, available online at *http://ai-depot.com/gameai/design.html*, January 2004.

[Stern99] Stern, A., 1999, AI Beyond Computer Games, *Presented at AAAI Symposium on Computer Games and Artificial Intelligence*, available online at *http://www.lggwg.com/wolff/aigc99/ stern.html*, May 2001.

[Sweetser03] Sweetser, P., Johnson, D., Sweetser, J. & Wiles, J., 2003, Creating Engaging Artificial Characters for Games, *Proceedings of the Second International Conference on Entertainment Computing*, Kluwer, pp. 1–8.

[Turkle94] Turkle, S., 1994, Constructions and Reconstructions of Self in Virtual Reality: Playing in the MUDs, *Mind, Culture and Activity*, vol. 1, no. 3.

[Watt01] Watt, A. & Policarpo, F., 2001, *3D Games: Real-time Rendering and Software Technology*, Addison-Wesley

[West98] West, N., 1998, The Way Games Ought to Be, Next Generation, Imagine Media Inc., Brisbane, CA, March 1998, pp. 104–105.

[Woodcock03] Woodcock, S. M., 2003, Games Making Interesting Use of Artificial Intelligence Techniques, available online at *http://www.gameai.com*, January 2004.

[Zubek02] Zubek, R. & Khoo, A., 2002, Making the Human Care: On Building Engaging Bots, *Proceedings of the 2002 AAAI Spring Symposium on Artificial Intelligences and Interactive Entertainment*. Palo Alto, California, pp. 103–108.

2 ⋮ The Embodiment of Artificial Players

In This Chapter

- The proportions of the human body and practical modeling
- The creation and use of animation
- Kinematics and kinetics
- The import of a model from 3D modeling software into a games engine

2.1 INTRODUCTION

Unfortunately, the old adage "you can't judge a book by its cover" doesn't apply to computer game characters. By this, we don't mean the ugliest looking characters couldn't turn out to be the worthiest of adversaries, but that the outward appearance and behavior of a computerized character is all the player has to interact with. To create the suspension of disbelief that so many game players crave, animators and programmers must present a believable character with acceptable looks, movements, and behaviors in line with those of humans or other real-life creatures. Whether complex AI procedures drive these outward performances is not the issue; whether the game player can be led to believe the character is more than the sum of its pixels and programming is the real problem. All the sweat and tears put into developing complex personalities capable of producing emotions and autonomous behaviors is lost if the outward persona of the character cannot carry out and complete the fantasy. What use is an intricate emotion-producing engine, capable of generating 20 or so emotions, to a character that can only smile and frown?

Disney animators Thomas and Johnson [Thomas81] describe the art of creating believable animated characters as the ability to use motion, sound, form, color, and staging to reveal the inner personality of a character. Their method works by making the characters behave in a way the audience expects, and what the audience expects is interpolated from their knowledge of the character's personality, beliefs, and desires. Predictions are often made about a character's behavior based on the

beliefs of the audience, rather than on the character's own beliefs. In a way, this type of expectation of what a character will do next is anthropomorphic, in that the audience attempts to interpret what is not human (a computerized character) in terms of human or personal characteristics. This type of projection works not only on humanoid characters but also on fictional characters. For example, although Dreamwork's ogre, Shrek, obviously is not human, the audience related to Shrek and could empathize with his behavior not only by understanding parts of his personality revealed during the story but by putting themselves in his shoes.

Before examining the behavioral aspects and internal workings of a virtual character in later chapters, we begin here with the most fundamental part of the character—the model. In this chapter we examine the facade of games characters. The discussion begins with a look at the modeling of a humanoid figure and progresses into practical modeling exercises and an in-depth examination of human movement and animation creation.

2.2 HUMAN PROPORTIONS

The examination of human proportions has its roots in both art and biology. Whereas biology insists on exact measurements, artists—especially those working from images in their minds—are not afforded that luxury. If you were asked to draw a human figure without a model, would you know how big the head should be in proportion to the rest of the body?

A few simple proportional rules can assist artists in their drawings of the human body [Jusko03]. Often the proportions are measured, not in centimeters or other familiar measuring units, but in heads. The body is first divided in half horizontally. Each half is exactly four heads in height. This method is illustrated in Figure 2.1 (a). The centerline, called the bend line, is the location of the natural bend of the human waistline. Next, the neck, shoulders, and hips are added. The shoulders are represented as two heads lying on their sides. The upper part of the torso is moved down by one-quarter the height of the head, and the shoulders are added at the top. This step is shown in Figure 2.1 (b). The downward movement of the upper torso also creates the one-quarter head height overlap of the hips and lower body.

Figure 2.1 (c) completes the illustration of human proportions. The shoulder line creates the top of the torso triangle. The upper-left and right corners of the torso triangle are located where the shoulder line intersects the shoulder ovals. The lower corner of the torso triangle is in the horizontal center of the body at the bend line. A bend line triangle can also be formed to fill the pelvic area between the hips

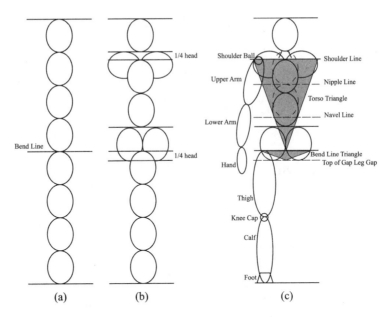

FIGURE 2.1 The proportions of the human body. a) Body divided in half by four head heights; b) Adding the shoulders and hips; c) Complete illustration of human proportions.

and the top of the gap between the legs. Just below the gap between the legs is the widest part of the pelvic region. The neck fills in the quarter-head height gap between the head and the shoulder line. The nipple line is one head height from the chin (the top of the neck) down the torso, and the navel line is another head height below this.

The arms begin at the upper corners of the torso triangle with the shoulder ball, which is represented by a circle one-quarter head heights in diameter. From the shoulder ball extends the upper arm. The upper arm is one-and-a-half head heights in length. Connected to the upper arm is the lower arm, which measures one-and-a-quarter head heights. Finally, the hand is three-quarters head heights in length.

The legs start at the upper corner of the bend line triangle. The thigh measures two head heights in length. This is connected to the kneecap. The kneecap is represented by a circle one-quarter head heights in diameter. Below this is the lower leg or calf. It extends two head heights to the ground. The foot is connected to the calf by an ankle point, which is one-quarter head heights from the ground.

Other body proportions are left to the creative mind of the artist. For example, not all arms that are the same length have the same thickness. Muscle structure, fat deposits, and bone width determine the final thicknesses of the parts of the body.

For this reason we all have different body shapes; clothing manufactures do not produce clothing sizes based on height alone.

When the final design of the virtual human has been decided, the model must be transformed into a digital representation for manipulation in its virtual world. You have numerous ways to achieve this, and the method you select depends on the intended final use of the model.

2.3 DAY OF RECKONING: CREATING A VIRTUAL HUMAN

In this practical exercise you learn how to use Milkshape to create the basic structure of a virtual human that will later be uploaded into the Apocalyx game engine. Milkshape is an inexpensive 3D-modeling software package that enables the easy creation of three-dimensional structures.

ON THE CD

A shareware version of the software is available on the CD-ROM and can be registered for a small fee (approximately $25 at the time of this publication) with the creator. (See *www.swissquake.ch/chumbalum-soft/*.) The software has all the essential functions that you also find in commercial products such as Maya® and 3ds max™. Milkshape can be installed from the installation archive in the Software/Milkshape folder on the CD-ROM.

2.3.1 Step One: Installing Milkshape

Unzip the Milkshape installation archive into a temporary directory. The Zip file contains just one file, *setup.exe*. Double-click this file and follow the setup instructions.

2.3.2 Step Two: Milkshape Orientation

When you run Milkshape, you are presented with the window shown in Figure 2.2. This window contains a number of different viewing windows. You can modify these as you wish. The image in Figure 2.2 has an object drawn in it to demonstrate the different views. When you first load Milkshape the windows are empty. You can modify the number of windows in view by clicking Window > Viewports and then the configuration from the menu. To change the view in the window, right-click in the desired window and select Projection from the shortcut menu. From here you can change the view of each separate window.

On the right side of the Milkshape workspace is a toolbar. You will become familiar with this toolbar because it contains most of the functions needed to create and manipulate a model. You also have a number of ways to view a model. You can

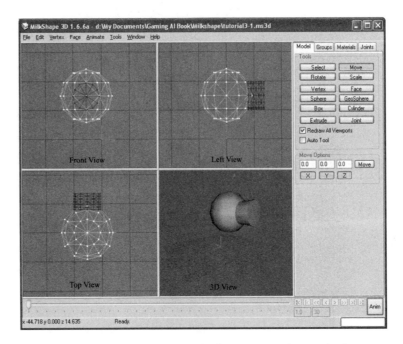

FIGURE 2.2 Milkshape interface displaying Front View, Left View, Top
View, and 3D View.

select from Wireframe, Flat Shaded, Smooth Shaded, or Textured. An example of
each view is shown in Figure 2.3. You will often find it best to work in Wireframe
view because the visible mesh vertexes are the parts of the image that you want to
manipulate. When viewing the model in 3D, it is a good idea to have a shaded or
textured view so the model appears solid.

Often you want to move the contents of the windows and zoom in and out as
your model grows. You may want to write these next commands down and stick
them on your computer monitor because they are the ones you will use the most.
To move the view in the window from side to side, press Ctrl and click and drag the
mouse from side to side in the view that you want to reposition. You can try this
without having drawn anything—the grid pattern moves up and down and left and
right. Next, to zoom in and out, press Shift and click and drag the mouse up to
zoom in and down to zoom out. If this method doesn't appear to work, make sure
that you do not have any of the tools selected on the Model tab of the toolbar. Be-
sides moving and zooming the usual views, you can also rotate the 3D view by
clicking and dragging the mouse around inside the window without pressing any
keys.

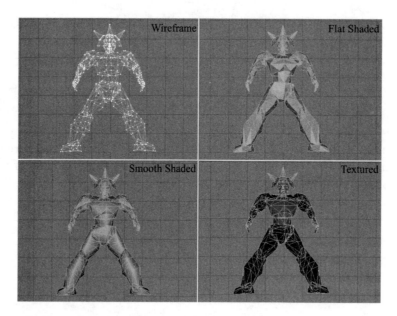

FIGURE 2.3 Model views in Milkshape.

2.3.3 Step Three: Drawing a Head

Let's begin our virtual human by drawing the head. A head is basically a sphere, so we begin by drawing one. According to the dimensions of a human body, as discussed in the previous section, the head is about one-eighth the height of the entire body. The head should be about 10 units in size. (See the mouse locator coordinates in the lower-left corner of the workspace.) Locate the origin on the grid. In the front view, the origin appears as a vertical blue line connected to a horizontal yellow line. The origin is where the model's feet will be placed; therefore, we must count up 80 units to position the head. Move the mouse up from the origin until the y-coordinate reads close to 80. Before you begin drawing you may want to change the view by clicking Window > Viewports > 3 Window (1 left, 2 right). Right-click in the left window and set the Projection to Front View. Most of the initial drawing occurs in the Front View; therefore, it is best if it is the largest window. If you set the lower-right window's projection to 3D, you can see your model come alive as you draw it.

To draw the head, click Sphere on the Model tab of the toolbar. Place the mouse in the Front View, then click and drag out a sphere, eight squares up from the origin and about one square in size (as shown in Figure 2.4 (a)). The sphere appears red, which means that it is currently selected. If you don't quite have the sphere in the right place, click Move on the toolbar, then drag the sphere into place. When the sphere is located where you want it, click Move again to turn the com-

mand off. Then press Shift and drag the Front View window to zoom in on the head. To create a simple nose feature on the sphere, first unselect the sphere by pressing Ctrl + Shift + A. Now click Select in the toolbar, click Vertex, then click the vertex in the Front View where you want the nose to be (usually in the center of the face). The selected vertex turns red. Because the sphere is symmetrical, when you select a vertex in Front View, you may not be entirely sure whether you selected a vertex on the front side or back side of the sphere. If you set the projection for the upper-left window to Top View, you will see that two vertices are selected. This is not what we want. We want only the vertex on the front side of the sphere. With Select still chosen, click in the Front View, away from the model. This action deselects any selected points. Now, make sure the Ignore Backfaces checkbox is selected on the toolbar. This option ensures that the next time you click the nose vertex, the front-most one is selected. Try selecting the nose again and check out the selection in the Top View.

(a) (b) (c) (d)

(e) (f) (g) (h)

FIGURE 2.4 Modeling in Milkshape. a) Drawing a sphere for the head; b) Dragging out a nose; c) Creating a cube for the upper torso; d) Extruding an existing shape; e) Scaling a shape to create definition; f) Completing the torso; g) Adding the arms; h) Completing the body.

To drag out the nose, click Move. In the Top View drag the nose vertex down. Notice in the 3D View the sphere now has a conelike structure poking out. (See Figure 2.4 (b).) To make a more serious-looking nose you can continue to select other vertices on the front of the face and move them about in either the Front View or Top View. Just remember to use Select to select the vertex and Move to move it.

2.3.4 Step Four: Extruding the Body

The next step is to draw the rest of the body. If you aren't a modeler, then this task may seem like a nightmare, but if you keep to the previously given body dimensions you should end up with something that doesn't look half bad.

The chest is made out of a cube. Click Box in the toolbar and drag out a cube about the same size as the head. Position the cube as shown in Figure 2.4 (c). This cube is probably a little too thick for the chest and shoulders, so let's scale it down. With the cube still selected, click Scale in the toolbar. Making sure the X and Y buttons are off and the Z button is on, set the Z scale to 0.8. Click Scale. In the Top View and the 3D View you see the cube shrink in the z-direction. This is probably still a little too wide, so click Scale again. Check out the 3D View to see how the cube has changed. This cube will be one side of the chest; the other side will be exactly the same.

Change the Top View to the Right View. Click Select, click Face, and ensure Ignore Backfaces is selected and By Vertex is not selected. In the Right View click the cube in the upper-left triangle. Notice in the Front View that the right side of the cube is now selected. We want to select the entire right face, but currently only half of it is selected. Now press Shift and click in the lower-left triangle in the Right View. The whole cube should appear selected, but in the Front View only the right side is. You can use Shift at any time to select multiple vertices or faces. To create the other side of the chest we extrude the right face. Click Extrude in the toolbar. Click in the Front View to the right of the cube and drag the face out toward the right to create another cube, as shown in Figure 2.4 (d).

Milkshape represents all solid objects as a series of connected triangles. The triangles form a polygon mesh. Each triangle is one face on a solid and can be selected by clicking inside.

To taper the chest into a waist, change the Right View to a Bottom View, click Select, click Face, and make sure both Ignore Backfaces and By Vertex are selected. In the Bottom View, press Shift and click each of the four corners of the chest. Notice in the Front View that the bottom face of the chest is selected. Now click Scale and set the X, Y, and Z values to 0.8. Making sure the X, Y, and Z buttons are se-

lected, click Scale. The bottom face of the chest should be reduced, as shown in Figure 2.4 (e).

With the bottom face still selected, click Extrude and drag the face down in the Front View to create a waistline about the size of one head. Now extrude downward again to create another set of boxes the same size as the waist. Click Scale and set the X, Y, and Z values to 1.2. Click Scale twice to create the hips. At this point the Front View of the model looks like that shown in Figure 2.4 (f).

Although this model is very basic, it will give you practice using the Milkshape tools. At any point during the drawing you can use Select and Move to move vertices around to give the model more form.

If you are having trouble selecting a vertex or face, you may need to move the object to another location. For example, if you have drawn an arm and it appears behind the torso in the side view, you will have difficulty selecting any of its faces without selecting parts of the torso. The best thing to do in this case is move the entire arm in the side view so that it is completely free of the torso and you can clearly see its vertices. When you have finished modifying the object, move it back into position using the Move command on the toolbar.

2.3.5 Step Five: Drawing the Arms and Legs

You draw the arms and legs of the model using the same methods you used for the body, namely, extruding and scaling. To begin drawing an arm, draw a box about one-quarter the size of the head near the left shoulder but a short distance away from the body. (We will position the arm later.) Select the left face. (You may need to go into the Right View for this.) Click Scale and scale the face by 1.2 in the x-, y-, and z-directions. Extrude another box from the scaled face about half as wide as the last one. Extrude another box about the same size as the first (one-quarter of the head), and scale the final face by 0.8 in the x-, y-, and z-directions. Click Scale twice to make a narrow elbow joint. Continue in this fashion to create the lower arm and hand, as shown in Figure 2.4 (g).

When you have completed the arm, select the entire arm by clicking Select > Face and dragging out a large rectangle around all the arm vertices. When the arm is selected, click Move and move the arm into place. Leaving the arm selected, again click Select and press Ctrl + D. This key combination creates a duplicate arm that we can use for the other arm. Unfortunately, the duplicate arm is in the same position as the original arm; therefore, you are unable to see it. To create a mirrored version of the arm for the other side of the body, click Vertex > Mirror Left <--> Right from the menu. This command mirrors the arm for you and selects it. Now all that is left to do is to click Move and move the new arm into place.

You can create the legs in exactly the same way. Draw one leg using Extrude and Scale, duplicate it, then mirror it. Your final model may look something like that shown in Figure 2.4 (h).

Be sure to save your model intermittently to avoid any losses if your computer crashes or you change your model beyond repair. Nothing is more frustrating than having to start over from scratch when you are almost finished. You should always save your work for later use at the end of all Day of Reckoning sections.

2.4 BODY LANGUAGE

Body language is a form of nonverbal communication conveyed through elements such as clothing, touch, gestures, movements, postures, and facial expressions. Character movement (through animation) is the only way the viewer has of knowing what the character is doing. For example, if the character is running, then the viewer perceives the character is running. However, further insight as to why the character is running is not possible unless the viewer knows the circumstances that caused the character to run. In addition to the action of running, body language, other than the action itself, could be incorporated to give the viewer more information. For example, a fearful facial expression can convey that the character is running away from something. Body language can communicate certain qualities such as personality, intentions, desires, emotional states, and abilities.

Five specific categories of body language can be used separately or in any combination to convey nonverbal communications. Each of these categories can be applied to the outward appearance, poses, or movements of an NPC to enhance its believability and improve its communication techniques. The categories are artifacts, haptics, chronemics, kinesics, and proxemics.

2.4.1 Artifacts

Artifacts relate to the use of objects or clothing to express the conveyor's interests, personality, and lifestyle. For a computer game character, artifacts can be effective in communicating the character's persona to the human player. Without interacting with the character, the player can instantly form an opinion of the character and associate it with known stereotypes. Artifacts immediately give the player a lot of information about the character's beliefs, desires, and intentions, which would otherwise take much longer in the form of a narrative. For example, the character Leisure Suit Larry, in the game of the same name released by Sierra in 1987, portrayed a lot of information to the player just through the apparel of the character. The leisure suit, invented by Jerry Rosengarten in 1970, soon became known as the

sleaze-ure suit and was associated with an easy (in several meanings of the word!) lifestyle. Larry fits the stereotypical middle-aged swinger, whiskey-drinking, gambling disco dancer well. It is no surprise when players find out what Larry is actually like because they have already inferred much from the way he dresses.

Other examples of the use of artifacts include the clothing worn by characters in strategy and RPGs. Uniforms in particular are essential in allowing the player to distinguish between players on his own team and the opponents. Once upon a time, characters in FPS arena environments could be stereotyped into goodies and baddies through their physical characteristics. For example, the bigger and uglier they were, the more lethal and harder to kill. Nowadays a quick search on the Internet reveals the plethora of character models that can be included in a game, and often their outward appearances can be deceiving. In *Quake 3 Arena* colors are used to distinguish the sides of the players and characters.

The old adage "a picture is worth a thousand words" is true when it comes to computer game characters. Creators can take advantage of the human trait to group others, often through simple visual cues, into stereotypical groups, thus enormously reducing their own workload because much of the characters' setup is performed in the players' minds. The only problem the creators have is to ensure that the visual representation of the character cannot be misinterpreted by the player.

2.4.2 Haptics

Haptics is communicating through touch. A touch can be a handshake, a pat, a punch, or some other physical interaction. It can also mean direct feedback to the player through their controller. Touch can be directed toward the player or toward the character. A player can experience touch when his controller vibrates. For example, in *Colin McCrae's Rally 4* for the Xbox®, the player experiences haptics through vibrations in the controller when his car hits a tree or drives over rough terrain. A technology called TouchSense™ developed by Immersion® allows gamers to receive tactile cues through their mouses. A special mouse called the iFeel™ mouse, released in November 2000, by Logitech®, allows users to experience the games environment through the touch of different surfaces and by interacting with objects and other characters. Games such as *Unreal*, *Half-Life*, and *Elite Force* use this technology, which simulates the feel of different weapons. In the future it is envisaged that this technology will be able to tactilely represent effects such as slapping, a fish eating out of your hand, magical spell-casting, fur, poo, straw, and many others [IGN01].

Haptics can also be used to affect a character. For example, players can interact with objects in the virtual world of *Black & White* through the use of a giant hand icon. Also, *Petz* players can interact with their pet using a hand icon to treat their pet to a pat or a belly rub. Although haptics is about enhancing the gaming experi-

ence, it also provides players with a way of receiving and giving nonverbal cues from and to the game environment.

2.4.3 Chronemics

Chronemics is another method of nonverbal communication through the use of time. The way people use time portrays aspects of their personality to others. Time can be perceived through punctuality, speed of speech and movement, patience, and concentration thresholds. Chronemics is often applied by a game player to determine if a character has seen or heard him. For example, if the player is attempting to sneak up behind a character and steps on broken glass or something that makes a noise, the player might crouch and pause his movement for a certain amount of time to determine if the character heard him. Chronemics can also be used in games where time is taken to repair damage. For example, in dungeons-and-dragons games, the more injured a player is, the longer he must camp before he is fully healed. The use of chronemics is also obvious in simulation games such as *SimCity* or *The Sims* where, all activity is based around some clock.

2.4.4 Kinesics

Kinesics is the use of gestures to relay information or enhance verbal communication. Sign language for the hearing impaired can be considered a form of kinesics. The gesture could be as simple as a hand wave or as specific as a total language. The pitcher, catcher, and coach in a baseball game have a set of kinesics used to convey information to the pitcher as to what type of pitch to throw. In *The Sims*, kinesics is used to express the desires of the characters. One example is when a character's bladder indicator is at full. The character clutches his crotch, gets an excruciated look on his face, bends his knees, and bounces up and down. Beside the fact that a little thought bubble appears above his head with the image of a toilet, it is obvious from his body language that he needs to relieve himself. Kinesics can also be used in a subtle manner. For example, a character that walks tall appears confident, unlike a character that is slumped. In this way kinesics can not only send an instant message but also reveal more about a character's personality. Certain body movements, such as shaking, can convey a timid personality.

2.4.5 Proxemics

The final category of nonverbal communication is proxemics. This type of communication is conveyed using space. The use of space falls into two areas: physical and personal. Physical space is the positioning of objects in an area and the use of these objects. For example, in many game environments, such as *Halo*, the environment is fixed. This means the players and characters cannot change the position

of bulkheads, trees, and so on. Both characters and players can use the arrangement of the environment to their advantage. A player who finds a hidden yet ideal sniping position may communicate to other players that he is devious and untouchable. Hidden places can also be used by *Halo* characters to hide out until they recover from a battle. Personal space, on the other hand, is an invisible boundary surrounding a person. Different people may have different personal spaces. For example, people who live in cities often have smaller personal spaces than people who live in the country. A person invading another's personal space may seem threatening. In a strategy game, such as *Dark Reign*, an invading force placing its troops close to the opponent's camp would communicate an impending attack. Proxemics can also be used in games to define the range of certain weapons and attributes to a player or a character's location within the environment. In *Splinter Cell*, the player can get only within a certain safe distance of a proximity-triggered bomb or machine gun without being injured. In the case of the proximity-triggered machine gun, the player knows he can get much closer to the gun from behind to turn it off.

2.4.6 Other Uses

Body language can also be used to provide a level of deception by purposely giving the wrong signal, knowing how it will be interpreted by an opponent. For example, in a Real-Time Strategy (RTS) game, one player might place troops close to the opponent, suggesting an attack in one location, while preparing for an ambush in another location. A player might also signal surrender by coming out with his hands up, thus distracting the opponent while another player attacks from behind.

As previously suggested, body language not only informs the viewer of what the character is doing but also gives insight into its emotional state. Although humans have numerous complex emotional states, research has found that viewers can best recognize six universal emotions— sadness, anger, joy, fear, disgust, and surprise [Elkman72]. Humans can also express more ambiguous emotions, such as pride, combined with physical states like tiredness; however, these combinations are often interpreted in different ways by different people. If used in a game character, the viewer could get the wrong idea.

Nonverbal communication by facial expression can be enhanced by introducing other body movements. Many documented movements can suggest the state of mind of the conveyor. A shoulder shrug, for example, is a universal sign of resignation, uncertainty, and submissiveness. In *The Sims*, a character can show its unwillingness to perform a task by slumping its shoulders, crisscrossing its hands in front of its torso, and shaking its head. In fact, in a game of *The Sims*, the actual emotional state of the character is not known. All the player knows is whether the character is in a good mood or a bad mood by a mood-level indicator. All nonverbal communication takes place through body language without facial expression.

EXERCISE

1. Using a pencil, draw six circles side by side, roughly 1 inch in diameter, on a piece of paper. Imagine that each circle represents a human head. On each head draw a facial expression representing one of the universally recognizable emotional expressions. Try to draw the expressions in a different order than that listed in the text. Now have a friend or colleague attempt to guess what emotional states the faces are expressing.

2. Can you think of examples in games, other than the ones in the text, in which each of the nonverbal communication categories (artifacts, haptics, chronemics, kinesics, and proxemics) have been applied?

3. Describe how you would use each of the nonverbal communication categories to create an NPC stereotyped as 1) a terrorist, 2) a secretary, 3) a police officer, 4) a CIA undercover operative, and 5) a nerdy geek.

2.5 DIGITAL REPRESENTATION

NPCs are rarely static and require not only a motionless computerized representation but also a dynamic and expressive set of animations for interacting with their environment and the human player. Animation can be achieved through a number of digital methods, which are discussed in the next sections.

2.5.1 Keyframe and Tweening

Probably the simplest, least processor-hungry yet inflexible method of character animation is that of keyframing. This technique creates a sequence of still frames that when played back in sequence appear as an animation. The image in each frame is slightly different from the previous frame. When viewed at more than 20 frames per second, the human eye has difficulty distinguishing between individual frames and the image appears to move in a smooth fashion.

Several methods are available for creating keyframe animation. The first is using hand-drawn frames. This process can be quite laborious. For example, for 10 seconds of animation, you need at least 150 drawings. Stop-motion animation is another example of keyframe animation. In stop-motion animation, each frame is a photograph of a real-life or model scene. The movie *Chicken Run* was created using clay figures. After each photograph is taken, the animators move the figures slightly towards their final pose. For one second of film, the 40 animators who worked on *Chicken Run* had to capture 24 frames. Last but not least, to reduce the workload of the artist in creating each and every frame, a computer graphics technique called in-betweening (or tweening) can be used to interpolate the sequence of images needed to fill in an animation between a start and end frame. If the animator wants to have a car move along a street, he could draw the first frame and the last frame and have

the computer create all necessary in-between frames to complete the animation sequence. Another use of tweening is morphing. This process is taking one object and having it slowly turn into another. For example, Michael Jackson's music video for his song "Black and White" displays a number of people's heads (one at a time) singing the song. Instead of a hard cut from person to person, the clip creators made each head morph into the next to create an interesting effect. To save the editors and animators drawing each frame by hand, a computer was used to interpolate how the frames would merge one head into another. For this technique, the animators select key points on the heads that should morph into the associated points on the next head and the computer fills in the rest.

Although some fantastic effects can be created with keyframe animation, once the animation is complete there is no changing it. Of course, it can be edited; however, after the animation is used in a product such as a computer game, it is there to stay and the animation sequence is always the same. For example, keyframe animation is used in the *Quake* character files. There can be many sequences designed to represent different behaviors. There would be a keyframe animation for walking, shooting, swimming, and dying. Each time the character dies, the sequence is always the same. This doesn't mean several death sequences can't be randomly selected to fit the actual scene, but they are still fixed and aren't adaptable to every possible specific environmental situation. Eventually, the player will see them all many times.

2.5.2 Motion Capture

The most accurate way of animating the movement of a humanoid character is to use real human movement [Bodenheimer97]. To capture the movement of a human, motion sensors are placed on a human's body, and their locations are tracked by special detectors. During the capture, the human subject is asked to act out the movement sequences the animators want to record. Data is captured on limb placement, joint angles, and degrees of freedom (DOF). Motion-capture methods can also be used to capture facial movements and expressions. The current types of motion-capture systems include prosthetic, acoustic, magnetic, and optical.

The prosthetic system is one of the earliest motion-capture systems used. It includes the use of a set of armatures attached to the subject's limbs. Each armature is connected by an encoder, which records the joint's rotational and linear movement. A device connected to the encoders records and analyzes the movement. The acoustic system uses a triad of audio receivers to record sounds made by audio transmitters attached to the subject's body. Each time a transmitter moves, it emits a clicking sound. This sound is triangulated by the receivers and converted into a three-dimensional coordinate used to map the position and movement of the subject. Unlike in an acoustic system, in a magnetic motion-capture system there is one transmitter that remains stationary and the receivers are strapped to the subject's

body. Each receiver can detect its movement by measuring its distance from the transmitter. The data collected represents each receiver's position and orientation. The optical system, which is the most popular motion-capture method, allows the subject greater freedom of movement. The system works by attaching directionally reflective balls to the subject's body. The location and orientation of these balls are recorded by at least three video cameras, each equipped with its own light source that illuminates the balls. The captured video is analyzed by a computer system, and the subject's movements are extracted.

In 2002, for example, Acclaim® Entertainment re-signed the world-renowned BMX stunt rider Dave Mirra to assist with the creation of their game *Dave Mirra Freestyle BMX 3*. The game incorporated motion-captured animation sequences of BMX rider moves performed by Dave.

In *NFL Game Day 2004* 989 Sports® used Ladainian Tomlinson from the San Diego Chargers to motion-capture football movements to include in the game. During the motion-capture session Tomlinson even performed a back flip after making a touchdown that was included in the game's animation. This type of real-ism gained from capturing a real-life motion sequence is difficult and time-consuming to create by hand. It not only delivers realistic human motion but also allows game developers to include body movements that are recognizable as certain real-life characters (such as athletes) into their games. In this way, especially in sports games, signature moves can be assigned to the players to make the game more believable.

Motion-capture data, when manipulated by the mathematical constraints of real human movement (from the study of kinematics discussed in the next section), can produce extrapolated and adaptable human-motion sequences. For example, in a football game, the collected data can be used to adapt the movement of players with different sizes and weights other than the player from which the data was captured. In addition the data can be used to create real-time animation sequences that fit the current environmental situation, such as providing realistic player collisions and simulating character injuries and moods [Meredith02].

As with keyframe animation, motion-capture animation, once created, remains static. To improve on motion capture and keyframe animation, the computer needs more control over the character model so that it can influence the character's movements in real time to suit the situation. One method used to achieve this is 3D hierarchic articulation.

2.5.3 3D Hierarchic Articulated Bodies

Many geometrical models have a hierarchical structure created through the induction of a bottom-up process. This is also true of the human body, in which different body parts can be represented by articulated objects stored in a hierarchical struc-

ture and joined at pivot points. A simple partial hierarchical representation of the body constructed in Figure 2.1 is shown in Figure 2.5.

Each object in the hierarchy is broken down into its components. For example, the leg as a whole contains the parts of thigh, kneecap, calf, and foot. The advantage of this type of model representation is that parts of the model can be referred to as whole parts rather than as individual parts. If an animator wanted to move the model's leg, he could manipulate the hip joint and all of the leg would move accordingly in the same way as if you lift your leg out in front of you keeping the knee straight. This means that all subparts of the leg remain connected at the joint parts. The manipulation of any joint results in a downward cascade effect within the hierarchy where the orientation of other body parts and joints below the specified point are affected.

One method for specifying the model hierarchy is given in the H-Anim standard created by the Humanoid Animation Working Group [Babski02]. The standard denotes a hierarchical way of representing humanoid structures in the Virtual Reality Markup Language (VRML) [Marriot02] for use in creating three-dimensional virtual environments on the Internet. The H-Anim standard is based on the joint structure of the human body, shown in Figure 2.6.

The standard specifies a human model by defining the human skeleton as a hierarchical series of joints and their connected body parts. The following, taken from the standard, is an example of the partial VRML code that fits the skeleton shown in Figure 2.6. Notice that each line contains two parts: first the joint name and then the bone or part name. Each successive line is indented if the part on that line is connected directly to the part on the previous line. For example, the left hip (`l_hip`) is the joint that connects the left thigh (`l_thigh`) to the pelvis.

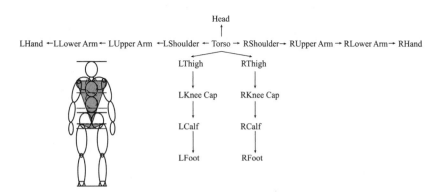

FIGURE 2.5 A partial hierarchical representation of the human body.

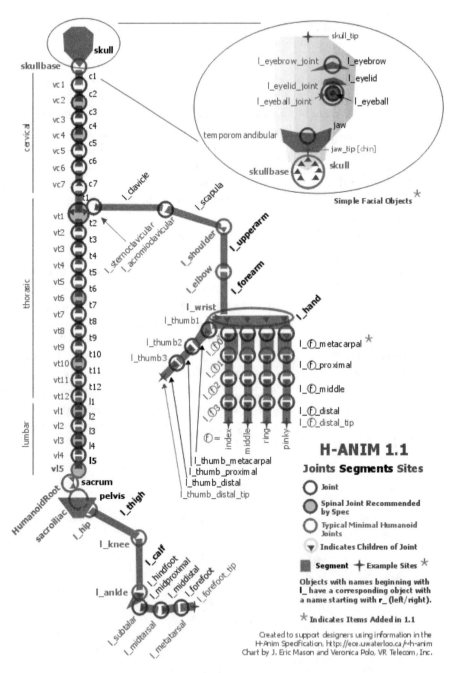

FIGURE 2.6 The joint structure used in the H-Anim standard. © Reprinted with permission from J. Eric Mason and Veronica Polo, VR Telecom.

```
HumanoidRoot : sacrum
sacroiliac : pelvis
> l_hip : l_thigh
> l_knee : l_calf
>  l_ankle : l_hindfoot
>  l_subtalar : l_midproximal
>   l_midtarsal : l_middistal
>   l_metatarsal : l_forefoot
> r_hip : r_thigh
> r_knee : r_calf
>  r_ankle : r_hindfoot
>  r_subtalar : r_midproximal
>   r_midtarsal : r_middistal
>   r_metatarsal : r_forefoot
```

A number of examples of virtual human models are defined on the Internet using the H-Anim standard. One of these is known as Baxter (see Figure 2.7 (a)), created by the Computer Graphics Lab at the Swiss Institute of Technology [Babski03].

Although Baxter is capable of basic movement, the character best illustrates the advantages of a 3D articulated hierarchy. First, as previously mentioned, sets of body parts can be moved collectively by manipulating the uppermost joint. In the virtual world of Baxter, the model's thigh can be selected with the mouse and the hip joint manipulated. This action moves the entire leg and rotates it around the hip joint (see Figure 2.7 (b)). In addition, to move just the lower leg and foot, select the calf. The lower leg then rotates around the knee joint (see Figure 2.7 (c)). This freedom of movement means the model can be animated in real time with the computer using special movement techniques called kinematics, which are discussed later in the chapter. In brief, kinematics allows the model to move with humanlike ability and react and interact with its environment on the fly. This means that animations for the virtual human do not have to be pre-programmed, and the character's movements become, in a way, autonomous, in that it can create animations as needed to interact convincingly with its environment.

The second advantage in using 3D articulated object hierarchies is that the memory usage to store the model is small. Each joint and part needs to be stored only once. Rather than creating repeated model definitions in which joints and parts are reused, references can be used instead. In the case of a simple humanoid figure, such as a robot created from a series of prisms, as shown in Figure 2.8, the arms and legs are the same; therefore, only one arm and one leg must be defined and then referenced twice in the hierarchy. In the case of a more human model such as Baxter with a mostly symmetrical body, the arms and legs are different

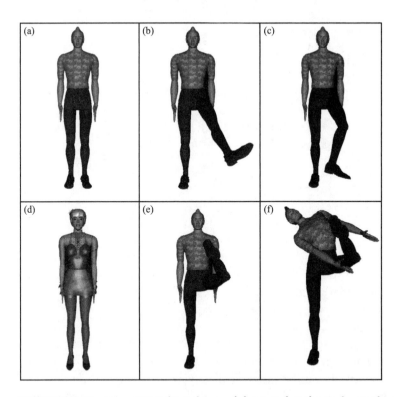

FIGURE 2.7 Baxter: a VRML/H-Anim model created at the Swiss Institute of Technology. a) Baxter; b) Leg rotating around the hip; c) Lower leg rotating around the knee; d) Nana; e) Unnatural leg rotation; f) Unnatural body positioning. © Reprinted with permission from Dr. Daniel Thalmann, Virtual Reality Lab, Swiss Federal Institute of Technology.

because they are mirror images of each other. They not only appear as mirror images but their movements are mirrored as well. In this case, the arms and legs must be defined only once but referenced twice in the hierarchy, assuming they are exact mirror images of each other. If the arms or legs in the hierarchy are then given subscripts to denote them as either left or right, the program can transform the object appropriately to create the desired mirrored object.

The third advantage, which relates to the second, is that once the hierarchy for a human model is stored as a series of references to the actual joints and parts, the model can be reused with a different set of parts to create another virtual human with a different appearance. An example is shown in Figure 2.7 (d), in which the Baxter hierarchy has been used with a different set of parts to create a new virtual human called Nana.

FIGURE 2.8 The joint hierarchy of a simple robot.

Some disadvantages also accompany 3D articulated object hierarchies. Because of the jointed nature of the model, as the model is manipulated it may become evident that unnatural-looking gaps exist between the body parts (see Figure 2.9 (a)). This problem is more evident with simple models created with simple block shapes, such as the robot in Figure 2.8. Often these gaps can be overcome by overlapping the body parts sufficiently so the gaps are hidden, as shown in Figure 2.9 (b). This fix, however, may result in undesirable visible seams.

EXERCISE

1. Discuss the advantages and disadvantages of a 3D articulated object hierarchy.
2. Devise and illustrate a 3D articulated hierarchical for an NPC canine companion.

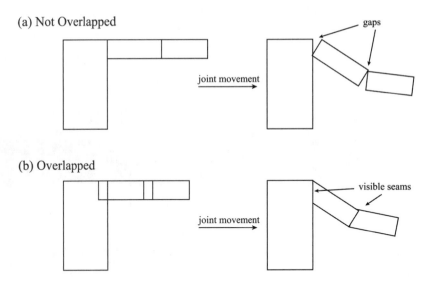

(a) Not Overlapped

joint movement

gaps

(b) Overlapped

joint movement

visible seams

FIGURE 2.9 A model manipulation example exposing gapping and overlapping. a) Non-overlapping arm movement; b) Overlapping arm movement.

2.5.4 Skeletons and Skins

A more desirable method of modeling a virtual human is to use a 3D articulated object hierarchy in which the body parts are replaced by the character's bone structure or skeleton. The entire skeleton is then covered with a mesh that defines the character's outward appearance. This mesh is called a skin. Both the skeleton and skin of a virtual character work in the same way that the actual human skeleton and skin work. Of course the virtual human's body is not as complex as a real human's. The skeleton provides the appropriate movements for the character, and the skin is bound to the skeleton in such a way that it deforms appropriately when the skeleton is moved.

The model's skeleton is made up of bones and joints. The bones form a ridged frame between the joints. The joints allow the skeleton to be positioned into different poses and allow for twisting and bending. A skeleton is shown in Figure 2.10 (a). The joints, shown as spherical icons, connect the bones, displayed as pyramids. The model's skin is a polygon mesh. The mesh is a three-dimensional object that represents the model's outward appearance. An example of a skin is shown in Figure 2.10 (b). The model's skeleton fits inside the skin, which is bound to the skeleton at the joint locations. This does not mean the skin is deformed through the binding process; particular joints affect the skin when they are moved. An example of a bound skin is shown in Figure 2.10 (c).

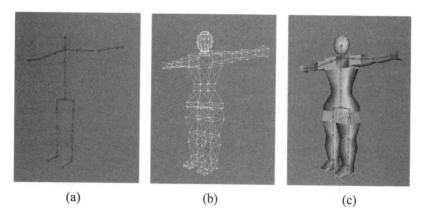

(a) (b) (c)

FIGURE 2.10 A model and its a) skeleton; b) skin; and c) bindings.

Each point on the skin can be set to be influenced by any number of joints. For example, if the skin around the wrist were set to be affected by the three closest joints, it would be deformed through movements of the shoulder, elbow, and wrist. It would not, however, be affected in any way by the movement of the hip joint—a fairly logical arrangement. Each joint can be set to have any degree of influence on a skin location. Sometimes the default joint influences are too great or too little to prevent undesirable skin formations. Figure 2.11 (a) shows an undesirable skin deformation in the pelvic region when the leg is lifted. The initial settings for this model have this area of skin affected equally by the hip and knee joints. The hip joint obviously has too much influence over this area of skin and, therefore, creates an exaggerated and unnatural-looking deformation. By decreasing the influence the hip has over this area of skin, as shown in Figure 2.11 (b), the skin becomes smoother and the deformation is not as pronounced.

Another problem with binding skin to skeletons is that joints, when bent, can appear to stick out through the skin, creating unnatural-looking curves. In addition, the skin deformation at the joint can appear exaggerated. An example, shown in Figure 2.12, is the elbow joint. In Figure 2.12 (a), the elbow is bent using the existing skeleton, and the elbow appears unnaturally deformed. In this case, the problem is solved by padding out the elbow area. In Figure 2.12 (b), a couple of small spheres are added inside the skin near the joint. The skin is then bound to the sphere. When the elbow is bent, the sphere prevents the skin from deforming in the areas where the sphere exists. To visualize this, imagine a hollow tube of cloth. If you bend the cloth in the middle, the bend causes the cloth to form a neat fold with no substance. Now imagine placing a tennis ball inside the cloth and bending the cloth around the ball. The ball now appears solid and prevents the cloth from folding in certain places. So too does the sphere inside the model's elbow joint. The

sphere in this example could be said to represent muscle mass. Some animators, including those who worked on *Shrek*, often pad their characters with realistic muscles to produce more accurate images and animations.

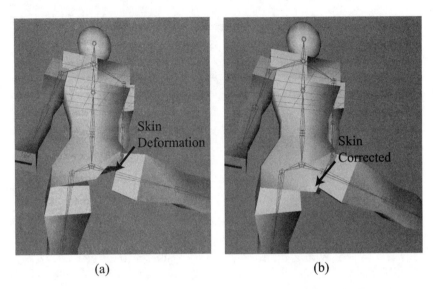

(a) (b)

FIGURE 2.11 Undesirable skin deformation and solution. a) Skin deformation; b) Skin correction.

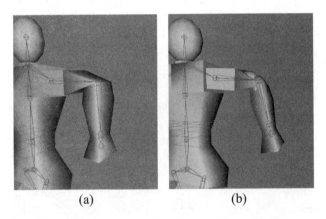

(a) (b)

FIGURE 2.12 Joint skin deformation and padding. a) Unnatural deformation of elbow joint when bent; b) Correcting deformation of elbow with internal padding using spheres.

The skeleton structure of these models can be stored as a 3D articulated hierarchy of bones and, therefore, requires little memory usage. The mesh and the joint influences on the skin points require slightly more storage than the simple 3D articulated hierarchy presented in the previous section; however, the mesh removes the problem of producing gaps in the model when the joints are manipulated. Just how the joints and bones can be moved using kinematics, which is discussed later, is a complex mathematical process.

2.6 DAY OF RECKONING: CREATING A SKELETON

In this practical exercise you learn how to use Milkshape to add a skeleton to a model.

You can use the model that you created in the last practical exercise or use *tutorbot1.ms3d* from the CD-ROM in the Chapter Two/Practicals folder.

2.6.1 Step One: Adding Joints

Open your model in Milkshape and set the View windows how you want them. The windows are set by default as they were the last time you used Milkshape. The best view to initially add the joints and bones in is the Front View. To add bones to a model, a basic knowledge of anatomy helps; however, if you are not sure, don't panic. The best model to go by for a humanoid figure is your own skeleton.

To add the first joint, select the Model tab on the toolbar and click Joint. Every time you click your model a joint is added. The first joint is located on the model's waist. Click near the center of the waist to add a joint. This joint appears as a red circle. Remember, red means it is currently selected. With the first joint still selected, click again in the center of the model's chest to add a second joint. This second joint is connected to the first with a blue triangle, which represents a bone. The model at this stage should look like that shown in Figure 2.13 (a). If you put a joint in the wrong place, you can press Delete to remove any selected joint. If the joints are not selected, go to the Joints tab on the toolbar. This tab displays a list of all joints. You can select a joint by double-clicking the joint name. From here you can press Delete to remove it. With the chest joint selected, add another three joints: one at the base of the neck, one at the base of the skull, and one right between the eyes. This completes the model's upper spine. At this point you can go to the Joints tab and rename the joints to make your life a little easier. (You will see why later.) The joint currently named joint3 should be the base of the neck. Double-click joint3; it is now selected in the Front View. To rename the joint, simply type a new name in the text box on the Joints tab next to the Rename button. Call it "neck base," then click Rename to allocate the new name.

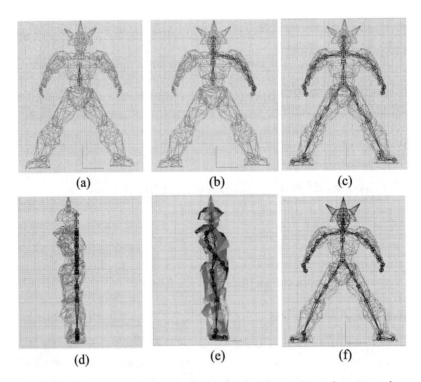

(a) (b) (c)

(d) (e) (f)

FIGURE 2.13 Adding joints in Milkshape. a) First two joint placements be-
tween tailbone and chest; b) Joint placements for a complete spine and
one arm; c) Joint placements for complete skeleton; d) Side view of initial
joint placements; e) Side view modification of joints; f) Front view of
complete joint set.

Before adding the arms you must decide to which spine joint to connect them.
The neck base is probably best, so double-click its name on the Joints tab to select
it. Before adding the first arm joint (the shoulder), ensure Joint is still selected on
the Model tab. Add six new joints down the arm, starting at the shoulder, as shown
in Figure 2.13 (b). If at anytime you do not like the position of any joint, in addi-
tion to deleting it, you can simply select it and use Move to change its location. For
convenience you can rename all the joints as, for example, shoulder, elbow, wrist,
and hand. Now add the other arm in the same way by selecting the neck base joint
first and clicking down the arm. Finally, add the leg joints in the same way as you
did for the arms. Select the spine joint as the attachment point, then work down
through the joints. (See Figure 2.13 (c).)

2.6.2 Step Two: Aligning the Skeleton in 3D

At this point you are probably looking at your model and thinking about the excellent job you have done. Without trying to disappoint you too much, change the Front View to a Left or Right View. The skeleton doesn't look all that great anymore, does it? Chances are it looks a little like that shown in Figure 2.13 (d). This is fine—All you need to do is use Move to move the joints around so they fit the model in the side view. This step is where the named joints come in handy. Locate the joints you need to move and adjust their locations. Note that the joints stay attached to each other no matter where you move them. Also, if you select the first joint drawn and move it, the entire skeleton moves. This happens because the first joint you drew is the root joint of the model. Any joint to which another was subsequently attached is a parent joint. If the parent joint moves, all joints added after and directly attached to it are also moved. For this reason, you should move the root node first and work your way down. For example, to move the arm, start with the shoulder and not the fingers; otherwise, you will find yourself forever adjusting joints as their parents are moved. The final skeleton should look like that shown in Figure 2.13 (e).

2.6.3 Step Three: Sticking the Skin to the Bones

To have the skin react to any bone movements, the vertices of the model's mesh must be attached to the skeleton joints. This placement ensures that when a particular joint is moved, any attached skin moves as well. Attaching the vertices is a long process and you must make sure that each vertex is attached to some joint; otherwise, when the skeleton moves, any unattached vertices stay behind. To begin, return to a Front View and set it to Wireframe so that you can see all the vertices.

Go to the Model tab and ensure Select and Vertex are selected. Return to the Joints tab to select the first joint. Select the joint at the top of the head. With this joint selected, press Shift and drag the mouse in the Front View to select all the vertices in the head, including the helmet (if you are using the *tutorbot1.ms3d* file). Alternatively, you can select groups of vertices from the Groups tab by selecting the desired group and clicking Select. To deselect, simply click Select again. To assign the helmet and head to the head joint, double-click the head joint on the Joints tab until it shows up in red in the Front View. Then press Shift and navigate to the Groups tab. Highlight *h_head*, click Select, select *h_helmet*, then click Select. In the Front View the head and helmet vertices as well as the head joint should be selected (as shown in Figure 2.13 (f)). Return to the Joints tab and click Assign. This command makes the helmet and head vertices stick to the head joint.

You must repeat this procedure for the entire body. Because the rest of the body is grouped into larger parts, you can select individual vertices to assign to the other joints so the parts can be shared among vertices. For example, the chest has

two joints: the base of the neck and the chest joint. The upper chest vertices should be assigned to the base of the neck joint and the lower chest to the chest joint. Select each joint in turn from the Joints tab, and one by one assign vertices to them. If you can't remember which vertices have been assigned to a joint, select the joint and click SelAssigned. This command selects all attached vertices. The SelUnAssigned button shows you all the vertices that remain unattached to joints. This command helps you finalize the attachment process.

When you are finished, save the model. In the next practical exercise you learn how to create keyframe animations of the model using kinematic principles.

2.7 BIOMECHANICS, KINEMATICS, AND KINETICS

Biomechanics is the study of the mechanical structure of living organisms. It is most often used to examine how bodies move with respect to their mechanical formation. A more general examination of movement occurs in the field of kinematics, where displacement, velocity, and acceleration of an object are examined. (The term *object* is used to describe any moving entity whether it is human, animal, plant, or brick.) Whereas kinematics studies movement and its relationship with distances and angles, kinetics focuses on the physical properties of the objects and examines movement with relation to mass and gravity.

2.7.1 Kinematics

Displacement of an object describes the straight line between the starting and ending points of an object's movement. Displacement is not the same as distance; displacement expresses the length traveled and the direction. Unlike distance, which measures the actual length of the traveled path, the length of a displacement is the length of the straight line between the starting and ending points. Displacement, Δd, is calculated as the difference between the starting location, d_1, and the ending location, d_2, as shown in Equation 2.1.

$$\Delta d = d_2 - d_1 \tag{2.1}$$

For example, an athlete who runs halfway around an oval track, as shown in Figure 2.14, travels a distance of 100 meters but has a displacement of 25 meters south.

The velocity of an object is its rate of change of displacement over time. This measurement differs from the object's speed, which is the rate of change of the distance traveled over time. Because velocity is based on displacement, the velocity has

Start (d₁) Time = 0 secs (t₁)

Distance = 100m

Displacement = 25m South

End (d₂) Time = 0 secs (t₂)

FIGURE 2.14 An athlete running an oval track.

a resulting direction associated with it. The velocity, v, of an object can be calculated using Equation 2.2, where Δt is the time to get from d_1 to d_2, namely $t_2 - t_1$. In the case of the athlete in Figure 2.14, if it took him one minute to travel halfway around the track, his velocity is 25 meters per minute and his speed is 100 meters per minute.

$$v = \frac{\Delta d}{\Delta t} \qquad (2.2)$$

The acceleration, a, of an object is its rate of change of velocity, which is calculated using Equation 2.3. A change in velocity is determined by taking the difference between two velocities, v_1 and v_2, where v_1 was measured at time t_1 and v_2 was measured at time t_2.

$$a = \frac{v_2 - v_1}{t_2 - t_1} \qquad (2.3)$$

If v_1 and v_2 are equal, then the acceleration is 0. Usually an athlete begins his race on a starting block; thus, his initial velocity, v_1, is 0 at time t_1. If at time t_2 (30 seconds later) his velocity is measured as 10 meters per second, his acceleration would be calculated as $(10-0)/(30-0) = 0.33$ meters per second². This equation translates to the athlete's velocity becoming 0.33 seconds faster with each passing second.

The effect of acceleration can be experienced in the racing game *Project Gotham Racing*. In the single-car timed trials with three laps, the player's car begins with a

velocity of 0 at the starting line. After performing each lap, the player's time is recorded. Provided the player has a sufficient skill level to reasonably complete each lap driving the best he can, the player will always obtain a slower time for the first lap because his car must accelerate from 0. This scenario is depicted in Figure 2.15.

In successive laps, the car is already traveling at the ideal speed when passing the starting line. Therefore, the time taken to accelerate from 0 is eliminated. This result can be illustrated mathematically. Assume the selected racing track is 1.5 kilometers long and the player drives flat out all the way without any collisions. On the first lap the car begins at time $t_1 = 0$, at the starting line, d_1. By time $t_2 = 10$ seconds, the car has reach d_2, which is 200 meters from d_1. At this point, the velocity of the car could be determined, using Equation 2.2, to be 200/10 = 20 meters per second. This measurement, however, is not accurate of the car's velocity for the first part of its journey. In the first few meters or so the car would not have been traveling at 20 meters per second because it was initially not moving at all and no car (or object, for that matter) can go from a resting position to moving very fast instantaneously. All we really know for sure is the car wasn't moving at $t_1 = 0$ and was 200 meters away from the start at $t_2 = 10$. To work out the actual velocity of the car after 10 seconds we must borrow a few more equations from the physics of movement, shown as Equations 2.4 thru 2.6.

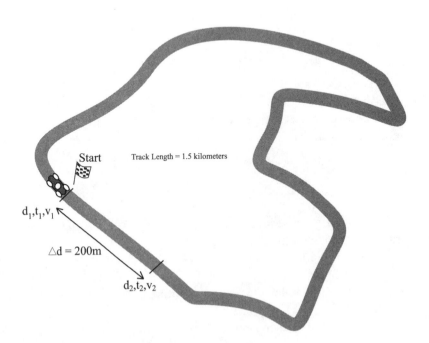

FIGURE 2.15 Effect of acceleration on lap time.

$$v_2 = v_1 + a\,\Delta t \tag{2.4}$$

$$\Delta d = v_1\,\Delta t + \frac{1}{2}a\,\Delta t^2 \tag{2.5}$$

$$v_2^2 = v_1^2 + 2a\,\Delta d \tag{2.6}$$

Because we know the car's starting velocity, displacement, and time, we can use Equation 2.5 to determine the acceleration. In this case, the acceleration is 4 meters per second2. This means at t_1, the car is traveling at 0 meters per second, one meter later it is traveling a 4 meters per second, another meter later it is traveling at 8 meters per second, and another meter later it is traveling at 12 meters per second and so on. By the time the car has traveled the 200 meters from d_1 to d_2, after 10 seconds it will be traveling at 40 meters per second, which is twice what we initially worked out. Now, if we assume the car cannot accelerate more than 40 meters per second and it stays at this velocity, one lap will take 42.5 seconds. This includes the 10 seconds to accelerate to its top velocity and another 32.5 seconds to travel the remaining 1,300 meters at 40 meters per second. For the next lap, the car will not have to accelerate for the first 200 meters as it did before because it will already be traveling at 40 meters per second. This lap will take the car a total of $1500/40 = 37.5$ seconds to complete, which is 5 seconds shorter than the first lap. Therefore, it has been demonstrated that the first lap will always be slower because of the initial acceleration time.

Now, you are probably asking yourself, what does a car driving around a track have to do with the movements of a virtual human? In brief, the physical principles of displacement, velocity, and acceleration are exactly the same and are more easily introduced with a simple example.

So far we have examined linear kinematics defined by the preceding equations. In addition to linear movement is angular movement. Angular kinematics is concerned with rotational movement. As values for linear displacement, velocity, and acceleration exist, there are also equivalent angular values with the same names. The angular displacement is given as an angle, ϕ, which represents a change in angular position, as expressed in Equation 2.7 and illustrated in Figure 2.16.

$$\Delta\phi = \phi_2 - \phi_1 \tag{2.7}$$

Angular velocity, ω, is measured as the change in angular displacement over time and can be expressed as Equation 2.8.

$$\omega = \frac{\Delta\phi}{\Delta t} \tag{2.8}$$

Angular acceleration, α, is the change in angular velocity over time and is expressed as Equation 2.9.

$$\alpha = \frac{\Delta\omega}{\Delta t} \qquad (2.9)$$

In the example of the baseball player, shown in Figure 2.16, the angular displacement is calculated by taking the backward swing (ϕ_1) away from the forward swing (ϕ_2). This gives the total angular displacement for the players swing as 135° counterclockwise. Remember, displacements have a direction as well as a length. Just as linear displacement and distance are different, so too are the angular equivalents. As shown in the example, the angular displacement is the difference between the starting position and the ending position. It does not include the total of the angles traveled. In this example, the angular distance would be $90 + 225 = 315$, which equates to approximately 5.4 radians. Note that angular values are by default expressed as radians in angular kinematics. To convert degrees to radians, simply multiply by $\pi/180$.

The velocity of the player's swing can be determined using Equation 2.8, if the displacement and the time to take the swing are known. For example, if the player's

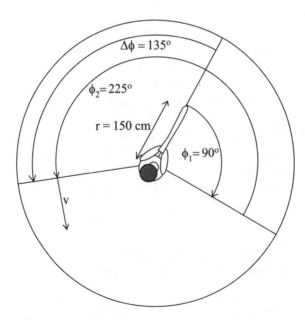

FIGURE 2.16 Angular measurements for a baseball batter.

forward swing of 225° takes 0.25 seconds from start to finish, the velocity would be $225/0.25 = 900$ degrees per second or 15.7 radians in the counterclockwise direction. This angular velocity can be converted into a linear velocity using Equation 2.10.

$$v = r\omega \tag{2.10}$$

where, r is the radius of the movement arc. In the case of the baseball player the radius would be proportional to the player's arm length and the length of the bat. Using the previous value of 15.7 radians per second, the linear velocity for the end of the bat at the end of the forward swing will be $1.5 \cdot 15.7 = 23.6$ meters per second.

So far we have looked at the movement of a whole object, such as a car or an athlete. In creating a virtual human we are concerned with both the holistic movement of the character's body (which is discussed later in this chapter) and the movement of individual appendages—the head and the torso, which make up animated postures such as sitting and actions such as walking. Given the length of a person's upper arm, forearm, and hand and the rotation angles of the shoulder, elbow, and wrist, kinematics can determine the location of the hand with respect to the person's body.

This method of generating animated movement in a game character is great if you know what the rotation angles should be. But what if you don't know? If the player needed to reach out and pick up an object that could be located anywhere in the environment, almost an infinite number of rotations would need to be stored to deal with the many differing locations of the object.

In the game *Splinter Cell*, one useful item that can be picked up by the player's avatar is a soda can. This soda can may be thrown almost anywhere in the environment and repositioned by the player at any time. Each time the can is retrieved, it is not necessarily located in the same place. Items in *Splinter Cell* are located either on the ground, on a table or box, or on a high shelf or cupboard. When the player attempts to pick up the soda can, a number of canned (no pun intended!) animations exist that show the avatar waving its arm somewhere near the item with the item magically being picked up. The problem that exists here is to determine the location of the soda can and the position of the avatar's arm before the animation for picking up the can begins. Then the rotation angles for each joint in the arm can be calculated to get the avatar's hand in the vicinity of the soda can. This process of working out movement in a backward fashion is called inverse kinematics. It has been popular in the domain of robotics and is being found useful in computer games animation.

Before continuing, you should be familiar with a few mathematical concepts used throughout the rest of this book. An important part of any computer graphics application is mathematics and geometry. The majority of this mathematics focuses

on vectors. If you are not familiar with vector mathematics, a crash course is available in Appendix C.

2.7.2 2D Inverse Kinematics

Although most virtual humans live in a 3D environment, it is best to begin a study of inverse kinematics in two dimensions. The simplest skeleton to manipulate with inverse kinematics is one with one joint and one bone. This simple structure also serves us well in examining the mathematics involved in more complex kinematics.

Given an elementary skeleton (one joint and one bone), the possible movement of the bone is in either a clockwise or counterclockwise direction about the joint, much like a hand on a clock. Given a target location we want to adjust the orientation of the bone so the end point (known as the end effector) is closest to some target. This process is illustrated in Figure 2.17.

The analytical approach to solving this problem is to examine the initial orientation of the bone, \mathbf{v}, and the desired orientation of the bone, \mathbf{w}. Having this information we can calculate the angle between the vectors \mathbf{v} and \mathbf{w} and apply this to the joint. To calculate the angle we find the dot product of the unit vectors and find the arccosine, as in Equation C.6 (see Appendix C), and then we use the cross product to determine the turn direction, as in Equation C.7.

For example, assume that $\mathbf{v} = \langle 5, -5 \rangle$ and $\mathbf{w} = \langle 6, 3 \rangle$. The angle between the vectors, using Equation C.7, equates to 72°, and the turn direction will be counterclockwise—can you arrive at this answer mathematically?

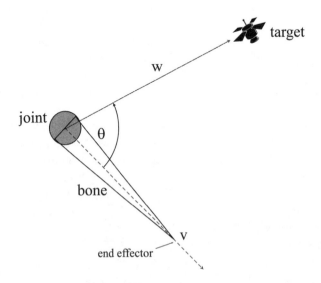

FIGURE 2.17 An elementary skeleton, end effector, and target.

In this case there is one solution. What makes life more difficult is when more joints and bones are added to the model. Figure 2.18 illustrates a two-jointed arm in two different positions, both of which achieve the desired position of the end effector.

To calculate the positions of the bones and joints, we can use the formulae derived in [Lander98]. Before we begin, we must know the location of the first joint (the origin, **O**), the length of both bones (L_1 and L_2), and the target location (\mathbf{T}_2). What we need to determine is the location of the second joint (\mathbf{T}_1) and the amount to turn each joint (θ_1 and θ_2). We can find θ_2 using the length of the bones and the final position of the end effector (\mathbf{T}_2). The formula is shown as Equation 2.11.

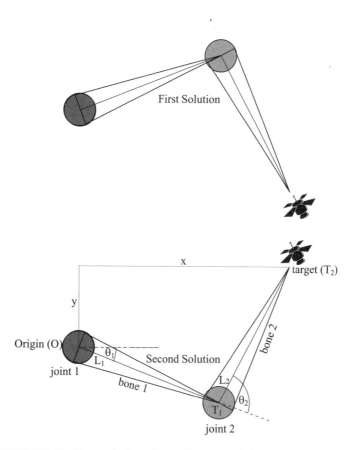

FIGURE 2.18 Two solutions for solving a single kinematic problem.

$$\theta_2 = \cos^{-1}\frac{(\mathbf{T}_2)_x^2 + (\mathbf{T}_2)_y^2 - L_1^2 - L_2^2}{2L_1L_2} \qquad (2.11)$$

Once this has been found, θ_1 can be calculated using Equation 2.12.

$$\theta_1 = \tan^{-1}\frac{y(L_2\cos\theta_2 + L_1) - xL_2\sin\theta_2}{x(L_2\cos\theta_2 + L_1) - yL_2\sin\theta_2} \qquad (2.12)$$

Finally, the location of \mathbf{T}_1 can be determined by Equation 2.13.

$$\mathbf{T}_1 = \langle L_1\cos\theta_1, L_2\sin\theta_1 \rangle \qquad (2.13)$$

Bear in mind, these equations are for models with only two joints and two bones. The solution is known as a closed form because it cannot be applied to other models. It can calculate the exact location of the bones quickly. Because these equations are restricted to a two-joint model, as more joints are added, new formulae must be derived to handle the models. As the number of joints increases the solutions become increasingly complex, and often you can have an infinite number of solutions.

As you can imagine, this type of analytical approach in a computer game is less than desirable because it could be impossible to come up with a decent solution. This brings us to an iterative solution in which each angle is adjusted slightly through a loop of iterations until the desired solution, if there is one, is found.

The method we are about to look at also introduces the concept of degree of freedom (DOF). DOF is particularly important in modeling skeletal structures because many of the joints in a skeleton often have restrictions on how they can be manipulated. The DOF of a joint defines how many axes around which the joint can rotate. For example, the human elbow has one DOF—it can bend in only one direction. Along with this restriction it also has a limit of rotation from 0 to about 175 degrees. This would be the total of the movement made if you stretched your arm out straight and then touched your hand to your shoulder. The human neck has three DOFs. You can experience this by 1) nodding as though you are saying yes; 2) shaking your head from side to side as though you are saying no; and 3) tilting your head back and forth as if you are trying to touch your ears to your shoulders. Each of these DOFs also has a different set of rotation restrictions. For example, if we assume 0 degrees to be looking straight ahead, then the second DOF (saying no) has a range of $+90°$ to $-90°$, depending on how flexible you are. DOF is used in the following algorithm to restrict the range of movement during inverse kinematics of a skeleton.

The algorithm about to be presented is called the cyclic-coordinated descent (CCD) [Welman93] inverse kinematic system and has been coded in [Lander98]. It

originated from the field of robotics [Wang91], where most inverse kinematic solutions arise. The CCD algorithm begins with the last joint in the chain, moving backward through the chain, making small adjustments until the end effector has reached its destination. The process also makes use of dot-product and cross-product calculations to determine angles and direction. The algorithm, modified from [Lander98], is shown in Listing 2.1.

LISTING 2.1 Pseudo code for a cyclic-coordinated descent algorithm

```
LAST_JOINT = 5;        //number of joints
MAX_CCD_LOOP = 50;     //maximum times to execute the CCD loop
IK_THRESHOLD = 1;      //how close to the target is good enough

joint = LAST_JOINT;    //current joint
attempts = 0;          //number of times CCD has been executed

do
{
    start_position = originOf(joint);      //location of joint
    end_position = endEffector(joint);     //end of bone
    desired_position = target_location;    //location of target

    //if not close enough to the target continue
    if( distanceFrom(end_position, desired_position) > IK_THRESHOLD)
    {
        //current bone vector
        bone_vector = end_position – start_position;

        //desired bone vector
        target_vector = desired_position – start_position;

        //cosine of rotation angle
        cosAngle = dotProduct( normalized(bone_vector),
            normalized(target_vector));

        //if rotation angle is greater than 0
        if( cosAngle < 1)
        {
            //determine the turn direction
            cross_vector = crossProduct( bone_vector, target_vector);
            turnAngle = acos(cosAngle);

            if(cross_vector.z > 0) //rotate clockwise
            {
```

```
              rotateJoint(joint, turnAngle);
          }
          else(cross_vector.z < 0) //rotate counterclockwise
          {
              rotateJoint(joint, turnAngle);
          }
      }
      //move to next joint working backward up the chain
      joint = joint - 1;
  }
  //continue calculating unit the end effector is
  //within the threshold distance
  //from the target or the maximum number of CCD loops
  //has been exhausted.
} while (attempts++ < MAX_CCD_LOOP && distanceFrom(end_position,
    desired_position) > IK_THRESHOLD)
```

DOF restrictions can easily be added to this algorithm by placing restrictions on the setting of the turn angle. If the turn angle is out of the allowable range for a joint, the joints angle can simply be set at its maximum in the turn direction.

2.7.3 Kinetics

Kinetics, more popularly called motion dynamics, is used to create realistic behaviors by examining the physical properties of an object, including calculating its mass and examining the forces on the object and gravity. Whereas kinematics certainly has a strong application in character animation, it is kinetics that adds an extra dimension of realism. For example, kinematics can explain how a character can be running towards a brick wall, but kinetics is needed to explain the force of the impact and the resulting effect the collision has on the character.

Kinematics can explain the angles of the joints of a character experienced during walking; however, it does not take into consideration the character's center of gravity [Ringuet01]. Whereas inverse kinematics explains the process of walking as the movement of the feet, kinetics examines it as a state of being out of balance and having to place one foot in front of the other to prevent falling over. Kinetics comes into its own in posing and moving not only humanoid models but also fictional characters.

In [Ringuet01], the process of animating characters focuses on the character's center of gravity. This method produces more realistic and believable poses and assists the animator in moving and posing nonhumanoids. Figure 2.19 (a) illustrates a humanoid figure in balance. Therefore, the body is positioned such that there is even mass on either side of the center of gravity. Ringuet suggests that for a

perfectly balanced figure, a vertical line connecting the base of the neck and ankle of the supporting foot can be drawn. If the figure is standing on both feet, a vertical line can be drawn from the base of the neck to a horizontal line connecting the two ankles. If the line between the base of the neck and the ankle or ankles is not vertical, then the figure is out of balance. Both Figure 2.19 (a) and (b) have vertical centers of gravity; therefore, the figures appear to be balanced. Figure 2.19 (c) does not have a vertical center of gravity, and it appears that the figure would topple over to the right.

The same rules can be applied to fictitious figures, such as those of aliens. Provided its poses and movements adhere to the laws of physics as we experience them, the character is more likely to be believable. For example, an alien with an outrageously large head would appear as though it would fall over if it were in any pose other than perfectly upright.

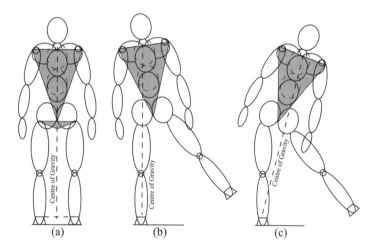

FIGURE 2.19 The effect of the center of gravity on a model's pose balance. a) Correct center of gravity; b) Body pose maintaining center of gravity; c) Body pose ignoring center of gravity.

2.8 DAY OF RECKONING: KEYFRAME ANIMATION

In this practical exercise you learn how to make a simple animation for the previously developed model.

ON THE CD If you aren't confident with your last attempt at modeling, you can work with the model *tutorbot2.ms3d* on the CD-ROM in the Chapter Two/Practicals folder.

2.8.1 Step One: Simple Bone Movements

To achieve the best movements you need to be looking at the model in a Front View and a Side View. The first thing we attempt is placing the model's legs together. This task can be achieved by rotating the leg joints. If you try to move a joint, the model is distorted because the bones are stretched. Rotating the joints keeps the bones the same length. Before any animation can occur, you must click Anim in the lower-right corner of the workspace. This option causes several text boxes and a variety of small buttons to become available. When this option is active the model's skeleton can be manipulated.

There is a small bug in Milkshape that sometimes causes the movement of a model to spring back into its original position when the mouse button is released. If you experience this problem, simply unselect and select Anim. This action seems to make the problem disappear. You can unselect Anim at any time without losing any animations you have created. They are there when you select Anim the next time (provided you have saved your work).

Select one of the pelvis joints. Select Rotate from the Model tab and ensure the X, Y, and Z buttons are selected and that each of the rotation angles is set to 0.0. With the pointer in the Front View window, drag the leg and notice how it rotates around the selected joint. Rotate both pelvis joints such that the legs are almost vertical (see Figure 2.20 (a)). You may want a 3D window open so that you can see the effect in 3D as the movements are made. The bot may now appear to be standing on its toes, so you must rotate the ankle joints as well. If necessary, you can also make rotations in the side view if the model's pose doesn't seem quite right.

If the model's feet are below the origin, you must move the entire model up a little. To do this, select the root joint (called *tail bone* in the *tutorbot2.ms3d* file), select Move, and drag the model upward until its feet are level with the floor.

To save this pose, you must set it as a keyframe. To do this, place the animation frame marker on frame one, either by typing 1 in the left text box near the Anim button or by sliding the slide bar at the bottom of the workspace all the way to the left. The other text box sets the number of frames for an animation. The default is 30. For this exercise, set it to 16. To set the keyframe, press Ctrl + K. This keystroke takes a shot of the model's current pose and places it in frame 1. If you don't set a keyframe for a pose and you accidentally move from frame 1 or unselect Anim, the pose is lost.

We will now make the model walk. Move the animation marker to keyframe 2. Rotate the pelvis and lift the knee in front as though the model were about to take a step. These movements must be made in a side view so you get the positioning right. (See Figure 2.20 (b).) Next, rotate the other leg back slightly, as shown in

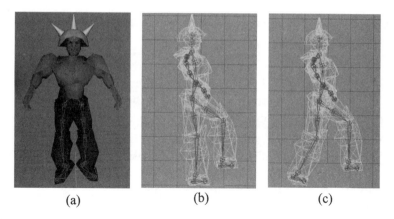

(a) (b) (c)

FIGURE 2.20 The animation of a model in Milkshape. a) Vertical positioning of legs; b) Positioning first leg for walking animation; c) Positioning both legs for walking animation.

Figure 2.20 (c). Before you lose all your hard work, press Ctrl + K to set the pose as a keyframe. To make a smooth walking animation the final frame must be the same as the first frame, or in this case the second frame, which contains the first frame for the walking animation. Slide the keyframe slide bar all the way to frame 16. Press Ctrl + K again to set this frame to the same pose. Now move back to frame 8. Before setting another keyframe, change the pose of the model by reversing the positions of the legs. By just rotating both pelvis joints, place the front leg in back and vice versa. Now press Ctrl + K to set this pose in keyframe 8.

The animation is now ready. Before continuing, save your work.

To display the animation, click the 3D View. To begin the animation click the > button. (This button starts an animation loop.) If all has gone well, the model should be walking. It may seem as though it has a slight stutter; this glitch is because frame 1 contains a still image that we don't necessarily want in the animation. You can remove this if you want. Stop the animation by clicking > again. Move the keyframe slider to frame 1, and press Shift + Ctrl+ K to remove the keyframe in that position. Now start the animation again. The walking should be a lot smoother. Don't save this animation; otherwise, you will overwrite the file with the static frame 1 in it. At this point you can just reload the last saved version.

Notice that all you had to do is create two frames—Milkshape filled in the gaps. In essence, it uses inverse kinematic techniques to tween between the frames. And you didn't even need to lift a calculator to work out all the vector mathematics!

2.9 LOADING A VIRTUAL HUMAN MODEL AND ANIMATION INTO A GAME ENGINE

FPS games such as *Quake 3 Arena* (Q3A) use a single track of animation that defines many separate animations. In Milkshape, the animation created in the last practical exercise looped over the entire number of frames. The animations for a Quakebot, for example, are played from specified frames, sometimes looped and sometimes not. To create a series of animations for a *Quake* character, a number of different animations must be specified and glued together. For example, the running animation might go from frame 30 to frame 45, and the swimming animation might go from frame 46 to frame 57.

Animations in Q3A must be set up in a specific order. The order and length of the animations are displayed in Table 2.1.

As shown in Table 2.1 the upper and lower animations are separate, with the exception of the death scenes. Therefore, the movement of the upper body is independent of those for the lower body. This division allows for different animation effects by combining differing animation parts. However, this separation can be a slight problem when two unrelated animations are combined. For example, an upper TORSO_ATTACK combined with a LEGS_SWIM would look strange. Although this system of animation has the drawback of creating inappropriate movements, it does provide for an overall greater number of animations.

Because many of the animation sequences do not have a defined length, an animation configuration file must be generated for the QA3 game engine so that it can locate the correct animation progressions. The configuration file, *animation.cfg*, is loaded into the QA3 engine with the appropriate model. The configuration file contains the following information on the first frame of the sequence: the length, in frames, of the sequence; the number of times to loop the animation; and how fast to play it. The file contains this information for each animation sequence in the order shown in Table 2.1. A partial example is shown in Table 2.2.

A model is defined as three separate parts: a head, a torso, and the legs. Each part of the model is linked internally by what is known as a tag. Tags control the locations at which the parts of the model are connected. Because each part is dealt with separately, the tags essentially join them together. There are three principal tags in a QA3 model: *tag_head* (which joins the head to the torso), *tag_torso* (which joins the upper body to the lower body), and *tag_weapon* (which provides a location to attach the weapon model).

ON THE CD

Milkshape .qc and .md3 files for a prototype weapon are given in the Chapter Two/Practicals/extra models/ folder. This model demonstrates how to create weapons or other models with the correct tag placements for use in the Apocalyx environment. Note that you can also create models of objects such as medical kits and place them anywhere in the map.

TABLE 2.1 Order and Frame Size of Animations used in Q3A[a]

Animation	Length (in frames)	Description
Category: Full Body		
BOTH_DEATH1	~30	Full body animation
BOTH_DEAD1	~1	Death scenes and final
BOTH_DEATH2	~30	Death poses
BOTH_DEAD2	~1	
BOTH_DEATH3	~30	
BOTH_DEAD3	~1	
Category: Upper Body		
TORSO_GESTURE	~45	For example, taunting
TORSO_ATTACK	6*	Attack other player
TORSO_ATTACK2	6*	"
TORSO_DROP	5*	Drop arms, as to change weapon
TORSO_RAISE	4*	Lift up new weapon
TORSO_STAND	1*	Idle pose for upper body
TORSO_STAND2	1*	"
Category: Lower Body		
LEGS_WALKCR	~10	Crouched while walking forward
LEGS_WALK	~15	Walking forward
LEGS_RUN	~12	Running forward
LEGS_BACK	~10	Backpedaling
LEGS_SWIM	~10	Swimming
LEGS_JUMP	~10	Jumping up forward
LEGS_LAND	~6	Landing after jump
LEGS_JUMPB	~10	Jumping up backward
LEGS_LANDB	~6	Landing after backward jump
LEGS_IDLE	~10	Idle pose for lower body
LEGS_IDLECR	~10	Crouched idle pose for lower body
LEGS_TURN	~8	Turning on the spot

[a] All animation lengths are approximations, with the exception of those indicated by a *, which must be exact.

TABLE 2.2 A Partial Animation Configuration File

Animation	First Frame	Number of Frames	Times to Loop	Frames Per Second
BOTH_DEATH1	0	30	0	25
BOTH_DEAD1	29	1	0	25
TORSO_GESTURE	90	40	0	15
TORSO_ATTACK	130	6	0	15

Each part of the model is stored in a separate binary file in .md3 format. The file can usually be generated by and exported from a modeling program such as Milkshape. Because QA3 deals with the model in parts, you must create three .md3 files: *head.md3*, *upper.md3*, and *lower.md3*. Within each .md3 file exists an identifier for each body part. The head is named *h_head*, the upper body is named *u_torso*, and the lower body is named *l_legs*.

Next, the model requires a skin. The skins define the coloring of the model in the game engine. The skins are created as two-dimensional images in a paint program. Because the skin is two-dimensional and will eventually be wrapped around a three-dimensional model, it can often look distorted in two dimensions. When creating a skin, you must take into account the way that it wraps onto the 3D model. For example, you would have a skin that defines the face and hair of the model that is molded onto the head. To create such a skin you must imagine how your face would look if you could take off your skin and lay it out flat. Each part of the model requires a skin. The skin files are provided to the game engine with the model and configuration files. Skin files for QA3 are required to be in .tga format. This format can be generated from most paint programs.

Finally, QA3 requires a set of .qc files, one for each model (*head.qc*, *upper.qc*, and *lower.qc*). This file links the models with their tags and skins. The format of a .qc file is shown in Listing 2.2.

LISTING 2.2 Format of a .qc file

```
$model "models/players/model/head.md3"
$frames 1 150
$flags 0
$numskins 0

$parenttag "tag_head"
```

```
$tag "tag_head"

$mesh "h_head"
$skin "models/players/model/skin.tga"
$flags 0
```

The first line of a .qc file identifies the location of the appropriate model with respect to where QA3 is installed. The second line indicates the starting frame and number of frames to use in its animation. Next, $flags can be defined for each model animation. A flag adds a special characteristic to a model [Wolfe00]. For example, if a flag is set to 8, the model will rotate. In this case the flag is simply set to 0 and not used. $numskins defines the number of skins to be used with the model. The skin image can be a single picture, and, therefore, $numskins is set to 0; otherwise, the skin image can contain a number of pictures and should be set to that number. The $parenttag tag indicates the tag to which the model is attached. In this example, the head model is attached to *tag_head*. Following this, all tags that are part of the model are listed after a $tag. The head has only one tag; however, if this were a file for the upper body, it would list both *tag_head* (which would also be its parent tag) and *tag_torso*. Finally, the model is attached to the skin in the last few lines.

2.10 DAY OF RECKONING: PREPARING A MODEL FOR THE APOCALYX GAME ENGINE

The Apocalyx 3D game engine uses the same .md3 model format as QA3. Therefore, if you don't have a copy of QA3 to practice your modeling, you can use Apocalyx. In this practical exercise you learn how to prepare the model created in previous sessions for use in Apocalyx. Many of the steps taken are similar to those for preparing a model for QA3.

ON THE CD

The Apocalyx 3D game engine source code is located in the Apocalyx/dev/src/apocalyx folder.

2.10.1 Step One: Separating the Body Parts

The first step in preparing your model for export from Milkshape into Apocalyx is to identify the separate body parts. To do this, you must group the appropriate body parts together. The tutorbot example already has the parts grouped. However, if you have created your own model, you must group the parts by hand.

Load your model into Milkshape and select the Group tab from the toolbar. Choose an item in the text box and click Select. The corresponding part is selected in the Front View and shown in red when viewed in Wireframe. The head is most

likely made up of just a single distorted sphere. However, if it isn't, continue selecting parts and clicking Select. When all parts that make up the head are selected, click Regroup to create a new group. With this new group selected in the text box, type the h_head in the Rename text box and click Rename. You have just created your first group.

The next step is to create the *u_torso* and *l_legs* groups. The procedure is the same as that for the head. Select the parts, regroup them, and rename them. If you have other parts of the model, such as a helmet, you can group these separately; however, they must be named with the prefix for the model part to which they are connected. For example, the helmet goes on the head. The prefix for the head is *h_*, so the helmet should be called *h_helmet*.

2.10.2 Step Two: Adding the Tags

The next step is to add the tags for each body part. A tag is represented by a non-displaying triangle. To create the head tag, go to the Model tab and select Vertex. Click out a right triangle to the side of the model that is twice as wide as it is high, as shown in Figure 2.21 (a). Make sure that you have Anim unselected; otherwise, the drawing won't appear. To finish the triangle, when you have three vertices drawn, select Face from the Model tab and click the triangle vertices in counterclockwise order until the vertices are connected with lines and the final triangle appears (as shown in Figure 2.21 (b)). To have the new triangle appear as a group, select it and press Ctrl + D to create a duplicate. You now see the duplicate group appear on the Group tab. Rename this duplicate *tag_head*. Duplicate two more and name them *tag_torso* and *tag_weapon* (as shown in Figure 2.21 (c)). Select the *tag_head* triangle and reposition it (use Move on the Model tab) to the base of the skull where the head and neck join, as shown in Figure 2.21 (d). Reposition *tag_torso* where the torso joins with the legs, and place *tag_weapon* on the hand that will hold the weapon. The weapon handle will rest in the right angle of the triangle, so you may want to rotate the tag to fit the hand posture. At this point, only the original triangle is left. Select this triangle and click Delete to remove it.

So that each tag moves with the appropriate body part, the tags must be assigned to joints. The tag can be attached to a joint using the same method used to attach skin vertices. To assign *tag_head* to the head, select the joint at the base of the skull in the Joints tab. Press and hold down Shift and select *tag_head* from the Groups tab by clicking it in the text box and clicking Select. In the Front View, the joint and tag are selected. Return to the Joint tab and click Assign. The skull base joint now has *tag_head* attached. The other tags also need to be assigned to joints. Repeating the same process, attached *tag_torso* to the root joint (the tail bone) and *tag_weapon* to a joint in the hand.

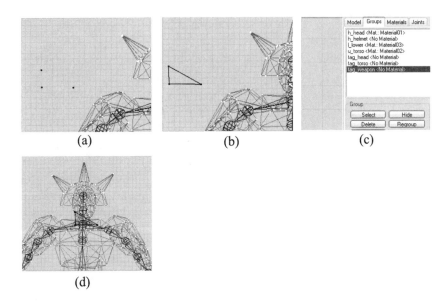

(a) (b) (c)

(d)

FIGURE 2.21 Adding *Quake* tags to a Milkshape model. a) Apex locations for tag triangle; b) Completed tag triangle; c) Grouping and naming tag triangles; d) Positioning head tag triangle.

2.10.3 Step Three: Adding the Skin Texture

You can add skin textures in Milkshape to determine how the final model will look. A texture does not always fit a model perfectly, and often some skin manipulation must take place to map certain parts of the skin onto particular model vertices. This section gives you practice in creating skins for your model and determining how they will look when loaded into the game engine.

The first step is to run a paint program. Adobe® Photoshop® is excellent, but if you don't have it, any paint package that can create a .jpg file will do. The height and width of the skin files in pixels should be a power of two (for example, 16, 32, 64, 128, or 256). The smaller the skin, the more efficient your game will be when run. If you are creating a skin that is all the same color with no detail, a 16×16 image would suffice. Where more detail is necessary, a 256×256 image may be needed.

The head skin can be created from a 128×128 image. Getting the head features correct can be quite challenging—a photograph of the front view of someone's face does not wrap neatly around a three-dimensional model. To begin with you need an image file for the head, as shown in Figure 2.22 (a). This image is a .jpg file, 128×128 pixels in size. Notice the actual face is not centered on the image. It

doesn't matter how you position the face in the image because it will be mapped to the head in Milkshape.

Having either created a skin for the head or using the one called *head1.jpg* supplied on the CD-ROM, load the practice head model from the CD-ROM called *tutorbot_head.ms3d*. Set up Milkshape so the largest Viewport is a 3D Textured View and another window is a Front View set to Wireframe.

NOTE

> *In the gaming environment* skin *is often the term used for the texture image pasted onto the mesh and not the mesh itself, with the skeleton and mesh jointly referred to as the model. Because environments such as* Quake *and* Unreal *use keyframe animations, the skeleton is discarded and does not come with the mesh/model file. For this reason, when you import a gaming model into Milkshape you get only the mesh. To manipulate the model, you must add your own skeleton.*

The next thing to do is create a material from the head image. To do this, go to the Materials tab and click *New*. On this tab you see a list of materials, a sphere, and some other buttons. Under the sphere are two buttons with <none> displayed on them. Click the top one. A dialog box opens, prompting you for the location of an image file. Locate your saved head image and click Open. Use the Rename text box and button to name this new material *head*. Go to the Groups tab, select *h_head* from the choices, then click Select to select all the head vertices. Return to the Materials tab and, with the head material highlighted, click Assign. The head image now appears wrapped around the *h_head* model in the 3D View (as shown in Figure 2.22 (b)).

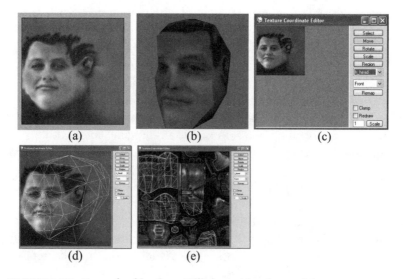

FIGURE 2.22 Example skins for a Milkshape/*Quake* model.

If the image does not appear in the 3D view wrapped around the model, right-click in this window and make sure that you have Textured selected instead of Smooth Shaded.

The *h_head* model has previously had some vertex/skin adjustments made to it to ensure almost a good fit. If it doesn't look quite right, you can now manipulate the image pixels to move the image around on the model using the Texture Coordinate Editor (TCE).

To open the TCE, press Ctrl + T (as shown in Figure 2.22 (c)). The TCE opens, displaying the currently selected material. Because this image is quite small you may want to enlarge it. Type 4 in the text box at the bottom of the TCE and click Scale to enlarge the image. If *h_head* was selected at the time, you now see an overlay of the model's vertices on the image. If not, go to the Groups tab, choose *h_head*, click Select on the Groups tab, return to the TCE, and click Scale again. You should now see the *h_head* vertices, as shown in Figure 2.22 (d). As previously mentioned, this model has been manipulated to fit the skin close to its final position.

Move the TCE to a location on the screen where you can clearly see both it and the 3D View. If you think the left eye doesn't look quite right, in the TCE select the vertex closest to the outer corner of the eye. You can select the vertex by clicking Select in the TCE and dragging out a small square around the desired vertex. The vertex turns red when it is selected. To reposition the skin around the eye, click Move in the TCE and drag the chosen vertex to the outer corner of the eye, as shown on the skin. To see the result of moving this point in the 3D View, click in the 3D View window to update the image. Note how moving the skin location changes the way the skin is mapped onto the face. You can continue moving the vertex and clicking on the 3D View until you get the positioning just right. This same process applies to all vertices. If you were starting this process from scratch with a new head model and skin, almost all the vertices would need to be moved. Moving vertices in the TCE only modifies the location of the skin; it does not affect the shape of the model.

The same process can be applied to the upper body and lower body. Often the skin for these parts is combined into one image file, with all the skin parts forming a kind of puzzle of pieces. Not all parts of the image need to be mapped onto a specific body part, and, therefore, the skins for several body parts can exist in one image file. Figure 2.22 (e) illustrates the mapping of the leg subparts onto skins in a combined skin file. The parts of the image in Figure 2.22 (a) not assigned are for mapping to the torso.

2.10.4 Step Four: Creating the Animation Configuration File

The Apocalyx game engine uses an animation configuration file similar to that used in QA3 with two exceptions: the file contains skinning information, and the file is

not called *animation.cfg*. The file can have any name with a .mdl extension. An example file is shown in Listing 2.3.

LISTING 2.3 The contents of *tutorbot.mdl*

```
lower.md3 body.jpg upper.md3 * head.md3 head.jpg
0          30       0        25      // BOTH_DEATH1
29         1        0        25      // BOTH_DEAD1
30         30       0        25      // BOTH_DEATH2
59         1        0        25      // BOTH_DEAD2
60         30       0        25      // BOTH_DEATH3
89         1        0        25      // BOTH_DEAD3
90         40       0        15      // TORSO_GESTURE
130        6        0        15      // TORSO_ATTACK
136        6        0        15      // TORSO_ATTACK2
142        5        0        15      // TORSO_DROP
147        4        0        15      // TORSO_RAISE
151        1        0        15      // TORSO_STAND
152        1        0        15      // TORSO_STAND2
153        8        8        20      // LEGS_WALKCR
161        12       12       20      // LEGS_WALK
173        9        9        18      // LEGS_RUN
182        10       10       20      // LEGS_BACK
192        10       10       15      // LEGS_SWIM
202        8        0        15      // LEGS_JUMP
210        1        0        15      // LEGS_LAND
211        8        0        15      // LEGS_JUMPB
219        1        0        15      // LEGS_LANDB
220        10       10       15      // LEGS_IDLE
230        10       10       15      // LEGS_IDLECR
240        7        7        15      // LEGS_TURN
```

The *tutorbot.mdl* file contains the same animation listing that would be included in a QA3 animation configuration file. The .mdl file differs from the usual animation configuration file in that it includes an initial line that lists each body part model followed by its skin. The creation of this file depends on where you have started and ended the animation frames for your own custom animations in Milkshape. If the skin files are written as a *, the preceding model part uses the previous listed skin file. In Listing 2.3, *upper.md3* would use the same skin as *lower.md3*—*body.jpg*.

2.10.5 Step Five: Exporting the MD3 Files

Before creating the set of required .md3 files, Milkshape requires a set of .qc files, such as those used by QA3. To create these files, click Tools > Quake III Arena > Generate Control File. Milkshape prompts you for a name. Type head.qc and save the file in the desired location.

 When creating all the files needed to import a model into Apocalyx, create a new folder and store all the files in the same place. This organization makes it easier when you have to modify the files and collect them for the importation process.

Use Wordpad or Notepad to edit this file. Notice that the format is the same discussed in Listing 2.2. Lines that begin with "//" are commented out. To get this file in the right format you must make some changes to a couple of the lines. First, make two more copies of this file and call them *upper.qc* and *lower.qc*. The first line in the files beginning with $model must be changed to reflect the model names. In *head.qc* this line should be changed to:

```
$model "head.md3"
```

The same change should be made in *upper.qc* and *lower.qc* where the model files are replaced with *upper.md3* and *lower.md3*, respectively.

Next, the parent tag should be uncommented in the appropriate files. In *head.qc* uncomment the parent tag for *tag_head*, and in *upper.qc* uncomment *tag_torso*. The *lower.qc* does not have a parent tag. The next section contains a list of all tags belonging to the model part. You must remove the tags that are not appropriate to the model's .qc file that you are editing. The only tag in *head.qc* should be *tag_head*. In *upper.qc* all tags remain, and in *lower.qc* only *tag_torso* should appear.

The next section contains the model references and skins for each body part. In the *head.qc* file, the lines should read as follows:

```
$mesh "h_head"
$skin "head.jpg"
$flags 0

$mesh "h_helmet"
$skin "body.jpg"
$flags 0
```

The lines for *u_torso* and *l_lower* can be removed because they do not belong to the head model. In the other two files (*upper.qc* and *lower.qc*) remove the lines that are

not appropriate for the model. This action leaves *u_torso* in *upper.qc* and *l_lower* in *lower.qc*.

The final files needed by the Apocalyx game engine are the actual binary model files in .md3 format. These files are easily created in Milkshape through the click of a few buttons. With your model loaded, click File > Export and select Quake III Arena MD3. Notice at this point that you can save the models created by Milkshape into formats acceptable to other games engines including *Unreal Tournament*. Save the first .md3 file as *head.md3*. Repeat the process twice more, but name the files *upper.md3* and *lower.md3*. The necessary configurations are taken from the .qc files; therefore, although it might seem strange to be saving the same file three times, the .qc files ensure the right information is added in the right files.

And that is that! Just to recap, by now you should have created the following files:

- *head.md3*
- *upper.md3*
- *lower.md3*
- *head.qc*
- *upper.qc*
- *lower.qc*
- *tutorbot.mdl*
- *body.jpg*
- *head.jpg*

In addition to having the correct files, ensure that:

- the number of frames specified in tutorbot.mdl equals the number of animation frames created in Milkshape. For example, if the final animation (LEGS_TURN) starts at frame 240 and goes for 8 frames, the total number of animation frames will be 247. This number needs to be the same number of frames created in Milkshape. Even if you haven't finished keyframing and creating all the animation sequences, as long as there are 247 frames (even if they all show the model standing still), you will still be able to test-load the model into Apocalyx.
- the name of the included .jpg files matches the skin names given in the .qc files.
- all tags have been added to the model parts in Milkshape and specified in the .qc files.

2.10.6 Step Six: Meeting Your Bot

Now for the time of reckoning and the most rewarding part of modeling—seeing your bot in action. To do this we are going to program a new bot class and plug it

into the Apocalyx 3D game engine. The initial code, which is short and simple, is displayed in Listings 2.4 and 2.5. Apocalyx has all the code necessary for displaying the bot in a 3D environment, and, therefore, the new class being created focuses on the bot's artificial intelligence (AI), although we haven't actually defined any yet. However, the bot's AI will need an outlet in the form of a graphical representation that we call the bot's avatar. Therefore, the initial code for the bot class focuses on setting up and assigning an avatar that will be controlled by future AI.

The first piece of source code is AIBot.h, shown in Listing 2.4. You see some familiar terms in this file, particularly in relation to the bot's animation sequences. The enumerated data types, UpperAnimation and LowerAnimation, are assigned values that relate directly to the animation sequences specified in the .mdl file. Following these data types are two pointers—one that points to the bot's environment (bsp) and one that points to the bot's avatar (botAvatar). The pointer to the environment is for the bot to access its surroundings. In Apocalyx the environment is specified by a binary-space partitioning (BSP) tree [Foley97]. If you want to create your own environment, Appendix C contains a set of step-by-step instructions. In addition, two properties (upperAnim and lowerAnim) are used to keep track of the current animation sequence when it is moving.

LISTING 2.4 Source for AIBot.h

```
#ifndef AIBOT_H
#define AIBOT_H
#define SMALLBUF 256

class AIBot
{
    public:
        enum UpperAnimation
        {
            BOTH_DEATH1, BOTH_DEAD1, BOTH_DEATH2,
            BOTH_DEAD2, BOTH_DEATH3, BOTH_DEAD3,
            TORSO_GESTURE, TORSO_ATTACK, TORSO_ATTACK2,
            TORSO_DROP, TORSO_RAISE,  TORSO_STAND,
            TORSO_STAND2, MAX_UPPER_ANIMATIONS
        };
        enum LowerAnimation
        {
            LEGS_WALKCR = 6, LEGS_WALK, LEGS_RUN, LEGS_BACK,
            LEGS_SWIM, LEGS_JUMP, LEGS_LAND, LEGS_JUMPB,
            LEGS_LANDB, LEGS_IDLE,LEGS_IDLECR, LEGS_TURN,
            MAX_LOWER_ANIMATIONS
        };
```

```
    protected:
        GLBsp* bsp;                     //environment map — bsp level
        UpperAnimation upperAnim;       //current upper animation
        LowerAnimation lowerAnim;       //current lower animation
        char botName[SMALLBUF];

    public:
        GLBot* botAvatar;      //physical appearance of bot
        AIBot();
        ~AIBot();

        int initialize(GLBsp *level, char *name);
            //setup initial bot state
    };
    #endif // AIBOT_H
```

The main code for the AIBot class resides in the *AIBot.cpp* file, shown in Listing 2.5. The initial code contains only one method: *initialize*. The initialize method accepts a pointer to the environment and assigns this to the bot's environment pointer. It also sets the initial pitch of the bot to be standing upright, moves the bot to a starting position (which is defined in the BSP file), makes the bot visible, and sets its initial animation sequences for the upper and lower bodies.

LISTING 2.5 Source for *AIBot.cpp*

```
    #include "../apocalyx/glmodel.h"
    #include "AIBot.h"
    #include <stdlib.h>
    #include <stdio.h>
    #include <math.h>

    AIBot::AIBot(){}
    AIBot::~AIBot(){ delete botAvatar; }

    int AIBot::initialize(GLBsp *level, char *name)
    {
        bsp = level;
        strcpy(botName, name);
        botAvatar->pitch(-M_PI/2);
        BSPVector& startBot = level->getStartingPosition();
        botAvatar->move(startBot.x + 100,startBot.y, startBot.z + 100);
        botAvatar->setVisible(true);
        botAvatar->setUpperAnimation(upperAnim = TORSO_STAND);
```

```
        botAvatar—>setLowerAnimation(lowerAnim = LEGS_IDLE);
        return 1;
}
```

ON THE CD
The main source code (*vh.cpp*) that links the bot with the game engine is listed in Listing 2.6. Because this code is quite long, the listing shows only the relevant parts. The complete code (including the AIBot files) is available in the Apocalyx/dev/src/Chapter Two-1 folder on the CD-ROM.

The code for *vh.cpp* begins by setting up the game environment. This setup includes initializing the environment's BSP map and adding the avatars. The avatars are for the bot and the human player, just like in any other FPS game. The first bolded line in Listing 2.6 highlights the point at which the game's handle on the bot is created. In the initialize method, data from the game is added from a file called *VirtualHuman.dat*. This file contains some default image files for the game environment as well the models for the bot and player avatars. This is the file in which you must put all the files created for your model, as listed in Step Five. The file is a zipped file and can be created and opened with WinZip® (available for download from *www.winzip.com*) or other archiving software. If you are having problems opening this file, rename the extension to .zip. Your operating system then detects it as an archive file. When you finish adjusting it, be sure to change its extension back to .dat or change its name in the *vh.cpp* file.

NOTE
Note that the default archiving facility that comes with Windows XP may create a zipped file incompatible with the Apocalyx game engine. Be sure to use WinZip or an equivalent.

Last but not least, the last four bolded lines in *vh.cpp* set up the bot. They open the model files, set up a link from the bot's AI to the environment's BSP, link the weapon model (included in *VirtualHuman.dat*) to the model's *tag_weapon* tag, and add the bot into the environment.

LISTING 2.6 Partial Source for *vh.cpp*

```
...
class MainScene: public Scene
{
    private:
        bool flyModeActive;
        bool runModeActive;
        GLHalfSkybox *skyBackground;
        GLEmitter* shotEmitter;
        GLBot* avatar;
```

```
        AIBot myBot;
    ...
};
...

bool MainScene::initialize(GLWin& glWin)
{
    glWin.setHelpMode(GLWin::REDUCED_HELP);
    glWin.getCamera().setOrtho();
    try
    {
        DRZipFile zip("VirtualHuman.dat");
        DRImage* splashImage = zip.getImage("loading.jpg");
        ...

        //add weapon model and player's avatar
        weapon = zip.getModel("gun.md3","gun.jpg");
        avatar = zip.getBot("grunt.mdl",true);
        avatar->pitch(-M_PI/2);
        BSPVector& start = bsp->getStartingPosition();
        avatar->move(start.x,start.y,start.z);
        avatar->getUpper().link("tag_weapon",weapon);
        avatar->setVisible(true);
        avatar->setUpperAnimation(TORSO_STAND);
        avatar->setLowerAnimation(LEGS_IDLE);
        glWin.getWorld().addObject(avatar);

        //————————————————————————————————————
        myBot.botAvatar = zip.getBot("warrior.mdl",true);
        myBot.initialise(bsp, "My Bot");
        myBot.botAvatar->getUpper().link("tag_weapon",weapon);
        glWin.getWorld().addObject(myBot.botAvatar);
        //————————————————————————————————————

        ...
```

The biggest question on your mind right now is probably, "So, how do I get all this to work?" First you need a C compiler, preferably Microsoft Visual C++®. If you don't have the Microsoft compiler, Apocalyx code is also available for the free Borland® Command Line Compiler (*www.borland.com*) from the Apocalyx Web site (*http://apocalyx.sourceforge.net*).

ON THE CD

To use the Apocalyx game engine, you must copy the Apocalyx directory from the CD-ROM onto your own computer. In the Apocalyx directory are two subdirectories: dev and prj. The dev directory stores all the source code for the bot projects, and the prj stores the Visual C++ workspace and other Apocalyx files.

To open the workspace in Microsoft Visual C++, double-click *Virtual Human.dsp* in the appropriate directory. For this practical exercise, open *Virtual Human.dsp* in the Apocalyx/prj/Chapter Two-1/ folder. The files copied from the CD-ROM come with an environment map in *pak2.pk3* and the model in *VirtualHuman.dat*. Compile and run the project. The Apocalyx engine displays the environment and the model. If more than one BSP is present in the *pak2.pk3* file, Apocalyx gives you a choice of levels from which to choose. Select the level by pressing the number on the keyboard that represents the level. The level then loads. If the bot appears to be floating in midair, check the starting location identified in the BSP map (see Appendix C) or the starting *y*-coordinate specified in the `initialize()` method of the `AIBot` class. Also notice that in addition to the bot's avatar, you have your own avatar to move around the map. You can control your avatar using the mouse and arrow keys on the keyboard.

TIP

The VirtualHuman.dat file comes with a number of bot models and skins for you to use. In Listing 2.6 the warrior.mdl model, which is considered the default model, is loaded. If you unzip the VirtualHuman.dat file you will see a number of folders called animech, honey, chicken, paladin, and so on. To use a model contained in these folders, set the bot avatar to use these. For example:

```
myBot.botAvatar = zip.getBot("animech/animech.mdl",true);
```

More models in the .md3 format are available from certain Web sites. For an excellent selection try *www.planetquake.com/polycount*. Once downloaded, ensure the model is in the Apocalyx format—this may mean changing the contents of the *animation.cfg* file to conform with the .mdl format and including the files *head.md3*, *upper.md3*, *lower.md3*, *head.jpg*, and *body.jpg*. Check out one of the model subdirectories in the *VirtualHuman.dat* file as a guide. The other files used with the *Quake* format are not needed. In addition to this file, the images may come as .tga files; you must convert these to .jpg files.

2.11 SIMPLE BOT MOVEMENTS

After you have placed an NPC in an environment, it is time to get it moving. Before we jump into the programming of an NPC's behavior in the following chapters, you need to be familiar with the methods employed in gaming environments for

moving the NPC around. In this section we look at two simple movement types: straight and random. More complex methods are examined in Chapter 5.

2.11.1 Straight Movement

The simplest way to move an object is along a straight line or curve between two points. This method is relatively straightforward when the start and endpoints or the equation of the line are known. If only the start and endpoints are given, we must assume the object will move along a straight line between these points. At this point, we will assume there are no obstacles between these points. If the path of the object is to be more complicated than a straight line, the equation of the line is required. When we start talking about programming an NPC's movement we must involve vector mathematics. (Refer to Appendix C.) Although this topic is covered as simply and straightforwardly as possible in this book, it would be advantageous that you have a decent knowledge of geometry to fully understand the ideas.

To begin you should be familiar with the orientation of a game environment. In a two-dimensional game such as Pac-Man, the environment is defined by two axes, x and y. Movement in the x-direction is horizontal relative to the computer screen, and movement in the y-direction is vertical. Movement along a straight line is determined by a change in the x or y locations. Figure 2.23 illustrates the movement of an object in a 2D space.

In Figure 2.23, the initial location of the object is denoted by (x, y). The final location, (x', y') is the result of changing the object's x-coordinate by dx and the y-coordinate by dy. The equation of the line passing through each point is defined by the equation $y = (dy/dx)x + c$, where c is the point at which the line crosses the y-axis. For our purposes, c becomes quite superfluous, because we never use the proper form of the line equation in our calculations of an object's position as it moves from one point to another. A bot has x-, y-, and z-coordinates that specify its geographical location in an environment. The bot could be moved from its current location to a goal location with the following code:

```
botLocation.x = goalLocation.x;
botLocation.y = goalLocation.y;
```

This code would be part of the main game logic that updates the states of the bots and runs their AI processes. Therefore, the only problem with this type of coding is that the bot starts in one location and then magically appears in another because each main game loop occurs quite quickly. This behavior is fine if the distance between the bot's location (x, y) and its goal location (x', y') is small. However, when the distance is large, the bot will appear to have performed a disappearing act, much like passing through a transporter in *Quake*, to appear in another

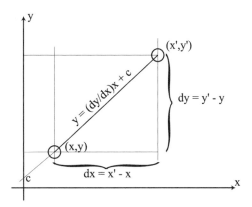

FIGURE 2.23 Movement in a 2D space.

location almost instantaneously. This is not how we want the bot to behave. We want the bot to appear as though it is moving along the line from (x, y) to (x', y'), as shown in Figure 2.23.

In programming the bot, we want to make the bot appear at a different location on the line from (x, y) to (x', y') with each game loop so that the bot appears to be smoothly moving along the line. Because the time taken for each game loop is fairly uniform, we cannot use this measurement to control the speed at which the bot moves. The speed of the bot in this case would be the distance it moves along the line with each update. The larger the distance, the smaller the number of game loops before the bot is at (x', y') and the faster the bot appears to move. It is at this point that we reintroduce the concept of velocity. In vector mathematics, velocity is not only the constant speed at which an object is moving but also the direction. Velocity is represented as a vector, and this vector can be calculated using dx and dy. A vector is simply a straight line that indicates the direction and distance between two points. The vector that defines the movement of an object from (x, y) to (x', y') is shown in Figure 2.24.

If the velocity is known, it can be used to update the bot's location with the following code:

```
botLocation.x += velocity.x;
botLocation.y += velocity.y;
```

If the length of the velocity vector is the same as this distance between (x, y) and (x', y'), the bot still appears to jump instantly from one point to the other in one game loop. What we actually want is for the bot to move a small distance in the direction of (x', y') for a number of game loops. The great thing about vectors is that

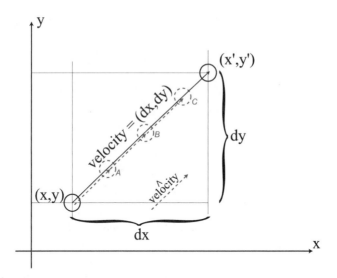

FIGURE 2.24 Movement along a vector.

we can modify their length without affecting the direction in which they are pointing. If we shorten the velocity vector, at each game loop, the bot appears to be moving along the line from (x, y) to (x', y') by moving a distance equal to the length of the shortened vector. But by how much do we shorten the vector? A very handy form of a vector is its normalized form, which has a length of one unit. If you reduce the bot's velocity to a normalized vector, the bot will move one unit length for each game loop. This unit could be 1 centimeter per second or 1 kilometer per second, depending on the relative distances and speed of the game. Once you have the vectors in unit lengths, it is easy to multiply them to speed up the movement or divide them to slow it.

A method you can use to calculate the normal version of a vector is shown in Listing 2.7. This function works with 3D coordinates because it includes the z-values in its calculation. How you calculate a normalized vector in a program depends on whether you are working in a 2D or 3D environment.

LISTING 2.7 A method to normalize a vector

```
vector.normalize()
{
    float length = sqrt( pow(vector.x,2) + pow(vector.y,2)
        + pow(vector.z,2) );
    vector.x /= length;
    vector.y /= length;
    vector.z /= length;
}
```

If for each game loop the bot's location is updated by the normalized vector after the first game loop, the bot would be located at point *A*, as indicated in Figure 2.24, and after the second game loop at *B*, and so forth. This velocity could be too fast or too slow for your game and you might like to speed it up or slow it down. To increase the velocity, you must increase the distance the bot travels in one game loop. You can achieve this easily by introducing the following speed variable to adjust the bot's velocity:

```
botLocation.x += (velocity.x * speed);
botLocation.y += (velocity.y * speed);
```

What might occur to you now is that if this method is iterated endlessly with the main game loop, the bot's location will be forever updated, meaning the bot's location will go off into infinity unless stopped. We have a couple ways to deal with this problem. First, we could include a test in the update method such that when the bot's location is equal to the goal location, the bot's location is no longer updated. The problem with this approach is that because the velocity has been reduced to normalized form, a multiplication with a positive speed may result in the bot never actually arriving exactly at the goal location—it may fall slightly short or go too far. If your bot isn't too pedantic, you can modified it to stop moving when it is *near* the goal location by using the following code:

```
if(!botLocation.near(goalLocation))
{
    botLocation.x += (velocity.x * speed);
    botLocation.y += (velocity.y * speed);
}
```

Here we assume there is a method called *near* that returns 1 if the location is close enough to the goal location and 0 if it is not. The definition of *near* in this instance can be left to the judgement of the programmer. Of course, *near* would have to include the location being less than or equal to the goal location; otherwise, if the location became greater than the goal location, the condition would never be satisfied and the bot would not stop moving.

The second method of moving the bot exactly to the goal location would be to move the bot to within less than one normalized vector length away from the goal location, then, in the next game loop, move the bot the shorter distance to stop right on the goal location, as shown in the following code:

```
if(botLocation.distance(goalLocation) < velocity.length())
{
    botLocation.x += (velocity.x * speed);
```

```
        botLocation.y += (velocity.y * speed);
    }
    else if (!botLocation.equals(goalLocation))
    {
        botLocation.x = goalLocation.x;
        botLocation.y = goalLocation.y;
        botLocation.y = goalLocation.y;
    }
```

This method is less than ideal. In many cases it can make the bot's movement look jerky as it jumps into the final goal location. Of course, there isn't a lot you can do about it—on the next update it would have moved past that location anyway, so you have no choice in stopping it at a shorter distance. A third way of solving this problem is to ensure the speed of the bot is a factor of the distance to be traveled. That way you know that in a whole number of updates the bot will be exactly at the goal location. This method isn't appropriate, however, if the bot needs to be traveling at a set speed.

All of this may seem as though we are making a mountain out of a molehill, and really, we are! If your environment is made up of discrete coordinates, such as a grid map of cells, you won't have this problem. The problem occurs only in environments with continuous coordinate values where normalizing and multiplying vectors can cause unwanted truncation of float or double values. In this case, it is not easy to keep track of the exact location of the bot—that is when methods that can decide if near enough is good enough become useful. For example, if the relative size of the bot is $100\,\text{cm} \times 50\,\text{cm} \times 50\,\text{cm}$ and the bot was $0.05\,\text{cm}$ out from being on its goal location, would this really be a problem? It is kind of like asking you to stand on a pinhead.

2.12 DAY OF RECKONING: MOVING THE BOT

ON THE CD

Moving the bot to the goal location using the previously outlined method is simple.

The initial project for this practical exercise is located on the CD-ROM in the Apocalyx/prj/Chapter Two-2/ folder with the associated source files located in Apocalyx/dev/src/Chapter Two-2/. Open the *Virtual Human.dsp* project file with Visual C++. It should have the program set up so that you can compile it immediately. The initial code loads both the player's and the bot's avatars. The player can move around the environment using the mouse and keyboard arrows; the bot remains stationary.

2.12.1 Step One: Creating an Update Method for the Bot

To process information on each game loop, the bot must have an update method that is called by the main game loop. This method links the bot's animation, movements, and AI. Add two new methods in the *AIBot.cpp* file named update() and isNear(). These methods should be coded as follows:

```
void AIBot::update()
{
    velocity.set(goalLocation.x – botAvatar–>getPositionX(), 0,
        goalLocation.z – botAvatar–>getPositionZ());

    velocity = velocity.normalize();

    BSPVector botPos( botAvatar–>getPositionX(),
        botAvatar–>getPositionY(),
        botAvatar–>getPositionZ() );

    if(!isNear(botPos,goalLocation, 50))
    {
        botAvatar–>setPosition(botAvatar–>getPositionX() + velocity.x,
            botAvatar–>getPositionY() + velocity.y,
            botAvatar–>getPositionZ() + velocity.z);
    }
}

bool AIBot::isNear(BSPVector a, BSPVector b, float threshold)
{
    float deltax, deltaz;
    deltax = fabs(a.x – b.x);
    deltaz = fabs(a.z – b.z);

    return( deltax < threshold && deltaz < threshold);
}
```

Rather than laboriously reminding you to add the appropriate method prototypes or properties into the AIBot.h file each time a new method or property is defined, you should do this automatically every time you adjust the AIBot.cpp file.

The botAvatar property of the AIBot class points to the bot's model. Many methods are already available in the Apocalyx game engine from manipulating models. Therefore, we will use these instead of writing our own. The setPosition(x,y,z) method shown next relocates the model to the (x, y, z) coordi-

nates in the game map. Both `goalLocation` and `velocity` are `BSPVector` datatypes and should be declared as properties of `AIBot` as follows:

```
BSPVector goalLocation;
BSPVector velocity;
```

Among the various methods available to a `BSPVector` (see *glbsp.h*) are a `normalize()` and a `set()` method. The `normalize()` method performs the obvious; the set method assigns the vector's coordinate values, for example:

```
goalLocation.set(200,0,200);
```

Although `goalLocation` is a point rather than a vector, the `BSPVector` datatype is convenient to use for its definition. A line of code such as the preceding one should be included in the bot's `initialize()` method to give it a starting goal location.

Adding the `update()` method to the bot does not make it automatically run with each game loop—the environment code must call it. Locate the `update()` method in the *vh.cpp* file and add the following code as the first line:

```
myBot.update();
```

Finally, the `isNear()` method is included to check the bot's location with respect to the goal location. In this case, if the bot is within 50 units of the goal location, that is considered close enough and the bot should stop moving.

Save, compile, and run the game. The bot now appears to move slowly away from you diagonally across the room until it gets to its goal, when it will stop. Modify the code so the goal location is at (1200,0,1200). Run the code and chase the bot with your avatar. What happens?

2.12.2 Step Two: Bumping into Walls

As you chased your bot in the previous step, did you notice it move through the wall? Obviously, you don't want this to occur (unless your bot has magical powers). Therefore, we will need to consider where the bot comes in contact a wall. Obstacle collision techniques can be used for this, but luckily, Apocalyx takes care of all the hard work for us. Modify the `update()` method so the `if` statement reads as follows:

```
if(!isNear(botPos,goalLocation, 50))
{
    bsp->slideCollision(botPos, velocity, extent);
    botAvatar->setPosition(botPos.x,botPos.y,botPos.z);
}
```

The GLBsp slideCollision() method takes the bot's current location, its velocity, and its size (known as extent) and determines if the bot will collide with a wall in the map. It then adds the velocity to the bot's current position, adjusting the final value to avoid walking through walls. For example, if the set velocity would take the bot beyond a wall when added to its current location, the slideCollision() method increases only the bot's location up to where the wall is and no further. The extent property is another BSPVector and can be initialized in the same way as goalLocation was in the initialize() method. The extent of the bot is the bot's size in the x-, y- and z-directions. Good starting values are (20, 20, 20). However, these values can be modified if you find parts of your bot merge into the walls.

Save, compile, and run the new code. Notice how the bot can no longer walk through walls. Because we normalized the bot's velocity, the bot moved in the velocity direction of 1 unit of distance at a time. To speed up its movement, you can introduce a speed property (a float should suffice) and multiply it against the x- and z-coordinates of the velocity vector after it has been normalized and before it is added with slideCollision() to botPos. Experiment with different speed values between 1.0 and 10.0.

2.12.3 Step Three: Random Motion and Environment Exploration

After the bot reaches its goal we want it to select a new random goal and start moving there. If we change the location of the goal, the if statement that tests the bot's location for being near the goal will no longer be true and the bot will begin moving toward the new goal. The if statement in the update() method should be modified as follows with the new code shown in bold:

```
if(!isNear(botPos,goalLocation, 50))
{
    bsp->slideCollision(botPos, velocity, extent);
    botAvatar->setPosition(botPos.x,botPos.y,botPos.z);
}
else
{
    goalLocation.set(getrandom(0,1000), 0, getrandom(0,1000));
}
```

Note the setting of the goal location in this example. It is assumed the map coordinates range from 0 to 1000 in both the x- and z-directions. (They do in the map supplied with the initial code.) If the map you are using is not this size, you must modify these values.

Now that the bot is moving around the map from one random location to another, you may want to enhance the visual aspect of the bot by adding some anima-

tion so the bot no longer slides along the floor but actually walks. We can also make the bot turn in the direction in which it is walking. Currently the bot is always facing in the same direction, which causes it to slide around the map, sometimes forward, sometimes backward, and sometimes sideways. To make the bot appear as though it knows where it is going, make it face toward its next goal location. This is not as simple as it may seem because it involves some vector mathematics. Don't panic though—we try to make it as painless as possible.

Figure 2.25 illustrates a bot moving along the vector **v**. When it reaches its goal, it will calculate a new vector to travel along to the next goal. The new goal will either make the bot turn to the left to travel along vector **q** or turn right to travel along vector **p**. If the bot turns to the left it must spin on the spot through an angle of α degrees. If it turns to the right it must turn through β degrees. How can we calculate these angles?

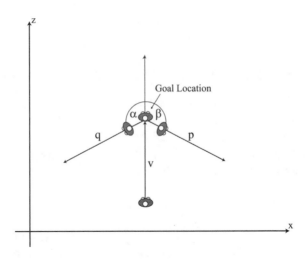

FIGURE 2.25 A bot turning from one vector to another.

The answer lies in using the normalized form of the vectors and finding their dot product. Because we are working in the x-z plane, any cross product will be a vector pointing directly up or directly down. Therefore, the only difference between **v**×**q** and **q**×**v** will be the value of the y-coordinate. Because **v** denotes the direction in which the bot is facing before turning in the direction of **q**, if **q** is a left turn the resulting cross product of **v**×**q** will point up; if **q** is a right turn the same cross product will point down. This means the y-coefficient, $(v_z q_x - v_x q_z)$ will be positive for a left turn and negative for a right turn. For the coefficient to evaluate to a negative value for a left turn, $v_x q_z$ must be greater than $v_z q_x$.

Knowing all this, we can now write a new method for the AIBot class to calculate the turning angle, as shown in the following code:

```
float AIBot::turnXZ(BSPVector v, BSPVector q)
{
    double alength = sqrt(v.x*v.x + v.z*v.z);
    double blength = sqrt(q.x*q.x + q.z*q.z);

    //if length of one of the vectors is 0
    //then angle cannot be determined
    if ((alength == 0) >> (blength == 0) )
        return 0.0;

    //work out the arccosine of the dot product
    //of the normalized vectors
    float temp = v.x/alength*q.x/blength + v.z/alength*q.z/blength;

    //test for annoying floating point errors
    if (temp < -1) temp = -1.0;
    if (temp > 1) temp = 1.0;

    double angle = acos(temp);

    if(v.x * q.z > v.z * q.x)        //left turn
        return (float) angle;
    else                             //right turn
        return (float) -angle;
}
```

The turnXZ() method takes the bot's previous velocity and the new velocity and determines the direction and the angle through which the bot's avatar should turn so that it is facing in the right direction. The update() method, with new code in bold, should be modified to look as follows:

```
void AIBot::update()
{
    BSPVector oldVelocity = velocity;
    velocity.set(goalLocation.x - botAvatar->getPositionX(), 0,
        goalLocation.z - botAvatar->getPositionZ());
    velocity = velocity.normalize();

    BSPVector botPos( botAvatar->getPositionX(),
        botAvatar->getPositionY(),
        botAvatar->getPositionZ() );
```

```
if(!isNear(botPos,goalLocation, 50))
{
    bsp->slideCollision(botPos, velocity, extent);
    botAvatar->rotateStanding(turnXZ(velocity, oldVelocity));
    botAvatar->setPosition(botPos.x,botPos.y,botPos.z);
}
else
{
    goalLocation.set(getrandom(0,1000), 0, getrandom(0,1000));
}
}
```

In addition to adding this method, set `velocity` to $(1,0,1)$ in the `initialize()` method to ensure `oldVelocity` gets a value on the first calling of `update()` to ensure the bot is initially facing in the correct direction.

Save, compile, and run your code. The bot will now turn toward its goal location.

Finally we want to add walking animation to the bot's legs to make it appear as though it is moving across the floor on its own accord. Because the plugs for the animation were set up with the original appearance of the bot, adding the animation is a straightforward procedure. All you need to do is add the following lines somewhere in the `initialize()` method:

```
if(lowerAnim != LEGS_WALK )
    botAvatar->setLowerAnimation(lowerAnim = LEGS_WALK);
```

Save, compile, and run your program. The bot will now randomly walk around the map.

2.13 SUMMARY

This chapter has paved the way for the creation of a virtual human by laying the foundation of the character: its physical being. It examined the use of a 3D modeling tool for the creation of meshes, skins, and skeletons. The movement of the skeleton was discussed using examples from inverse kinematics, and these methods were used to create a keyframe animation of simple motion sequences for the model. Throughout the chapter practical step-by-step exercises were presented that took the virtual human from design stage through to implementation in a 3D games engine.

REFERENCES

[Babski02] Babski, C., Ballreich, C., Beitler, M.T., Crampton, S., Lewis, M., Mason, J.E., Parsons, K., Ressler, S., and Roehl, B., October 20, 2002, Specification for a Standard Humanoid, available online at *http://h-anim.org/Specifications/H-Anim1.1/*.

[Babski03] Babski, C., VRML Body Examples, Baxter HANIM 1.0 and 1.1 Bodies, available online at *http://ligwww.epfl.ch/~babski/ StandardBody/*, January 14, 2003.

[Bodenheimer97] Bodenheimer, B., Rose, C., Rosenthal, S., and Pella, J., The Process of Motion Capture: Dealing with the Data, *Computer Animation and Simulation '97*, Eurographics Animation Workshop, Sept. 1997, D. Thalmann and M. van de Panne, eds., Springer-Verlag, Wien, pp. 3–18.

[Elkman72] Elkman P., Friesen W.V., Ellsworth P. *Emotion in the Human Face*, Pergamon Press, 1972.

[Foley97] Foley, J.D., van Dam, A., Feiner, S.K., Hughes, J.J., and Phillips, R.L., 1997, *Introduction to Computer Graphics*, Addison-Wesley, Boston.

[Hill01] Hill, J.S., 2001, *Computer Graphics Using OpenGL*, Prentice Hall, Upper Saddle River.

[IGN01] IGN.com, 2001, *Better Gaming Through Haptics*, ING Insider (January 2001) available at *http://pc.ign.com/articles/090/ 090721p1.html*.

[Jusko03] Jusko, D., Painting on Location, available online at *www.mauigateway.com/~donjusko/human.htm*, August 1, 2003.

[Lander98] Lander, J., Making Kine More Flexible, *Game Developer Magazine* (November 1998): pp. 15–22.

[Marriot02] Marriot, A. and Stallo, J., 2002, VHML-Uncertainties and Problems, A Discussion, *In proceedings of AAMAS02 Workshop on Embodied Conversational Agents—Let's Specify and Evaluate Them*, Bologna, Italy.

[Meredith02] Meredith, M., 2002, Kinematics and Biomechanics in Adapting Motion Capture Data for Use in Computer Games, available online at *www.dcs.shef.ac.uk/graphics/research/mocap/*, January 20, 2004.

[Ringuet01] Ringuet, J.M., Three-Axis Animation: The Hardships of Animating Three-Dimensional Characters in Real-Time Games, *Gamasutra* (July 2001), available online at *www.gamasutra.com/ features/20010727/ringuet_01.htm*, 2001.

[Thomas81] Thomas, F. and Johnson, O., 1981, *The Illusion of Life: Disney Animation*, Hyperion, New York.

[Wang91] Wang, L.T. and Chen, C.C., A Combined Method for Solving the Inverse Kinematics Problem of Mechanical Manipulators, *IEEE Transactions on Robotics and Automation*, vol. 7, no. 4, (August 1991, pp. 489–499.

[Welman93] Welman, C., 1993, *Inverse Kinematics and Geometric Constraints for Articulated Figure Manipulation*, Master's Thesis, School of Computing Science, Simon Fraser University.

[Wolfe00] Wolfe, D., Kray-ZeE's Modeling Guide, available online at *www.planetquake.com/modeling/*, September 2, 2003.

3 Classical Game Theory and Human Behavior

In This Chapter

- Human game-playing behavior
- Classical game theory
- The application of payoff matrices to NPC programming
- NPC skill balance testing

3.1 INTRODUCTION

To understand how a believable gaming NPC can be developed we must examine ourselves and how we behave when playing games. This understanding begins not with models of cognitive processes but in evolution and biology. Over millions of years of evolution the human species developed instincts necessary to ensure survival. These instincts included behaviors for hunting and gathering food, keeping out of the way of mammoths, and reproduction. Koestler [Koestler67] suggests the motivations for these behaviors fall into one of two categories: self-survival and species survival. Evolution occurred over millions of years, and in the brief time that civilization as we know it has existed we have been unable to unlearn instincts. It is not that they are no longer needed, but they are not as prevalent as they once were. Nature's way of instilling behaviors in us is to provide us with a reward when we have acted according to nature's wishes. This reward is in the format of pleasure and is delivered to us through our own biology—the release of chemicals that make us feel good. For example, eating not only assures our survival but is also pleasurable. In order to eat we had to learn to hunt; thus, hunting became an enjoyable activity. Nowadays we don't need to hunt for food, but our instincts still provide us with mechanisms to experience the thrill of the hunt, even when it isn't prey but a familiar yellow dot chasing ghosts on the computer screen ☜.

When faced with a confrontational situation such as hunting for food or facing an aggressor, the human body releases the hormones adrenaline and noradrenaline.

These hormones place the body in a state of arousal and stress and lead to an increased amount of fuel in our bloodstream that prepares the body for fighting or fleeing. In addition to the hormone release, the heart beats faster and the lungs breathe more rapidly to increase the supply of fuel-rich oxygenated blood to the body. Although we are not placed in such primal situations as our ancestors were, these responses are still genetically programmed into our bodies. These exact symptoms have been observed in people playing computer games [Walsh02], which implies the same pleasure experienced by our ancestors in outrunning a pack of wolves is, if not to the same degree, the same physiological response experienced during game play.

A funny yet perhaps insightful quote related to this issue was posted on the MUD-Dev-L newsgroup:

```
————Original Message————
From: rayzam

> Game designers are directing the evolution of our
> species :) Well,
> if they continue making games of specific
> genres for tens of
> thousands of years. We could become very
> adept at FPS games! :)

Only if women start finding a high-frag count
and callused elbows sexually arousing.

—Dave Rickey
```

In relation to the body's physiological changes during game play, psychologists have discovered that whereas the state of arousal does increase the person's level of performance, too much arousal may impede performance [Lefton94]. The state of arousal is also related to anxiety. As arousal increases, a person's level of performance increases to an optimal level, at which point any further arousal causes the level of performance to decrease. This theory explains why athletes such as football players perform better at the start of the season when the pressure is off and their arousal is at optimum and tend to make more mistakes in the finals when anxiety levels and arousal levels have exceeded the optimum. You may also have experienced this when playing a computer game. How often have you been able to complete a level of a game the first time you turn your computer or game console on than on subsequent attempts? This could be the basis for the phenomena that we know as beginner's luck.

Obviously NPCs do not have an internal biology that allows them to experience physiological changes associated with game playing. We cannot program an NPC to have an adrenaline release when faced with danger. Therefore, we turn to cognitive theories that attempt to explain the process of game play conceptually and categorically. Although the internal motivations of the human to play a game differ from those of an NPC, what we really care about is the final outward behavior. The NPC should act as closely as possible to a human in the same situation to make that NPC believable to an observer.

This chapter examines how humans play games through a philosophy called game theory. Game theory is a highly mathematical model of the interactions between people in a competitive situation. The theory takes into consideration the rational thinking of each player and attempts to quantify specific outcomes of the game as they are perceived by the players. Following this, we use the Apocalyx game engine to create two games between NPCs programmed in the tradition of game theory. The chapter concludes with a look at how NPCs in a game can be tested and analyzed for skill balance and fair play.

3.2 CLASSICAL GAME THEORY

Classical game theory is the study of the decision-making behavior of people in competitive situations. It is often used in the disciplines of mathematics, sociology, biology, and economics to examine the strategies chosen by people during social interactions where 1) there are two or more decision makers; 2) each person has a choice of two or more strategies to select from that can alter the outcome; and 3) each person has a preference as to which outcome he wants. Game theory is applicable in massively multiplayer (MMP) games to ensure the NPCs' abilities are a fair match with each other and the human players. The theory described in this section also provides the game developer with a structured method for defining the behavior of the game, making it easier to implement than ad hoc systems developed through excessive testing [Olsen03]. Although real human players don't take the time to develop complex theories about their game play, as described in this chapter, the theories have been the result of analyzing actual human behavior during game play and are, therefore, applicable to the programming of such behavior into an NPC.

In brief, game theory aims to determine which strategies a person should choose to give him the highest probability of achieving the outcome that best matches his own goals. In classical game theory, three types of games are considered: games of skill, games of chance, and games of strategy.

3.2.1 Games of Skill

Games of skill are one-person games in which the player has complete control over the outcome of the game through the strategies he chooses. The player can pursue his own goals knowing his choices will lead to a certain outcome. Games where the outcomes can be influenced by luck or other players are not considered games of skill in the mathematical sense. For example, although golf is a game played by a solitary player, each of the player's choices does not necessarily lead to his most preferred result. Even after estimating the distance to the hole, considering the weather, and selecting a club, the player cannot be 100 percent certain where the ball will land. Thus, there is an element of chance in play. On the other hand, solving an optimization problem, such as determining the shortest path to get from point A to point B, is considered a game of skill. The strategy to solve this game is to examine all routes from A to B and pick the one with the shortest distance.

This may sound pretty easy. Consider, however, the age-old problem of the traveling salesman. A salesman must visit a number of cities and needs to determine the shortest path that will take him through each city just once. To solve this problem you must determine all the possible routes that would take the salesman through each city just once and calculate the distances between each city in the route to determine the overall distance. Assuming that each city is directly connected to each other city, the number of possible routes to select from will be the factorial of n, where n is the number of cities. If the salesman has five cities to visit, he has five starting cities to consider. After selecting the first city, the salesman now has four cities to select from to be the second place to visit. Therefore, $5 \times 4 = 20$ different possible combinations of the first two cities could be selected. Thus, the total number of different routes through all cities is $5 \times 4 \times 3 \times 2 \times 1 = 120$. As the number of cities in the problem increases so do the number of routes. For 15 cities the number of routes to select from is 1,307,674,368,000. For 25 cities, the number of routes is 15,511,210,043,330,985,984,000,000. Imagine having to determine all of these possible routes and then comparing the distances between them. It would certainly take a monumental effort and a lot of computing power.

Can computer games that require player skill be classified as games of skill? It depends on the game. For example, dungeon-and-dragon-type games are primarily based on dice rolling and, therefore, contain some element of luck; therefore, they cannot be classified as a game of skill. Games such as the racing game *Project Gotham*, however, could be. Consider a solitary player game where the driver selects a car and a racing circuit and decides to play for kudos (points). Kudos are accumulated as the player completes sections of the road without hitting any buildings or side rails or executes an elegant handbrake turn to maximize slide. Every time the player drives the circuit, it is always the same. The outcome of the race is decided entirely by the player's skill. However, it could be argued the player's own physical reflexes introduce the element of luck into the game. Knowing that the

button representing the handbrake on the game console's control has to be pressed at exactly the right moment and actually pressing that button at the right time are two different things.

The difference between solving the traveling salesman problem and playing *Project Gotham* (besides the fact that one is obviously more fun) is that the traveling salesman problem, once solved, can always be solved the same way. Although it is nearly impossible to solve the problem for increasing numbers of cities in a reasonable time, once a solution is found, that solution remains the solution. For every time the problem is solved with the same set of cities the solution is always the same. However, in playing *Project Gotham*, it would be very rare to find someone who could drive a racecourse following exactly the same path and collecting the same number of kudos each time the game is played.

In games of skill, the player can be absolutely sure about the result of any decision. This is known as decision under certainty. From the point of creating an exciting new computer game, making decisions under certainty is about as exciting as flicking a light switch, knowing the light will go on. Having said this, games do need components of certainty; otherwise, they would be impossible to play. If you were trying to drive a race car and the console control buttons assigned to various functions of the car randomly changed, the game would be very difficult and frustrating. You would soon give up playing.

3.2.2 Games of Chance

Games of chance are one-person games in which outcomes are influenced not only by the player's decisions but also by an element of probability. These games are usually defined as two-player games where one of the players is known as nature. In these types of games, the player can either assign probabilities to the strategies that could be played by nature or they cannot. These categories of games of chance are referred to as risky decisions and decisions under uncertainty, respectively.

In risky decision making, the player is aware of the probabilities associated with nature's strategies. For example, in a game of roulette, the probability of a single number coming up is 1 out of 37. Each time the player bets on a single number he knows his chances of winning. We can extend the principles of probability theory in predicting the choice a player will make in a game of risk. We might assume that given a number of choices and the probabilities of the outcomes for each, the player would select the choice that is best. Consider a person with $50 who walks into a casino. Assume he has a choice of playing the following two games:

- A game of roulette in which the wheel has 37 numbers and the player can place $50 on just one number. If his number comes up, he gets his $50 bet back, plus another $50. (Assume for simplicity's sake that the player can also bet on 00, even though this is not the case in a real roulette game.)

■ A game of pick-a-box in which it costs $50 to select one from 10 boxes. Two boxes contain $100, three boxes contain $50, and five boxes contain nothing.

The expected value of the person's choices is directly related to the probability of each. If the player were to play roulette he would have a 1 in 37 chance of doubling his money and a 36 in 37 chance of losing it. The expected value for playing roulette in this case is $(2 \times 50 \times 1/37) + (-50 \times 36/37)$, which equates to $-$45.95$. If the player were to play pick-a-box, the expected value would be $100 \times 2/10 + 50 \times 3/10 - 50$, which would be $-$15$. It would seem sensible in this case that the person play the pick-a-box game because it has the greatest expected value.

However, there is one choice in the previous example that we have not considered—the choice of not playing at all. If the person were not to play either one of the games, the expected value for this choice would be zero. Because this choice has a greater expected value than either of the two games, could we assume the person would choose not to play at all? If this were the case, casinos around the planet would go bankrupt. Therefore, this straightforward method of predicting a player's choice does not always work. In examining human gambling behavior, we can conclude that human beings do not always attempt to maximize their expected value.

In 1738, mathematician Daniel Bernoulli [Bernoulli38] attempted to solve the problem by suggesting the value of choices to a person are not strictly determined by actual monetary value and that monetary value is relative to a person's situation. For example, $10 is worth more to a pauper than to a millionaire. Although the monetary value is the same for each person, the pauper might go to greater lengths to get $10 out of the gutter than a millionaire would. This difference means that an amount of desirability is given to a person's choices. Quantifiably this desirability is called utility. Bernoulli suggested that utility was related to a person's starting capital, where the greater the starting amount the smaller the utility for a fixed monetary increase. This theory was not entirely adequate to explain all games of risk. In the case of the gambler, it does not explain why a choice where the expected value of a game is less than not playing would be chosen. In 1947, John von Neumann and Oskar Morgenstern modified the concept of utility and suggested that utility be a value that expresses a person's preferences among his choices. In the case of the gambler, the person's utility toward gambling the $50 is far greater than not playing at all, and, therefore, the person's choice is to eliminate the choice of not playing. We can now return to our initial prediction the person would choose to play pick-a-box, assuming the person's preferences toward each game were the same. If the preferences are the same, then the utility for each game becomes equal to the expected monetary outcome for each. This method of selecting according to preference is known as the principle of expected utility maximization.

Games of chance involving decisions under uncertainty occur when the probabilities of nature's strategies are not known. Both games involving risk and deci-

sions under uncertainty contain some unknown factor about the future. However, in the latter case, the future is unpredictable. Take, for example, betting on horse racing. When you place a bet on a horse you are making a decision under uncertainty because you can never be sure about the condition of the horse, the condition of the racetrack, or the weather. Although bookmakers give you odds for each horse, these odds are more about the popularity of the horse and returns the bookmaker can afford to pay you and everyone else who bets on the same horse if it wins. Odds are not in any strict sense of the word probabilities. Probabilities in a game of risk always amount to unity (one). For example, the probability of getting a six when rolling a die is one in six, and the probability of rolling a 1, 2, 3, 4, or 5 is five in six. 1/6 plus 5/6 equals one. With horse racing the odds very rarely add up to one.

3.2.3 Games of Strategy

Games of strategy differ from games of chance in that they model competitive social interactions between two or more players (excluding nature). The outcomes of the game depend on the choices that each player makes. Therefore, each player has a partial influence over the final result. Strategy games come in three categories: coordination games, zero-sum games, and mixed-motive games.

Coordination Games

Players in coordination games all agree on the best outcome for the game. Coleman [Coleman95] gives the example of a game he calls Head On. In this game two people are approaching each other in a corridor. The game requires coordination because the best outcome for both parties is to avoid a collision. The players must decide whether to swerve right, swerve left, or continue straight ahead. If they both swerve to the same side or continue straight ahead, a collision results. This outcome is unfavorable for both people. The best moves would be for each person to swerve to a different side, thus avoiding a collision.

In coordination games of perfect information, in which each player knows the other's move, analysis and strategy selection are trivial. However, coordination games of imperfect information, in which the players cannot communicate, create more of a challenge. In the game of Head On, in choosing a side to swerve to, it would be advantageous to the players to know to which side the other will move. In this case it would be easy to avoid a collision. However, if neither player knows which side the other will choose, they may both move to the same side and a collision will occur.

Informal analysis of these types of games in which a uniquely optimal solution is not available has revealed the presence of a quasi-solution in which players can attempt tacit coordination without communicating with each other [Schelling60].

Through a series of experiments Schelling discovered that some strategies in a co-ordination game are focal points (called Schelling points), where that strategy appears a more prominent choice for each player. Strategies with prominence are called salient. Schelling illustrated the presence of salient strategies with a number of experiments.

In one experiment, Schelling asked two participants to pick from heads or tails. Each participant was told that if both participants called heads or both called tails, they would both win; otherwise, they would both lose. The results revealed that 86 percent of the participants in the game chose heads. In this case heads is obviously the salient choice because people notice some precedence over tails. This precedence may simply arise from the fact that in a game of Heads or Tails, the word *Heads* appears first.

In another experiment, Schelling told participants the location and date but not the time for a meeting with someone they had never met. The participants had to select a time to be at the meeting place that would be within a minute of the time the other person would be there. Although there are 1,440 minutes in a day from which to select, Schelling found that nearly all of his subjects selected 12 P.M. (noon). In this example, 12 P.M. is the most salient strategy.

The type of knowledge that a human considers in recognizing strategies of salience is difficult to formalize. It can be based on past experiences, the ability to predict human behavior, intuition, and sometimes sheer luck. For this reason, no formal classical game theory analysis is available for such games because it could be nearly impossible to program a computer with the types of knowledge used for such decision making when the knowledge is not entirely clear in the first place.

EXERCISE

1. Take a poll of your classmates, colleagues, or friends. Ask them *where* they would meet with someone on a certain day and at a certain time.

Zero-Sum Games

Players in zero-sum games have preferences that are mutually opposite. Chess, for example, is a zero-sum game. Each player desires to win, which means each prefers the other player lose. At the end of the game the utilities for the preferences (also called payoffs) to the players add up to zero. If we assign payoff values of 1 to a win, −1 to a loss, and 0 to a draw, then when the game is over, if one person has won, the total of the payoffs will be 1 plus −1, which equals 0. If the game is a draw, the payoffs still total $0 + 0 = 0$.

One way to determine the best strategy for playing a zero-sum game is to generate a game tree. A game tree displays all the players' choices of alternating moves. The tree begins with a single node, which represents the initial state of the game. This node branches into nodes representing the choice of moves available to the

first player. Each of these nodes branches into nodes for the second player. Often the move made by the second player is influenced by the move made by the first player. Therefore, the nodes displayed for the second player are influenced by the first player's node. For example, in a game of tic-tac-toe, if the first player places a X in the upper-left corner of the board, the second player cannot place a O there. Figure 3.1 illustrates a partial game tree for tic-tac-toe.

The initial state of the game is an empty board. For the first move, Player 1 has a choice of nine locations in which to place an X. By placing an X in any location, Player 1 can be certain that when Player 2 moves, he will not be able to place a O in the same square. The game tree is constructed by creating nodes for all of Player 1's possible moves. Each node branches to another set of nodes representing the moves that can be made by Player 2 in response to a certain move (represented by the parent node) made by Player 1. The game of tic-tac-toe ends when one of the players has three of his tokens in a straight line on the board. These winning states are represented as terminal nodes on the game tree. In Figure 3.1, two of these terminal states are shown in which Player 1 wins.

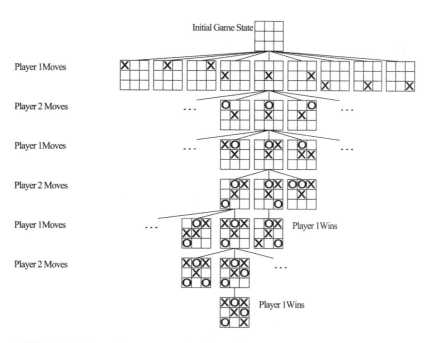

FIGURE 3.1 A partial game tree for tic-tac-toe.

To determine a winning strategy, Player 1 could draw a game tree and search down all the branches to find the terminal nodes in which he wins. This practice would then give Player 1 several sequences of play he could follow during the game. Unfortunately, Player 1 cannot be certain of the choices Player 2 will make, and, therefore, Player 1 cannot pick a single strategy to stick to, nor can he predict where Player 2 will place his token until the final moves of the game. However, Player 1 can pick the strategy that best leads him to a win, and after Player 2 makes his choice, Player 1 can revisit the game tree to determine the next best move.

As you can imagine, the complete game tree for tic-tac-toe is quite complex; however, imagine the game tree for chess. At the start of the game, Player 1 has a choice of 20 possible moves. He can move one of the eight pawns forward one or two places, or he can move one of the two knights to a possible two locations. This choice immediately creates a game tree with 20 initial nodes. For each of these nodes, Player 2's moves are added. Because this move is Player 2's first, he also can make 20 possible moves. As play continues, more or fewer following moves are available to each player. On average chess has a branching factor of around 35 nodes, and games that can go to 80 moves (40 by each player) have a game tree with 35^{80} (3.353×10^{123}) nodes! These games have game trees that are too large to examine on paper, so we will examine a simpler game in which each player has one move.

The game of paper-scissors-rock is a children's game in which each player makes a hand gesture representing either paper, scissors, or a rock. The hand gestures are made at exactly the same time by each player, so that neither player knows what gesture his opponent will produce. If one player gestures paper and the other rock, the winner is paper (because paper covers rock). If one player produces rock and the other scissors, the winner is rock (because rock smashes scissors). If one player produces scissors and the other paper, the winner is scissors (because scissors cuts paper). The game tree for this game is shown in Figure 3.2.

From the game tree for paper-scissors-rock, you can see that no matter which option Player 1 selects, his chances of winning are even. By searching the game tree, Player 1 determines that each of his choices can lead to a possible payoff value of +1. If Player 1 selects paper and Player 2 selects paper, the payoff for Player 1 is 0 because the game is a draw. If Player 1 selects paper and Player 2 selects scissors, Player 1 loses and the payoff is −1. Last, but not least, if Player 1 selects paper and Player 2 selects rock, the payoff is +1 because Player 1 wins. Knowing the whole game tree in this example does not give either player an advantage. The only thing it does prove is that each player has an equal chance of winning. From this both players could conclude that it does not matter which gesture they select because each has an equal chance of winning. We would say this game is fair.

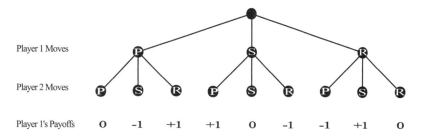

FIGURE 3.2 The game tree for paper-scissors-rock.

In a game that is not fair, both players attempt to maximize their payoffs, regardless. Consider the following scenario: King Arthur's archers provide extra protection for Camelot by shooting arrows at approaching enemies before they have reached the city walls. Two paths lead into Camelot, one to the east and one to the west. The western path travels across a plain, and enemies approaching from this direction can be bombarded with arrows for up to 20 minutes before reaching the walls. The eastern path winds through a dense forest, and enemies looming from that direction can be attacked for only 12 minutes before reaching the wall. King Arthur has only one archery battalion, which he can place either on the western or eastern side of Camelot. If the battalion is on one side of the city when an enemy is visible on the other side, it takes five minutes for the battalion to relocate. King Arthur has received word that his enemy, Sir Mordred, is about to attack. However, King Arthur is not sure from which direction Sir Mordred will attack. What is King Arthur's best option to ensure his archers get the maximum amount of time to strike at the enemy before they reach the city walls, assuming the enemy is unaware of the battalion's location?

The game tree for this problem is shown in Figure 3.3. If King Arthur has his battalion situated on the same side as the attack, then the enemy will be fired upon from the time they are visible. On the western side, this timeframe is 20 minutes; on the eastern side, it is 12 minutes. However, if the battalion in on the opposite side of the city, the battalion must deduct a five-minute travel time to get across the city before they can shoot their arrows, which equates to 15 minutes if the battalion is on the eastern side when the attack is from the west and seven minutes if they are on the western side when the attack comes from the east.

We should assume that Sir Mordred is no fool and that he is also aware of the game tree and his options. Because neither leader is aware of the other's attack plan, this game is one of imperfect information. Each player moves unaware of the other's move (just as in the previous paper-scissors-rock example), and the game tree is exactly the same if the nodes for Sir Mordred preceded those of King Arthur.

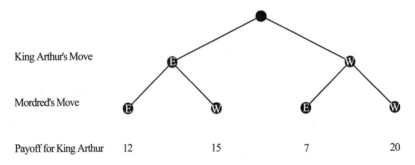

King Arthur's Move				
Mordred's Move				
Payoff for King Arthur	12	15	7	20

FIGURE 3.3 The game tree for the attack on Camelot.

The maximum possible amount of time King Arthur has to barrage Sir Mordred is 20 minutes, but this maximum time is available only if Sir Mordred decides to attack from the west. If Sir Mordred attacks from the east, Arthur would do best to have his army on the eastern side of the city to gain 12 minutes of arrow firing. However, it seems that King Arthur cannot determine his best strategy without knowing how Sir Mordred will move. Surprisingly, this is not the case. If Arthur positions his battalion on the western side, the worse he could do is attack for seven minutes. However, if he is positioned on the eastern side, the worse would be 12 minutes. If Arthur takes this pessimistic view of the game, he can make the best out of the worst situation by selecting the maximum of the minimum payoffs. This is called a maximin strategy. In this case, Arthur's best choice is to position his archers on the eastern side of Camelot.

But how does this work out for Sir Mordred's analysis of the game? Sir Mordred will attempt to keep the archers' attack on his army to a minimum. If Sir Mordred attacks from the east, the greatest time his army would be under attack is 12 minutes; if he attacks from the west, he can expect, at worst, 20 minutes of firing. Also, the best Sir Mordred could achieve if he attacked from the west would be 15 minutes. Therefore, attacking from the east is his best option because it minimizes the maximum damage that could be done to his army. This is called a minimax strategy.

This game tree can be represented in normal form in a table, as shown in Table 3.1.

The strategies chosen by both King Arthur and Sir Mordred conform to the minimax principle of game theory. This principle states that the optimal strategies available to both players in a zero-sum game are their maximin and minimax strategies. In these types of games, both strategies are referred to as minimax because one player's minimax is the other player's maximin. The minimax strategy is easy to find in Table 3.1. The strategy is identified as the table cell with a value that

TABLE 3.1 The Defense of Camelot, Part I

		Sir Mordred	
		E	W
King Arthur	E	12	15
	W	7	20

is the minimum in its row and the maximum in its column, in this case, 12. This cell location is also known as the game matrix's saddle point, and its value, the game's value, is the equilibrium point or Nash equilibrium, named after the Nobel Prize-winning game theorist portrayed in the movie *A Beautiful Mind*.

In a game with a Nash equilibrium, if any player deviates from the minimax strategy, the player receives a result that is less desirable than the value of the game and the other player obtains a more favorable payoff. For example, if Sir Mordred decided to attack from the western side and King Arthur stayed on the eastern side (Arthur's minimax), it would be to Sir Mordred's detriment because he would be attacked for 15 minutes instead of 12.

This form of game theory analysis assumes both players to be rational, selecting their best option according to the minimax principle. If Arthur suspects that Sir Mordred is irrational, he might predict Sir Mordred to attack from the western side. By placing his archers on the same side King Arthur would ensure himself 20 minutes of bombardment. If Sir Mordred knows that Arthur suspects he is irrational, he could expect Arthur to be waiting for him on the western side, in which case Sir Mordred's best move would be to attack from the eastern side, ensuring him the minimum attack time of seven minutes. This kind of reasoning could continue ad infinitum. Trying to second-guess the other player does not add any value to the minimax theory and proves detrimental to the player who deviates from the Nash equilibrium, as previously demonstrated.

Games with multiple saddle points can be solved as easily as games with one saddle point. Table 3.1 is extended in Table 3.2 to demonstrate this principle by adding attack routes to Camelot from the southern and northern sides of the city.

In Table 3.2, the saddle points are denoted by a *, for which the values are the minimums in their row and the maximums in their column. The value of this game is again 12. However, four possible minimax strategies exist, all of which lead to the same amount of attack time by the archers. This time King Arthur can make a choice between the eastern side and the northern side, knowing that both locations are equally as advantageous if Sir Mordred selects to attack from the northern or

TABLE 3.2 The Defense of Camelot, Part II[a]

		Sir Mordred			
		E	W	S	N
	E	12*	14	19	12*
King Arthur	W	7	20	20	9
	S	5	11	18	6
	N	12*	19	20	12*

[a] The asterisks after the values in the table indicate a saddle point.

the eastern side. The same rule of self-destruction for single-saddle-point games applies to players who divert from the Nash equilibrium in multiple-saddle-point games. Diverting unilaterally from the equilibrium and deciding to attack from the western or southern sides while King Arthur is on the eastern or northern side would be to Sir Mordred's detriment, thus increasing the time his army is attacked.

Unfortunately, not all games have saddle points. To illustrate this, we must modify the King Arthur versus Sir Mordred scenario. Assume now that King Arthur has been given a catapult. The catapult is far too large to wheel across the city on a minute's notice, so King Arthur must position the catapult on either the western or eastern side, having removed the northern and southern access points. When the catapult is on the western side facing the path across the plain, King Arthur's men have a clear shot at advancing troops and can wipe out 80 percent of the army. On the eastern side, the forest hampers the view, and they can destroy only 40 percent of them. Because King Arthur has disarmed his archers to pay for ammunition for the catapult, if Sir Mordred's troops attack from the opposite side of the city, they can reach the city walls unharmed. The game matrix for this scenario is shown in Table 3.3.

TABLE 3.3 The Defense of Camelot, Part III

		Sir Mordred	
		E	W
King Arthur	E	40	0
	W	0	80

It is clear in examining Table 3.3 that this game does not have a saddle point. There is no cell with a value that is the minimum in its row and the maximum in its column. The principle of minimax cannot be applied in this case because the minimum time Sir Mordred's army can be attacked is 0, and this applies to approaching the city from either side. It then depends on King Arthur's decision. The most King Arthur can achieve is 80 percent annihilation of his enemies. This chance may cause King Arthur to place his catapult on the western side. However, Sir Mordred, knowing King Arthur's optimal choice, could approach from the east and save his men. In this scenario, trying to outguess the opponent's move is a futile activity because the minimax and the maximin strategies are different due to the fact there is no saddle point. In the previous scenario the saddle point provided a game matrix in which each player's optimal strategy coincided. In this case, however, a problem now exists that makes it essential for each opponent to know the other's move before he makes his in order to select the best possible outcome. This, of course, could be achieved by planting spies in either camp. Because the possibility of having a traitor on his side would have crossed the minds of both leaders, their best strategy is to make a decision at the last available minute so as not to give any moles who might be in their armies the chance to get a message to the other side.

The leaders might, therefore, decide to flip a coin, roll a die, or select colored marbles from a bag to determine which side of the city to choose. This method of selection ensures their opponents could not anticipate their move and would assign equal probability to each of their choices. In game theory, this move selection is called a mixed strategy, as opposed to a pure strategy, which is used in games with saddle points (as in the previous example). The problem now is to determine what probabilities to apply to each strategy to ensure that the minimum expected payoffs are equal, irrespective of the opponent's choice. For King Arthur, these probabilities can be written as a pair of values, p and $1-p$ for each row, respectively, as shown in Table 3.4.

TABLE 3.4 The Mixed Strategy Probability Calculations for King Arthur

		Sir Mordred		
		E	W	Probability
King Arthur	E	a	b	p
	W	c	d	$1-p$

King Arthur can determine p by examining his expected payoffs for each of Sir Mordred's choices using Equation 3.1:

$$ap + c(1-p) = bp + d(1-p) \tag{3.1}$$

In this case, p and $1-p$ equate to:

$$40p + 0(1-p) = 0p + 80(1-p)$$

$$p = \frac{2}{3}$$

$$1-p = \frac{1}{3}$$

Arthur can now calculate new expected payoffs for his choices using these probabilities. The probabilities are multiplied by their respective values in the column of the opponent's move and added. If Sir Mordred sticks to pure strategy, King Arthur can expect a payoff of $40 \times \frac{2}{3} + 0 \times \frac{1}{3} = 26.67$ if Sir Mordred attacks from the east and $0 \times \frac{2}{3} + 80 \times \frac{1}{3} = 26.67$ if Sir Mordred comes from the west. Therefore, King Arthur's minimum expected payoff is 26.67, irrespective of the direction from which Sir Mordred attacks.

If Sir Mordred uses a mixed strategy, the probabilities for his choices are, in this case, the same as Arthur's, because the column totals are equal to the row totals. Sir Mordred must calculate q and $1-q$ for each of the columns, as shown in Equation 3.2.

$$aq + b(1-q) = cp + d(1-q) \tag{3.2}$$

In this case, q and $1-q$ equate to:

$$40q + 0(1-q) = 0q + 80(1-q)$$

$$q = \frac{2}{3}$$

$$1-q = \frac{1}{3}$$

The new game matrix displaying the probabilities can now be displayed as Table 3.5.

If King Arthur is waiting on the eastern side, Sir Mordred's expected payoff will be $40 \times \frac{2}{3} + 0 \times \frac{1}{3} = 26.67$, and if King Arthur is on the western side, $0 \times \frac{2}{3} + 80 \times \frac{1}{3} = 26.67$. With these probabilities, Sir Mordred's choices are equal with

TABLE 3.5 The Mixed Strategy Probabilities for Both Leaders

		Sir Mordred		
		E	**W**	**Probability**
King Arthur	**E**	40	0	2/3
	W	0	80	1/3
	Probability	2/3	1/3	

respect to payoff. What all this has determined is how the leaders should randomly select their choices. They should both select east with $\frac{2}{3}$ probability and west with $\frac{1}{3}$. How can they do this? To make their choice they should roll a die. If the numbers 1, 2, 3, or 4 come up, they should select the eastern side, and if 5 or 6 come up, they should be located on the western side.

Of course, these probabilities will be of very little comfort to Sir Mordred if on the first attack he comes from the west and King Arthur is there waiting for him because he will lose 80 percent of his army. What it does mean is that, on average, if the game were played many times these are the best probabilities to ensure equal outcomes for both sides. Again, this information is useless for Sir Mordred to know if he loses 80 percent of his army in the first battle. It is, however, his best strategy.

Mixed-Motive Games

A mixed-motive game is one in which the players neither totally agree nor disagree on the best outcomes. They are a combination of both coordination and zero-sum games. Sometimes the players may cooperate and other times compete. In the zero-sum games previously examined the payoff values for each player were the same under the same decision choice, although a single payoff would be preferable to one player and undesirable to the other. For example, as shown in Table 3.5, if both leaders choose east, the destruction to Sir Mordred's army would be 40 percent. This means a 40 percent victory for King Arthur and a 40 percent defeat for Sir Mordred. In contrast, a mixed-motive game can have different payoff values for each player under the same set of decisions. An example is shown in Table 3.6, in which each cell contains two payoff values, the first being the payoff for Player 1 and the second for Player 2. The payoff values may be the same or different.

In Table 3.6, if Player 1 selects choice D and Player 2 selects C, the expected payoff to Player 1 is 1 and the payoff to Player 2 is 2. Each payoff value (in this example 1, 2, or 3) represents ordinal significance only. The higher the number, the

TABLE 3.6 A Mixed-Motive Game Matrix

		Player 2	
		C	**D**
Player 1	**C**	3, 3	2, 1
	D	1, 2	1, 1

more desirable the outcome. Therefore, 3, in this case, is the most preferred option. Because mixed-motive games allow the players to either cooperate or compete, the choices are labeled *C* for *cooperation* and *D* for *defection from cooperation*. The reason for the use of the word *defection* rather than *competition* for the *D* choice is that in some mixed-motive games, when a player decides not to cooperate with the other it does not always lead to a competitive situation. For example, in a competitive situation a player selects a choice that benefits him rather than the opponent. However, in mixed-motive games, in some instances the decision not to cooperate can lead to an undesirable payoff. This outcome is demonstrated soon.

Game theorists Rapoport and Guyer have shown that exactly 78 strategically distinct two-player mixed-motive games are possible [Rapoport62]. Of these games, 12 are symmetrical, such as the one shown in Table 3.6. This means that if the players swap roles, the resulting game matrix remains the same. Eight of these games contain optimal equilibrium points that correspond to the Nash equilibrium for the games. As shown in Table 3.6, the equilibrium point occurs when both players cooperate. Game matrices of this type are simple to solve because the Nash equilibrium is evident and they require little analysis. Of all two-player mixed-motive games, only four symmetrical games lack optimal equilibria. These games have been dubbed the archetypes of two-player mixed-motive games [Rapoport67]. They include four simple games with which you may be familiar. The following sections examine each in turn.

Leader

The game of Leader describes the efforts of two players aiming for the same goal. However, a bottleneck in the game plan ensures that one player must move before the other. The player that moves first is called the leader and the other the follower. The payoff for the player who moves first is greater. Obviously both players want to move first; however, if they both move at the same time, they collide in the bottleneck, and the payoffs are undesirable. This game can be illustrated by a number of real-life scenarios, including the following, given in [Coleman95]. Two drivers ar-

rive at the entrance to a busy freeway at the same time. They must wait for a gap in the traffic before entering. The entrance is only big enough for one car at a time. If both drivers proceed at the same time, there is a collision. One driver must proceed before the other, but the driver who goes first is delayed the least. This game is represented by the matrix shown in Table 3.7.

TABLE 3.7 A Game of Leader

		Player 2	
		C	D
Player 1	C	2, 2	3, 4
	D	4, 3	1, 1

If a driver cooperates (C), he forfeits going first. In this case, the driver who allows the other to proceed is delaying his entrance onto the freeway. This forfeiture is represented by a payoff value of 2, which is better than the case in which the drivers collide (a selection of D), given a value of 1. The best payoffs in this game are where one driver allows the other to go first. When this is the case, their entry onto the freeway is much smoother. However, the more courteous driver who lets the other go first pays a small price in being delayed more than the other. There are two pure-strategy Nash equilibria in this game in which neither player can do any better by unilaterally deviating from that choice. These equilibria are shown in Table 3.7 in the upper-right cell and the lower-left cell. The only problem is that Player 1 would prefer the lower-left scenario because it gives him the highest payoff and Player 2 the upper-right. Therefore, each player prefers the other let him go first.

An interesting point to make about this game is that a player who deviates unilaterally from the maximin point benefits more than the other player. In this game the maximin values intersect at (C,C). The maximin point in this case does not constitute a Nash equilibrium because each player has an incentive to deviate from this choice. If Player 1 selects the maximin C and the other player deviates and selects D, then although both players benefit, the player who deviated—Player 2— receives a higher payoff than Player 1.

No formal solution is given to this type of game in game theory. The only hope in this situation is that the players agree on one of the Nash equilibria to be more salient than the other. This means the players both hold the same belief that one choice is more acceptable than the other. In Australia, one traffic rule states "give

way to your right." In this game, if both drivers hold this belief, the driver on the left would let the other driver go first. If this were a medieval scenario involving King Arthur and Sir Lancelot and if we replaced the cars with horses and the freeway with a narrow bridge one-horse wide, you might expect the game to be solved with Sir Lancelot allowing his king to cross first out of courtesy.

Battle of the Sexes

This common dilemma, named by Luce and Raiffa [Luce57], examines the choices made by two players where the decision not to cooperate can lead to an unfavorable payoff. The matrix for this game is shown in Table 3.8.

TABLE 3.8 A Game of Battle of the Sexes

		Player 2	
		C	D
Player 1	C	2, 2	4, 3
	D	3, 4	1, 1

Consider the following scenario: A couple must agree on their night's entertainment. One person prefers opera and the other prefers monster truck rallies. Other than going alone to separate events, each person places a high payoff on being together. In this case, a C decision means the player selects his or her favorite event, and D means he or she selects the other's favorite event. If each player selects C, where they select their respective favorite events, it means they go alone and the payoff gives a value of 2. This situation is much better than if they both decide to go to the other's event (D), in which case, they each go alone but to an event they don't like. The payoff in this case would be 1. The Nash equilibria in this game occur when one player sticks to his or her guns and the other decides to give in. Then they get to go to an event together, but one player is at an undesirable event. These situations are considered better than their other options and given payoffs of $(3,4)$ and $(4,3)$. The maximin solution for this game is like that for Leader and occurs for the decisions (C,C). What makes Battle of the Sexes different from Leader is that a player who deviates from his or her maximin solution benefits, but the benefit is less than that of the other player. For example, if Player 1 decides to select the maximin C and Player 2 selects D, then Player 1 benefits more than the player who deviated.

Again, no formal solution is available for this game. However, one way of solving it would be for one of the players to tell the other he or she is undyingly dedicated to his or her choice. If one person announced he or she were going to go to the monster truck rally no matter what, the other person would have no choice other than to cooperate if he or she wanted to maximize his or her payoff.

Chicken

The next archetypical mixed-motive game, Chicken, is a familiar one. This game involves two players in a battle of will power. A draw in the game is better than a loss, and a win is better than a draw. The most familiar version of this game goes as follows: Two drivers are speeding toward each other. If neither of the drivers swerves at the last minute, a fatal collision results. If one of the drivers swerves, he is branded a chicken. If both drivers swerve, it is a draw. The payoff matrix is shown in Table 3.9.

TABLE 3.9 A Game of Chicken

		Player 2	
		C	D
Player 1	C	3, 3	2, 4
	D	4, 2	1, 1

A choice of C denotes swerving, and D driving straight ahead. If both drivers drive straight ahead, they will fatally collide, thus resulting in a payoff of 1 for each. If both drivers swerve, they avoid a collision and neither is branded a chicken. If one driver drives straight ahead he wins the ultimate payoff (4) and the other driver suffers a payoff of 2 (that of being a chicken, but better than being dead). Again, the maximin strategy is (C,C), but this is not a Nash equilibrium. In this game, the Nash equilibria occur at (C,D) and (D,C). Unlike the previous two games in which player deviation from the maximin resulted in payoff gains for both players, in a game of Chicken, a player who deviates unilaterally from his maximin incurs a greater payoff, and the other player receives a lesser payoff. If Player 1 decides to swerve (C), his maximin, and Player 2 decides to drive straight ahead, thus deviating from his maximin, the payoff is greater for Player 2 and lesser for Player 1.

Although no formal solution is available for this game, a player can gain an advantage by seeming irrational to the other player. For example, if Player 1 were

viewed as crazy by Player 2, then Player 2 might assume Player 1 would do anything to win and would surely be driving straight ahead. If Player 2 valued his life, his best option would be to swerve. In Chicken, one player can act in a deliberate manner to instill fear in his opponent and thus gain an advantage.

The Prisoner's Dilemma

One of the most famous mixed-motive games is that of the Prisoner's Dilemma. In this game two suspects in a serious crime are held prisoner for questioning by authorities. Crucial information is needed from one or both of the suspects to lay charges. Each suspect is placed in a separate interrogation room, unable to communicate with the other. If neither suspect reveals anything to the police, both go free (a payoff of 3). If both suspects reveal information, both will be convicted with a light sentence (a payoff of 2). If one suspect discloses relevant information, that suspect will go free with a reward (a payoff of 4) and the other will receive a harsh sentence (a payoff of 1). The game matrix for the prisoner's dilemma is shown in Table 3.10.

TABLE 3.10 A Game of The Prisoner's Dilemma

		Player 2	
		C	D
Player 1	C	3, 3	1, 4
	D	4, 1	2, 2

In Table 3.10, a C decision denotes the concealment of information and a D is a decision to reveal information. D is obviously the best choice for each player because it gives the player the greatest payoff, regardless of the other player's choice. However, the maximin strategies for this game intersect at (D, D). The maximin is the best of a player's worst possible outcomes and because going to prison is the worst outcome, going to prison with a light sentence (2) is better than going with a heavy sentence (1). These strategies create a paradox in this game. If both players select their best strategy (D) and reveal the information they have, both lose by going to prison. On the other hand, if both players decide not to say anything (C), they go free. Not knowing if the other suspect will reveal information or not, if Player 1 selects C, he is playing the martyr because he knows if Player 2 reveals in-

formation, then Player 1 will go to prison with a much heavier sentence and will be allowing Player 2 to gain a reward.

As with the three previously examined games, the Prisoner's Dilemma does not have a formal solution in classical game theory. Although the maximin strategy points to both players defecting, in this case it would be better for both to cooperate, which leads to the question of trust between players. If both players can trust each other to cooperate and not reveal anything to the police, they will both be released. In this case it is not a question of what is best for the individual, but rather what is the collective best that can be achieved. Again this comes down to a question of how well one player knows the other. If each player knows the other has his best interest at heart he should select *C*. If one player is suspicious that the other player does not, he should select *D*. In real life most often players have a history with the other player, and if not, as the same game is repeated a number of times with the same players a history develops. Therefore, the payoff values should not only consider the self-interest of the player but also how his strategy affects the other. This consideration can lead to cooperation between players in strategy selection.

Consider the Prisoner's Dilemma game. If both players have an excellent rapport due to some previous encounter, both players may decide their best strategy is the one that rewards the other player the most. By examining Table 3.10, it can be seen that if Player 2 wants to reward Player 1, he will select strategy *C* because this would lead to the greatest payoff for Player 2 (although Player 1 will suffer). Provided Player 1 feels the same about Player 2, he will also select *C*. This creates a situation of cooperation between the players and both escape going to prison. This, however, doesn't make sense in terms of selecting the maximin solution of classical game theory and would lead to confusion in other games where different rules would have to be applied to different games.

The solution to this problem is to adjust the payoff values. If Player 2 thinks it would be bad for Player 1 to go to prison, then the payoff to Player 2 for not confessing (*C*) is greater than if he does confess (*D*), which could land Player 1 in prison. The payoff matrix is thus changed from the traditional Prisoner's Dilemma game to that shown in Table 3.11.

In Table 3.11, each player's maximin solution intersects at (*C*,*C*), thus creating the ideal solution where both players go free. In this case the game is no longer a dilemma because a maximin solution exists that benefits both players. This constitutes a Nash equilibrium because neither player does any better by selecting the *D* strategy.

TABLE 3.11 A Game of Friendly Prisoner's Dilemma

		Player 2	
		C	D
Player 1	C	3, 3	4, 1
	D	1, 4	2, 2

EXERCISE

1. What would happen in a game of Prisoner's Dilemma if both players hated each other and wanted the worst for the other? Is there a Nash equilibrium solution to the payoff matrix?

2. A girl wants to help her boyfriend find a job. She is willing to support him financially while he does not have a job but does not want to contribute to his laziness. The boyfriend is more interested in playing computer games and is not motivated to look for work while he is supported by his girlfriend. The payoff matrix for this situation follows. Is there a Nash equilibrium? If not, is there a unique mixed strategy?

		Boy	
		Look for Work	**Play Computer Games**
Girl	**Support Boyfriend**	(2,3)	(−1,3)
	Don't Support	(−1,1)	(0,0)

3. King Arthur wishes to travel from Avalon to Camelot via Camlann. Sir Mordred learns that Arthur is going to travel this route. He assumes he will be able to capture the king if he can make it to Camelot by horse slightly ahead of King Arthur rather than attempt a dangerous boarding of the royal carriage while it is moving. As King Arthur's carriage pulls out from Avalon, he notices Sir Mordred starting off on his horse. King Arthur knows that if Sir Mordred reaches the destination before his carriage, he will be captured. King Arthur's other possibility is to stop in Camlann and avoid running into Sir Mordred at Camelot. Sir Mordred also knows this is another strategy for King Arthur. Therefore, each party must decide on its best final destination. King Arthur's chances of avoiding Sir Mordred are 0 percent if they stop at the same destination, 100 percent if King Arthur continues to Camelot and Sir Mordred stops at Camlann, and 50 percent if

King Arthur stops at Camlann and Sir Mordred continues to Camelot. In the last scenario the probability of capture is possible because if King Arthur is in Camlann, then Sir Mordred still has the opportunity of capturing him before he eventually reaches Camelot. Draw up the payoff matrix for this game. Is there a Nash equilibrium, and, if not, what is the mixed strategy?

3.3 REPETITIVE GAME PLAY

An interesting twist to classical game theory has been to examine the effect of repetitive play in which the same two players play the same game matrix again and again. Of course, if each player always chooses his maximin solution, the outcome after much iteration would be the same. This research differs from the previously examined game matrix maximin solutions in that each player may not select his maximin solution to attain a higher accumulated payoff after many games.

In 1980, Axelrod organized a computer tournament of an Iterated Prisoner's Dilemma (IPD) game in which researchers were allowed to submit programs to play the game against all other submitted programs [Axelrod81]. The idea was that the programs should depart from the maximin solution to obtain the best total payoff after many repetitions. The program that won was the shortest and simplest. It was submitted by psychologist Anatol Rapoport and called *Tit-For-Tat*. The program began play by cooperating first (choosing *C*). For each iteration of the game, the program copied the previous choice made by its opponent. The program was therefore being nice to an opponent that was previously nice to it and retaliatory toward any program that was previously nasty.

From the results of the tournament, Axelrod concluded the most effective way to play a repetitive game of Prisoner's Dilemma [Axelrod84] was to:

- begin by being cooperative (choosing *C*);
- respond to an opponent's behavior with reciprocity;
- avoid being envious of how the other player is performing; and
- don't try to be too clever (for example, don't try to guess what your opponent is going to do).

The same set of programs submitted to Axelrod's competitions was also tested in another game called the Iterative Compromise Dilemma (ICD) [Yoshida97]. The payoff matrix for the ICD is shown in Table 3.12. The maximum payoff for a player is to select *D*. However, if his opponent also selects *D*, then they both suffer the

TABLE 3.12 The Compromise Dilemma Payoff Matrix

		Player 2	
		C	**D**
Player 1	**C**	2, 2	2, 3
	D	3, 2	1, 1

lowest payoff. Therefore, the better choice is to cooperate (*C*). On the other hand, if one player selects *C* and the other selects *D*, then the first player has sacrificed the highest possible payoff to his opponent.

When the ICD game was played by the IPD programs, a different set of results were observed. This time the game that achieved the best result was called *Impudent*. This program always selected to defect (*D*) unless its opponent chose to defect. In ICD, *Tit-For-Tat* performed poorly. The differing results obtained for the ICD and IPD games illustrate the fact that what strategies work in one game do not necessarily work in another. It shows that fixed algorithms written to play a specific game are not necessarily as successful when the rewards of the game change, even when the structure of the game is basically the same. In all the previously given examples, the games are played in exactly the same way. Two players select one of two given strategies without knowledge of the other's selection to achieve a maximum payoff. This characteristic makes it easy to change the values in the payoff matrix without adjusting the algorithms to test them under differing payoff conditions.

Algorithms to play computer games either as the game's controlling entity or an NPC are written specifically to play to the conditions and rules of the particular game for which they were created. For example, it is not reasonable to think that a chess program could be given a Scrabble board and have no problem in adjusting all by itself, just like it is not reasonable to think that a *Sim* could successfully survive for any decent amount of time in *Quake 3 Arena*. Writing such an adaptive program would be a monumental task, and it is fanciful to think this technology will be available anytime soon. However, learning algorithms are being developed to begin addressing this problem, although the games they are being adapted for are simplistic.

One of these algorithms is called the Strategy Learning Algorithm (SLA) [Freund95]. The SLA attempts to learn the strategy of its opponent in order to combat it. The opponents of the SLA are computationally bounded, which means they are not human and, therefore, have an algorithmic strategy approach that can be analyzed by the SLA during game play. The opponents of the SLA fall into two categories. The first category of opponents selects a strategy for the current round

of a game based on the recent history of game play, such as *Tit-For-Tat*. The second type of opponent uses simple statistics about the entire history of the game to deduce the best strategy. The developers of the SLA claim the algorithm can learn to play any zero-sum game nearly optimally against any other game-playing algorithm using a mixed strategy. In brief, the SLA works by analyzing the history of its opponent's moves and developing an approximation of move probabilities for the opponent. In other words, it creates a close replica of its opponent. When the replica is used to play against the actual opponent, the payoff achieved is close to optimal.

3.4 EXCEPTIONS TO THE RULE

Throughout history many researchers have had varied positions on classical game theory [Kimbrough02]. One view is that people don't actually behave as prescribed by the classical theory. Coleman [Coleman95] refutes this position and argues that it is a fundamental misunderstanding of the role of payoffs in the game matrices. The theories thus far presented assume a high degree of self-interest on the part of the game players, where they are playing only for their own benefit and selfish gain. This, however, is not always true, and, as demonstrated in Table 3.11 in which a friendly game of Prisoner's Dilemma is shown, the payoff values can be and should be adjusted to the player's own interests. These interests are not always selfish and often deviate from the philosophy due to a number of basic primary human behaviors. Several of these are now discussed.

3.4.1 Loss Aversion

Loss aversion is a feature of game playing in which people tend to value losses more than gains. For example, in domains where the sizes of gains and losses can be measured, people value modest losses at about twice the value of the same-sized gains [Rabin98]. This valuation relates to the endowment effect [Thaler80], where people tend to value an object more when it is in their possession than when it is not. The value of giving up a possessed item, such as a car, would be more than the value of acquiring one. In addition, loss aversion is comparable to a phenomenon known as status quo bias [Knetsch89]. In this case, people tend to prefer things the way they are (status quo) as opposed to making a loss that is offset by a comparable gain. People don't tend to swap items of value with other items unless the swap will provide them with an acceptable gain, where the gain need not be represented by a monetary value but by the person's own recognized payoff.

3.4.2 Diminishing Sensitivity

Diminishing sensitivity refers to a person's perception of change and how the change is made with respect to the person's reference level. The reference level is some starting state experienced by the person before a change occurs. The final state is then analyzed with respect to the starting state. If some measurement can be assigned to the change, depending on the reference level, a person may not evaluate two separate events for which the change is equal as being the same. For example, a hungry person may consider his change in appetite after eating an apple pie far greater than if he ate the apple pie after he had finished a three-course banquet. In this case, the effect that an apple pie has on the hunger of a person has a diminished effect the less hungry the person is.

3.4.3 Unselfish Acts

Many of the classical games outlined in game theory use payoff values that represent the self-interests of each player. However, many scientific studies have shown that people are not always motivated by self-interest. Other motivating unselfish factors include equity and fairness, where people put a value on the well-being of others. It could be argued that such behavior is really a selfish act, because although unselfish acts appear to benefit others, they also bring the apparently unselfish person pleasure and, therefore, should really be classified as a selfish act. A truly unselfish act would be one that benefitted others to the detriment of the person acting. For example, a Biblical parable tells of a beggar on the streets asking for money. A rich man walks by and gives the beggar two gold coins. Next, a poor man comes by and gives the beggar two gold coins. The rich man had plenty of money to spare, and the two coins barely made a dent in his fortune. The poor man, however, had given the beggar all of his gold. The moral of the story is the poor man had been truly unselfish because he had given the beggar his all, whereas the rich man did not suffer at all. This parable also demonstrates diminishing sensitivity. Although the coins of both men had the same monetary value, the poor man's gold coins were worth more to the poor man than the rich man's coins were to the rich man.

3.4.5 Reciprocity

Psychological research has found that people place value on their preferences based not only on their own wants and needs but also based on others' behaviors, motivations, and intentions [Rabin98]. Reciprocity refers to the action of treating others in the same manner in which they treat you. Put simply, it refers to the old phrase "an eye for an eye." Although this suggests that if someone does something bad to you, you do something equally as bad in return, reciprocity also works on nice acts. If someone is nice to you, then you tend to be nice to him. Reciprocity differs from

an unselfish act in that its effects on a person's behavior are based on the behavior of others, whereas an unselfish act tends to be a personality trait not motivated by others. Rabin [Rabin98] gives the following example. During a drought, water conservation is important. The less water there is, the more valuable it is (an example of diminishing sensitivity). On seeing others carelessly splurging on their water use, a truly unselfish person would step up his efforts to conserve more water for the common good. However, the actual observed case is that if people see other people using more water, then they do, too. The opposite is also true. If people see others conserving water, then so do they.

3.5 REAL HUMAN BEHAVIOR

As shown in Table 3.5, in which a mixed-strategy solution is calculated using probabilities, many games are too complex to solve in a reasonable time. For example, had not the example shown in Table 3.5 been given, would you have been able to find the best strategic solution? Game theory is often thought to dictate how humans *should behave* rather than how they *do behave*. However, many humans have never heard of game theory and behave in the manner in which they want. Therefore, we should view game theory as a tool for predicting behavior rather than a mold into which game players should be made to fit.

The problem with many games is that the best solution is not always evident and often may be far too complicated for a person to calculate. For example, chess is a strictly competitive game with perfect information. Game theory tells us a definite solution is possible when playing the game. However, the working out of this solution is so complex that it is unreasonable to assume that any human player (or computer for that matter) could come up with the best move in the limited time during game play. All moves considered, there are about 30^{80} possible games that can be played. This is greater than the estimated number of particles in the universe (estimated to be around 10^{79}). It is totally unreasonable to assume that any optimal strategy can be found.

So how do humans handle games in these situations? Simon [Simon57] came up with the idea that humans explore a limited number of strategies and select one that is satisfactory based on their own criteria. This method is known as satisficing. For example, when buying a car the potential purchaser has a list of characteristics he wants the car to have. Within this list are a set of minimal characteristics for which the purchaser will settle. Is it likely the purchaser will examine all known cars to find the one he is after? Indeed not. What is more likely to happen is that within a timeframe set by the purchaser, the most ideal car fitting the wanted characteristics will be settled upon. The same scenario could be applied to finding a restaurant

in a new town. Are you going to call each restaurant to find out what is on the menu?

EXERCISE

1. Can you list five other examples where satisficing is used to pick a game strategy?

3.6 GAMES WITH VIRTUAL HUMANS

Although human game-playing behavior is complex, game theory shows us that it is, to some extent, predictable. Simple zero-sum games with Nash equilibria are truly predictable if each player plays for his own self-interest. These types of games would become boring after a while because the outcome would always be the same, or at least have several limited outcomes that could easily be predicted. For example, the game of tic-tac-toe is invariably predictable and found uninteresting by adults who have played the game many times. On the other hand, without the element of predictability, humans would cease to play games because they would become frustrating and unrewarding. Imagine playing chess with a player who makes random moves. Many strategies in chess are formulated by the player counting on the other player reacting to his moves in a certain way, and much of the joy of chess is not only in formulating a strategy but in predicting the strategy of the other player.

The game theory philosophy can also be applied in the context of programming believable NPCs. If human players expect certain behaviors from their human counterparts, should they also not expect the same from a virtual player? Shakespeare's character Shylock, from *The Merchant of Venice*, makes the following observation:

"He hath disgraced me, and hindered me half a million, laughed at my losses, mocked at my gains, scorned my nation, thwarted my bargains, cooled my friends, heated mine enemies; and what's his reason? I am a Jew. Hath not a Jew eyes? Hath not a Jew hands, organs, dimensions, senses, affections, passions? Fed with the same food, hurt with the same weapons, subject to the same diseases, healed by the same means, warmed and cooled by the same winter and summer, as a Christian is? If you prick us, do we not bleed? If you tickle us, do we not laugh? If you poison us, do we not die? And if you wrong us, shall we not revenge? If we are like you in the rest, we will resemble you in that. If a Jew wrong a Christian, what is his humility? Revenge. If a Christian wrong a Jew, what should his sufferance be by Christian example? Why, revenge. The

villainy you teach me I will execute, and it shall go hard but I will better the instruction."—Shakespeare, The Merchant of Venice

His point is that although Christians and Jews are considered to be different, their characteristics and behaviors are essentially the same and, therefore, predictable. In creating a NPC, the programmer should attempt to make the character believable by giving it characteristics and behaviors expected by the human player. This is not to say the NPC will be totally predictable—game theory shows us it should not be the case; however, random behaviors and unmotivated actions would not be acceptable. Interestingly, as a sidebar, Shylock talks of the expected human characteristic of reciprocity.

Although game theory is concerned with human cognitive processes, the previous quote from Shakespeare raises another issue: outward physical behavior. If the NPC designer is to create a convincing character, he should ensure that its physical form reacts and interacts with its environment as expected by the human player. For example, in *Wolfenstein*, if an NPC is assaulted by a player with a Gatling gun, the player would expect the NPC to be seriously injured, if not die (hence, *If you prick us, do we not bleed?*). Superhuman strength and ability is not unheard of in NPCs; however, these characteristics must be justified and made aware to the player. NPCs in *Doom* and *Quake* tend to become bigger and uglier as their strength and fighting abilities increase. The player can also develop an understanding of an NPC through interaction. If the first time the player throws a grenade at an NPC it blows up into a million pieces, then the player would expect the same thing to happen the next time he throws a grenade at the same character. If the NPC develops a resistance to grenades throughout play, this characteristic needs to be made clear to the player. Otherwise, the game's behavior will seem unpredictable and the player will soon lose interest.

3.6.1 Applying Game Theory

Although we have stated that simple games do not always predict the behavior of players, we start by applying these probabilities to a game with two NPCs because they are the simplest and can easily be implemented. By building a payoff matrix for the interaction between two NPCs, we can examine their best strategies during an encounter. Let's begin by looking at a payoff matrix for two evenly matched opponents, inspired by Olsen [Olsen03] and shown in Table 3.13. The matrix depicts a simple fighting game.

The players in this game have two options: attack or retreat. The payoff values in this example represent the effect on the player's health. For example, if both players decide to attack, their health is decreased by 10 points. By analyzing the matrix we can find the minimax solution in the cell where both players retreat. This

TABLE 3.13 The Payoff Matrix of Health Effects for a Simple Fighting Game

		Player 2	
		Attack	**Retreat**
Player 1	**Attack**	−10,−10	−1,−5
	Retreat	−5,−1	0,0

cell is selected because the players attempt to minimize the maximum damage that could occur. The maximum damage that could occur is −10. This is undesirable, so the players should select the attack strategy that ensures they never incur the −10. When retreat is selected the worst they can do is −5 and the best is 0. This situation is not ideal because each player will refuse to engage the other, which makes for a very boring game.

Putting this problem aside for one moment, each player can use the matrix to determine his best move when the move of the other player is known. If Player 1 is attacking, Player 2 knows his best option would be to retreat because this action minimizes the damage sustained. If Player 1 is attacking, Player 2 knows his choices yield a −10 or a −5. Because in this case −5 is a better option, Player 2 should retreat. The minimax solution is still the best, even when the movements of the other player are known.

Whereas this matrix may represent the payoffs to the player's health, it does not reflect other motivations that would normally keep the game in play. Have you ever encountered a Quakebot (an NPC program to play *Quake*) that keeps its distance from you because it is afraid of being hurt? The point here is that the Quakebot is more concerned with injuring its enemy than it is about preserving its own health. Therefore, the game payoff matrix must be altered to take this motivation into consideration. The modified matrix is shown in Table 3.14.

TABLE 3.14 The Payoff Matrix of Motivations for a Simple Fighting Game

		Player 2	
		Attack	**Retreat**
Player 1	**Attack**	$[-10,10,\mathbf{0}],[-10,10,\mathbf{0}]$	$[-1,10,\mathbf{9}],[-5,-20,\mathbf{-25}]$
	Retreat	$[-5,-20,\mathbf{-25}],[-1,10,\mathbf{9}]$	$[0,-20,\mathbf{-20}],[0,-20,\mathbf{-20}]$

Table 3.14 now shows three payoff values for each player, enclosed in square brackets. The first value is the damage to health, the second value is the player's self-esteem, and the third, in bold, is the sum of the previous two. For example, Player 1 and Player 2 consider the retreat strategy to result in negative self-esteem (−20), whereas the attack option raises it (10). This lowers the payoffs for the retreat strategies. The sum of the two initial payoffs is being used to simplify the matrix. There is no particular reason why the sum is being used except as a straightforward way to combine the two payoffs. If it were deemed necessary, a more complex formula could be used. However, the sum will suffice for now.

From the payoff values in Table 3.14, you can see that the tables are now turned for the two fighting players. The minimax value now occurs where both players attack. Retreating is now viewed as a damaging strategy to the players' self-esteem. These new values keep the action going until one of the players dies. In this simple case, each time a player attacks, the other player's health is reduced by a flat 10 points. Assuming the players take turns to attack, whoever attacks first will always win. Often in real games, a random element is added that allows attacks to cause a range of damage, which also depends on the players' aim. We will address these issue later.

Thinking logically about the game between these players, the payoff matrix aside, it would seem that the best move for a player to make when his health is low is to retreat. However, according to the payoff matrix, a retreating player suffers greater damage to his self esteem if attacked; therefore, retreating isn't seen as a viable strategy. If the other player sees his opponent retreating, it is in his best interest to attack (or stab the retreating player in the back). This aside, we want to make the retreat strategy more appealing to a player as his health wanes. To do this, we employ the concept of diminishing sensitivity. If the player's health is high, then his motivation to fight should be greater. However, as his health decreases, his motivation to retreat should increase. Table 3.15 suggests a method of implementing diminished sensitivity in the payoff matrix.

According to Table 3.15, if Player 2's health is at 100 points and his maximum health is 100, then his payoff for attacking is $-10+100 = 90$, and his payoff for retreating is $-5+100-100 = -5$, making attacking the better option. When Player 2's health decreases to 50, his payoff for attacking is $-10+50 = 40$, and his payoff for retreating is $-5+50 = 45$, thus making retreating the better option. In brief, the players' payoffs for attacking decrease with their health. This is just one example of how formulae can be implemented in the payoff matrix to modify the behavior of the players. The formulae in Table 3.15 are not hard and fast by any means and are meant as an example. You may find more complex formulae that better meet your needs when it comes to coding a player fight.

TABLE 3.15 The Payoff Matrix with Diminished Sensitivity for a Simple Fighting Game[a]

		Player 2	
		Attack	**Retreat**
Player 1	**Attack**	$[-10, H_1, -10+H_1],$ $[-10, H_2, -10+H_2]$	$[-1, H_1, -1+H_1],$ $[-5, H_2, -5+MH_2-H_2]$
	Retreat	$[-5, H_1, -5+MH_1-H_1],$ $[-1, H_2, -1+H_2]$	$[0, H_1, MH_1-H_1],$ $[0, H_2, MH_2-H_2]$

[a] H_1 and H_2 are the respective health levels of the players, and MH_1 and MH_2 are the maximum health levels.

Of course, now we have a player who retreats when his health is low and the opponent may keep attacking. Because being attacked while retreating also inflicts damage on the player, retreating is a sure-fire way of dying more quickly than the other player. However, in this fighting game the players have no choice but to die because no strategy is available to them to replenish their health. In the next section, the payoff matrix from this simple fighting example is implemented using the Apocalyx game engine, and the matrix is extended to allow for health replenishing.

3.7 DAY OF RECKONING: IMPLEMENTING A SIMPLE GAME USING A PAYOFF MATRIX

In this practical exercise, you use the payoff matrix concepts learned in this chapter to implement a simple fighting game using the Apocalyx game engine. The game includes two NPCs whose behavior is determined by a payoff matrix.

ON THE CD

The initial project for this exercise can be found in the Apocalyx/prj/Chapter Three-2 folder and associated source code in the Apocalyx/dev/src/Chapter Three-2 folder. Use *Virtual Human.dsp* in the Apocalyx/prj/Chapter Three-2 folder to open the project and set up the environment. After you compile and run the initial code, you will have two NPCs moving randomly around the environment.

3.7.1 Step One: Applying a Payoff Matrix to the Update Method

Examination of the initial code for this exercise reveals that each bot is aware of the other through the opponent property. This property allows each bot to track and determine the state of the other. In addition to this new property, the AIBot class

has a new enumerated data type called botState, which defines the three states of a bot: ATTACK, RETREAT, or DEAD. In *AIBot.cpp*, some new methods can now be defined, as shown in Listing 3.1.

LISTING 3.1 An update method for the AIBot class

```
void AIBot::update()
{
    //PART A
    if (opponent->state == ATTACK)
    {
        if( (health-10) > (100-health-20))
            state = ATTACK;
        else
            state = RETREAT;
    }
    else if (opponent->state == RETREAT)
    {
        if( (health-1) > (100 - health) )
            state = ATTACK;
        else
            state = RETREAT;
    }

    //PART B
    //if opponent is dead - no need to do anything
    if (opponent->state == DEAD)
    {
        if(lowerAnim != LEGS_IDLE )
            botAvatar->setLowerAnimation(lowerAnim = LEGS_IDLE);
        if(upperAnim != TORSO_STAND )
            botAvatar->setUpperAnimation(upperAnim = TORSO_STAND);
        return;
    }

    //PART C
    //if health below 0 then you are dead
    if (health <= 0)
    {
        state = DEAD;
        if(upperAnim != BOTH_DEAD1 )
            botAvatar->setAnimation(upperAnim = BOTH_DEATH2);
        else
            botAvatar->setAnimation(upperAnim = BOTH_DEAD1);
        return;
```

```
}

//PART D
//get bot's position and bot's opponent's position
BSPVector botPos( botAvatar->getPositionX(),
    botAvatar->getPositionY(), botAvatar->getPositionZ() );
BSPVector opponentPos( opponent->botAvatar->getPositionX(),
    opponent->botAvatar->getPositionY(),
    opponent->botAvatar->getPositionZ() );
BSPVector oldVelocity = velocity;
//remember bot's current velocity

//PART E
if (state == ATTACK)
{
    if(!isNear(botPos,opponentPos, 50))
    {
        if(upperAnim != TORSO_STAND2 )
            botAvatar->setUpperAnimation(upperAnim = TORSO_STAND2);

        //head towards opponent
        velocity.set(opponentPos.x - botPos.x, 0,
            opponentPos.z - botPos.z);
    }
    else
    {
        if(upperAnim != TORSO_ATTACK2 )
            botAvatar->setUpperAnimation(upperAnim = TORSO_ATTACK2);

        if(opponent->state == ATTACK)
        {
            opponent->health = opponent->health - 10;
        }
        else
        {
            opponent->health = opponent->health - 20;
            health = health - 1;
        }
        return;
    }
}
else if(!isNear(botPos,opponentPos, 50) && state == RETREAT)
{
    randomWander();
}
```

```
//PART F
else if(state == RETREAT)
{
    if(upperAnim != TORSO_STAND2 )
        botAvatar->setUpperAnimation(upperAnim = TORSO_STAND2);

    //head away from opponent
    velocity.set((botPos.x - opponentPos.x), 0,
        (botPos.z - opponentPos.z));
}

//PART G
health += 0.01;    //slowly recover from attack

//move towards opponent -
//distance traveled based on speed
velocity = velocity.normalize();
botAvatar->rotateStanding(turnXZ(velocity, oldVelocity));

BSPVector botVel = velocity;
botVel.x *= speed;
botVel.z *= speed;
bsp->slideCollision(botPos,botVel,extent);
botAvatar->setPosition(botPos.x,botPos.y,botPos.z);
}

//PART H
void AIBot::randomWander()
{
    if(rand()%100 == 1)
    {
        velocity.set(getrandom(0,1000)-botAvatar->getPositionX(),
            0, getrandom(0,1000)-botAvatar->getPositionZ());
    }
}

//PART I
char *AIBot::getBotDetails()
{
    char detailStr[SMALLBUF];
    sprintf(detailStr,"%s Health: %.2f State: %d",
        botName, health, state);
    return detailStr;
}
```

The code shown in Listing 3.1 has been divided into parts using comments to make discussion simpler. Each part of the code acts in the following manner:

Part A: The first section of the code sets the bot's state. The state is determined by the state of the bot's opponent and the payoff values in the matrix shown in Table 3.15. Basically, the bot works out its best strategy to play against its opponent. Its strategy is based on the value of its health. Therefore, as the bot's health decreases it prefers a state of RETREAT instead of ATTACK.

Part B: The next part of the code determines if the bot's opponent is in the DEAD state. If it is, there is no need for the bot to do anything and its lower animation is set to LEGS_IDLE. No further update processing is performed after this state, as indicated by the return statement.

Part C: This part of the code checks if the bot's health has fallen below 0. If it has, the bot's animation is set to BOTH_DEATH2. This setting displays the bot falling to the ground. No further update processing is performed after this state, as indicated by the return statement.

Part D: Because the bot is constantly on the move, it is important to determine the bot's location with each update. In this section, both the bot's and its opponent's locations within the environment are obtained. The bot's current velocity is stored in a temporary variable (velocity_old) and used later to determine how the bot's velocity has changed during the update procedure to calculate any turning angles that must be executed to ensure the bot is facing in the right direction.

Part E: This section processes the bot's behavior when in an ATTACK state. The bot can only attack if it is *close enough* to its opponent, as determined by the isNear method. If the bot is not within attacking distance of the opponent, it sets a new velocity to travel toward it. If the bot can attack the opponent, its health and the opponent's health is affected as per the payoff matrix shown in Table 3.15.

Part F: If the bot is in a state of RETREAT, a vector is calculated that takes the bot away from its opponent.

Part G: The last part of the update() method updates the bot's health by a small amount. This update gives the bot the chance to recover its health when it is retreating from its opponent and not being attacked. Without this update, both bots would simply die and the match would be uninteresting. This value is not shown in the payoff matrix, but it can be added as another value in factoring the total payoff for a strategy. The remainder of the code in the update() method moves the bot according to its speed in the direction of its velocity vector.

Part H: The `randomWander()` method changes the direction of the bot's velocity randomly once approximately every 100 updates. This change causes the bot's wandering to be in a random and changing direction without being too erratic.

Part I: The `getBotDetails()` method is useful for displaying the states of the bot on the screen for you to see while the program is running. Essentially, you can print out whatever bot properties you want in here and have it appear on the screen. This feature is great for debugging. This method should be run from the `MainScene::getHelpLine()` method in the *vh.cpp* file as follows:

```
const char* MainScene::getHelpLine(int line)
{
    switch(line)
    {
        case 10: return "Virtual Human";
        case 9: return bot1.getBotDetails();
        case 8: return bot2.getBotDetails();
        case 7: return "[ MOUSE ] Look Around";
        case 6: return "[LEFT CLICK] Shoot";
        ...
```

You can add other strings into the case statement and display them on the screen during game play when you press F1. Be sure to keep the case statements numbered consecutively.

Type these new methods, then save, compile, and run the code to watch the behavior of the bots. Press F1 to watch their property values change.

When run, this simple fighting game produces bots that attack their opponent when their health is adequate and retreat when not. It produces situations in which both bots are attacking each other at the same time, one bot is retreating while being pursued and attacked by the other, and both bots are retreating. The retreat code is very simplistic; the bots retreat in a direction away from their opponent until they hit an obstacle in the environment (for example, a wall). This code doesn't prevent a random retreating bot from accidentally running into its opponent, so you could make the code more intelligent by selecting a location in the map that is a decent distance away from the opponent's location. This chapter isn't about improving the movement skills of the bot, so further investigation of this matter is left for you to experiment with and is discussed in future chapters.

3.8 MATCHING SKILLS

The simple game presented in the previous section, although initially fun to play with, soon becomes monotonous and boring. Why? Beside the fact that you can only watch and not participate (did you wonder how you would include the players' avatar in the scenario?), the bots have only three playing states (ATTACK, RETREAT, and DEAD), and the methods of attack available to the bots is limited to one simple attacking action, which decreases the opponents' health by a predetermined, predictable amount. Because each bot is an instance of the AIBot class, they are evenly matched. You could predict that over a number of tournaments played between the bots in your game, each bot would win and lose as frequently as the other.

This is, of course, the very idea you should have in mind when developing NPCs that do not always win or lose but possess skills equal to that of a human opponent. Although their skills and behaviors may be different, they should be evenly matched to some extent to prevent one bot from always winning, which quickly causes another monotonous and boring situation. Who likes to play a game against someone who constantly wins? Where is the fun in knowing you are going to lose before you start playing? The idea is to develop NPCs with varying skills of attack while keeping them evenly matched.

In the previous fighting game, the payoff matrix was a simple two-by-two table. As more complex NPCs are dreamed up, the payoff matrix rapidly expands, often to the point where it could be impossible to write down. Let's consider a new game scenario, again with two players, but with different skills. Rather than just attacking, we will give the players differing methods of attack. The scenario resembles a fantasy role-playing game, including a magician named Merlin and an ogre named Schreckle. Merlin has two attacking abilities available to him: Fire Bomb and Sword-o-Venom. Schreckle also has two attacking skills: Wrestle and Thump. Besides attacking, the characters can also duck and retreat. The payoff matrix for the combat between these two characters is shown in Table 3.16.

TABLE 3.16 The Health Payoff Matrix for Merlin and Schreckle's Combat

		Schreckle			
		Wrestle	**Thump**	**Duck**	**Retreat**
	Fire Bomb	−15,−10	−5,−20	−1,0	−1,−6
Merlin	**Sword-o-Venom**	−5,−20	−10,−15	−1,0	−1,−9
	Duck	−1,−1	−1,−1	5,5	6,8
	Retreat	−7,−1	−9,−1	5,5	7,9

Table 3.16 shows the health payoff values for each player on the selection of a particular strategy. For example, if Merlin decides to Fire Bomb Schreckle while Schreckle is Wrestling him, more damage will occur to Merlin—this may be because Merlin will take some of the brunt of the Fire Bomb himself. Four minimax points exist in Table 3.16 where neither player will sustain damage. These points occur when the players select either Duck or Retreat. Again, as with the initial payoff matrix for the simple fighting game shown in Table 3.16, the use of the minimax theorem on Table 3.16 gives neither player an incentive to attack the other. Therefore, a factor of diminished sensitivity should be included to motivate the players to attack each other when they are healthy and to retreat when they are not.

A characteristic of this game that cannot be shown in the payoff matrix is the duration, frequency, and sequence of each state. For example, the Fire Bomb state may take Merlin 5 seconds to conjure up and execute, after which he cannot create another one for 10 minutes. Schreckle, on the other hand, may not be able to Duck immediately after a Wrestle. This type of information is better represented in a finite-state machine, which is discussed in Chapter 5.

In addition to these restrictions on the states, each state may have to be executed at a different distance. For example, Schreckle would have to be very close to Merlin to execute a Tackle; Merlin may have to be a decent distance away from Schreckle when performing a Fire Bomb in order not to get hit by any backlash. Another consideration might be the characters' awareness of each other. In the simple fighting game, each bot knew exactly where the other bot was, even when its back was turned. To make the characters more believable, it would be a good idea to restrict their sensing abilities. They should be able to see things only within a certain viewing range and be able to hear things only in close proximity and when making audible noises. And last, but definitely not least, many games include probabilities on damage made to the other player and factors of accuracy in the attacks. In dungeons-and-dragons-type games a magic spell may have a range of damage that it can do. At the time of use a die is rolled to determine how much damage occurs. Also, the simple fighting game does not take into consideration the accuracy of an attack. Although the bots are programmed to be facing their opponent when attacking, they could be programmed with a certain probability of actually hitting their target.

All of these new considerations begin to make a game with just two characters and four states very complex. However, what is good to know is that once the programming has been done, analysis on the effectiveness of the values in the payoff matrix can be achieved quite simply to balance the players' skills.

3.9 DAY OF RECKONING: IMPLEMENTING THE MERLIN VERSUS SCHRECKLE GAME

Implementation of the game shown in Table 3.16 can be achieved by reusing most of the code from the simple fighting game. However, this time two random factors are added to spice up the game. The first is a damage range. Instead of specifying a maximum damage value, the game matrix includes a minimum and maximum for a certain type of damage. The program calculates a random value in this range to assign as damage at the time of an attack. In addition to the random damage, an accuracy factor is included. Accuracy specifies how often a player actually hits the other player in an attack. For example, if Schreckle has an accuracy rate of 50 percent when attempting to Wrestle Merlin while Merlin is trying to Fire Bomb Schreckle, then Schreckle will succeed in actually causing damage to Merlin half of the time.

ON THE CD
The initial code files for this practical exercise can be found in the Apocalyx/prj/Chapter Three-2 folder. Open *Virtual Human.dsp* to begin.

3.9.1 Step One: Setup of the Payoff Matrix

The game payoffs (minimum damage, maximum damage, and accuracy) are declared in a matrix, partially coded as follows:

```
const int M[4][4][6] =
{
    //WRESTLE                THUMP
    //MERLIN  SCHRECKLE  MERLIN  SCHRECKLE
    /*BOMB*/ -15,-5,4, -10,-4,3, -5,-10,6,  -20,-8,5, ...,
    /*SWORD*/ -5,-8,3, -20,-6,7, -10,-3,6, -15,-8,5, ...,
    /*DUCK*/ -1, 0,6, -2, 0,9, -1, 0,6,  -2, 1,9, ...,
    /*RETREAT*/-7,-5,6, -1, 0,3, -9,-4,4,  -1, 0,7, ...,
};
```

In this code the values for Schreckle's Duck and Retreat are not shown because of the lack of space; however, the completed code is available in the *vh.h* file. The matrix is arranged in groups of three. The first value is the minimum damage that can be caused to the player, the second value is the maximum damage that can be caused to the player, and the third is the player's accuracy. If Merlin were to select the strategy Fire Bomb when Schreckle had selected Wrestle (represented by the first three values in the matrix), Merlin could expect a maximum damage of −15 and a minimum damage of −5. Merlin's accuracy during this encounter would be 4/10 or 40 percent. Note that all accuracies in this matrix are assumed as values out of 10, where 10 is the maximum, or 100 percent, accuracy. However, it is not Mer-

lin's accuracy that affects the damage that will occur to him—it is Schreckle's, which in this case is 30 percent. To evaluate how this range of damage could affect each player's health, each player is programmed with a minimax strategy that works to minimize the maximum damage that could occur. In Merlin's case, he would take the maximum damage for this encounter to be −15. The maximum damage value is then multiplied by the other player's accuracy to come up with a payoff value for the game matrix cell. In this case it will be Merlin's maximum damage of −15 multiplied by Schreckle's accuracy of 30 percent, which would equate to −4.5. Such is the circumstance that a player could consider a smaller damage with greater accuracy to be worse than a higher damage with a low accuracy.

Although much of the code for both players remains the same, each player is created from a different class. Schreckle uses the modified AIBot class, and Merlin is created from a new class, simply called Merlin. When you have the players up and running, the separate classes enable you to add different AI features to each player as you see fit and to peg them against each other in a tournament.

Although you haven't modified the code taken from the CD-ROM, compile and run the code to display Merlin and Schreckle engaged in the simple fighting game. You may even want to change the model of one of the bots in *vh.cpp* to make them look different.

3.9.2 Step Two: Updating the Bots with the Payoff Matrix

For now, however, because both classes are basically the same, we examine the crux of the code for the AIBot: the update() method. This code is displayed in Listing 3.2. Again, it is divided into parts for ease of explanation.

LISTING 3.2 New methods for the AIBot

```
void AIBot::update()
{
    //PART A
    //if opponent is dead - no need to do anything
    if (opponent->state == DEAD)
    {
        if(lowerAnim != LEGS_IDLE )
            botAvatar->setLowerAnimation(lowerAnim = LEGS_IDLE);
        return;
    }

    //if health below 0 then you are dead
    if (health <= 0)
    {
        state = DEAD;
```

```
    if( upperAnim != BOTH_DEATH1 && upperAnim != BOTH_DEAD1)
        botAvatar->setAnimation(upperAnim = BOTH_DEATH1);
    else if( upperAnim == BOTH_DEATH1)
        botAvatar->setAnimation(upperAnim = BOTH_DEAD1);

    opponent->wins++;
    reset();
    opponent->reset();

    return;
}

//PART B
state = WRESTLE;
float iLoading, stateLoading;
for(int i = 0; i < 4; i++)
{
    if(i == WRESTLE || i == THUMP)
        iLoading = health;
    else
        iLoading = 100 - health;

    if(state == WRESTLE || state == THUMP)
        stateLoading = health;
    else
        stateLoading = 100 - health;

    if ( (M[opponent->state][state][3] + stateLoading) <
        (M[opponent->state][i][3] + iLoading))
            state = i;
}

//PART C
if(lowerAnim != LEGS_WALK )
    botAvatar->setLowerAnimation(lowerAnim = LEGS_WALK);

//get bot's position and bot's opponent's position
BSPVector botPos( botAvatar->getPositionX(),
    botAvatar->getPositionY(),
    botAvatar->getPositionZ() );
BSPVector opponentPos(opponent->botAvatar->getPositionX(),
    opponent->botAvatar->getPositionY(),
    opponent->botAvatar->getPositionZ() );
BSPVector oldVelocity = velocity;
//remember bot's current velocity
```

```
//PART D
if(!isNear(botPos,opponentPos, 50))
{
    if (state == WRESTLE || state == THUMP)
    {
        if(upperAnim != TORSO_STAND2 )
            botAvatar->setUpperAnimation(upperAnim = TORSO_STAND2);

        //head towards opponent
        velocity.set(opponentPos.x - botPos.x, 0,
            opponentPos.z - botPos.z);
    }
    else if (state == RETREAT)
    {
        health = health + 0.1;
        wander();
    }

    //update health if neither is attacking
    if((state == DUCK || state == RETREAT) &&
        (opponent->state == DUCK || opponent->state == RETREAT))
            health = health +
                (getrandom(M[opponent->state][state][3],
                M[opponent->state][state][4])*
                genProb(M[opponent->state][state][5]));
}
else //near opponent
{
    if(state == WRESTLE || state == THUMP)
    {
        if(upperAnim != TORSO_ATTACK2 )
            botAvatar->setUpperAnimation(upperAnim = TORSO_ATTACK2);
    }
    else if(state == RETREAT)
    {
        if(upperAnim != TORSO_STAND2 )
            botAvatar->setUpperAnimation(upperAnim = TORSO_STAND2);

        //head away from opponent
        velocity.set((botPos.x - opponentPos.x), 0,
            (botPos.z - opponentPos.z));
    }
    health = health + (getrandom(M[opponent->state][state][3],
        M[opponent->state][state][4])*
```

```
                genProb(M[opponent->state][state][5]));
        }

        if(state == DUCK)
        {
            if(lowerAnim != LEGS_IDLECR )
                botAvatar->setLowerAnimation(lowerAnim = LEGS_IDLECR);
            return;
        }

        //PART E
        velocity = velocity.normalize();
        botAvatar->rotateStanding(turnXZ(velocity, oldVelocity));

        BSPVector botVel = velocity;
        botVel.x *= speed;
        botVel.z *= speed;
        bsp->slideCollision(botPos,botVel,extent);
        botAvatar->setPosition(botPos.x,botPos.y,botPos.z);
    }

    //PART F
    void AIBot::reset()
    {
        health = 100;
        state = WRESTLE;
        BSPVector& startBot = bsp->getStartingPosition();
        botAvatar->setPosition(getrandom(0,1000),startBot.y,
            getrandom(0,1000));
    }
```

As previously stated, much of the code in Listing 3.2 is similar to that in Listing 3.1. Therefore, any explanation of this repeated code is skipped over in this section. Each part of the code works as follows:

Part A: The first part of the code determines if either the bot or its opponent is dead and sets the appropriate animation.

Part B: The next section loops through each of the game matrix states, comparing the payoff values for each. The state with the best payoff is chosen as the bot's next strategy. As with the simple fighting game, that state's payoffs are evaluated differently using the sample formulae from the simple fighting game. The formulae are treated as payoff loading values. For attacking states (Wrestle and Thump), the loading is the value of the bot's health. For the passive states

Duck and Retreat, the loading value is set to the bot's maximum health minus its current health. These loadings ensure that as the bot's health deteriorates, the bot prefers to act passively rather than attack the other player.

Part C: This part of the code determines the location of the bot and its opponent in the game environment.

Part D: The next section of the code causes the bot to act on the state selected in Part B. If the bot is not near its opponent and wants to attack, it begins moving toward the opponent. If the bot does not want to attack, it simply wanders the map. If the bot is close enough to attack or be attacked, the values in the appropriate cell of the payoff matrix are used to update the bot's health. First, a random number is found between the maximum and minimum damage values. Next, a probability generator function, `probGen` (listed in *vh.h*), is used to calculate if the opponent's accuracy caused a hit. If the opponent missed the bot, the bot's health is not affected. However, if the opponent hit the bot, then the bot's health is adjusted by the random damage value. All parts of the code set the bot's animation appropriately.

Part E: The last part of the `update()` method modifies the bot's location within the environment.

Part F: The `reset()` method reinitializes the bot's health and state and relocates it within the environment, ready for the next fight.

Add the new methods to the `AIBot` class. The same methods can also be added to the `Merlin` class. Because Schreckle and Merlin access the same payoff matrix, however, the Merlin bot must access different values within the matrix; therefore, the code is slightly different. Parts of the `update()` method such as

```
if ((M[opponent->state][state][3] + stateLoading)
    <(M[opponent->state][i][3] + iLoading))
        state = i;
```

should be changed for Merlin to

```
if ((M[state][opponent->state][0] + stateLoading)
    <(M[i][opponent->state][0] + iLoading))
        state = i;
```

where the differences are shown in bold. Add a new `update()` method and a `reset()` method to the `Merlin` class.

After compiling the code for the Merlin versus Schreckle game, you can see the state changes and movements of each player. To examine the current health and state of each player, add new values into the getBotDetails() *method and press F1 to display the players on the screen.*

3.10 BALANCING THE PAYOFF MATRIX

The Merlin and Schreckle game differs from the simple fighting game in that it has more playable strategies and the players' strategies diverge. In the simple fighting game, the players have only two choices and the payoff values are evenly balanced. In the Merlin and Schreckle game, this is not the case. The matrix is unbalanced, with payoff values differing between strategies. In this type of complex game it is important to determine how balanced the players' payoffs are to determine if they are equally matched. Because the code for each of the bots in the Merlin and Schreckle game are identical, we can be sure that the game payoff values determine how each bot fares during competition.

The best way to determine if the payoff matrix is evenly matched is to play several tournaments with the bots and analyze the outcomes. Two main game characteristics should be examined—first, the number of wins and losses for each bot, and second, the frequency of each state. To demonstrate the analysis, the Merlin versus Schreckle game was run for 25 rounds. Table 3.17 displays a count of the states for each player.

Table 3.17 reveals many aspects of the Merlin versus Schreckle game. For one, the game payoff matrix is grossly unbalanced in favor of Merlin—he did not lose a single round. Next, Merlin spends the majority of his time attacking with the Fire Bomb whereas Schreckle spends most of his time ducking. This imbalance makes Merlin a much more aggressive player with Schreckle being somewhat passive.

TABLE 3.17 Frequency of States for Each Player in Merlin versus Schreckle for 25 Rounds

	Merlin	Schreckle
FIRE BOMB/WRESTLE	19,359	4,771
SWORD-O-VENOM/THUMP	1,396	1,117
DUCK	4,539	18,399
RETREAT	1,807	825
DEAD	0	25

Given these values, we can determine that Schreckle's payoffs for attacking should be increased to make the states more attractive to the bot when selecting its strategy. However, it is not just a matter of updating the payoff for Schreckle's states. It is obvious that Schreckle's Wrestle could do more damage or that Merlin's Fire Bomb could do less damage, but when? Should they be increased or decreased for all states of the opponent or only in certain conditions? For example, maybe Schreckle's Wrestle needs to be updated only when used against Merlin's Fire Bomb. A further analysis of the data shown in Table 3.18 reveals the most popular combined game states.

TABLE 3.18 Frequency of Combined Game States

	WRESTLE	THUMP	DUCK	RETREAT
FIRE BOMB	1	1,396	3,374	0
SWORD-O-VENOM	1,006	0	111	0
DUCK	17,347	0	1,052	0
RETREAT	982	0	0	825

Table 3.18 shows the number of times that each state was played against each other state over the 25 rounds. For example, Merlin played the Fire Bomb when Schreckle played Thump 1,396 times. The table shows which states were the most popular and which states should be targeted for having their payoff values adjusted. Because Merlin currently has the advantage, it would be a good idea to hit him where it hurts. By examining Table 3.18, you can see that most of the time when Schreckle selects Wrestle, Merlin selects Duck. This strategy is effective for Merlin because it causes the least damage when Schreckle is in the WRESTLE state (see Table 3.16).

By modifying the Duck/Wrestle cell for Merlin's payoff values, you can change the game. If the values are changed such that the payoff for selecting this strategy becomes less ideal than another choice, the bot will select another strategy instead. As we know, the current payoff settings are making Merlin prefer this state. Therefore, we must modify the values so that they do not make the strategy any less appealing, but change the outcome during game play. Because the payoff is calculated by multiplying the maximum damage with the other player's strategy, Merlin's Duck with Schreckle's Wrestle calculates to an estimated payoff of $-1 \times 0.9 = -0.9$. The relative payoffs for the other strategies are Fire Bomb: $-15 \times 0.3 = -4.5$; Sword-o-Venom: $-5 \times 0.7 = -3.5$; and Retreat: $-7 \times 0.3 = -2.5$. If Duck is to remain Merlin's

best strategy, its payoff value must remain higher than the next highest strategy, which is Retreat with a payoff of −2.5. By changing just the maximum damage value for Duck, the tables can be instantly turned on Merlin because it creates a constant damage increase. However, if we change both the maximum damage and decrease the accuracy, the element of probability is changed and Schreckle now has less of a chance of always defeating Merlin.

Another outcome of a game after we adjust the matrix could be that the players are so evenly matched there is never a victor and the game keeps playing indefinitely. Because the Merlin versus Schreckle game matrix contains positive values that can increase the bots' health with certain strategy combinations, the bots' health may rise and fall equally, meaning that neither bot will ever die. In this instance you could also assume the bots are evenly matched. However, this makes for an uninteresting tournament!

When you modify Merlin's Duck values, as suggested previously, you find a very delicate balance between Merlin winning, Schreckle winning, or a draw (a never-ending game). When no other changes are made except to Merlin's Duck/Wrestle maximum damage (the value illustrated in bold in Listing 3.3), you will see that Merlin wins every game for values greater than or equal to −1, the game is a draw for values between −2 and −7, and Schreckle wins every game for values less than or equal to −8. In the last case, for values less than or equal to −8, the game changes and Duck is no longer Merlin's best strategy when Schreckle chooses Wrestle.

LISTING 3.3 Partial view of the Merlin versus Schreckle game matrix code

```
const int M[4][4][6] =
{
    //WRESTLE
    //MERLIN  SCHRECKLE
    /*BOMB*/  −15, −5, 4, −10, −4, 3, ...,
    /*SWORD*/ −5, −8, 3, −20, −6, 7, ...,
    /*DUCK*/  −1, 0, 6,  −2, 0, 9, ...,
    /*RETREAT*/−7, −5, 6,  −1, 0, 3, ...,
};
```

Selecting good values for the game matrix is a matter of trial and error. As an example, the values of −3 for Merlin's Duck/Wrestle maximum damage and 4 for Schreckle's associated accuracy (the value to be positioned where the number 9 is italicized and underlined in Listing 3.3) were selected. These values allow Schreckle to win. You will find that Schreckle likes to Duck when Merlin chooses to Fire Bomb. If the maximum damage and accuracy for Schreckle's Duck are slightly adjusted, the game matrix is better balanced. When the values for Merlin's Fire

Bomb/Duck are adjusted to $(-1, 0, 5)$ and Schreckle's values for the same cell are adjusted to $(-2, 0, 10)$, the game tournament plays out more evenly. After one tournament with these new settings, Merlin won seven times and Schreckle won eight times. The tournament played out for much longer than the previous time when Schreckle lost 25 times because the players were better matched and each game took longer to play. However, playing just one set of 25 games is not enough to accurately measure the payoff matrix balance. Correct statistical analysis dictates that many more tournaments must be run to obtain a more precise estimate of the matrix's balance.

3.11 SUMMARY

The field of game theory stems back to the mid-1600s. Since then the theory has been used to describe strategic human behavior for situations involving choice in domains such as mathematics, economics, and psychology. In this chapter the structures of many elementary two person-games have been described. Analysis of these games has led to the creation of algorithms developed to play tournaments of repetitive games and to diverge from the minimax strategy to outwit opponents and gain the greater payoff. Knowledge of not only these strategies but also the elementary minimax theory and the identification of Nash equilibria could lead to the development of more efficient and well-defined behaviors for NPCs.

Game theory not only explains choices by rational human game players in an effort to maximize payoffs but also considers other elements of human behavior that can also influence decision making. These elements include characteristics such as loss aversion, diminished sensitivity, and reciprocity.

Often when programming the AI for a NPC, you may prefer to just add a neat `if` statement that says "if the bot's health is below 50 percent, then retreat" rather than mucking around with payoff matrix values. That is perfectly fine and understandable! As the complexity of a game increases, it may be impossible to represent the entire payoffs of a game in a simple matrix. However, for specifying simple payoff values (devoid of formulae), a game matrix is a compact way of describing a game. It might also be better to represent differing payoff values in more than one matrix. For example, damage and self-esteem might be represented in two different matrices.

The examples presented in this chapter are not the be-all and end-all of programming bot behavior. They are given to simply show you how payoff matrices can be used and how powerful they can be. They help to conceptualize human decision making in competitive situations and, due to their numerical nature, can easily be translated into programming code. Given a known bot with near-equivalent

human skills, even if you don't use a payoff matrix to specify game values you can still analyze the outcomes of this bot against other bots to determine which bots are evenly pegged and which bots need more work.

REFERENCES

[Axelrod81] Axelrod, R. and Hamilton, W.D., 1981, *The Evolution of Cooperation*, Science, vol. 242, pp. 1385–90.

[Axelrod84] Axelrod, R., 1984, *The Evolution of Cooperation*, Basic Books, New York.

[Bernoulli38] Bernoulli, D, 1738, Specimen theoriae novae de mensura sortis, *Comentarii Academii Scientarum Imperialis Petropolitanae*, vol. 5, pp. 175–92. [Trans. L. Sommer, *Economeetrica*, 1954, vol. 22, pp. 23–26.

[Coleman95] Coleman, A. M., 1995, *Game Theory and its Applications in Social and Biological Sciences*, Butterworth and Heinemann, Oxford.

[Freund95] Freund, Y., Kearns, M., Mansour, Y., Ron, D., Rubinfeld, R. and Schapire, R.E., 1995, Efficient Algorithms for Learning to Play Repeated Games Against Computationally Bounded Adversaries, in the *Proceedings of 36th Annual Symposium on Foundations of Computer Science*, pp. 332–41.

[Kimbrough02] Kimbrough, S. O., 2002, *Notes for Agents, Games and Evolution*, Class Notes for OPIM 325, Operations and Information Management, University of Pennsylvania.

[Knetsch89] Knetsch, J., 1989, The Endowment Effect and Evidence of Non-reversible Indifference Curves, *American Economic Review*, vol. 79, no. 5, (December 1989), pp. 1277–84.

[Koestler67] Koestler, A. 1967, *The Ghost in the Machine*, Penguin Books Ltd., London.

[Lefton94] Lefton, L. A., 1994, *Psychology, Fifth Edition*, Allyn and Bacon, Boston.

[Luce57] Luce, R. D. and Raiffa, H., 1957, *Games and Decisions: Introduction and Critical Survey*, Wiley, New York.

[Olsen03] Olsen, J. M., Game Balance and AI Using Payoff Matrices, in *Massively Multiplayer Game Development*, Alexander, T., (Ed), Charles River Media, 2003.

[Rabin98] Rabin, M., 1998, Psychology and Economics, *Journal of Economic Literature*, vol. 36 (March 1998), pp. 11–46.

[Rapoport62] Rapoport, An., 1962, The Use and Misuse of Game Theory, *Scientific American*, vol. 207, no. 6, pp. 108–18.

[Rapoport67] Rapoport, An., 1967, Escape from Paradox, *Scientific American*, vol. 217, no. 1, pp. 50–56.

[Shelling60] Shelling, T.C, 1960, *The Strategy of Conflict*, Harvard University Press, Cambridge.

[Simon57] Simon, H., 1957, *Models of Man*, Wiley, New York.

[Thaler80] Thaler, R. H., 1980, Toward a Positive Theory of Consumer Behavior, *Journal of Economic Behavior*, vol. 1, no. 1, (March 1980), pp. 39–60.

[Walsh02] Walsh, D., 2002, Video Game Violence and Public Policy, in *Proceedings of Playing by the Rules Conference*, Chicago.

[Yoshida97] Yoshida, S., Inuzuka, N., Naing, T., Seki, H., and Itoh, H., 1997, A Game-Theoretic Solution of Conflicts Among Competitive Agents, *Agents and Multi-Agent Systems Formalisms, Methodologies and Applications*, Springer Verlag, Heidelberg, pp. 193–204.

4 Logic, Knowledge Representation, and Inference

In This Chapter

- The languages of proposition, first-order, and temporal logic
- Probability theory and Bayesian networks
- Fuzzy logic and its implementation in an NPC

4.1 INTRODUCTION

For an NPC to function it needs *knowledge*. Knowledge for an NPC is its theoretical and practical understanding of the environment in which it lives. The most common forms of knowledge for programming NPCs are *production rules* or *if-then* statements. A production rule takes the following form:

IF premise
THEN conclusion

where the premise includes a Boolean-type statement that equates to true or false. If the premise is true, then the conclusion is considered true. A collection of production rules constitutes a *knowledge base*.

An NPC must have not only a knowledge base that contains all the things that it knows about its environment and procedures for interacting with it, but also a set of processes that can assess and apply the knowledge. These processes are defined in an *inference engine*. The inference engine contains the techniques the NPC uses to reason about the contents of its knowledge base. The inference engine also handles any incoming information gathered by the NPC about its outside world or its current internal state and integrates it with the knowledge base. Many different inferencing methods can be applied, as you will see in this chapter.

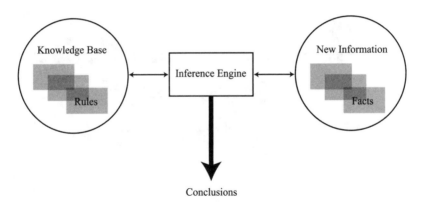

FIGURE 4.1 The basic model of an NPC's knowledge handling center.

The basic model of an NPC's knowledge and reasoning center is illustrated in Figure 4.1. The model shown in Figure 4.1 is similar to that which is the basis for an *expert system*. An expert system is a system that contains knowledge collected from many human experts in a specific domain. For example, a medical diagnosis expert system contains the expert knowledge from a number of doctors on how they diagnose certain illnesses. An expert system can be used in place of a human expert when no human experts are available, environmental conditions are inhospitable for humans, or as a second opinion. An NPC can contain an expert system with knowledge given to it by its programmer. This information is considered necessary for it to interact with its environment in an intelligent manner. Although the NPC may gather its own facts, it still needs to know how to deal with them, and the rules given to it by the programmer are paramount. Hard-coding is the most common technique in game programming for instilling knowledge and reasoning in NPCs and is examined in this chapter. In Chapter 5 we examine methods such as neural networks and genetic algorithms, with which the NPCs can come up with their own knowledge and reasoning techniques.

This chapter introduces you to a number of methods used in representing the rules in a knowledge base and several techniques for inferencing. To get you thinking logically, this chapter starts with an overview of theoretical logic and rule creation.

4.2 RULES AND LOGIC

Rule-based AI is an established approach for programming the behavior of NPCs because 1) the approach takes its principles from familiar programming languages, 2) NPCs with rule-based behavior are predictable and, therefore, easy to debug, and

3) most games programmers lack training in complex AI methods and avoid these when game deadlines are due [Woodcock99]. Rules are used by an NPC to make inferences or deductions about its world or environment.

The syntax of rule-based AI is familiar to all computer programmers because the rules are structured in the same way as *if* statements. Rules are used to represent the knowledge base of an NPC. The knowledge base holds all the information that an NPC knows about its environment, the objects in the environment, their properties, and the relationships between them. Rules in the knowledge base are constructed from languages called *logics*. Logics consist of a language syntax (the formal formatting of the language) with semantics (how the logic translates into useful information) and a proof theory for making deductions about the knowledge [Russell95]. This section examines the use of several logics in the creation of a simple knowledge base for an NPC and illustrates a few methods in which an NPC can add, extract, and make inferences about its knowledge. Each logic varies with the type of information that is stored about the environment and how the NPC interprets the information.

In this section, different types of logic are examined with respect to the simple grid game *Minesweeper*, which is available in many formats and comes with the Windows operating system. The game is represented by a grid, as shown in Figure 4.2.

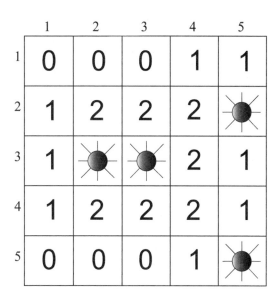

FIGURE 4.2 An example of the grid setup for a *Minesweeper* game.

The objective of *Minesweeper* is to find all the hidden mines in the grid without uncovering and activating them. The game begins with all cells of the grid covered. The player uncovers a cell by selecting it. A cell can contain a number (between 0 and 8), a mine, or nothing. We refer to a cell using its row and column position. For example, the cell in row 3 and column 5 is denoted (3,5). If the cell contains a number, the player is safe. In the example shown in Figure 4.2, cell (1,1) is a safe cell. The number tells the player how many adjacent cells have mines. If the player uncovers cell (2,2) to reveal the number 2, the player knows two mines are in cells immediately adjacent to cell (2,2). If the player has already uncovered other adjacent cells that do not have mines, the player can deduce which covered cells might contain mines. In this case, the player can elect to flag a cell to remind himself that cell has a potential mine and not to uncover it accidentally. The game ends when the player has uncovered all cells except the ones with the mines.

In the following sections on logic languages we examine the use of logic in representing an NPC player's knowledge about *Minesweeper* and discuss how it might make decisions about playing the game. Although a program that plays *Minesweeper* is not traditionally thought of as an NPC, the thought processes for solving such a game illustrate how an NPC could be programmed to deal with complex game environments in which such problem-solving skills could be beneficial to its survival. And although not all games require NPCs with such devoted game-playing abilities, the understanding of the logic and inferencing are crucial to developing an effective knowledge base for any NPC.

4.2.1 Propositional Logic

Propositional logic is a simple logic that represents facts as Boolean expressions. What an NPC knows about itself and the environment based on the facts is true, false, or unknown.

The Theory

Each statement made in propositional logic—and for that matter, all other logics—is called a *sentence*. A sentence is constructed from a set of logical symbols, including logical constants (true and false), propositional symbols (*A* and *B*), logical connectives (\land: *and*, \lor: *or*, \otimes: *xor*, \rightarrow: *implies*, \leftrightarrow: *equal* and \lnot: *not*), and parentheses. Propositional symbols connected with a \land are called *conjunctions*; symbols connected with a \lor are called *disjunctions*. The propositional symbols are just that—symbols. They can represent simple values or more complex propositions. If you are familiar with Boolean algebra and writing a lot of *if* statements in program code, most of the concepts of propositional logic are easy for you to understand. A sentence can be created by combining logical symbols to represent a fact. An *if-then* rule or sentence is written containing the \rightarrow symbol. For example:

$$(A \wedge B) \rightarrow C$$

which can be said as *if A and B then C.* Just as would be determined in programming code, this sentence implies that if $(A \wedge B)$ is true, then C is also true. It should be noted that propositional symbols such as A, B, and C can represent simple binary values or complex notions. A could represent the laws of thermodynamics, B could represent an egg sitting in a saucepan, and C might be a hard-boiled egg.

A sentence containing a \leftrightarrow, called an *equivalence,* can be written as follows:

$$(A \wedge B) \leftrightarrow (B \wedge A)$$

which states that if $(A \wedge B)$ is true, then $(B \wedge A)$ is also true. The reverse also holds: if $(A \wedge B)$ is false, then $(B \wedge A)$ is false. Sentences can also be constructed from atomic elements. This means that just *true* by itself is a sentence, and B is also a sentence. The most elementary of sentences can be written in a truth table in the same way that 1s and 0s can be used in Boolean algebra. A truth table displaying all the logical connectives is displayed in Table 4.1.

Truth tables such as Table 4.1 hold true across all logics. If you can understand and remember the elementary rules in the truth table, half the battle in implementing logics is over. The rules within also hold true for programming language logic contained in *if, while, for,* and other Boolean statements. In Table 4.1, you can see that if A and B are both true, then $A \wedge B$ is also true, and if A and B are both false, then $A \wedge B$ is also false. For programmers, the values in Table 4.1 are no surprise. In brief, both values on either side of an \wedge must be true for the sentence to be true, either side of an \vee can be true for the sentence to be true, \neg simply flips a true to a false and vice versa, and the \leftrightarrow sentence is true if both sides are the same (for example, true \leftrightarrow true or false \leftrightarrow false). The dark horse in propositional logic is the \rightarrow connective. Basically, a sentence such as A *implies* B is always true unless A is true and B is false. For the cases of true *implies* true and false *implies* false being true

TABLE 4.1 A Truth Table for Propositional Logic

A	B	\negA (not)	A \wedge B (and)	A \vee B (or)	A \otimes B (xor)	A \rightarrow B (implies)	A \leftrightarrow B (equal)
True	True	False	True	True	False	True	True
True	False	False	True	True	True	False	False
False	True	True	False	True	True	True	False
False	False	True	False	False	False	True	True

sentences, it makes perfect sense. However, *true implies false is false* and *false implies true is true* don't sit quite right with our supposedly logical brains. Consider the sentence, *cows eat grass implies there are 64 squares on a chessboard*. Definitely an odd sentence; however, according to propositional logic the sentence is true. The confusion stems from our need to find causality in the sentence. When we read the sentence we infer there are 64 squares on a chessboard because cows eat grass. However, propositional logic does not apply any causality between sentence sub-parts separated with a \rightarrow. Instead we must think of $A \rightarrow B$ holistically as meaning that if A is true, we also claim that B is true, and if A is false, then we cannot claim anything about B. (It could be true or false.)

Sentences written in propositional logic also have a set of algebraic laws associated with them that allows for the contents of the sentences to be modified and rearranged without changing their value. These laws are similar to the ones that can be applied to mathematical equations, and some relevant ones are listed in Table 4.2.

TABLE 4.2 Algebraic Laws for Propositional Logic[a,b]

Law ID	Name	Example
1	Implies	$A \rightarrow B \equiv \neg A \vee B$
2	Excluded Middle	$A \vee \neg A \equiv \text{True}$
3	Contradiction	$A \wedge \neg A \equiv \text{False}$
4	Idempotency	$A \vee A \equiv A$
5	"	$A \wedge A \equiv A$
6	Commutative	$A \wedge B \equiv B \wedge A$
7	"	$A \vee B \equiv B \vee A$
8	Associative	$C \vee (A \vee B) \equiv (C \vee A) \vee B$
9	"	$C \wedge (A \wedge B) \equiv (C \wedge A) \wedge B$
10	Distributive	$C \vee (A \wedge B) \equiv (C \vee A) \wedge (C \vee B)$
11	"	$C \wedge (A \vee B) \equiv (C \wedge A) \vee (C \wedge B)$
12	de Morgan	$\neg (A \vee B) \equiv \neg A \wedge \neg B$
13	"	$\neg (A \wedge B) \equiv \neg A \vee \neg B$
14	Absorption	$A \vee (A \wedge B) \equiv A$
15	"	$A \wedge (A \vee B) \equiv A$
16	Domination	$A \vee \text{True} \equiv \text{True}$
17	"	$A \wedge \text{False} \equiv \text{False}$

[a] The law IDs listed here are for the purposes of references in the text and have no other relevance.
[b] The symbol \equiv is used here to denote equivalence of expression of *can also be written as*.

These rules become useful when the propositional logic in a knowledge base is added to and sentences must be modified to include new information. Their use is demonstrated in the next section in which the *Minesweeper* game is examined.

CRASH COURSE

Prove by laws of propositional logic that:

$$(A \land \neg B) \lor (\neg A \land B) \equiv (A \lor B) \land \neg(A \lor B)$$

$(A \land \neg B) \lor (\neg A \land B)$

$\equiv ((A \land \neg B) \lor \neg A) \land ((A \land \neg B) \lor B)$ (distributive law)

$\equiv ((A \lor \neg A) \land (\neg B \lor \neg A)) \land ((A \lor B) \land (\neg B \lor B))$ (distributive law)

$\equiv (\text{True} \land (\neg B \lor \neg A)) \land ((A \lor B) \land \text{True})$ (excluded middle)

$\equiv (\neg B \lor \neg A) \land (A \lor B)$ (dominance)

$\equiv \neg (B \lor A) \land (A \lor B)$ (de Morgan)

$\equiv (A \lor B) \land \neg (A \lor B)$ (commutative and associative)

Sentences in a knowledge base must also be checked for validity to ensure the NPC to which the knowledge base belongs has a correct view of its environment. Take the sentence:

$$(A \land B) \lor \neg A \leftrightarrow (B \lor A)$$

We can work out whether or not this equates to true or false by examining both sides of the \leftrightarrow symbol. If both sides are true, then the sentence is true; otherwise, it is false. Before the sentence can be solved, we must know the values of A and B. Therefore, let's assume A is true and B is false. The order of precedence in a logical sentence is \neg, \land, \lor, \rightarrow, and \leftrightarrow. Parentheses, just like in mathematical equations, indicate preferential operation precedence; therefore, we can reduce the sentence by solving the parts in parentheses to:

$$(A \land B) \lor \neg A \leftrightarrow (B \lor A)$$

$$\equiv \text{False} \lor \neg A \leftrightarrow \text{True}$$

$$\equiv \text{False} \lor \text{False} \leftrightarrow \text{True}$$

$$\equiv \text{False} \leftrightarrow \text{True}$$

$$\equiv \text{False}$$

The solution can be found by examining the subparts of the sentence and using the truth table to deduce whether or not the sentence is true or false. If this sentence exists in an NPC's knowledge base and it equates to false, why not just write false or not include it? The answer is that although this sentence is false in this instance, it may not always be false. For example, if B were to become true, then this sentence

would equate to true. A sentence is only considered to be *valid* if it equates to true for all possible combinations of truth values for the propositional symbols (in this case *A* and *B*). The preceding sentence is not valid because for different values of *B* the value of the sentence differs. To determine if a sentence is valid, draw up a truth table to examine all possible outcomes given the different values for the propositional symbols. Therefore, given the sentence

$$A \vee B \vee C \rightarrow \neg(A \wedge B \wedge C) \vee A$$

we can draw a table as shown in Table 4.3, which displays all the values for the sentence.

Because the results for the sentences in Table 4.3 are true for each row, the sentence is valid. The importance of validity says that if an NPC is given information as a premise and some possible conclusion in the form *premise → conclusion*, then the NPC can come to a proper deduction about the information being true based on propositional logic. The NPC is then able to determine whether information given to it in the form of rules is valid. Establishing the validity of sentences can be extended to classes of sentences in which many sentences are examined at once through *inference rules* [Russell95]. Inference rules examine patterns of inferences within a knowledge base and reduce the need for building massive truth tables to test the validity of individual sentences. Essentially, sentences are validated in groups. An inference rule is written as

$$\frac{\alpha}{\beta}$$

TABLE 4.3 A Truth Table Examining the Validity of a Sentence

A	B	C	$A \vee B \vee C$	$\neg(A \wedge B \wedge C) \vee A$	$A \vee B \vee C \rightarrow$ $\neg(A \wedge B \wedge C) \vee A$
True	True	True	True	True	True
True	True	False	True	True	True
True	False	True	True	True	True
True	False	False	True	True	True
False	True	True	True	True	True
False	True	False	True	True	True
False	False	True	True	True	True
False	False	False	False	True	True

where α and β match any sentence. The rule infers that if a sentence in the knowledge base matches the premise α (or whatever is above the line), then the sentence below the line is concluded. For example, if α represented $A \vee B \wedge C$ and β represented $P \wedge Q$, if α were true, then $P \wedge Q$ would also be considered true. Seven inference rules can be used in propositional logic:

Modus Ponens:

$$\frac{\alpha \rightarrow \beta, \alpha}{\beta}$$

This inference rule introduces the notation shown in the equation, including a comma between sentences. If a comma appears above or below the line, it is separating sentences. Note that more than one sentence can be in the premise or conclusion. The Modus Ponens inference rule states that if a sentence of the form $\alpha \rightarrow \beta$ and a sentence of the form α exist in the knowledge base, then we can conclude β (or add it as a new sentence in the knowledge base). For example, given the sentences $A \wedge C \rightarrow D \vee P$ and $A \wedge C$, we can conclude the sentence $D \vee P$ where α is $A \wedge C$ and β is $D \vee P$.

And-Elimination:

$$\frac{\alpha_1 \wedge \alpha_2 \wedge \alpha_3 \wedge \cdots \wedge \alpha_n}{\alpha_i}$$

The And-Elimination inference rule states that if many sentences are joined with an \wedge, then any of the sentences on their own can be concluded. For example, if we have the sentence $A \wedge (C \vee D) \wedge (P \rightarrow B)$, then any of the subsentences (enclosed in parentheses) joined by the connective \wedge can be added to the knowledge base as the individual sentences A, $C \vee D$, and $P \rightarrow B$.

And-Introduction:

$$\frac{\alpha_1, \alpha_2, \alpha_3, \ldots, \alpha_n}{\alpha_1 \wedge \alpha_2 \wedge \alpha_3 \wedge \cdots \wedge \alpha_n}$$

This inference rule states that if a list of sentences exists, then it can be inferred they can exist as a single conjunctive sentence with each individual sentence from above the line joined with the connective \wedge. For example, if the knowledge base contains the sentences $C \vee D$, $P \wedge B \rightarrow A$, and $C \vee D \rightarrow Q$, then the

single sentence $(C \vee D) \wedge (P \wedge B \rightarrow A) \wedge (C \vee D \rightarrow Q)$ can be added to the knowledge base.

Or-Introduction:

$$\frac{\alpha_i}{\alpha_1 \vee \alpha_2 \vee \alpha_3 \vee \cdots \vee \alpha_n}$$

The Or-Introduction inference rule implies that given a single sentence, it can be included in a rule that joins it using the \vee connective with any other—even all—sentences from the knowledge base. For example, if the knowledge base includes the sentences $C \vee A$, $P \wedge B \vee C \leftrightarrow Q$, and $A \vee D \rightarrow Q$, and given a new sentence $A \wedge B$, the sentence $(A \wedge B) \vee (C \vee A) \vee (P \wedge B \vee C \leftrightarrow Q) \vee (A \vee D \rightarrow Q)$ can be written.

Double-Negation Elimination:

$$\frac{\neg\neg\alpha}{\alpha}$$

This inference rule infers that a double-negative sentence infers a positive sentence. In other words, the two negatives cancel out each other, leaving the original sentence. For example, given the sentence $\neg\neg(P \wedge B \vee C \leftrightarrow Q)$, it can be concluded that $P \wedge B \vee C \leftrightarrow Q$.

Unit Resolution:

$$\frac{\alpha \vee \beta, \neg\beta}{\alpha}$$

The Unit Resolution inference rule surmises that if two sentences are joined with an \vee (or) and one of those sentences is false, then the other must be true. For example, given the sentences $(A \wedge B) \vee (C \vee D)$ and $\neg(C \vee D)$, then $(A \wedge B)$ can be added as a new sentence to the knowledge base.

Resolution:

$$\frac{\alpha \vee \beta, \neg\beta \vee \gamma}{\alpha \vee \gamma}$$

The Resolution inference rule states that if the sentence β is negative in one of the disjunctive sentences in the premise, then either α or γ must be true, which

would make the conclusion true. For example, given the sentences $(A \wedge B) \vee (C \vee D)$ and $\neg(C \vee D) \vee (P \wedge B \leftrightarrow Q)$, it can be concluded that $(A \wedge B) \vee (P \wedge B \leftrightarrow Q)$ is true.

Armed with the notation and processes of propositional logic, we now examine the creation of a simple knowledge base and action inferences for a *Minesweeper* NPC.

Applying Propositional Logic to Minesweeper

Assuming the NPC can sense information only from the cell it is in, new information can be added to the knowledge base with each move. The example *Minesweeper* grid displayed in Figure 4.2 is used in this example. Sentences are written as $value_{row,col}$, where *value* is the number in the cell located at row number *row* and column number *col*. For example, if the NPC uncovered the cell $(2,2)$ the sentence $2_{2,2}$ would be added to the knowledge base. Besides having a number in it, a cell can contain a mine or a flag. In these cases, the sentences $M_{row,col}$ and $F_{row,col}$ are added, respectively. These types of sentences containing information the NPC has sensed from its environment are called *percepts*.

In addition to percepts, the NPC must also possess a number of rules in its knowledge base that inform it of environmental conditions. The conditions in the case of *Minesweeper* should inform the NPC how to locate a mine. If a cell contains a 1, for example, then any of the surrounding cells might contain a mine. This situation can be written as the Equation 4.1.

$$1_{r,c} \rightarrow$$
$$\left(M_{r,c+1} \otimes M_{r,c-1} \otimes M_{r+1,c} \otimes M_{r+1,c+1} \otimes M_{r+1,c-1} \otimes M_{r-1,c} \otimes M_{r-1,c+1} \otimes M_{r-1,c-1} \right) \wedge \neg M_{r,c} \quad (4.1)$$

Equation 4.1 states that if the number 1 is in a certain cell, then a mine is in one of the eight surrounding cells but not in the cell with the 1 in it. The \otimes connective also ensures that *only* one mine can be in any of the eight surrounding cells. Unfortunately, writing a rule in propositional logic isn't as simple as stating a general case. Propositional logic does not handle expressions such as $M_{r+1,c}$ with variable values. Facts in propositional logic must be expressed as exact facts. Therefore, instead of writing $1_{r,c}$ to represent all cells with a 1 in them, we must write down the exact cells with 1 ($1_{4,1}$, $1_{1,5}$, $1_{2,1}$, and so on), This means that instead of writing one simple rule like that shown in Equation 4.1, the rules must be specified, one for each cell, as partially shown in Listing 4.1.

LISTING 4.1 A partial listing of the rules in a *Minesweeper* NPC's knowledge base

Rule 1: $1_{1,1} \rightarrow \left(M_{1,2} \otimes M_{2,1} \otimes M_{2,2}\right) \wedge \neg M_{1,1}$

Rule 2: $1_{1,2} \rightarrow \left(M_{1,1} \otimes M_{1,3} \otimes M_{2,1} \otimes M_{2,2} \otimes M_{2,3}\right) \wedge \neg M_{1,2}$

Rule 3: $1_{1,3} \rightarrow \left(M_{1,2} \otimes M_{1,4} \otimes M_{2,2} \otimes M_{2,3} \otimes M_{2,4}\right) \wedge \neg M_{1,3}$

...

Rule 6: $1_{2,1} \rightarrow \left(M_{1,1} \otimes M_{1,2} \otimes M_{2,2} \otimes M_{3,1} \otimes M_{3,2}\right) \wedge \neg M_{2,1}$

Rule 7: $1_{2,2} \rightarrow \left(M_{1,1} \otimes M_{1,2} \otimes M_{1,3} \otimes M_{2,1} \otimes M_{2,3} \otimes M_{3,1} \otimes M_{3,2} \otimes M_{3,3}\right) \wedge \neg M_{2,2}$

Rule 8: $1_{2,3} \rightarrow \left(M_{1,2} \otimes M_{1,3} \otimes M_{1,4} \otimes M_{2,2} \otimes M_{2,4} \otimes M_{3,2} \otimes M_{3,3} \otimes M_{3,4}\right) \wedge \neg M_{2,3}$

...

Rule 11: $1_{3,1} \rightarrow \left(M_{2,1} \otimes M_{2,2} \otimes M_{3,2} \otimes M_{4,1} \otimes M_{4,2}\right) \wedge \neg M_{3,1}$

...

Rule 16: $1_{4,1} \rightarrow \left(M_{3,1} \otimes M_{3,2} \otimes M_{4,2} \otimes M_{5,1} \otimes M_{5,2}\right) \wedge \neg M_{4,1}$

This process must continue until there is a rule specifying what to imply if a 1 exists in any cell in the grid. In this case, the grid measuring 5×5 would have 25 such rules. Another 25 rules would state the conclusions that could be made from finding a 2 in any of the cells. In the case of a 2, the rule would be much more complex because now any two surrounding cells can contain a mine. We leave these rules as an exercise for you.

Given the rules in Listing 4.1 and the algebraic laws in Table 4.2, we now show how an NPC can deduce the location of a mine. The NPC knows it has located a mine when a sentence of the form $M_{row,col}$ appears in its knowledge base. Let's assume the NPC has visited cells $(2,1)$, $(3,1)$, and $(4,1)$. Along with the rules shown in Listing 4.1, the NPC can add the following facts to its knowledge base:

$$1_{2,1}$$

$$1_{3,1}$$

$$1_{4,1}$$

These facts allow the use of the Modus Ponens inference rule to deduce more facts. For example, because the NPC knows that $1_{2,1}$, $1_{3,1}$, and $1_{4,1}$ are facts, it can apply Modus Ponens on Rules 6, 11, and 16 from Listing 4.1 to give:

$$\left(M_{1,1} \otimes M_{1,2} \otimes M_{2,2} \otimes M_{3,1} \otimes M_{3,2}\right) \wedge \neg M_{2,1}$$

$$\left(M_{2,1} \otimes M_{2,2} \otimes M_{3,2} \otimes M_{4,1} \otimes M_{4,2}\right) \wedge \neg M_{3,1}$$

$$\left(M_{3,1} \otimes M_{3,2} \otimes M_{4,2} \otimes M_{5,1} \otimes M_{5,2}\right) \wedge \neg M_{4,1}$$

Each of these sentences is a conjunction so the And-Elimination inference rule can be applied to modify these rules into:

$$\left(M_{1,1} \otimes M_{1,2} \otimes M_{2,2} \otimes M_{3,1} \otimes M_{3,2} \right)$$
$$\neg M_{2,1}$$
$$\left(M_{2,1} \otimes M_{2,2} \otimes M_{3,2} \otimes M_{4,1} \otimes M_{4,2} \right)$$
$$\neg M_{3,1}$$
$$\left(M_{3,1} \otimes M_{3,2} \otimes M_{4,2} \otimes M_{5,1} \otimes M_{5,2} \right)$$
$$\neg M_{4,1}$$

Next, by applying the Resolution inference rule, each of the cells that don't contain a mine (for example, $\neg M_{2,1}$) can be removed from the \otimes sentences giving:

$$\left(M_{1,1} \otimes M_{1,2} \otimes M_{2,2} \otimes M_{3,2} \right)$$
$$\neg M_{2,1}$$
$$\left(M_{2,2} \otimes M_{3,2} \otimes M_{4,2} \right)$$
$$\neg M_{3,1}$$
$$\left(M_{3,2} \otimes M_{4,2} \otimes M_{5,1} \otimes M_{5,2} \right)$$
$$\neg M_{4,1}$$

At this point we seem to have hit a brick wall because no inference rules or propositional algebraic laws explain the manipulation of \otimes sentences. The solution is to convert the \otimes sentences by replacing the connector \otimes with \vee, \wedge, and \neg connectors. For an \otimes statement such as $A \otimes B$ to be true, either one or the other propositional symbols must be true but not both of them at the same time. The truth table for \otimes is included in Table 4.1. The following rule is one way to remove the \otimes connective from a sentence:

$$A \otimes B \equiv (A \vee B) \wedge \neg (A \wedge B)$$

This sentence says that *A or B* can be true as long as not *A and B* are true. This rule can be extended for multiple \otimes connectives for which it is fine for any one of the propositional symbols to be true but no two in a pair can both be true, where all propositional symbols in the sentence must be paired with every other symbol in a \neg-ed \wedge sentence. This rule can be applied to the existing \otimes sentences in the knowledge base to give:

$$\left(M_{1,1} \otimes M_{1,2} \otimes M_{2,2} \otimes M_{3,2} \right)$$
$$\equiv \left(M_{1,1} \vee M_{1,2} \vee M_{2,2} \vee M_{3,2} \right) \wedge \neg \left(M_{1,1} \wedge M_{1,2} \right)$$

$$\wedge \neg \left(M_{1,1} \wedge M_{2,2} \right)$$

$$\wedge \neg \left(M_{1,1} \wedge M_{3,2} \right)$$

$$\wedge \neg \left(M_{1,2} \wedge M_{2,2} \right)$$

$$\wedge \neg \left(M_{1,2} \wedge M_{3,2} \right)$$

$$\wedge \neg \left(M_{2,2} \wedge M_{3,2} \right)$$

$$\left(M_{2,2} \otimes M_{3,2} \otimes M_{4,2} \right)$$
$$\equiv \left(M_{2,2} \vee M_{3,2} \vee M_{4,2} \right) \wedge \neg \left(M_{2,2} \wedge M_{3,2} \right)$$
$$\wedge \neg \left(M_{2,2} \wedge M_{4,2} \right)$$
$$\wedge \neg \left(M_{3,2} \wedge M_{4,2} \right)$$

$$\left(M_{3,2} \otimes M_{4,2} \otimes M_{5,1} \otimes M_{5,2} \right)$$
$$\equiv \left(M_{3,2} \vee M_{4,2} \vee M_{5,1} \vee M_{5,2} \right) \wedge \neg \left(M_{3,2} \wedge M_{4,2} \right)$$
$$\wedge \neg \left(M_{3,2} \wedge M_{5,1} \right)$$
$$\wedge \neg \left(M_{3,2} \wedge M_{5,2} \right)$$
$$\wedge \neg \left(M_{4,2} \wedge M_{5,1} \right)$$
$$\wedge \neg \left(M_{4,2} \wedge M_{5,2} \right)$$
$$\wedge \neg \left(M_{5,1} \wedge M_{5,2} \right)$$

Now that the \otimes connector has been removed from the knowledge base, further inferences can take place. Using the And-Elimination rule, all sentences containing \wedge connectives can be split into subsentences, which are entered into the knowledge base as facts. Any duplicate facts need be entered only once, giving:

$$\neg M_{2,1}$$

$$\neg M_{3,1}$$

$$\neg M_{4,1}$$

$$\left(M_{1,1} \vee M_{1,2} \vee M_{2,2} \vee M_{3,2} \right)$$

$$\neg \left(M_{1,1} \wedge M_{1,2} \right)$$

$$\neg \left(M_{1,1} \wedge M_{2,2} \right)$$

$$\neg \left(M_{1,1} \wedge M_{3,2} \right)$$

$$\neg \left(M_{1,2} \wedge M_{2,2} \right)$$

$$\neg(M_{1,2} \wedge M_{3,2})$$
$$\neg(M_{2,2} \wedge M_{3,2})$$
$$(M_{2,2} \vee M_{3,2} \vee M_{4,2})$$
$$\neg(M_{2,2} \wedge M_{4,2})$$
$$(M_{3,2} \vee M_{4,2} \vee M_{5,1} \vee M_{5,2})$$
$$\neg(M_{3,2} \wedge M_{4,2})$$
$$\neg(M_{3,2} \wedge M_{5,1})$$
$$\neg(M_{3,2} \wedge M_{5,2})$$
$$\neg(M_{4,2} \wedge M_{5,1})$$
$$\neg(M_{4,2} \wedge M_{5,2})$$
$$\neg(M_{5,1} \wedge M_{5,2})$$

Next, by using the And-Introduction inference rule, the three largest sentences can create the new conjunction:

$$(M_{1,1} \vee M_{1,2} \vee M_{2,2} \vee M_{3,2}) \wedge (M_{2,2} \vee M_{3,2} \vee M_{4,2}) \wedge (M_{3,2} \vee M_{4,2} \vee M_{5,1} \vee M_{5,2})$$

which through the distributive algebraic law (with id 10 in Table 4.2) simplifies to:

$$(M_{1,1} \vee M_{1,2} \vee M_{2,2} \vee M_{3,2}) \wedge (M_{2,2} \vee M_{3,2} \vee M_{4,2}) \wedge (M_{3,2} \vee M_{4,2} \vee M_{5,1} \vee M_{5,2})$$
$$= M_{3,2} \vee (M_{1,1} \wedge M_{1,2} \wedge M_{2,2} \wedge M_{2,2} \wedge M_{4,2} \wedge M_{4,2} \wedge M_{5,1} \wedge M_{5,2})$$
$$= M_{3,2} \vee (M_{1,1} \wedge M_{1,2} \wedge M_{2,2} \wedge M_{4,2} \wedge M_{5,1} \wedge M_{5,2})$$

We now have a sentence in the form that can be used with the Resolution inference rule where $\alpha = M_{3,2}$ and $\beta = (M_{1,1} \wedge M_{1,2} \wedge M_{2,2} \wedge M_{4,2} \wedge M_{5,1} \wedge M_{5,2})$. All we need to apply the Resolution rule is to find another sentence in the knowledge base that equates to $\neg\beta$. As luck would have it, the list of negated sentences in the knowledge base can be used to create such a sentence. First, by applying the de Morgan's law (ID 13 in Table 4.2), each negated sentence is transformed from the format $\neg(M_{5,1} \wedge M_{5,2})$ into $\neg M_{5,1} \vee \neg M_{5,2}$. This transformation creates a list of \vee connected sentences with negated propositional symbols. These sentences can then be connected by applying the Or-Introduction rule. Because the final sentence we are after does not contain $M_{3,2}$, any sentences containing $M_{3,2}$ are left as is. The knowledge base now looks as follows:

$$\neg M_{2,1}$$

$$\neg M_{3,1}$$

$$\neg M_{4,1}$$

$$M_{3,2} \vee \left(M_{1,1} \wedge M_{1,2} \wedge M_{2,2} \wedge M_{3,2} \wedge M_{4,2} \wedge M_{5,1} \wedge M_{5,2} \right)$$

$$\neg M_{1,1} \vee \neg M_{3,2}$$

$$\neg M_{1,2} \vee \neg M_{3,2}$$

$$\neg M_{2,2} \vee \neg M_{3,2}$$

$$\neg M_{3,2} \vee \neg M_{4,2}$$

$$\neg M_{3,2} \vee \neg M_{5,1}$$

$$\neg M_{3,2} \vee \neg M_{5,2}$$

$$\neg M_{1,1} \vee \neg M_{1,2} \vee \neg M_{2,2} \vee \neg M_{4,2} \vee \neg M_{5,1} \vee \neg M_{5,2}$$

Again, we can apply de Morgan's law to the final rule in the knowledge base to give:

$$\neg \left(M_{1,1} \wedge M_{1,2} \wedge M_{2,2} \wedge M_{4,2} \wedge M_{5,1} \wedge M_{5,2} \right)$$

which provides us with the $\neg\beta$ we were after to apply the Resolution inference to the first rule. After applying this rule, the knowledge base will be:

$$\neg M_{2,1}$$

$$\neg M_{3,1}$$

$$\neg M_{4,1}$$

$$M_{3,2}$$

$$\neg M_{1,1} \vee \neg M_{3,2}$$

$$\neg M_{1,2} \vee \neg M_{3,2}$$

$$\neg M_{2,2} \vee \neg M_{3,2}$$

$$\neg M_{3,2} \vee \neg M_{4,2}$$

$$\neg M_{3,2} \vee \neg M_{5,1}$$

$$\neg M_{3,2} \vee \neg M_{5,2}$$

At this point, you may look at the knowledge base and say, "Hey, there must be a mine in $(3,2)$," but this is not necessarily the case. The Or-Introduction rule tells us that a disjunction can be inferred from a list of sentences, which is what we now have. This list gives us all of the preceding sentences \otimes together and tells us that one or more of these might be true for the knowledge base to be true. Indeed, if there is

a mine at $(3,2)$, then the disjunction equates to true. Given that the last six sentences in the knowledge base can be rewritten as conjunctions, they tell us the pairs of cells where there cannot be simultaneous mines. For example, $\neg M_{3,2} \vee \neg M_{5,2}$ becomes $\neg(M_{3,2} \wedge M_{5,2})$, meaning there cannot be a mine in both $(3,2)$ and $(5,2)$ at the same time. The knowledge base reads that there might be a mine at $(3,2)$ or not one at $(3,2)$ and $(5,2)$ or not one at $(3,2)$ and $(5,1)$, and so on. If you examine the possible locations for a mine, as shown in Figure 4.3, you see that all the sentences in the database are true. For example, a mine cannot be in both $(3,2)$ and $(5,2)$ at the same time. At this point the NPC must uncover more cell values in the grid before it can make any deductions about the exact location of a mine.

Let's look at another example. Assume the NPC is playing a different game on a larger grid and it uncovers a value of 8 in the cell $(8,9)$. From this we can deduce that each of the adjacent cells must contain a mine. In propositional logic, this would be:

$$8_{8,9} \rightarrow M_{7,8}, M_{7,9}, M_{7,10}, M_{8,8}, M_{8,10}, M_{9,8}, M_{9,9}, M_{9,10}$$

What we would like to state as a fact is *if there is an 8 in a cell, then all adjacent cells are mines*. However, in propositional logic it isn't that easy—a rule must be written for each cell in which there could be an 8. Therefore, including the preceding rule, another $(MaxRows-1) \times (MaxCols-1)$ rules would need to be written where *MaxRows* is the number of rows in the grid and *MaxCols* is the number of columns.

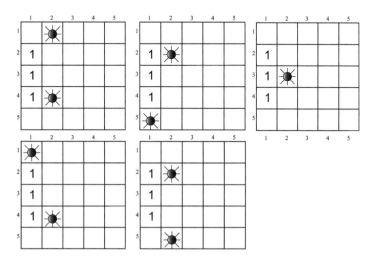

FIGURE 4.3 Other viable locations for mines given a 1 in cells $(2,1)$, $(3,1)$, and $(4,1)$.

This gives us a rule for each of the cells in the grid with the exception of cells on the outside edges because these cells are not surrounded by eight cells and, therefore, could not possibly contain a value of 8. This leads us into a discussion on the limitations of the use of propositional logic for defining the knowledge base of an NPC. First, the number of rules needed can grow out of control as the NPC's environment gets bigger. The simple rule *flag all adjacent cells to a cell with a value of 8 as having a mine*, while sounding quite elementary, would require 81 propositional logic rules to define where a mine could be should a cell contain an 8 in a 10×10 grid. For example:

$$8_{2,2} \rightarrow M_{1,1}, M_{1,2}, M_{1,3}, M_{2,1}, M_{2,3}, M_{3,1}, M_{3,2}, M_{3,3}$$
$$8_{2,3} \rightarrow M_{1,2}, M_{1,3}, M_{1,4}, M_{2,2}, M_{2,4}, M_{3,2}, M_{3,3}, M_{3,4}$$
$$8_{2,4} \rightarrow M_{1,3}, M_{1,4}, M_{1,5}, M_{2,3}, M_{2,5}, M_{3,3}, M_{3,4}, M_{3,5}$$
$$\ldots$$

When you change the size of the grid, the number of rules needed grows as well. For a grid measuring 20×20, 361 such rules would need to be written, and these rules are only for the case of a cell containing an 8. Besides creating an absolute nightmare for the programmer, the more rules that are needed the slower the NPC is in working with its knowledge base and inferencing information from it. In addition to these problems—and a particular disadvantage when it comes to games (not necessarily *Minesweeper*)—is that propositional logic cannot handle temporal changes efficiently. For example, in a real-time strategy (RTS) game, the NPC must know not only where it is but also where it has been. If the fact $NPC_{3,2}$ is entered into the knowledge base to represent the NPC being in cell $(3,2)$ of a game environment map, then it only remains true while the NPC is in cell $(3,2)$. This limitation could be rectified by including a time aspect in the fact, such as $NPC_{3,2,5}$, which may denote the NPC was in cell $(3,2)$ during time increment 5 of the game clock. This might sound like a good solution until you think about modifying the rules. Consider the example where an NPC could shoot at an enemy in another cell provided the cell was immediately adjacent to the NPC's cell. Both the NPC and the enemy would have to be in the appropriate cells at the same time instance. For the situation in which the NPC is in cell $(5,6)$ at time 9, we could write the rule:

$$NPC_{5,6,9} \wedge \left(Enemy_{4,5,9} \vee E_{4,6,9} \vee E_{4,7,9} \vee E_{5,5,9} \vee E_{5,7,9} \vee E_{6,5,9} \vee E_{6,6,9} \vee E_{6,7,9} \right)$$
$$\rightarrow Shoot$$

where you need not only one rule for each cell in the grid (excluding the edge cells) but also a set of rules for each time step in the game. If the game ran for 1,000 time

steps in a 10×10 grid, you would need 81,000 rules just to define how to shoot at the enemy.

Propositional logic can get an NPC so far with a set of well-structured sentences, algebraic laws, and inference rules, but it cannot represent the knowledge necessary to interact with a temporally dynamic world. Nor can it represent an object in the environment and any relationships that might exist between that object and the NPC. To create a knowledge base capable of this level of sophistication, we next examine first-order logic.

EXERCISE

1. Complete the following truth table.

A	B	$B \land \neg A$	$B \land \neg A \lor \neg B$
True	True		
True	False		
False	True		
False	False		

2. Use a truth table to show that $(A \lor B) \land \neg(A \land B) \equiv (A \land \neg B) \lor (\neg A \land B)$.

3. Sentences that are valid (always equate to true) are also called tautologies, and sentences that are always false are called contradictions. Which of the following are tautologies and which are contradictions (or neither)?

- $((R \to S) \land \neg S) \to \neg P$
- $(\neg P \land P)$
- $(\neg P \lor P)$
- $(A \land B) \to (C \lor A)$
- $(\neg B \lor B \lor A \lor C) \to$ True
- $(\neg B \lor B \lor A \lor C) \to$ False

4. Using the laws of propositional logic show that:

$$(\neg P \land (Q \lor R)) \lor ((\neg P \lor \neg Q) \land (\neg P \lor R))$$
$$\equiv \neg((P \lor \neg(Q \lor R)) \land (P \land (Q \lor \neg R)))$$

5. Given the following knowledge base, show that $M_{2,1}$ is true:

$$1_{1,1}$$

$$1_{1,2}$$

$$1_{2,2}$$
$$1_{1,1} \rightarrow M_{1,2} \otimes M_{2,1} \otimes M_{2,2}$$
$$1_{1,2} \rightarrow M_{1,1} \otimes M_{2,1} \otimes M_{2,2}$$
$$1_{2,2} \rightarrow M_{1,1} \otimes M_{1,2} \otimes M_{2,1}$$

4.2.2 First-Order Logic

Unlike propositional logic, which states only true and false facts, first-order logic can also represent *objects* and possible *relationships* between these objects. Objects are individual entities in an environment with *properties* that distinguish them from other objects. For example, a car is an object. It might have the properties *blue* and *four-wheel drive*. Another object might be Joe. His relationship to the car object could be *owns*.

The Theory

Many of the constructs used in first-order logic are the same as those for propositional logic. These constructs include the connectives (\vee, \wedge, \rightarrow, and \leftrightarrow) and the use of sentences. Three types of symbols are used in first-order logic. The first are *constant symbols*, such as *A, B, Joe,* and *Car*. These symbols represent objects. Each object has exactly one constant symbol, so if two cars are in the environment, they must be renamed so it is clear which symbol refers to which car, for example *Car1* and *Car2*. Second, predicate *symbols* are used to specify relationships existing between objects. *Owns* might be a relationship that exists between *Joe* and *Car*. Other relationships might include *Brother, Younger,* and *Friend*. Finally, *function symbols* are used to specify one-to-one relationships in which an object is related to exactly one other object. It could be thought of as a simple function that when run on an object returns only one value. For example, the function symbol *MotherOf* when applied to an object (assuming the object has a mother) can return only the name of one other object. Due to this, the function symbol can often be used to replace the name of an actual object. Let's assume that *Betty is the mother of Joe*. This would make *Betty* and *Joe* objects. However, instead of writing *Betty*, we could write *MotherOf(Joe)*. In this example, a function symbol is used in conjunction with an object that followed the function symbol in parentheses. The use of a function symbol in this way is called a *term*.

By using the predefined symbols of first-order logic, you can build sentences to represent knowledge. The first type of sentence is an atomic sentence, which is made up of a predicate symbol and the associated objects. The syntax for an atomic sentence is the same as a term. For example, the sentence *Friend(Joe, Bill)* is constructed from the predicate symbol *Friend* and the objects *Joe* and *Bill*. The sentence states that *Joe is a friend of Bill*. Atomic sentences can also be constructed from

terms, where the term replaces the object. For example, *Friend*(*MotherOf*(*Joe*), *MotherOf*(*Bill*)) replaces actual objects with the term constructed from the function symbol *MotherOf*. An atomic sentence can be said to be true if the relationship indicated by the predicate exists between the objects; otherwise, it is false.

Atomic sentences can be linked into *complex sentences* using logical connectives (just like those used in propositional logic). The complex sentences can then be used to represent rules in an NPC's knowledge base because they can be inferred as true or false. For example:

- *MotherOf*(*Joe*) = *Betty* is true if Betty is Joe's mother.
- *Friend*(*Joe*, *Bill*) ∧ *Friend*(*MotherOf*(*Joe*), *MotherOf*(*Bill*)) is true only when Joe is a friend of Bill and Joe's mother is a friend of Bill's mother.
- *Friend*(*MotherOf*(*Joe*), *Bill*) ∨ *Owns*(*Joe*, *Car*) is true if Joe's mother is a friend of Bill or Joe owns the car.
- ¬*Friend*(*Bill*, *Joe*) is true when Bill is not a friend of Joe.
- *Owns*(*Joe*, *Car*) → ¬(*Owns*(*Betty*, *Car*) ∨ *Owns*(*Bill*, *Car*)) states that if Joe owns the car then neither Betty nor Bill owns the car.

An advantage of first-order logic over propositional logic is that it can specify the properties of a whole class of objects without having to spell out a rule for each individual. For example, let's say that Joe is a man with the sentence *Man*(*Joe*), where *Man* is a predicate. We could also say that Bill is a man with the sentence *Man*(*Bill*). We also want to indicate that if Joe is a man, then Joe is also human with *Human*(*Joe*) and that Bill is also human with *Human*(*Bill*). Now consider the case where we have added 50 or so men into the knowledge base. Does this mean that to indicate they are all human we must add another 50 sentences, such as *Human*(*Bob*), *Human*(*Dave*), *Human*(*Peter*), and so on? Not in first-order logic. First-order logic allows us to make the premise that *all men are human*. We could take this even further to declare that *all humans are mammals*. But how is this expressed in first-order logic? Unlike propositional logic, which doesn't allow for generalizations using variables, first-order logic allows the use of arguments such as x and y to take the place of individual but unspecified objects in a sentence. These arguments are expressed in sentences using one of two *quantifiers*, which allow us to express properties of entire object classes.

The first quantifier is the universal quantifier written as ∀ and pronounced *for all*. The format for a sentence using the universal quantifier is

$$\forall x \; P$$

which when translated states *for all values of x, P is true*, where x is a class of objects and P is a logical expression. To express *all men are human*, the sentence would be

$$\forall x \, Man(x) \rightarrow Human(x)$$

where $Man(x) \rightarrow Human(x)$ is equivalent to the conjunction of all sentences inferring each individual man is human, thus:

$$(Man(Joe) \rightarrow Human(Joe)) \wedge (Man(Bill) \rightarrow Human(Bill)) \wedge$$
$$(Man(Peter) \rightarrow Human(Peter)) \wedge \cdots$$

This means the sentence $\forall x \, Man(x) \rightarrow Human(x)$ can be true only when all the preceding sentences are true.

The second quantifier is the *existential quantifier*, written as \exists and pronounced *there exists*. The existential quantifier allows us to make a statement about an object without naming it. For example, to say that *Joe has a mother who is human*, we would write the following sentence:

$$\exists x \, Mother(x, Joe) \wedge Human(x)$$

This sentence can be read *there exists an object that is the mother of Joe and also a human*. The sentence equates to true if there is indeed an object in the knowledge base that is human and also Joe's mother. $Mother(x, Joe) \wedge Human(x)$ is a disjunction of

$$(Mother(Betty, Joe) \wedge Human(Betty))$$
$$\vee (Mother(Bill, Joe) \wedge Human(Bill))$$
$$\vee (Mother(Car, Joe) \wedge Human(Car))$$
$$\vee \cdots$$

where the x is replaced by all the objects in the knowledge base. As you can see, each subsentence is \vee together; therefore, only one of the cases must be true to make the initial sentence, $\exists x \, Mother(x, Joe) \wedge Human(x)$, true.

Quantifiers can also have more than one argument. For example:

$$\forall x, y \, Mother(x, y) \rightarrow Child(y, x)$$

which states that *for all x and y, if x is the mother of y, then y is the child of x*. That makes sense, whereas, this sentence wouldn't:

$$\forall x, y \, Mother(x, y) \rightarrow Child(x, y)$$

Why? Because the mother of someone cannot also be his child! Quantifiers can also be mixed to create sentences, such as there is someone who is the ancestor of everyone, or:

$$\exists x \ \forall y \ Ancestor(x, y)$$

Sure, a bold statement, however in a limited knowledge base, it could be true.

Equivalence also exists between quantifiers. Can we rewrite a universal quantified sentence as an existential quantified sentence and vice versa? The answer is yes. Because of the conjunctive nature of the universal quantifier and the disjunctive nature of the existential quantifier, they obey the de Morgan rules, such as those expressed in Table 4.2, as shown in Listing 4.2 [Russell95]:

LISTING 4.2 de Morgan's rules as applied to the logical quantifiers

$$\forall x \ \neg P \equiv \exists x \ P$$
$$\neg \forall x \ P \equiv \exists x \ \neg P$$
$$\forall x \ P \quad \equiv \neg \exists x \ \neg P$$
$$\exists x \ P \quad \equiv \neg \forall x \ \neg P$$

Applying the rules shown in Listing 4.2, we can state facts such as:

$$\forall x \ Drives(x, Honda) \equiv \neg \exists x \ \neg Drives(x, Honda)$$

which states that *everybody drives a Honda*, which is equivalent to saying that *there doesn't exist anyone who does not drive a Honda.*

Finally, we examine the use of set theory as implemented in first-order logic. A set is a convenient way to manage a group of objects that may not necessarily belong to the same class. A set in first-order logic can be manipulated in the same way as a mathematical set. The set properties and operations are defined as constants, predicates, and functions. The set names, such as *MySet* or *EmptySet,* are constants and used to refer to a particular set. The predicates used are *Member, Set,* and *Subset. Member* takes an object and a set and returns true if the object is in the set; otherwise, it returns false. For example, if $Set1 = \{1, 4, 5\}$, then $Member(4, Set1) = True$. The *Set* predicate returns true if the given constant is a set; otherwise, it returns false. For example, $Set(Set1) = True$. *Subset* compares two sets. If the objects contained in the first set are also contained in the second set, then the predicate returns true; otherwise it returns false. For example, $Subset(\{3\}, Set1) = False$. The set functions are *Intersection, Union,* and *Adjoin.* Intersection takes two sets and returns a smaller set of objects that exists in both original sets. For example, if

$Set2 = \{4,6,5,9\}$, then $Intersection(Set1, Set2) = \{4,5\}$. The *Union* function takes two sets and returns a set that contains the objects in both sets without repeating any common objects. For example, given *Set1* and *Set2* as before, $Union(Set1, Set2) = \{1,4,5,6,9\}$. Finally, *Adjoin* takes an object and a set and adds the object into the set. For example, $Adjoin(2, Set1) = \{1,2,4,5\}$.

Many more constructs and special notation can be used in first-order logic; however, we leave the discussion here because this basic introduction is enough to demonstrate its use in a *Minesweeper* NPC. The interested reader is encouraged to read [Russell95] for a more in-depth examination of first-order logic.

Applying First-Order Logic to Minesweeper

Our mine-sweeping NPC gathers facts about the grid as it uncovers more and more cells. The value that an NPC finds in a cell helps it deduce information about other surrounding cells that it may not yet have uncovered. This behavior was shown in the section where propositional logic was applied to the problem. The percept that an NPC can obtain from its environment is the cell value. This information can be expressed in a string in the form [*state, value*], where value is the number in the cell indicating adjacent mines or *mine* if it contains a mine. For example, the percept [*Cleared*,1] informs the NPC that the cell has been uncovered and that it has one mine in an adjacent cell.

To begin a new knowledge base for the NPC using first-order logic, the facts specified in the previous section in propositional logic must be included. First, however, they must undergo slight syntactical modification. Before the NPC begins to explore its environment and add new facts to the knowledge base as it uncovers and receives percepts from cells, a basic knowledge base must be constructed from rules and facts that inform the NPC how to handle the new knowledge. First, we must define the values and states of the grid cells. A cell can contain a value for 0, denoting no neighbors with a mine, to 8, meaning all neighbors contain a mine. We can represent the internal value of a cell location, I_l, as follows:

$$Member(I_l, \{0,1,2,3,4,5,6,7,8, mine\})$$

and the internal value of a cell can be returned using the function:

$$InternalValue(l)$$

A cell location, *l*, also has a visible state that tells the player whether it has been uncovered or not. We signal an uncovered cell as *Cleared*, a covered cell as *Uncleared*, and a suspected mine as *Flagged*. The visible state of a cell location, V_l is defined as follows:

$$Member(V_l, \{Cleared, Uncleared, Flagged\})$$

and the visible state of the cell can be tested with the following predicates:

$$Cleared(l)$$
$$Uncleared(l)$$
$$Flagged(l)$$

The state of all cells is initially set to *Uncleared* by the game environment. Therefore, the knowledge base would receive the initial fact:

$$\forall l\, Uncleared(l)$$

which reads *all locations are uncleared*. The NPC can then begin uncovering cells one by one and examining the values. The NPC must know when to stop uncovering cells. Therefore, we give it some terminal conditions. This game has two ending conditions: the NPC uncovers a mine and explodes, or all safe cells are cleared and only the mines remain covered. We can represent these conditions with the following rules:

$$\forall l\, Cleared(l) \wedge InternalValue(l) = mine \rightarrow Dead(NPC)$$
$$ClearCount = (GridSize - MineCount) \rightarrow Finished(NPC)$$

where the *ClearCount* is the number of cells cleared by the NPC, *GridSize* is the number of cells in the grid, and *MineCount* is the number of mines located in the grid.

Next, because the values in the cells indicate the number of mines in adjacent cells, the NPC must know the definition of an adjacent cell. In this case the cell that has row or column coordinates that differ by 0 and/or 1 but are not the same as the first cell can be considered adjacent, thus:

$$\forall [r_1, c_1], [r_2, c_2]\, Adjacent([r_1, c_1], [r_2, c_2]) \rightarrow$$
$$Abs(r_1 - r_2) = 1 \wedge Abs(c_1 - c_2) = 1 \wedge \neg(r_1 = r_2 \wedge c_1 = c_2)$$

where the function *Abs()* returns the absolute value (that is, positive) of the given subtraction.

The NPC plays the game by selecting a cell and uncovering it. Provided the cell isn't a mine, the NPC gets some clues from the cell's internal value as to what is in the surrounding cells. The value that would give the NPC the best information would be an 8. From this, the NPC could conclude that all the adjacent cells contain

mines and that these cells should be flagged. This information can be written with the rule:

$$\forall l_1, l_2\ (Cleared(l_1) \wedge InternalValue(l_1) = 8) \wedge (Adjacent(l_2, l_1) \rightarrow Flagged(l_2))$$

In contrast, a rule can also be written to conclude that adjacent cells to a cell containing a value of 0 do not contain a mine and can, therefore, be safely cleared, as follows:

$$\forall l_1, l_2\ (Cleared(l_1) \wedge InternalValue(l_1) = 0) \wedge (Adjacent(l_2, l_1) \rightarrow Cleared(l_2))$$

The key to safely clearing and flagging other cells is to examine the patterns of the values in cleared cells for which there is a finite number. The pattern we will examine is shown in Figure 4.4.

In the pattern displayed in Figure 4.4, a 1 or 2 denotes the internal value of the cell and a *c* denotes a cleared cell that contains any value other than a 0 or a *mine*. This 3×4 pattern could occur anywhere in the *Minesweeper* grid. It could be located against the grid boundaries or somewhere in the center. By examining Figure 4.4, can you determine where the mine would be? The 2 in cell (j, j) tells an NPC a mine is in two of the adjacent cells that have not yet been uncovered. These two mines cannot both be located in cells that are adjacent to the cell (j, i) containing the 1 because it would contradict its value. Because cell (k, k) is the only cell uncleared that is adjacent to the value 2 and not adjacent to the value 1, this cell must

FIGURE 4.4 A *Minesweeper* pattern.

contain one of the mines. Therefore, the NPC can flag (k,k) as the location of a mine. Now only one uncleared mine is located in cell (i,i), (i,j), (k,i), or (k,j). The NPC would only be guessing which one to clear, so the probability exists that it might unclear a mine, thus ending the game. Because we don't want this to happen, the NPC doesn't make any guesses. Instead it can make one final set of deductions. There is a mine somewhere in the preceding list of cells, so the value of 1 in (j,i) is satisfied. Therefore, any other cells adjacent to (j,i) can be considered safe and can, therefore, be cleared. The NPC can then confidently clear cells (i,h), (j,h), and (k,h). From this reasoning, we can now write the rule as Equation 4.2.

$$\forall r, c\ InternalValue([r,c]) = 2 \wedge InternalValue([r,c-1]) = 1$$
$$\wedge Cleared([r,c]) \wedge Cleared([r,c-1])$$
$$\wedge Uncleared([r-1,c-1])$$
$$\wedge Uncleared([r-1,c])$$
$$\wedge Uncleared([r+1,c-1])$$
$$\wedge Uncleared([r+1,c])$$
$$\wedge Uncleared([r+1,c+1])$$
$$\wedge (Cleared([r-1,c+1]) \wedge InternalValue([r-1,c+1]) > 0$$
$$\wedge \neg InternalValue([r-1,c+1]) = mine)$$
$$\wedge (Cleared([r,c+1]) \wedge InternalValue([r,c+1]) > 0$$
$$\wedge \neg InternalValue([r,c+1]) = mine)$$
$$\rightarrow Flagged([r+1,c+1]) \wedge InternalValue([r+1,c+1]) = mine,$$
$$Cleared([r,c-2]), Cleared([r-1,c-2]), Cleared([r+1,c-3]) \quad (4.2)$$

This exact reasoning also works for patterns that are the vertical and horizontal mirror images of Figure 4.4, as shown in Figure 4.5, where the location of the mine is adjusted accordingly

For any of the pattern matching rules to work in flagging a mine, some cleared cells must exist. In the previous rule when the mine location was flagged, three other cell locations were cleared. Most pattern-matching rules create new cleared cells that, in turn, cause the pattern-matching rules to be reactivated. However, at the beginning of the game all cells are completely uncleared, and, therefore, the NPC must select one cell. Therefore, we could write the rule:

$$ClearCount = GridSize \rightarrow Cleared(StartingLocation)$$

FIGURE 4.5 Mirrored patterns in *Minesweeper*.

where *StartingLocation* is a cell of the programmer's choice. It might simply be $(0,0)$ or chosen at random. Of course, we assume in all cell-clearing rules that the NPC is not dead or has not found all safe cells.

As you can see, *Minesweeper* is a complex game. Using pattern-matching rules increases an NPCs chance of success. One way to examine how an NPC can identify patterns is to play the game of *Minesweeper* yourself and analyze your own strategies.

1. Using first-order logic express the following statements:

 ■ All princes will become kings.
 ■ Some frogs who are kissed by princesses will become princes.
 ■ It's never easy being green.

2. Show that Equation 4.2 holds when the value in cell (r,c) is 3 and the value in cell $(r,c-1)$ is 2. Does this also work for (r,c) values of 4 and 5 with $(r,c-1)$ values of 3 and 4, respectively?

3. Show that the new values introduced for Equation 4.2 in Exercise 2 hold for all mirrored versions of Equation 4.2.

4. Devise five other pattern-matching rules that could be introduced into the NPC's knowledge base to help it deduce the location of mines and clear other safe cells.

4.2.3 Temporal Logic

Temporal logic is a convenient language for describing reactive and temporally dynamic environments. Temporal logic describes environmental states in an infinite sequence in which each state has a successor.

The Theory

Temporal logic attempts to define the relationships between time and events by specifically referring to times at which facts are true. Temporal logic extends propositional and first-order logic with a set of operators that refer to the past and the future. The operators representing future truths follow. (The syntax for the operators is shown in bold inside the parentheses after the operator name.)

Henceforth ($[]\,p$): Indicates proposition p will be true from this time forward. For example, if a Quakebot wins a death match, it will from that moment onward be a past winner of the game. This could be written:

$$\forall q\, Win(q) \rightarrow []\, PastWinner(q)$$

Eventually ($<>\,p$): Infers that proposition p will be true sometime in the future. For example, to say that a Quakebot walking through a lava pit will eventually die, we could write:

$$\forall q\, Walking(q) \wedge Location(q, LavaPit) \rightarrow <> Dead(q)$$

Until ($p\,U\,q$): Suggests proposition p will hold until another proposition, q, is true. For example, we could say that an undefeated Quakebot will remain undefeated until it is beaten, thus:

$$\forall q_1, q_2\, Undefeated(q_1)\, U\, Beat(q_2, q_1)$$

Awaits ($p\,A\,q$): Infers proposition p is always true or is true until proposition q becomes true. For example, we could say that a Quakebot killed during a death match will remain dead awaiting the respawn time. (Respawn is a term that describes the reincarnation of a player in a FPS game. Some games allow players to be reincarnated a finite number of times before they are out of the game.) If the Quakebot has been respawned the maximum number of times, it will remain dead. This can be written:

$$\forall q \, Dead(q) \, A \, Respawn(q)$$

Holds (() p): Allows for the specification of proposition p to occur in the next time instance. For example, we could say that if any Quakebot is mortally wounded by a head shot now, in the next time instance it will be dead. This could be expressed as:

$$\forall p \, HeadShot(p) \rightarrow () \, Dead(p)$$

In addition to representing truths about the future, temporal logic also has a list of operators that express past truths. These include:

So-far ([-] p): Suggests proposition p has been true up until this point in time; however, no conclusions can be made about its truth in the future. For example, to say that Joe's Quakebot has won all the arenas it has fought in, so far, we could write:

$$\exists q \, Owns(Joe,q) \wedge [\text{-}] \, Undefeated(q)$$

Once (<-> p): Allows for the writing of proposition p that was once true but is no longer. For example, if Joe's Quakebot lost its next fight, we might say that it was once undefeated, thus:

$$\exists q \, Owns(Joe,q) \wedge <\text{-}> Undefeated(Quakebot)$$

Since ($p \, S \, q$): Infers proposition p has been true since proposition q became true. For example, we could say that Joe's Quakebot was undefeated until Bill's Quakebot beat it. Therefore, Joe's Quakebot has been <-> $Undefeated(Quakebot)$ (once undefeated) since Bill's Quakebot won, hence:

$$\exists q_1,q_2 \, Owns(Joe,q_1) \wedge Owns(Bill,q_2) \wedge <\text{-}> Undefeated(q_1) \, S \, Beat(q_2,q_1)$$

Backto ($p \, B \, q$): Conjectures proposition p has been true since proposition q or that p is so far true because q has not yet occurred. We could say that if Bill's Quakebot victory over Joe was Bill's first fight, then Bill's Quakebot has been undefeated from this current moment in time back to the fight with Joe's Quakebot, for example:

$$\exists q_1,q_2 \, Owns(Joe,q_1) \wedge Owns(Bill,q_2) \wedge Beat(q_2,q_1) \wedge Number_Fights(q_2)=1 \rightarrow$$
$$Undefeated(q_2) \, B \, Beat(q_2,q_1)$$

Previously Held ($-p$): Infers proposition p was true before the current time instance. For example, we could say that Joe's Quakebot was previously undefeated before the current win by Bill's Quakebot. This can be written:

$$\exists q_1, q_2 \; Owns(Joe, q_1) \wedge Owns(Bill, q_2) \wedge Undefeated(q_1) \wedge Beat(q_2, q_1) \rightarrow$$
$$-Undefeated(q_1)$$

Previously or Currently Holds ($\square p$): Deduces that proposition p is true at this time instance as well as previously. For example, if Joe and Bill's Quakebots are currently in combat and the winner hasn't been decided, then Joe's Quakebot is and was undefeated. We can express this as:

$$\exists q_1, q_2 \; Owns(Joe, q_1) \wedge Owns(Bill, q_2) \wedge Undefeated(q_1) \wedge Fighting(q_2, q_1) \rightarrow$$
$$\square \; Undefeated(q_1)$$

The previously defined operators relate to the concept of linear time in which time is considered to be a single line beginning at some time index 0 and continuing infinitely into the future. This form of temporal logic is called *Linear Temporal Logic*. A second type of temporal logic called *Branching Temporal Logic* considers the possibility of multiple futures and can conceptually be represented as a tree, beginning at a single root point in time and branching out in all directions. Branching temporal logic makes use of the preceding operators as well as two others. These operators are for *all futures* and *some futures*. Because the syntax for these conflicts with those given for the preceding operators, for the purposes of this text we denote them as *aF* and *sF*, respectively. (The symbols for many temporal operators are disagreed upon among references. Therefore, the symbols used herein are taken from the most commonly used ones.) Given the sentence

$$\forall q \; Walking(q) \wedge Location(q, LavaPit) \rightarrow <> Dead(q)$$

which states that *all Quakebots that walk through lava will eventually die* in Branching Temporal Logics could be rewritten as:

$$\forall q \; Walking(q) \wedge Location(q, LavaPit) \rightarrow aF(<> Dead(q))$$

or

$$\forall q \; Walking(q) \wedge Location(q, LavaPit) \rightarrow sF(<> Dead(q))$$

where the first sentence is equivalent to the original, stating that *all Quakebots that walk through lava **will** eventually die*, and the second states that *all Quakebots that walk through lava **may** eventually die*, with the emphasis on the bolded words.

Many forms of temporal logic exist, and its adoption in the AI realm is varied. Whereas temporal logic refers to events and states along temporal intervals using specific time-dependent operators, the predisposition in AI has been to refer to time directly as situation through the use of situation calculus. For this reason, our discussion on temporal logic concludes at this point. The objective in including this section was to introduce you to the possibility of representing temporal dynamics and to think about how propositions in a knowledge base change with time and are influenced by the outcome of events.

4.2.4 Logical Inferencing

Having a set of rules is one thing. Processing them can be quite another. As has been presented in this section, the processing of rules to make deductions is quite complex. The examples examined using the inference rules (Modus Ponens, And-Introduction, and so on) and Boolean algebraic laws (de Morgan's, double negative, and so on) while presenting the power of logical deductions may have seemed more a matter of human intuition on their application rather than a coherent program. Did you wonder as you were reading about the topics how on earth you would implement such a system?

When first exposed to the rules in the *if-then* format, most people immediately equate them with the *if-then* statements in C-type languages, and rightly so, because the Boolean presentation and processing of such rules is identical. However, the rules in a knowledge base can represent far more complex concepts than can easily be achieved in an ordinary programming language. The difference between traditional programming and the knowledge base/inference engine concept is that in traditional programming the rules are contained within the procedures that execute them, whereas the rules in a knowledge base are separate from the inference engine. For example, if a certain *if-then* statement were to be used in a traditional program and needed to be used many times, its syntax would have to be duplicated and placed in the appropriate location within the code. Just because an *if-then* statement exists somewhere within a program doesn't mean it can instantly be accessed. On the other hand, rules in a knowledge base are separate from the inference engine and are, therefore, always available. In addition, to add more rules to a traditional program can mean much restructuring, programming, and compiling. However, with a knowledge base, the rule is simply added and the inference engine does not need to be touched. A knowledge base/inference engine pair could be likened to a traditional program where all the *if-then* statements were removed and placed in an external file, which could at anytime be accessed by the program.

Besides the Boolean algebraic laws and inference rules, an inference engine can process rules in two ways: *forward chaining* and *backward chaining*. Forward chaining works by starting with facts and drawing conclusions from them. The best way to demonstrate this is with a simple example. Assume the knowledge base:

Rule 1: $\forall x, y\ Troll(x) \land Elf(y) \rightarrow Stronger(x, y)$
Rule 2: $\forall x, y\ Elf(x) \land Human(y) \rightarrow Stronger(x, y)$
Rule 3: $\forall x, y, z\ Stronger(x, y) \land Stronger(y, z) \rightarrow Stronger(x, z)$

This knowledge base defines the relative strength of characters in a fantasy-type RPG where all Trolls are stronger than all Elves and all Elves are stronger than all Humans. If we add the fact $Troll(Harry)$ to the knowledge base, no rules will fire because $Troll(Harry)$ matches only the first part of Rule 1. If this face is followed with the fact $Elf(Jenna)$, Rule 1 fires, meaning the left side of the rule has been matched and the right side can be added as a fact to the knowledge base. The knowledge base now reads:

Rule 1: $\forall x, y\ Troll(x) \land Elf(y) \rightarrow Stronger(x, y)$
Rule 2: $\forall x, y\ Elf(x) \land Human(y) \rightarrow Stronger(x, y)$
Rule 3: $\forall x, y, z\ Stronger(x, y) \land Stronger(y, z) \rightarrow Stronger(x, z)$
Fact 1: $Troll(Harry)$
Fact 2: $Elf(Jenna)$
Fact 3: $Stronger(Harry, Jenna)$

In this case the inference engine has taken Facts 1 and 2 and deduced Fact 3. This is forward chaining.

Backward chaining works in the opposite way. It starts with a deduction and attempts to find the facts. For larger collections of rules and facts, backward chaining is more efficient than forward chaining. Assume the knowledge base:

Rule 1: $\forall x, y\ Elf(x) \land Troll(y) \rightarrow Faster(x, y)$
Rule 2: $\forall x\ Green(x) \land Smelly(x) \rightarrow Troll(x)$
Rule 3: $\forall x\ Slim(x) \land Pointy_Ears(x) \rightarrow Elf(x)$

Given a deduction such as $Faster(Jenna, Harry)$, using backward chaining the right side of Rule 1 can be matched to give the facts:

$$Elf(Jenna)$$

$$Troll(Harry)$$

In turn, these facts fire Rules 3 and 2, respectively, and the final knowledge base contains:

Rule 1: $\forall x, y\ Elf(x) \land Troll(y) \rightarrow Faster(x, y)$
Rule 2: $\forall x\ Green(x) \land Smelly(x) \rightarrow Troll(x)$
Rule 3: $\forall x\ Slim(x) \land Pointy_Ears(x) \rightarrow Elf(x)$

Fact 1: *Faster*(*Jenna*, *Harry*)
Fact 2: *Elf*(*Jenna*)
Fact 3: *Troll*(*Harry*)
Fact 4: *Slim*(*Jenna*)
Fact 5: *Pointy_Ears*(*Jenna*)
Fact 6: *Green*(*Harry*)
Fact 7: *Smelly*(*Harry*)

A number of programming languages have existing inference engines. One of these is PROLOG, which stands for *programming in logic*. PROLOG has a backward-chaining inference engine. The next practical exercise provides you with a crash course in creating a simple knowledge base and making deductions using PROLOG.

4.3 DAY OF RECKONING: PRACTICE WITH PROLOG

In this practical exercise you can use the knowledge you have gained about logic, in particular, first-order logic, to create a simple knowledge base using the PROLOG programming language.

ON THE CD
A freeware version of PROLOG is in the Software/Prolog folder called SWI-Prolog. Double-click the *w32pl5210.exe* file to install the PROLOG system on your computer. In the same folder is a manual for use of the entire system in the file *refman.pdf*.

4.3.1 Step One: Install SWI-Prolog

Obtain the SWI-Prolog installation file from the CD-ROM and install the software on your system. The included file works for the Windows operating systems. If you would prefer to use SWI-Prolog under another operating system, see *www.swiprolog.org* for additional installation files. The installation requires you to select a folder in which to place the software. When you have installed it, you can run SWI-Prolog by double-clicking *plwin.exe* in the bin folder of the installation to open a new window containing the following introductory text:

```
machine% pl
Welcome to SWI-Prolog (Version 5.2.0)
Copyright (c) 1990-2003 University of Amsterdam.
SWI-Prolog comes with ABSOLUTELY NO WARRANTY.
This is free software, and
you are welcome to redistribute it under certain conditions.
```

```
Please visit http://www.swi-prolog.org for details.
For help, use ?- help(Topic). or ?- apropos(Word).
1 ?-
```

4.3.2 Step Two: Creating a Knowledge Base

The first step in using PROLOG is to create a knowledge base. A good knowledge base should be expressive, concise, unambiguous, context-insensitive, effective, clear, and correct [Russell95]. The first step in creation is to define the domain of the knowledge. If the knowledge base is to contain rules and facts about a fantasy RPG, then the information placed into the knowledge base should reflect this. There is no use including rules about rose gardening in the context of a RPG where it is not relevant. Thus, keep the knowledge base concise. Second, the *ontology* of the knowledge base should be defined. This is the terminology and vocabulary that is used to express the predicates (relations), functions, and constants of the logic.

Let's create the knowledge base for a RPG. This defines the domain. The ontology consists of predicate, function, and constant names suitable for expressing the domain. To begin we define some simple relationships that declare the relationships of races, such as Human and Elf. The rules are written in a text file that PROLOG compiles. Therefore, using Wordpad or a text editor, open a new file called *rpg.pl* and type the following lines:

```
%% A Simple RPG Knowledge Base

parent(tom,joe).
parent(jenna,joe).

human(X) :-
    parent(Y,X),
    parent(Z,X),
    human(Y),
    human(Z).

human(tom).

elf(X) :-
    parent(Y,X),
    parent(Z,X),
    elf(Y),
    elf(Z).

elf(jenna).
```

```
half_elf(X) :-
    parent(Y,X),
    parent(Z,X),
    elf(Y),
    human(Z).
```

The syntax for PROLOG is fairly simple. Predicates, functions, and constants are written in lowercase with variables in uppercase. Each rule or fact must end with a full stop. A comma "," denotes the connector ∧. The rules are also written in the reverse order of first-order logic, with the deduction on the left. For example, the rule

$$\forall x, y, z \; Parent(y, x) \wedge Parent(z, x) \wedge Human(y) \wedge Human(z) \rightarrow Human(x)$$

is written in PROLOG as:

```
human(X) :-
    parent(Y,X),
    parent(Z,X),
    human(Y),
    human(Z).
```

This rule states that if both parents of an individual are human, then the individual is also human. The other rules in the knowledge base define the race of an individual if the parents are *elf and elf* and *elf and human*. We have also included some facts that state that Tom and Jenna are the parents of Joe.

To use this knowledge base to make inferences, you must compile it with PROLOG. Save the text file containing the knowledge base and return to the SWI-Prolog window. In this window click File > Consult from the menu and locate and select *rpg.pl*. If all goes well, PROLOG gives you a compilation message without any errors.

4.3.3 Step Three: Querying the Knowledge Base

When the knowledge base has been loaded, you can use PROLOG to make queries. Let's say we want to know if Joe is human. In the PROLOG window type:

```
human(joe).
```

Typing this line does not enter knowledge into the knowledge base but is taken as a question asking *is Joe human?* Don't forget the full stop at the end of the query. When you press Enter, PROLOG responds with Yes or No, depending on the knowledge base contents. In this case, you see Yes. This is obviously incorrect, if you make

your own logical deductions about Joe. Considering that one of Joe's parents is Human and the other is Elf, we have to say that Joe should be a Half-Elf. PROLOG, in this case, does not agree. However, it is not PROLOG's fault—it is how we have structured the knowledge. During the inferencing process, PROLOG attempts to match known facts with rules to make them fire. In the case of the rules defining race, the right sides must match facts of the form $parent(A,B)$, $human(A)$, and $elf(A)$. It does not automatically discriminate between variables. For example, $parent(tom, joe)$ can be matched to $parent(Y,X)$ and $parent(Z,X)$ in the same rule. Therefore, the $human(X)$ rule fires for Joe. To eliminate this error we must explicitly state that both parents must be different individuals. This change requires a simple rule of the form $not(Y == Z)$, included thus:

```
human(X) :-
    parent(Y,X),
    parent(Z,X),
    human(Y),
    human(Z),
    not(Y==Z).
```

Change all the rules about race in the *rpg.pl* file to reflect the preceding code. Save the file and reload into PROLOG. Now when you retype the query human(joe)., the system should respond with No. You can also make queries about Joe being one of the other races with elf(joe). and half_elf(joe).. You should find that Joe is considered to be a Half-Elf.

We can also query the knowledge base to determine if an individual is a parent of Joe with the query parent(tom,joe).. If Tom is a parent of Joe, which indeed he is, PROLOG returns with a Yes. We can also list all the parents of Joe with the query parent(X,joe)., where X is matched to existing facts in the knowledge base and reported one at a time. To see the next response, type a semicolon (;) after the given information. For example:

```
?- parent(X,joe).
X = tom ;
X = jenna ;
No.
```

If you keep typing semicolons, PROLOG continues to try matching the query until it runs out of facts. When this occurs, you get a No response.

4.3.4 Step Four: Writing a Simple Program

So far you have learned how to create a knowledge base, add rules and facts, and run queries. The next step is to write a small program. To the beginning of the *rpg.pl* file, add the following lines, just before parent(tom,joe).:

```
%% List of Dynamic Predicates
:- dynamic (human/1).
:- dynamic (elf/1).
:- dynamic (half_elf/1).
:- dynamic (parent/2).

go:-
    write_ln('Your wish is my command: '),
    read(Command),
    process(Command),
    go.

process(stop) :- abort.
process(race) :-
    setof(X, human(X), HUMANS),
    setof(Y, elf(Y), ELVES),
    setof(Z, half_elf(Z), HALF_ELVES),
    nl, write_ln('—— MEMBERS OF RACE ——'),
    write('Humans: '), write(HUMANS), nl,
    write('Elves: '), write(ELVES), nl,
    write('Half Elves'), write(HALF_ELVES), nl, nl.

process(Fact) :-
    assert(Fact),
    write('Adding: '), write(Fact), nl, nl.
```

What you have now created is a recursive rule called go that, when run, loops continuously until it encounters an abort command. The go rule runs through forward chaining when the user types go in the SWI-Prolog window. Once executed, a prompt is written to the screen with the write_ln() function. This function works in the same way as printf() in C, with a new line on the end. write() prints a line without a new line. The read() function gets data from the user. Here it is stored in the Command variable. This new data is then sent to a new rule called process(), which decides how the program should continue running. The process() rule has three definitions, which are similar to overloaded methods in C++. If the user types stop. at the read() function, the program is aborted. If race is entered, a list of individuals belonging to each race in the knowledge base is printed. If anything else is

entered, PROLOG assumes it to be a new fact and adds it to the knowledge base with the `assert()` function. The declaration of some of the rules being `dynamic` at the top of the program allows you to add new rules after the knowledge base is added with the `assert()` function. The `setoff()` function gathers all individuals (`X`) who equate to true for a certain fact (`human(X)`) and stores them in a list (HUMANS).

Remember, constant and literal values such as tom *and* stop *should be expressed in lowercase in PROLOG. Otherwise, the system assumes they are variables.*

Before using the new knowledge base, reload *rpg.pl* into SWI-Prolog. A typical user interaction with the program may look like the following lines:

```
1 ?- go.
Your wish is my command:
|: race.

——— MEMBERS OF RACE ———
Humans: [tom]
Elves: [jenna]
Half Elves[joe]

Your wish is my command:
|: human(bill).
Adding: human(bill)

Your wish is my command:
|: human(jill).
Adding: human(jill)

Your wish is my command:
|: parent(bill, phil).
Adding: parent(bill, phil)

Your wish is my command:
|: race.

——— MEMBERS OF RACE ———
Humans: [bill, jill, tom]
Elves: [jenna]
Half Elves[joe]

Your wish is my command:
|: parent(jill, phil).
Adding: parent(jill, phil)
```

```
Your wish is my command:
|: race.

── MEMBERS OF RACE ──
Humans: [bill, jill, phil, tom]
Elves: [jenna]
Half Elves[joe]

Your wish is my command:
|: stop.
% Execution Aborted
2 ?─
```

In the preceding sample, the user starts the program and types race. This action displays a list of the individuals that exist in the *rpg.pl* file and belong to each race. Next, the user adds Bill and Jill as humans with the appropriate facts. After this, Bill is declared to be the parent of Phil. At this point, when the user types race, the list of race now includes Bill and Jill as humans. However, Phil is not included because although the knowledge base knows that one of Phil's parents is human, it does not know the race of the other and cannot draw any deductions. When Jill is finally added as one of Phil's parents, the appropriate rule is fired that adds the fact human(phil). Phil then shows up in the list of humans.

The semantics and syntax of PROLOG are so expansive (just like a programming language) that it is impossible to cover all topic areas in just a couple of pages. This practical exercise has given you a brief introduction to using PROLOG, and interested readers are encouraged to read through the reference manual supplied with the SWI-Prolog installation for more information. You can even link the PROLOG inference engine with a C++ program. For more information on the appropriate APIs, see *www.swi-prolog.org*.

ON THE CD For the inquisitive mind a PROLOG program written to solve the *Minesweeper* problem is listed in the files *mines.pl* and *minefield.pl* in the Software/Prolog folder.

EXERCISE

1. Add the race *Troll* to the knowledge base and define the parental relationships. Assume that Trolls and Elves cannot interbreed. Modify the race command to display all members of the Troll race.
2. Add new rules to define Faster(x, y), as illustrated in Section 4.2.4. Assume Elves are faster than Humans, who are faster than Trolls. Create a new command, beat_troll, which prints a list of individuals who are faster than Trolls. For this you must use setoff(X, faster(X, troll), BEATTROLL).

3. Include a rule in the knowledge base to infer that Elves and Half-Elves are the only races that can cast spells. Test your knowledge base with several queries such as:

```
cast(tom).
```

4. Include a state for each individual in the knowledge base, such as `Dead(X)` and `Alive(X)`. Create a new command, `state`, that prints a list of which individuals are alive and dead. When an individual is added, its state should be set to `Alive`. Write a rule that sets the state of all Trolls to `Dead` if a Full-Elf casts a spell called `Flesh_to_Stone`. Note, an individual cannot be alive and dead at the same time; therefore, one of the facts must be removed. The opposite of an `assert()` function is `retract()`. For example,

```
assert((alive(tom))).
```

adds the fact `alive(tom)` to the knowledge base and

```
retract((alive(tom))).
```

removes it.

4.4 BAYESIAN INFERENCING

Uncertainty is something that humans must deal with every day. When making decisions we are often given incomplete, inconsistent, or imperfect information with which to reason. Somehow we manage to deal with such situations. Computers, however, tend to deal in true and false answers and, therefore, have difficulty with information that is deficient. Bayesian inferencing attempts to handle reasoning under such conditions and is modeled on the way that humans reason in these situations. Although NPCs have access to perfect and complete knowledge of their environment, often such a superhuman NPC is not desired. An NPC that can reason with humanlike logic makes its performance less accurate and less predictable, resulting in some interesting game play. We begin our discussion on Bayesian inferencing by looking at the theory on which it is based, probability.

4.4.1 Probability Theory

Probability, as we saw in Chapter 3 in association with games theory, deals with the chances of some event occurring or some fact being true. Probability is expressed

mathematically as a real number between 0 and 1, where an occurrence with a probability of 0 means that it will never happen and a probability of 1 means that it will definitely happen. A probability of 1 can also be construed as a *success*, whereas a probability of 0 can be taken to mean *failure*. The probability of success can be expressed as Equation 4.3 and failure as Equation 4.4.

$$p(success) = \frac{number_of_past_successes}{number_of_attempts} \tag{4.3}$$

$$p(failure) = \frac{number_of_past_failures}{number_of_attempts} \tag{4.4}$$

For example, an archer may have hit the bull's-eye 256 times out of 2,450 attempts. His probability for successfully hitting the bull's-eye is $256/2450 = 0.10$, or you can say he has an accuracy of 10 percent. The probability that he will not hit the bull's-eye can be calculated from the fact that the probability of success plus the probability of failure always equals 1, as shown in Equation 4.5. Therefore, the archer's failure rate is 0.9 or 90 percent.

$$p(success) + p(failure) = 1 \tag{4.5}$$

The probability of an event, E, can also be expressed as the ratio of desired outcomes to all outcomes, as expressed in Equation 4.6.

$$p(E) = \frac{number_of_desired_outcomes}{number_of_possible_outcomes} \tag{4.6}$$

For example, a die contains six numbers. The probability of rolling a 5 is 1/6, or 0.167, where the number of desired outcomes is one because the die has only one 5, and the number of possible outcomes is six because the dice has six sides. Outcomes that can occur with the throwing of a die (1, 2, 3, 4, 5, or 6) are independent and mutually exclusive, because we cannot obtain, for example, a 6 and a 3 in the same roll. However, it is often the case that events are not independent and the outcome of one event can influence the outcome of another event. In this case we consider *conditional probability*, which examines the probability of event A occurring if event B occurs, or vice versa. The conditional probability that event A will occur if event B occurs is expressed as Equation 4.7.

$$p(A|B) = \frac{p(A \cap B)}{p(B)} \tag{4.7}$$

where $p(A \cap B)$ is the probability that both A and B will occur, and $p(B)$ is the probability of B occurring. The reverse case, where we want to calculate the probability of event B occurring if event A occurs, can be expressed as Equation 4.8, where the symbols for A and B are simply swapped.

$$p(B|A) = \frac{p(B \cap A)}{p(A)} \text{ or } p(B \cap A) = p(B|A) \times p(A) \tag{4.8}$$

Given that $p(B \cap A) = p(A \cap B)$, we can substitute Equation 4.8 into Equation 4.7 to give Equation 4.9, known as the *Bayesian Rule*.

$$p(A|B) = \frac{p(B|A) \times p(A)}{p(B)} \tag{4.9}$$

4.4.2 Bayesian Rules

The Bayesian rule allows for the reversal of any probabilistic statement. Therefore, we can express $p(A|B)$ as a rule as follows:

if A is true
then B is true with probability p

This rules implies that if event A occurs, then the probability of B occurring is p. For example, consider the question *if the house is clean, then what is the probability the maid has been here?* With Bayesian inferencing, the rule can be reversed to *if the maid has been here, then what is the probability the house is clean?* This rule allows for humanlike reasoning that can make conclusions about the *effects from causes* or the *causes from effects*.

Thus far we have examined one event dependent of others; however, what if an event is dependent on multiple mutually exclusive events? In the spirit of Equation 4.8, the probability of A being dependent on n number of events, B_i, is demonstrated in Equation 4.10.

$$p(A) = \sum_{i=1}^{n} p(A|B_i) \times p(B_i) \tag{4.10}$$

Consider the production rule:

if B is true
then A is true with probability $p(A|B)$

which implies that if B occurs (evaluates to true), then the probability of A occurring is $p(A)$. This rule actually implies that A is not only dependent on B begin true but is also affected by B being false, and, therefore, is dependent on two mutually exclusive events: B and $\neg B$. In Bayesian reasoning the reverse also holds that B is dependent on A and $\neg A$, which makes B also dependent on two events. In this case, the Bayesian rule that expresses the production rule will be that of Equation 4.10 with Equation 8 substituted for probabilities of A and B, producing Equation 4.11.

$$p(A|B) = \frac{p(B|A) \times p(A)}{p(B|A) \times p(A) + p(B|\neg A) \times p(A)} \qquad (4.11)$$

Equation 4.11 suggests that we must know the probability of both A and B occurring before the production rule can be solved. Although the probability of A and B is not explicitly stated in the production rule, this does not mean it is unknown. When a knowledge base is created these probability values must be stated as initial facts. Whether it is performed by the programmer or a knowledge engineer does not matter. We must assume the knowledge base contains these values. $p(A)$ and $p(B)$ are called *prior probabilities*, and $p(A|B)$ is called the *posterior probability* of A upon observing B.

CRASH
COURSE

Joe lives in a neighborhood with a burglary crime rate of 5 percent. Joe has a special engine demobilizer installed in his car, which gives him a 10 percent chance of his car going missing as the result of a crime. In addition, Joe's girlfriend likes to borrow his car 20 percent of the time without asking. Joe awakens one morning to find his car is gone. How confident can Joe be that it was stolen? Let's examine the rule:

if car is gone (X)
then car was stolen (Y) with probability of $p(Y|X)$

The probability the car was stolen resulting in its absence using Equation 4.11 is:

$p(Y) = 0.05$ (*crime rate*)
$p(X|Y) = 0.1$ (*chances of Joe's car being gone after it is stolen*)
$p(X|\neg Y) = 0.2$ (*chances of Joe's car being gone if it is not stolen*)

$$p(Y|X) = \frac{p(X|Y) \times p(Y)}{p(X|Y) \times p(Y) + p(X|\neg Y) \times p(Y)}$$

$$= \frac{0.1 \times 0.05}{0.1 \times 0.05 + 0.2 \times 0.05}$$

$$= 0.33$$

This means that if Joe's car is gone, then there is a 33 percent chance that it was stolen. Joe could best put his mind at ease by asking his girlfriend to tell him when she borrows the car!

4.4.3 Bayesian Networks

A Bayesian network is an acyclical graph with nodes representing propositions and edges showing causal relationships, called a *belief graph* or *belief network*. For example, if A causes B, this could be represented by the graph shown in Figure 4.6. In this case, A is considered a parent of B and B is a child of A.

FIGURE 4.6 A belief graph.

Inferencing in Bayesian networks is the same as that used in Bayesian rules. Let's consider the following example. One night you are watching television. Suddenly, all the lights go out and the television switches off. You believe there are three reasons why the electricity may have been switched off: 1) Your roommate forgot to pay the electricity bill; 2) you have blown a fuse; or 3) the district grid has gone down. Without getting up to investigate, what could you consider to be the most likely cause? Could it be one of these reasons or a combination? This scenario is represented by the belief network shown in Figure 4.7.

To begin, we must make an independent assessment of the probability of each reason occurring separately. In this case let's say the probability that your roommate forgot to pay the electricity bill, which we denote as $p(B)$, is 0.009. The probability a fuse has blown, $p(F)$, is 0.005, and the probability the grid has gone down, $p(G)$, is 0.001. Next, we estimate the probability of any combination of these things occurring at the same time. These values are taken from your expertise of the situation and past events and are not determined through any mathematics involving the singular probabilities. The combined probabilities can be drawn up in a truth table, as shown in Table 4.4.

FIGURE 4.7 A belief network for an electricity outage.

For example, Table 4.4 shows the probability of the electricity going down because of all three events occurring at the same time is 0.05 percent, and the probability of it occurring only because the bill is overdue is 10 percent. Given this information the actual probabilities of the events causing the electricity failure can now be determined. These values are shown in Table 4.5.

TABLE 4.4 A Truth Table with Probabilities of Combined Events

| Bill Forgotten | Blown Fuse | Grid | No Electricity $p(E\,|\,[B,F,G])$ |
|:---:|:---:|:---:|:---:|
| True | True | True | 0.0005 |
| True | True | False | 0.05 |
| True | False | True | 0.01 |
| True | False | False | 0.1 |
| False | True | True | 0.2 |
| False | True | False | 0.25 |
| False | False | True | 0.03 |
| False | False | False | 0.001 |

TABLE 4.5 The Actual Probabilities of Events Causing an Electricity Outage[a,b,c]

$p(B)$	$p(F)$	$p(G)$	$p(E\|[B,F,G])$	$p(E)$	$\acute{p}(E)$
T=0.009	T=0.005	T=0.001	0.0005	0.00000000002	0.00000
T=0.009	T=0.005	F=0.999	0.05	0.00000224775	0.00099
T=0.009	F=0.995	T=0.001	0.01	0.00000008955	0.00004
T=0.009	F=0.995	F=0.999	0.1	0.00089460450	0.39522
F=0.991	T=0.005	T=0.001	0.2	0.00000099100	0.00044
F=0.991	T=0.005	F=0.999	0.25	0.00123751125	0.54672
F=0.991	F=0.995	T=0.001	0.03	0.00002958135	0.01307
F=0.991	F=0.995	F=0.999	0.001	0.00098505896	0.04352

[a] T values taken from Table 4.4. F values calculated as $1-T$ in line with Equation 4.5.
[b] $p(E) = p(B) \times p(F) \times p(G) \times p(E|[B,F,G])$
[c] $\acute{p}(E)$ is the normalized value of $p(E)$, such that the $\acute{p}(E)$ column adds up to 1. The value is calculated by dividing each value of $p(E)$ by the total of the $p(E)$ column. This method is the same as using Equation 4.11.

After normalizing the values of $p(E)$, denoted by $\acute{p}(E)$, we can say the best explanation for the electricity outage is that a fuse has blown and neither of the other events occurred with a probability of 54.7 percent. The second-best reason, with a probability of 39.5 percent, is that your roommate forgot to pay the bill.

Bayesian networks can be used by NPCs to reason about events occurring in their environment and the impact these events may be having on other environmental states or other events. Consider an NPC playing a RTS game. If the NPC is to play in a humanlike manner, then it cannot have access to the entire game states. For example, if the opponent is building up a squadron of flying crafts in a hidden location, then the opponent should assume the NPC cannot see this from afar. Rather, some evidence would be needed in the NPC's area of the map that suggested the opponent was building a secret squadron. Let's consider the dependency graph in Figure 4.8, called a *tech tree*, which describes the order in which buildings and battle units can be built in a RTS. This tech tree also is the NPC's Bayesian network. The nodes in the graph are based on the buildings and units that can be created in the game *Dark Reign*, although the relationships are not entirely true to the game.

For the network in Figure 4.8 we assume that all relationships are mutually exclusive. For example, the *Advanced Assembly Plant* can be built after a *Head Quarters 2* or an *Assembly Plant*. The arrows in the network show not only the cause-

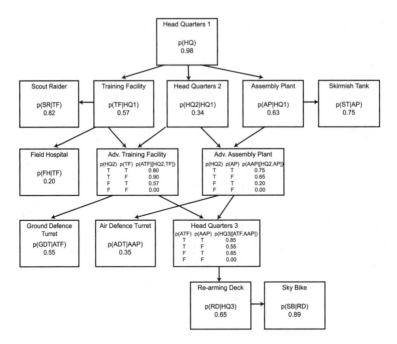

FIGURE 4.8 A Bayesian network for a RTS game.

and-effect relationships but also the order in which things can happen. Note that not all Bayesian networks are like this. In the case of the electricity failure, the electricity could go out for no apparent reason. However, in this RTS example, an *Air Turret,* for example, cannot be built unless the player has an *Advance Assembly Plant.* In this way we are kind of cheating for space by combining the tech tree and the Bayesian network. The values within the nodes of Figure 4.8 are the probabilities that a type of building or unit will be built considering the building represented by the parent node has been built. For example, if there is a *Head Quarters 1*, then the probability that a *Training Facility* exists is 57 percent. However, because the network is also a tech tree, reasoning backward from child to parent is much more exact. If an opponent's Scout *Training Facility* is spotted, its probability of existence is equal to 100 percent. (Unless it is a decoy!) From this it must also be inferred that the probability of existence for a *Head Quarters 1* must also be 100 percent because the *Training Facility* cannot be built without it. Of course, the *Head Quarters 1* may have been destroyed after the *Training Facility* was built, but this type of reasoning goes beyond this example. Thus, we assume $p(parent \mid child) = 1$. If you are wondering where the probability values come from to populate a network in the first place, they are based on human expert knowledge or statistics of past events. In this example, we assume the values for the network have come from previous encounters the NPC has had with other players.

Given the Bayesian network, the NPC can calculate the *joint probability* of any state of the environment by multiplying together the appropriate probabilities for all network nodes [Charniak91]. For example, the probability of the state that includes a *HQ1*, *AP*, *AAP*, *HQ3*, *RD*, and *SB* and none of the other units can be written:

$$P(HQ1, AP, AAP, HQ3, RD, SB, \neg SR, \neg TF, \neg HQ2, \neg ST, \neg FH, \neg ATF, \neg GDT, \neg ADT)$$
$$= P(HQ1) \times P(AP \mid HQ1) \times P(APP \mid \neg HQ2, AP) \times P(HQ3 \mid \neg ATF, AAP) \times$$
$$P(RD \mid HQ3) \times P(SB \mid RD) \times \neg P(SR \mid \neg TF) \times \neg P(TF \mid HQ1) \times \neg P(HQ2 \mid HQ1) \times$$
$$\neg P(ST \mid AP) \times \neg P(FH \mid \neg TF) \times \neg P(ATF \mid \neg HQ2, \neg TF) \times \neg P(GDT \mid \neg ATF) \times$$
$$\neg P(ADT \mid AAP)$$
$$= 0.98 \times 0.63 \times 0.2 \times 0.65 \times 0.89 \times 1 \times 0.43 \times 0.66 \times 0.25 \times 1 \times 1 \times 1 \times 0.65$$
$$= 0.002$$

Therefore, the probability of a *HQ1*, *AP*, *AAP*, *HQ3*, *RD*, and *SB* existing without the other units is 0.2 percent. Note in the previous calculation the probabilities used for each node are based on the effect of their parents. For example, $P(HQ3)$ is translated to $P(HQ3 \mid \neg ATF, AAP)$, which if we look up the probability table for *HQ3* in Figure 4.8 where *ATF* is *F* and *AAP* is *T* the probability is 0.65. Values such as $\neg P(SR \mid \neg TF)$ equate to 1 because the probability of an *SR* (*Scout Raider*) existing if there is no *TF* (*Training Facility*) is 0 and $\neg 0$ gives 1. Therefore, the astute reader may conclude the joint probability of an environment with a *SR* but not *TF* would be 0, which makes sense because a *Scout Raider* cannot be constructed without the existence of a *Training Facility*.

When the Bayesian network has been established, the NPC can perform two operations on it: *belief revision* and *belief updating* [Santos99]. Belief revision is concerned with finding the most probable cause for a particular effect, and belief updating takes a given effect and updates the probability of the causes. For example, let's assume the NPC has spotted a *Sky Bike*. It can calculate the most probable cause for its existence through belief revision by examining all possible scenarios and picking the one with the highest probability. The bigger the network the more arduous this task becomes because it involves listing all possible states of the environment where a *Sky Bike* exists, calculating the environment's joint probability for each state, and selecting the state with the maximum probability. For every n nodes with values of either true or false, there are 2^n states to examine. Therefore, for the current example there are 2^{13} states to examine with *SB* always equal to true. The probability table has 8,192 rows of values and probabilities to compare. A small sample of these states is shown in Table 4.6. The actual solution to this example is left to the reader as an exercise.

Belief updating works by revaluating probabilities given new evidence. For example, all things considered, an NPC may believe the probability of the existence of a *HQ3* is 0.55, given that it knows there is definitely an *AAP* and definitely not an *ATF*. In turn, the probability of there being a *RD* would be $0.55 \times 0.05 = 0.0275$. If the NPC were to observe a *Sky Bike* before it could visually confirm the existence of a *RD* or a *HQ3*, it could update its beliefs of a *RD* and *HQ3* existing to be 1. During belief updating any new evidence that changes belief probabilities is propagated forward and backward through the network from the affected node, and probabilities are updated accordingly.

TABLE 4.6 A Partial Display of the Joint Probability for All Environment States

HQ1	SR	TF	HQ2	AP	ST	FH	ADF	AAP	GDT	ADT	HQ3	RD	SB	P
T	T	T	T	T	T	T	T	T	T	T	T	T	T	0.000836
T	T	T	T	T	T	T	T	T	T	T	T	F	T	0
T	T	T	T	T	T	T	T	T	T	T	F	T	T	0
T	T	T	T	T	T	T	T	T	T	T	F	F	T	0
T	T	T	T	T	T	T	T	T	T	F	T	T	T	0.000209
T	T	T	T	T	T	T	T	T	T	F	T	F	T	0
T	T	T	T	T	T	T	T	T	T	F	F	T	T	0
...														

It is impossible in such a short amount of space to adequately discuss all the issues relating to the use of Bayesian networks for use with NPCs. This section has provided a brief overview of the topic. The main point to make is that Bayesian networks are excellent for dealing with beliefs with associated probabilities and for updating and reasoning about the likelihood of the states of an environment. The biggest downfall is that reasoning with a Bayesian network grows exponentially with the number of nodes, which may partly explain why they have not yet been implemented in any known game. However, with advanced search algorithms and the availability of faster CPUs, they might yet see the light of day in the gaming domain.

ON THE CD

If you are interested in exploring the realm of Bayesian networks, check out the Netica C API included in the Software/Netica folder. For more information, source code, and documentation on how to build your own Bayesian networks, see *www.norsys.com/netica_c_api.htm*.

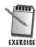

1. In the electricity failure example, suppose that you learn the grid went down. This would make $T = 1$ and $F = 0$ for $p(G)$. Change these values in Table 4.5 and recalculate the probabilities. What conclusions can you now draw?

2. Consider the following scenario: Abbey wakes up one morning and walks outside to check on her vegetable patch. She finds the grass is wet and concludes that it has either rained or the sprinklers were on. The chance of the grass being wet because it rained ($P(grass = wet \,|\, rain = T)$) is 0.9, and the chance of the grass being wet because the sprinklers were on ($P(grass = wet \,|\, sprinklers = T)$) is 0.5. If the grass is wet, there is a 67 percent chance the vegetables will not need watering, and if it is dry there is a 2 percent chance they will not need watering. Draw a Bayesian network to describe this scenario. What is the chance that it rained, the sprinklers did not come on, and the grass and vegetable patch is dry? If the vegetable patch is wet, what is the most probable cause?

3. In the *Dark Reign*-inspired RTS Bayesian network of Figure 4.8, what is the probability of the scenario where there exists an $HQ1$, $HQ2$, and $HQ3$ but none of the other units?

4. Consider the following scenario: You attempt to make a purchase over the Internet to pay for a new Xbox game. In the past you have experienced rejection problems with your credit card because 1) is was over the limit ($p(L) = 0.02$); 2) there was a problem at the bank ($p(B) = 0.05$); and 3) your Internet connection dropped out ($p(I) = 0.03$). The probabilities that your credit card will be rejected during this particular transaction due to these problems are shown in the following table.

| L | B | I | $p(R\,|\,L,B,I)$ |
|---|---|---|---|
| T | T | T | 0.95 |
| T | T | F | 0.90 |
| T | F | T | 0.85 |
| T | F | F | 0.60 |
| F | T | T | 0.75 |
| F | T | F | 0.45 |
| F | F | T | 0.40 |
| F | F | F | 0.10 |

Having dealt with this particular Web site before, you know there is an 80 percent chance the Web site manager will e-mail you about your credit card being rejected ($p(E\,|\,R) = 0.8$) and a 20 percent chance he will e-mail you about something else ($p(E\,|\,\neg R) = 0.2$). Draw a Bayesian network to

describe this situation. Work out the probabilities for all states of the network where the Web site manager e-mails because your credit card has been rejected. What is the most likely reason?

4.5 FUZZY LOGIC

Computer programmers are used to working with discrete answers of true and false. But how often do you answer a question with a *yes* or *no*? If someone asked you *do you play computer games?*, you might answer *maybe, sometimes,* or *hardly ever.* In this case, not only are you giving a yes answer, but you are specifying a degree of truth. As we have seen, Boolean algebra, proposition, and first-order logic use discrete distinctions for properties. For example, the statement *it is always hot at the beach* could not be expressed in first-order logic because the term *hot* is too subjective and ambiguous and could refer to a range of actual temperature values. If, however, we said that something is hot if it is over 95°F (35°C), then we could write:

$$\forall l \; Beach(l) \wedge Temperature(l) > 35 \rightarrow Hot(l)$$

Because we are working with sharp distinctions, does this mean that any beach with a temperature of 95°F or less is cold? Of course, you could add another category of temperature, such as warm, to make a more sensible scale; however, the cut-off values would still create harsh divisions. Fuzzy logic can help avoid such illogicalities.

4.5.1 Fuzzy Set Theory

Fuzzy logic provides a way to infer a conclusion based upon vague, ambiguous, inaccurate, and incomplete information. Humans work with these restrictions in making decisions, and from one human to another there is an unspoken agreement as to the interpretation of a vague statement. As vague terminology is often used by many people to express knowledge, it seems inevitable that a language should exist that allows a computer to understand knowledge fed to it in this format. Fuzzy logic is based on the concept that properties can be described on a sliding scale. For example, when spoken about, properties such as temperature, height, and speed are often described with terms such as *too hot, very tall,* or *really slow,* respectively.

Fuzzy logic works by applying the theory of sets to describe the range of values that exists in vague terminologies. Classical set theory from mathematics (as used in the section on first-order logic) provides a way of specifying whether some entity is a member of a set. For example, given the temperatures $a = 36$ and $b = 34$ and the

set called *Hot*, which includes all numerical values greater than 35, we could say that *a* is a member of the set *Hot* with the notation

$$a \in Hot$$

and *b* is not a member of the set *Hot* with:

$$b \notin Hot$$

Classical set theory forces lines to be drawn between categories, which make their use in producing distinct true and false answers ideal. For example, *Member*(*b*, *Hot*) would equate to false. What we need with fuzzy logic is a way to blur the borderlines between sets (or make them fuzzy). This can be achieved with fuzzy set theory. Whereas classical set theory operates with only two values, true (1) and false (0), fuzzy set theory works with a range of real values between 0 and 1. Instead of an entity being a member of a set, fuzzy set theory allows for a degree of membership. This theory can best be explained with the following example.

Consider the classical and fuzzy sets *HotC* and *HotF*, shown in Figure 4.9. In the case of the classical set, *HotC*, temperature values under 36°C have a degree of membership of 0, indicating they are not in the set, and temperature values 36°C and over have a degree of membership of 1, indicating they are in the set. In contrast, the degree of membership of the *HotF* set is not as clear-cut. For example, a temperature of 40°C has a degree of membership of 0.58. Given a temperature, the classical set asks *is the temperature hot?* and the fuzzy set asks *how hot is the temperature?* The answer for the classical set is *no*, and the answer for the fuzzy set is *0.58 hot*.

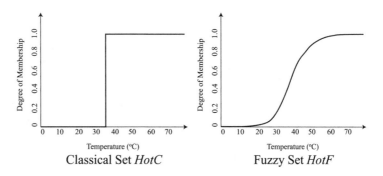

FIGURE 4.9 Membership of the sets *HotC* and *HotF*.

Because a fuzzy set contains continuous values, it can be represented by a computer as a mathematical equation where the equation, μ, is applied to a given value, x, and returns the values degree of membership, δ, as shown in Equation 4.12.

$$\delta = \mu(x) \qquad (4.12)$$

This creates a set, F, with n members of degree of membership/value pairs, which can be expressed as Equation 4.13. Note in the syntax of fuzzy sets the "/" symbol *does not* mean division.

$$F = \{\delta_1/x_1, \delta_2/x_2, \ldots, \delta_n/x_n\} \qquad (4.13)$$

In theory, the function μ is derived from example data given by experts. The function is usually expressed as a sigmoid, Gaussian, or pi function. However, in practice these functions, while expressing the real data in fuzzy sets, increase computation time. Therefore, the fuzzy sets are expressed as *linear fit functions* that best describe the data. To determine a linear function, two points are needed for each line. In the example of the *HotF* set, we could express it using Equation 4.13 as:

$$HotF = \{0/15, 1/65\}$$

Using these values the fuzzy set can be redrawn as shown in Figure 4.10.

Other categories in fuzzy-set classification can also be represented in the same way. In the current example, we could also include a set for warm (*WarmF*) and

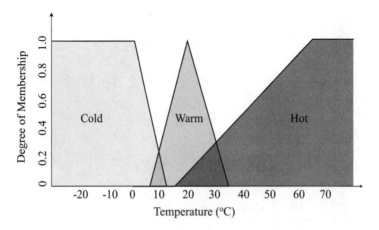

FIGURE 4.10 Linear fit fuzzy sets for hot, warm, and cold.

cold (*ColdF*). These are shown together with *HotF* in Figure 4.10. The fuzzy areas of the sets are indicated by the overlapping areas. These areas are where values could be members of both sets. For example, the temperature 25°C is 0.2 hot and 0.75 warm.

Furthermore, each category can be described using what is known as a *hedge*. A hedge modifies the shape of a fuzzy set. Hedges include adverbs such as *very*, *somewhat*, *slightly*, *hardly ever*, *moderately*, and *more often than less*. They are used to create new fuzzy set categories such as *very hot* or *slightly cold*. A hedge works with a given fuzzy set and modifies the shape of its upper or lower range. For example, *HotF* is used with the *very* and *somewhat* hedges to create the new fuzzy sets *VeryHotF* and *SomewhatHotF*, as shown in Figure 4.11. A temperature such as 40°C, which is considered *0.58 hot*, is now also *0.22 very hot*.

Hedges are applied using a mathematical expression that adjusts the value of the degree of membership for a given base set. Where the degree of membership is determined by the function, μ, a hedge function, λ, is applied to the output, as shown in Equation 4.14.

$$\lambda(\mu(x)) \tag{4.14}$$

Some examples of hedge functions, taken from [Negnevitsky02], are displayed in Table 4.7.

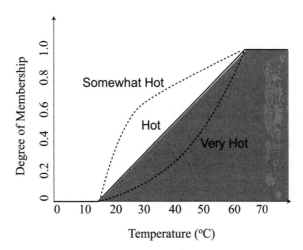

FIGURE 4.11 *HotF* set with the hedges *very* and *somewhat* applied.

TABLE 4.7 Hedge Functions for Fuzzy Logic

Hedge	Equation	Graphical Representation
Slightly	$[\mu(x)]^{1.7}$	
Very	$[\mu(x)]^2$	
Extremely	$[\mu(x)]^3$	
Somewhat	$\sqrt{\mu(x)}$	

Fuzzy sets can be operated on like classical sets using the compliment, subset, intersection, and union operators. However, because fuzzy sets do not have clearly cut boundaries like classical sets, the operators function a little differently. The compliment of a fuzzy set, A, written $\neg A$, is the opposite of a set. The compliment of *HotF*, $\neg HotF$, is a set containing *NOT hot temperatures*. The compliment doesn't contain simply all the values that are not in the fuzzy set as it would in classical set theory because entities in the set have degrees of membership. $\neg A$ contains all the entities that are in A with the associated degrees of freedom equal to:

$$\delta_{\neg A} = 1 - \mu(x)$$

For example, the sets of *WarmF* and $\neg WarmF$ might be:

$$WarmF = \{0/18, 0.2/15, 1/20, 0.8/25, 0/36\}$$
$$\neg WarmF = \{1/18, 0.8/15, 0/20, 0.2/25, 1/36\}$$

The subset of a fuzzy set is the same as for subsets of classical sets. A set is a subset of a fuzzy set if all the entities are members of the fuzzy set. For example, the set *VeryHotF* is a subset of *HotF*. The only difference is that the entities of a fuzzy sub-

set have smaller degrees of membership in the subset than they do in the larger set. This point can be illustrated by examining the contents of *HotF* and *VeryHotF*.

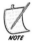

The HotF set has been expanded to include more values, which would be positioned along the lower range but were cut off for illustration purpose. Because HotF is defined by a linear fit function, it need only contain two values: the value where degrees of freedom is 0 and the value where degrees of freedom is 1. Also notice that the degrees of freedom calculated for VeryHotF are the squared values of the associated entities in HotF. This is in line with the very hedge function, shown in Table 4.7.

$$HotF = \{0/15, 0.2/25, 0.4/35, 0.6/45, 1/65\}$$
$$VeryHotF = \{0/15, 0.04/25, 0.16/35, 0.36/45, 1/65\}$$

The intersection of fuzzy sets A and B, written as $A \cap B$, results in a set that contains the entities present in both A and B. Because the entities may have different degrees of membership in A and B, the lesser of the values is kept as expressed in Equation 4.15.

$$\delta_{A \cap B} = \min\{\mu(x_A), \mu(x_B)\} \qquad (4.15)$$

For example if

$$A = \{0/10, 1/30, 0/80\}$$
$$B = \{0/50, 1/80, 0/110\}$$

then

$$A \cap B = \{0/50, 0.37/61.35, 0/80\}$$

Because the contents of a fuzzy set are continuous, it may not be evident from examining the preceding example exactly how the set $A \cap B$ was formed. What you have to remember is that although the sets contain only three values, these values represent the start and end points of a triangle representing the fuzzy set. Therefore, the fuzzy set contains not only the three values but all the values under the triangle, as shown in Figure 4.12 (a). The intersection of the sets, therefore, contains the values in the graphical representation shown in Figure 4.12 (a), where the two sets overlap. The overlapping area is triangular, so it can also be specified as a set with three values. Hence, the value 0.37/61.35 in $A \cap B$ represents the apex of the intersection.

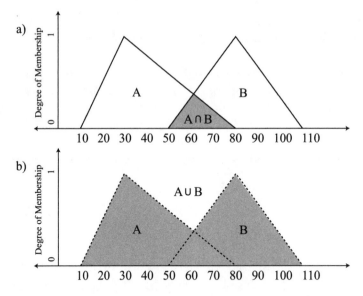

FIGURE 4.12 A graphical representation of a) $A \cap B$ and b) $A \cup B$.

Last, but not least, the union of two sets A and B, denoted $A \cup B$, merges the contents of A and B into one set and, in contrast with the intersection operation, retains the larger of the degrees of membership as specified in Equation 4.16.

$$\delta_{A \cup B} = \max\{\mu(x_A), \mu(x_B)\} \tag{4.16}$$

For example if

$$A = \{0/10, 1/30, 0/80\}$$
$$B = \{0/50, 1/80, 0/110\}$$

then

$$A \cup B = \{0/10, 1/30, 0.37/61.35, 1/80, 0/110\}$$

The resulting set is illustrated in Figure 4.12 (b).

4.5.2 Inferencing with Fuzzy Rules

A fuzzy rule can be written as

if x is A
then y is B

where *x* and *y*, known as *linguistic variables*, represent characteristic being measured (temperature, speed, height, and so on), and *A* and *B*, known as *linguistic values*, are the fuzzy categories (hot, fast, tall, and so on). A fuzzy rule can also include *AND* and *OR* statements similar to those in Boolean algebra, propositional logic, and first-order logic. Examples of fuzzy rules follow:

if	temperature is hot
or	UV_index is high
then	sunburn is likely

if	temperature is warm
and	humidity is low
then	drying_time will be quick

Given a set of fuzzy rules, which constitute a knowledge base, and a number of inputs (or percepts), an output value can be deduced using fuzzy inference. Two common ways to use inference on fuzzy rules are Mamdani style and Sugeno style, both named after their creators. The Sugeno style works well with optimization and adaptive techniques for control type problems. The Mamdani style is widely accepted for capturing human knowledge and uses a more intuitive form of expressing rules. For this reason, we now examine the Mamdani style. If you are interested in the Sugeno style, we encourage you to read [Negnevitsky02].

Mamdani-style inference takes four steps: fuzzification, rule evaluation, aggregation, and defuzzification. Each of these steps is discussed with the aid of an example, which determines the risk of an attack on an NPC. Consider the following knowledge base:

Rule 1:	if	health is good
	and	armor is adequate
	then	risk is low
Rule 2:	if	health is bad
	or	armor is marginal
	then	risk is medium
Rule 3:	if	health is bad
	and	armor is inadequate
	then	risk is high

The fuzzy sets for this knowledge base are shown in Figure 4.13.

The first step is to take inputs, which are in the form of discrete values for the NPC's health and armor strength, and fuzzify them. We assume these values to be 45 percent and 65 percent, respectively. To fuzzify them, we simply pass them

through the respective fuzzy sets and obtain their degrees of membership. The value for health belongs to both the fuzzy sets *Bad* and *Good* (as shown in Figure 4.13) with the degrees of membership 0.5 and 0.17, respectively. The value for armor belongs to both the *Marginal* and *Adequate* sets, with degrees of membership 0.25 and 0.25, respectively. These values are shown as the dotted lines in Figure 4.13. Because armor is not in the *Inadequate* set, Rule 3 is not activated; however, the others are.

The next step is rule evaluation. Using the degrees of membership determined by fuzzification, the fuzzy rules in Rule 1 and 2 are applied. The *and* and *or* in the rules are similar to ∩ and ∪ previously discussed in relation to fuzzy set theory and are evaluated in the same way. For an *and*, the minimum degree of membership is taken in line with Equation 4.15. For an *or*, the maximum (see Equation 4.16) is used. These values are then applied to the *then* part of the rule. Substituting the degrees of membership into the rules gives:

if 0.17 and 0.25 then risk is (0.17) low (where 0.17 is the minimum for and)
if 0.5 or 0.25 then risk is (0.5) medium (where 0.5 is the maximum for or)

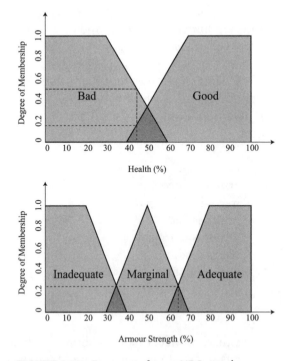

FIGURE 4.13 Fuzzy sets for an NPC attack.

These values are then used to *clip* the fuzzy sets pertaining to risk. As shown in Figure 4.14, the given degrees of membership are used as cut-off points for the fuzzy sets *Low* and *Medium*, giving us two new fuzzy subsets.

The third step in fuzzy inferencing is rule aggregation. Put simply, this step takes the union of the clipped fuzzy sets from the previous step and creates a new fuzzy set, as shown in Figure 4.15.

The final step is defuzzification, which means taking the final aggregated fuzzy set shown in Figure 4.15 and converting it into a single value that is the fuzzy inference output. The final fuzzy set contains the value; all that is needed now is to

FIGURE 4.14 Clipping of the risk fuzzy sets.

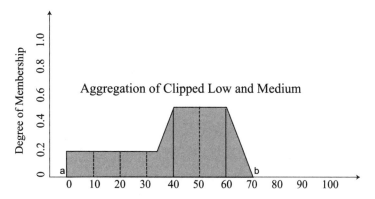

FIGURE 4.15 Rule aggregation of the clipped fuzzy sets.

extract it. The simplest method for doing this is called the *centroid* technique. This method finds the vertical line that would slice the fuzzy set in half so that each half is of equal mass. To do this the mathematical center of gravity, *G*, is found with Equation 4.17.

$$G = \frac{\sum\limits_{x=a}^{b} \mu(x)x}{\sum\limits_{x=a}^{b} \mu(x)}$$

(4.17)

where *a* and *b* are the start and end vertical range of the fuzzy set (as shown in Figure 4.15), and *x* represents equal vertical slices of the set, shown in Figure 4.15 as dashed vertical lines. Equation 4.17 gives only an estimate of the center of gravity because the real center of gravity should be calculated over continuous values of *x*. However, this method is computationally faster. The more vertical slices taken, the more accurate the answer is. By applying Equation 4.17 to the set in Figure 4.15 we get:

$$G = \frac{(0+10+20+30)\times 0.17 + (40+50+60)\times 0.5 + 70 \times 0}{0.17+0.17+0.17+0.17+0.5+0.5+0.5+0}$$

$$= 39.1$$

This means the risk involved in attacking under the given inputs is 39.1 percent.

EXERCISE

1. Using the rules from the previous example, calculate the risk of attacking for an NPC player with health = 56 and armor = 32.

4.6 DAY OF RECKONING: IMPLEMENTING FUZZY LOGIC WITH AN NPC

Writing your own fuzzy logic inference engine would take quite a bit of effort. Therefore, we are using the open source Free Fuzzy Logic Library (FFLL) for this practical exercise [Zarozinski02]. The FFLL is integrated with the bot previously created in Apocalyx to be used as the bot's reasoning mechanism.

4.6.1 Step One: Obtain FFLL API Files

ON THE CD

The first step to creating a bot with fuzzy logic for a brain is to get the FFLL API from the CD-ROM and place it into the same directory as your bot code. The files

that you need are *ffllapi.lib*, *ffllapi.dll*, and *ffllapi.h* in the Apocalyx/ffll folder. For this exercise, we modify an Apocalyx program that has the bot following the user's avatar around the map. The initial project file, *Virtual Human.dsp*, can be found in the Apocalyx/prj/Chapter Four folder.

4.6.2 Step Two: Creating a Fuzzy Knowledge Base

The knowledge base used with the FFLL API is created as a simple text file with the fuzzy rules written in the Fuzzy Control Language (FCL). The structure of the knowledge base is similar to the rules used in the previous example and should look familiar. Listing 4.3 illustrates a simple knowledge base.

LISTING 4.3 A simple knowledge base for an NPC

```
FUNCTION_BLOCK

VAR_INPUT
    Health      REAL; (* RANGE(0 .. 100) *)
    Armor       REAL; (* RANGE(0 .. 100) *)
END_VAR

VAR_OUTPUT
    Risk        REAL; (* RANGE(0 .. 100) *)
END_VAR

FUZZIFY Health
    TERM Bad := (0, 0) (0, 1) (30, 1) (60, 0);
    TERM Good := (40, 0) (70, 1) (100, 1) (100,0);
END_FUZZIFY

FUZZIFY Armor
    TERM Inadequate := (0, 0) (0, 1) (20, 1) (40,
    TERM Marginal := (30, 0) (50, 1) (70, 0);
    TERM Adequate := (60, 0) (80, 1) (100, 1) (100,
END_FUZZIFY

FUZZIFY Risk
    TERM Low := (0, 0) (0, 1) (20, 1) (40, 0);
    TERM Medium := (30, 0) (50, 1) (70, 0);
    TERM High := (60, 0) (80, 1) (100, 1) (100, 0);
END_FUZZIFY

DEFUZZIFY valve
    METHOD: COG;
```

```
END_DEFUZZIFY

RULEBLOCK first
    AND:MIN;
    ACCUM:MAX;
    RULE 0: IF Good AND Adequate THEN Low;
    RULE 1: IF Bad OR Marginal THEN Medium;
    RULE 2: IF Bad AND Inadequate THEN High;
END_RULEBLOCK

END_FUNCTION_BLOCK
```

An FCL file, as shown in Listing 4.3, starts and ends with the keywords FUNCTION_BLOCK and END_FUNCTION_BLOCK. Next, the input and output values are defined. In this example we have two input values, HEALTH and ARMOR, and one output value, RISK. All values are defined as real numbers in the range 0 to 100. Next, the linguistic variables are declared. Each variable begins with a FUZZIFY followed by the variable name and ends with a END_FUZZIFY. Within each linguistic variable the linguistic value fuzzy sets are defined. The sets shown in Listing 4.3 take the values from the previous example of the attacking NPC. For example, the variable HEALTH contains two fuzzy sets: Good and Bad. The name of the set is preceded by the keyword TERM and followed by a list of coordinates that specify the linear fit function for the fuzzy set. In FCL, all coordinates surrounding the polygon that makes up the fuzzy set's representation in graphs, such as those in Figure 4.13, must be specified. For example, the set for Bad, as shown in Figure 4.13, is a polygon with the coordinates $(0,0)$, $(0,1)$, $(30,1)$, and $(60,0)$. This list is the same as was used in Listing 4.3 to define the fit function for Bad. Note that unlike previous syntax where the degree of membership was presented first when values were listed, in FCL the convention is the same as (x, y), where x is the value of the linguistic value and y is the degree of membership.

Next, the defuzzify method is defined. Because we have already examined the center of gravity method, we use this in the FCL. You may note through the use of this file the output value for the inputs of 45 and 65 is around 36, as opposed to our previously calculated 39.1. This difference is due to the error in our calculation of the center of gravity where the values we used were sparsely distributed. You can expect the FFLL to return a more accurate output. Other methods and processes are used through the evaluation of fuzzy logic, and these can also be implemented in FCL. However, they are not discussed here, but you are encouraged to read [FCL97] for more information.

Finally, the rules are defined between the keywords RULE_BLOCK and END_RULE_BLOCK. As can be seen in Listing 4.3, rules can be written without reference

to the linguistic variables. The rule of thumb is that the values in the rules relate to the order of the inputs. For example, in Rule 0, Good refers to the first input, HEALTH, and Adequate refers to the second input, ARMOR. Inside this block, the way in which AND, OR, and the method of rule aggregation can also be declared. If you are interested in learning about the other methods refer to [FCL97]. To implement the Mamdani style, leave the settings as shown in Listing 4.3.

Create an FCL file for yourself. Start by copying the code in Listing 4.3. Name it anything you want, and add the extension .fcl, for example, *fuzzybot.fcl*. The FCL file should be placed in a directory accessible by your bot, namely the bot code directory.

4.6.3 Step Three: Integrating the Knowledge Base with the Bot

Integrating the FFLL API into the bot's code is easier than you might think. The first thing to do is add ffllapi.h to the include statements in *AIBot.h*. Next, the protected properties

```
int fm;    //fuzzy model
int fmc;   //fuzzy child
```

should be added to the AIBot class. The fuzzy model property points to the knowledge base and the fuzzy child property is an object that uses the knowledge base. If the same knowledge base is used for a number of different NPCs, each has a child property that accesses the knowledge base with differing input and output values. The model and child properties can now be initialized in the bot's intialize() method in *AIBot.cpp* by adding the following lines:

```
// setup fuzzy model
fm = ffll_new_model(); //create a fuzzy model object
int ret = ffll_load_fcl_file(fm, "fuzzybot.fcl");
if (ret < 0)
{
    printf("Could not locate FCL file");
}
fmc = ffll_new_child(fm);
```

As you can see, the ffll_load_fcl_file() function returns a value less than 0 if it cannot find the FCL file. Therefore, you must ensure that your program can locate it. Also you might like to replace the printf statement in the preceding code with a MessageBox.

Before trying to compile your code, be sure that you have linked to ffllapi.lib. In Visual C++ you can do this by clicking Project > Add Existing Item from the menu and then adding ffllapi.lib.

4.6.4 Step Four: Putting the Knowledge Base Through Its Paces

Now that you have the knowledge base set up, it is time to use it. We use it to work out a risk factor for attacking a player and then turn this value into the bot's new state. First, you should feed the bot's health and armor values into the knowledge base on each update. Therefore, in the update() method add:

```
// set input
ffll_set_value(fm, fmc, HEALTH, health);
ffll_set_value(fm, fmc, ARMOR, armor);

// get output
output = (float) ffll_get_output_value(fm, fmc);
```

where output is a protected floating point property of the AIBot class and HEALTH and ARMOR are the enumerated data types:

```
enum FUZZY_INPUTS
{
    HEALTH, ARMOR
};
```

The new completed update() method looks similar to that in Listing 4.4.

LISTING 4.4 New AIBot update() method implementing a fuzzy logic knowledge base

```
void AIBot::update()
{
    //only allow maximum health
    if(health > 100) health = 100;
    if(armor > 100) armor = 100;

    //Use Fuzzy Rules to Determine Next Move
    // set input
    ffll_set_value(fm, fmc, HEALTH, health);
    ffll_set_value(fm, fmc, ARMOR, armor);

    // get output
    output = (float) ffll_get_output_value(fm, fmc);
```

```
if (output < 20) state = ATTACK;          //low risk
else if (output < 80) state = PURSUE; //medium risk
else state = RETREAT;                     //high risk

if(lowerAnim != LEGS_WALK )
    botAvatar->setLowerAnimation(lowerAnim = LEGS_WALK);

//get bot's position and bot's opponent's position
BSPVector botPos( botAvatar->getPositionX(),
    botAvatar->getPositionY(),
    botAvatar->getPositionZ() );
BSPVector opponentPos( opponent->getPositionX(),
    opponent->getPositionY(),
    opponent->getPositionZ() );
BSPVector oldVelocity = velocity;
if(!isNear(botPos,opponentPos, 50) || state == RETREAT)
    //not within 50 of opponent
{
    if (state == PURSUE || state == ATTACK)
    {
        velocity.set(opponentPos.x - botPos.x, 0,
            opponentPos.z - botPos.z);
    }
    else if(state == RETREAT)
        velocity.set(botPos.x - opponentPos.x, 0,
            botPos.z - opponentPos.z);

    velocity = velocity.normalize();
    botAvatar->rotateStanding(turnXZ(velocity, oldVelocity));

    BSPVector botVel = velocity;
    botVel.x *= speed;
    botVel.z *= speed;
    bsp->slideCollision(botPos,botVel,extent);
    botAvatar->setPosition(botPos.x,botPos.y,botPos.z);
}
else
{
    if(lowerAnim != LEGS_IDLE )
        botAvatar->setLowerAnimation(lowerAnim = LEGS_IDLE);
}

if (state == ATTACK)
{
    if(upperAnim != TORSO_ATTACK2 )
```

```
                    botAvatar—>setUpperAnimation(upperAnim = TORSO_ATTACK2);
        }
        else
        {
            if(upperAnim != TORSO_STAND )
                botAvatar—>setUpperAnimation(upperAnim = TORSO_STAND);
        }

        if(!isNear(botPos,opponentPos, 500))
            //not within 500 of opponent
        {
            //update health and armor
            health+= 0.2;
            armor+= 0.1;
        }
    }
```

The code in Listing 4.4 changes the bot's state according to the output from the knowledge base. The rest of the code takes care of the bot's animation. The final part of the method updates the value of the bot's health and armor by a small amount if the bot is a distance of 500 units from the player. For the bot's health and armor values to decrease, the player must attack the bot (that is, shoot at it). This is easily implemented in the *vh.cpp* file. In the MainScene::update() method, locate the following code and add the line shown in bold. Note that this code allows the player to shoot and hit the bot no matter which direction it is facing. You can adjust this as you see fit.

```
//Weapon Shooting Animation
if(glWin.isLeftButtonPressed() &&
    (avatar—>getUpperAnimation() != TORSO_ATTACK))
{
    avatar—>setUpperAnimation(TORSO_ATTACK);
    M3Reference linkTransform;
    if(avatar—>getLinkTransform("tag_weapon",linkTransform))
    {
        shotEmitter—>set(linkTransform);
        shotEmitter—>moveSide(1*SCENE_SCALE);
        shotEmitter—>setVisible(true);
        shotEmitter—>reset();
    }

    //apply damage to bot
    bot1.takeDamage( getrandom(1,30) );
}
```

In addition to adding this line you must also create the `takeDamage()` method for the bot as follows:

```
void AIBot::takeDamage(float damage)
{
    health -= damage;
    armor -= getrandom(1, damage);
}
```

Save, compile, and run the code. You should find the bot now pursues your avatar, attacks, or, if seriously injured, retreats.

EXERCISE

1. The current knowledge base as shown in Listing 4.3 has a lot of holes in the rules. By this, we mean that the rules don't completely account for every possible set of values for the bot's health and armor. Modify and add to the existing rules to make them more complete and examine how it affects the bot's behavior.

2. The output from the current knowledge base is a floating point value between 0 and 100. As you can see in the bot's `initialize()` method, handling the large range of output values can become quite cumbersome. To fix this, we can have the knowledge base categorize the output for us before it is returned. To do this replace the following lines

```
    Risk    REAL; (* RANGE(0 .. 100) *)
```

with:

```
    Risk    REAL; (* RANGE(0 .. 4) *)
```

and:

```
    TERM Low := (0, 0) (0, 1) (20, 1) (40, 0);
    TERM Medium := (30, 0) (50, 1) (70, 0);
    TERM High := (60, 0) (80, 1) (100, 1) (100, 0);
```

with:

```
    TERM Low := 1 ;
    TERM Medium := 2 ;
    TERM High := 3 ;
```

The preceding FCL changes modify the fuzzy sets of Risk from a range of values into a single value. Fuzzy sets represented in this way are called *singletons*. The output now returns the values from 0 to 4, where 0 and 4 are undetermined, 1 is low, 2 is medium, and 3 is high. Modify the AIBot code to handle the new return values for the output.

4.7 SUMMARY

Logic is serious business in any programming. If you can understand logic, half your programming battles are over. Logic is not only useful for directing the flow of a program but is invaluable in representing an autonomous agent or NPC's knowledge about its environment and the way in which it processes the information to determine its next move.

This chapter has briefly examined propositional logic, first-order logic, temporal logic, probability theory, Bayesian networks, and fuzzy logic with the hope of expanding your awareness of varying ways to implement logic in the programming of an NPC. By implementing more complex ways of representing and processing information in a humanlike manner, it allows for more believable and complex behaviors in NPCs. These, together with the more complex AI techniques of neural networks and genetic algorithms introduced in the next chapter, allow the programmer to explore the vast domain of human problem solving and to work toward the NPCs of the future.

REFERENCES

[Charniak91] Charniak, E., 1991, Bayesian Networks without Tears, *AI Magazine.*

[FCL97] Sub-Committee 65, 1997, *Fuzzy Control Programming*, International Electrotechnical Commission.

[Negnevitsky02] Negnevitsky, M., 2002, *Artificial Intelligence: A Guide to Intelligent Systems*, Pearson Education Limited, Harlow.

[Russell95] Russell, S., and Norvig, P., 1995, *Artificial Intelligence: A Modern Approach*, Prentice Hall, Upper Saddle River.

[Santos99] Santos, E., 1999, *Bayesian Networks Tutorial*, available online at *http://excalibur.brc.uconn.edu/~baynet/tutorial.html*, August 12, 2003.

[Woodcock99] Woodcock, S., 1999, Game AI: The State of the Industry, *Game Developer Magazine*, August.

[Zarozinski02] Zarozinski, M., 2002, An Open-Source Fuzzy Logic Library, *AI Programming Wisdom*, Rabin, S. (ed), Charles River Media, Hingham.

5 AI Techniques for Programming Believable Behaviors

In This Chapter

- Finite state machines
- Environment navigation with waypoints and the A* algorithm
- Decision trees
- The evolution of the perfect NPC with genetic algorithms
- Building an artificial neural network

5.1 INTRODUCTION

AI has had a long association with games, from the simple rule-based opponent in *Space Wars* to the complex A-Life characters in *Creatures*. With the bulk of computer memory and processing resources concentrated on graphics and sound, traditionally very little computer processing time has been available for AI processes. As such, simplistic AI methods were originally used to bring an element of intelligence to the NPCs. What may have passed as humanlike intelligence in an NPC 20 years ago does not cut it in today's games with players insisting on more believable and challenging artificial characters. As a consequence, and with an increase in available computing resources, programmers are now looking for new AI techniques that can be used for developing advanced behaviors in NPCs.

In the past, AI was added to a game as an afterthought, when the programming effort had completed the graphics and sound elements. Often the level of complexity of the AI technique used is a product of the knowledge of the overworked programmer who, with his tight working schedule, has very little time to keep up with the latest AI techniques coming out of academic research. This results in the same tried and true AI techniques, such as finite state machines, being used over and over again. And although finite state machines are an efficient and effective way of

achieving several behavioral control mechanisms in artificial characters, they have their limitations.

The objective of this chapter is to examine several popular AI techniques that can be used in programming the behavior of NPCs. Because these techniques have evolved in academia, much of the background is based in complex mathematical equations, proofs, and algorithms. Don't panic—to ease the nonacademic reader into each topic, a minimal amount of academic background has been included before giving concrete examples with practical programming exercises. It is hoped that through this melding of academic concepts and practical examples you can become more comfortable investigating the latest AI offerings from the academic domain without baulking at the technical language and format of research papers. In turn, the practical games programmer may gain insight in how to present his work to the research community.

This chapter begins by examining traditional finite state machines. As an extension, techniques such as fuzzy state machines and probability state machines are discussed to enhance the performance of NPCs using state machines as a primary AI technique. Following this, we quickly examine searching algorithms in relation to navigation. In this section, the popular and efficient A* algorithm is examined and implemented. Next, an AI technique called decision trees (used for the first time in a game in *Black & White*) that can be used for learning is illustrated. The chapter concludes by examining the complex domains of evolutionary computing and neural networks.

5.2 FINITE STATE MACHINES

The most popular form of AI in many games and NPCs is *non-deterministic automata,* more commonly known as *finite state machines* (FSM). A FSM can be represented by a directed graph (digraph) in which the nodes symbolize states and the directed connecting edges correspond to state transitions [Gould88]. States represent an NPC's current behavior or state of mind. In previous chapters we used the states ATTACK, WANDER, PURSUE, and so on. Formally, a FSM consists of a set of states, *S*, and a set of state transitions, *T*. For example, a FSM might be defined as *S* = {*WANDER, ATTACK, PURSUE*} and *T* = {*out of sight, sighted, out of range, in range, dead*}, as shown in Table 5.1. This FSM can be represented visually, as shown in Figure 5.1.

TABLE 5.1 State Transition for a FSM

State	Transitions (opponent is . . .)				
	out of sight	*sight*	*sighted out of range*	*in range*	*dead*
WANDER	WANDER	PURSUE	—	—	—
PURSUE	WANDER	—	PURSUE	ATTACK	—
ATTACK	—	—	PURSUE	ATTACK	WANDER

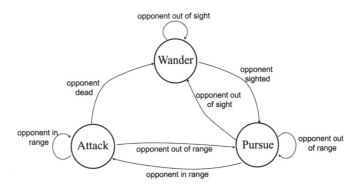

FIGURE 5.1 A finite state machine.

In brief, the state transition functions define how to get from one state to another. For example, in Table 5.1, if the NPC is in state Wander and it sights its opponent, then the state transitions to Pursue. The state is used to determine elements of the NPC's behavior. For example, when the NPC is in the Attack state, the appropriate attacking animation should be used.

5.2.1 Implementing a FSM

In previous chapters you already implemented crude states associated with the Apocalyx bots. However, no consideration was given for the order in which states could be transitioned. In the previous examples, the NPCs have been able to go into any state they want, rather than having to follow some particular order, with one exception. If the NPC transitioned from any state to the DEAD state, it could not move into another state. A state that could follow the DEAD state would be RESPAWN, as used in *Quake* and *Unreal* to resurrect NPCs after a certain amount of time. The actual processing of the FSM occurs inside the NPCs update() method, which can cause a few problems with processing the states. A common example you

may have encountered when using the Apocalyx game engine is that if a bot is in a state—for example, DEATH—then the appropriate animation should be played. The code might look as follows:

```
if ( state == DEAD )
{
    botAvatar->setAnimation(BOTH_DEATH1);
}
```

The problem with this type of coding is that although the bot remains in the state DEAD, the setAnimation() method continually plays the BOTH_DEATH1 animation. This action causes the bot to continuously loop through the BOTH_DEATH1 scene without ever actually coming to a final death pose (lying still on the ground). For this reason, we have been using the properties upperAnim and lowerAnim to keep track of the current animation and if it has already played, or is being played, ensuring it is not restarted.

Another common problem occurs in the following code:

```
if( state == DEAD)
{
    if( upperAnim != BOTH_DEATH1 && upperAnim != BOTH_DEAD1)
        botAvatar->setAnimation(upperAnim = BOTH_DEATH1);
    else if( upperAnim == BOTH_DEATH1)
        botAvatar->setAnimation(upperAnim = BOTH_DEAD1);
}
```

This code is inside the update() method and is, therefore, called with each game loop. On the first loop when this is executed for the first time, the BOTH_DEATH1 animation runs. On the next loop, the BOTH_DEAD1 animation runs. The problem here is that the BOTH_DEATH1 animation may take longer to play out than one game loop. Therefore, the scene is cut short and replaced with the BOTH_DEAD1 animation. Implementing a FSM can solve this problem by allowing the programmer to specify the amount of time (or game loops) an NPC should remain in a certain state before transition. Rabin [Rabin02] suggests a state machine language that implements three events for each state: *OnEnter, OnExit,* and *OnUpdate.* In short, a code implementation of this concept might look like that shown in Listing 5.1.

LISTING 5.1 Code for simple finite state machine

```
void FSM()
{
    switch( state )
```

```
    {
        case ATTACK:
            if (event == ENTER){/*Process Enter*/}
            else if (event == UPDATE) {/*Process Update*/}
            else if (event == EXIT) {/*Process Exit*/}
            break;
        case DYING:
            if (event == ENTER) {/*Process Enter*/}
            else if (event == UPDATE) {/*Process Update*/}
            else if (event == EXIT) {/*Process Exit*/}
            break;
        case DEAD:
            if (event == ENTER) {/*Process Enter*/}
            else if (event == UPDATE) {/*Process Update*/}
            else if (event == EXIT) {/*Process Exit*/}
            break;
    }
}
```

The scripting languages that accompany both *Quake* and *Unreal Tournament* also work along the same lines, allowing for different events to occur while the bot is in a certain state. *Unrealscript* even allows a programmer to define how and which functions execute when the bot is in a particular state. This control allows a programmer to turn functions on and off when appropriate. For example, *Unrealscript* has a function called HearNoise(), which is activated for the bot by the game engine when another player makes a noise (such as walking) close enough to alert the bot to the player's presence. *Unrealscript* allows for each state to be defined, which includes both the ignoring of functions and the rewriting of functions. Therefore, if the bot is in the DEAD state, it should not take any notice of HearNoise() functions. In *UnrealScript* this code is written as:

```
state Dead
{
    ignores HearNoise;
}
```

5.2.2 FSM Extensions

Traditional FSMs are deterministic, in that the transitions from state to state are somewhat static and make the behaviors of an NPC more predictable and less believable. To address these problems, several annexes have been made to FSMs to enhance their capabilities, including fuzzy state machines (FuSM), hierarchical state machines (HSM), and probabilistic state machines (PSM). These extensions are

used to reduce the deterministic nature of the traditional FSMs discussed in the preceding sections.

A FuSM combines the theory of fuzzy logic (from Chapter 4) with FSMs to allow degrees of membership of a state. Whereas a traditional FSM ensures that an NPC be in only one state at a time, a FuSM allows the NPC to be partially in one state and possibly in more than one state. The code for a simple FSM, shown in Listing 5.1, illustrates this point because the case statement processes only one state at a time. In a FSM, a query about the NPC's state returns either a true or false value; in a FuSM, the answer is vaguer. For example, given the state HUNGER, in the FSM the NPC is either hungry or not hungry; however, in a FuSM the NPC might be very hungry, quite hungry, a bit hungry, or not really hungry.

By allowing an NPC to be in more than one state at a time, a FuSM reduces the state machine to a multiple output concurrent system. This situation defeats the original goal of a FSM, which is sequential ordering and processing of states. The strength of using a FSM is in knowing the state of the NPC at any given time. Although partial membership in a given state appears valuable, allowing practical membership in several states complicates the NPC's program and brings up several new issues.

If an NPC is allowed to be partially in one or more states, it should be reflected in the outward behavior. Depending on the number of vague values for a state, the animation must reflect each one if the player needs to know the degree of membership. For example, if the NPC can be slightly angry, moderately angry, or very angry, appropriate animations for each are needed. In addition, if the NPC is allowed to be in more than one state at a time, animations must be created for all possible state combinations. For example, if the NPC can be partially in the states of HUNGRY and ANGRY, animations must be created for slightly angry and very hungry, slightly angry and not really hungry, very angry and quite hungry, and so on. As the states and vagueness terms increase, you may have a potential explosion of animation needs.

Another problem with multiple states is their coordination and combination. It might not be suitable for an NPC to be in two conflicting states at once or to have high degrees of membership in several sets. For example, it would not be believable that an NPC be very angry and very happy at the same time, whereas being very happy and moderately surprised might be plausible. Similarly, physical constraints dictate what multiple actions the NPC can be performing at any one time. For example, an NPC could not be in a state of DRIVE_CAR and COOK_BBQ at the same time, whereas it may be able to be in the simultaneous states of DRINK_BEER and COOK_BBQ.

With some clever programming and tight state transitions, many of the preceding difficulties can be overcome. These issues aside, just as fuzzy logic as implemented in Chapter 4 provides an NPC with believably unpredictable behavior; a

FuSM can be used for exactly the same purpose while allowing state transitions and handling outward behaviors.

A HSM is a FSM in which states can be decomposed into their own FSMs, as shown in Figure 5.2. Here ATTACK is decomposed into a FSM that illustrates the substates of ATTACK. For example, the NPC can be in a state of ATTACK and MOVE_LEFT. The existing state transitions for ATTACK, which allow the NPC to move out of a state of ATTACK and into another state, still exist. In addition each substate in a state's FSM can be decomposed into a FSM of its own. The depth of the hierarchy depends on the level of detail required to control the NPC.

One advantage to using HSMs over FSMs is that they allow for the capture of commonality that exists among states. In real life many substates are repeated among states. In a game this means that code to handle an NPC during a substate need be programmed only once and then reused during the actions of multiple states. For example, consider the states LOOK_FOR_FOOD and LOOK_FOR_OPPONENT. The FSM for each of these states in a HSM would include a lot of similar substates to help the NPC navigate around the environment looking for an object. In one state, the object is food and in the other, the object is the opponent. Besides the difference in objects, the NPCs movement substates of MOVE_LEFT, MOVE_RIGHT, and so on, can be used in the FSM for each and, therefore, need be defined only once.

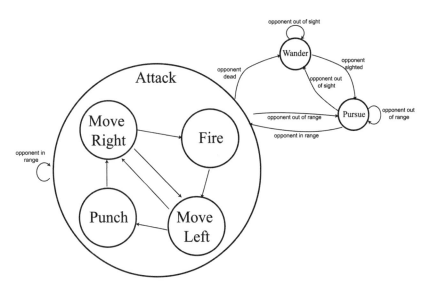

FIGURE 5.2 A hierarchical state machine showing decomposition of the ATTACK state.

Of course, HSMs that implement simple FSM in the definition of each state are still deterministic. However, no hard and fast rule says that each state cannot be represented by a FuSM to add an element of unpredictability. Another type of state machine that also provides unpredictable behaviors is the PSM, which places probabilities on the state transitions occurring. An example is shown in Figure 5.3.

In this case the transition from one state to another is determined randomly within given probabilities for the set of transitions leaving a state. For example, in Figure 5.3 is a 30 percent chance the next action after GO_FORWARD will be TURN_LEFT. By assigning probabilities to the transitions, the NPC's behavior is somewhat predictable in terms of probability, yet varied enough that the player can believe in the unpredictable nature of the state changes. The idea behind the PSM is to program the NPC with a pattern of behavior that is believably humanlike by considering the preferences humans place on transitioning between states. For example, analysis of sports games can show which plays or tactics are favored by the teams and the probabilities that the team will divert from its favorite tactics and the probability of its second preference. This information can be used to come up with a strategy for combating the other team. The same type of probability patterns of behavior are used in Bayesian networks (as examined in Chapter 4), where the network of behavior sequences and the probability of one activity following another are analyzed. This very same technique is also discussed in Chapter 7 when natural language generation and analysis are examined.

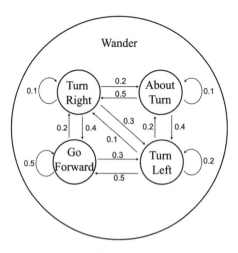

FIGURE 5.3 A probabilistic finite state machine.

5.2.3 Advantages and Disadvantages of FSMs

The simplicity of FSMs makes them easy to implement, for even novice programmers. The predictability of the traditional FSM means that for any given set of inputs the programmer assumes the output and uses this knowledge for testing and debugging. In addition, FSMs have a rapid design and implementation time. FSMs are a tried and true AI method and are a popular choice for use in games development. Their low processor overheads make them ideal for use in games where memory and processor allocations for AI are small. The predictable nature of deterministic FSMs is often not desired in games where players require more realistic behavior from the NPCs. The extensions of FuSM, HSM, and PSM attempt to overcome these problems by adding an element of perceived randomness.

As the number of states for an NPC becomes larger, the implementation of a FSM can be difficult to manage and maintain without much forethought to its design. The code for the state transitions can become complex and difficult to follow. FSMs are suited only to problems when all possible states and transitions are known beforehand and code can be written to cater for them.

The next section modifies code from previously created Apocalyx bots to include a FSM to program bot behavior sequencing and improved animation.

EXERCISE

1. Draw the FSM as a graph, as described in the following state transition table.

State	Transition			
	w	**x**	**y**	**z**
S_0	S_0	S_4	S_1	S_2
S_1	S_2	S_3	S_4	S_0
S_2	S_4	S_3	S_1	S_2
S_3	S_3	S_0	S_1	S_4
S_4	S_1	S_2	S_4	S_0

2. Construct a FSM for the Merlin NPC from Chapter 3. Assume that Merlin cannot follow one magical spell with another and must rest in between. Draw up the state transition table to represent the FSM.
3. A FSM can also be used to define an *activity digraph*. Such a graph is simply a complex FSM that presents the order of activities that must be executed

to accomplish a plan. The activity digraph to acquire some money might look like the FSM shown in Figure 5.4.

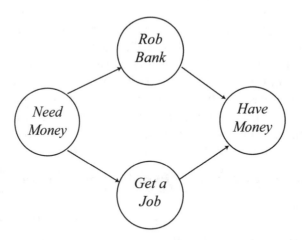

FIGURE 5.4 An activity digraph planning the acquisition of money.

4. Construct an activity digraph for the building of a house.
5. A farmer has two ducks and two foxes to send to market. Unfortunately, he has only one crate in which to transport them and it can hold only two animals at a time. Therefore, at some time there will be two animals at the farm, in the crate, or at the market. For some bizarre reason, if the number of ducks outnumbers the foxes at any location, the foxes leave the ducks alone; otherwise, the foxes will eat them. A state in this situation can be described as $\{d, f, l\}$ where d is the number of ducks, f is the number of foxes, and l is the location. A transition is represented by $\{d, f\}$, which shows the number of ducks and foxes moving from one location to another. Figure 5.5 shows the basic structure of the FSM.

 The partial FSM shown in Figure 5.5 displays what happens when two foxes are moved from the farm to the crate and then to the market and vice versa. It also shows what the state is if one duck and one fox are placed in a crate. Notice that you cannot get back to the state $\{2,2,F\}$ from the state $\{dead,1,C\}$. Complete the FSM for all possible environment states and transitions.

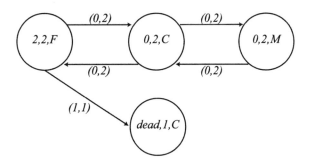

FIGURE 5.5 A partial FSM for the transportation of ducks and foxes.

5.3 DAY OF RECKONING: IMPLEMENTING A FSM

In this practical exercise, you use the premise of the code in Listing 5.1 to implement a FSM in an Apocalyx bot.

ON THE CD

The initial project files for this exercise are located in the Apocalyx/prj/Chapter Five-1 folder. The code, when compiled and run, displays the bot a short distance from the player's avatar. The player can shoot at the NPC and, when the player presses F1, watch the bot's health decline. There is no content in the bot's update() method; therefore, it will not react.

5.3.1 Step One: Processing a Finite State Machine

The FSM can be represented as one large case/if statement. In this exercise we want to create a FSM that causes the bot to attack the player while the player can shoot at it. As the player attacks, the bot's health declines. When the health falls below 0, the bot's dying animation sequence plays, followed by the bot lying dead on the floor. After a certain amount of time the bot is respawned to continue its attack. The bot's attack on the player is inconsequential because it doesn't affect the player in any way. You could, however, program this into the game, if you like. The FSM code is displayed in Listing 5.2.

LISTING 5.2 A FSM for a bot

```
void AIBot::FSM()
{
    switch( state )
    {
        case ATTACK:
            if ( event == ENTER )
```

```
                {
                    botAvatar->setUpperAnimation(
                    upperAnim = TORSO_ATTACK);
                    botAvatar->setLowerAnimation(
                    lowerAnim = LEGS_WALK);
                    event = UPDATE;
                }
                else if ( event == UPDATE )
                {
                    BSPVector botPos( botAvatar->getPositionX(),
                        botAvatar->getPositionY(),
                        botAvatar->getPositionZ() );
                    BSPVector opponentPos( opponent->getPositionX(),
                        opponent->getPositionY(),
                        opponent->getPositionZ() );
                    BSPVector oldVelocity = velocity;
                    if(!isNear(botPos,opponentPos, 50))
                    {
                        velocity.set(opponentPos.x - botPos.x, 0,
                            opponentPos.z - botPos.z);
                        velocity = velocity.normalize();
                        botAvatar->rotateStanding
                            (turnXZ(velocity, oldVelocity));

                        BSPVector botVel = velocity;
                        botVel.x *= speed;
                        botVel.z *= speed;
                        bsp->slideCollision(botPos,botVel,extent);
                        botAvatar->setPosition(botPos.x,botPos.y,botPos.z);
                    }
                    else if(lowerAnim != LEGS_IDLE )
                        botAvatar->setLowerAnimation(lowerAnim = LEGS_IDLE);

                    if (health <= 0)
                    {
                        event = EXIT;
                    }
                }
                else if ( event == EXIT )
                {
                    state = DYING;
                    event = ENTER;
                }
                break;
            case DYING:
```

```
        if ( event == ENTER )
        {
            botAvatar->setAnimation(upperAnim = BOTH_DEATH1);
            time( &botTimer1 );
            time( &botTimer2 );
            event = UPDATE;
        }
        else if ( event == UPDATE )
        {
            //allow 3 seconds for dying animation
            time( &botTimer2 );
            if ((botTimer1 + 3) < botTimer2)
                event = EXIT;
        }
        else if ( event == EXIT )
        {
            state = DEAD;
            event = ENTER;
        }
        break;
    case DEAD:
        if ( event == ENTER )
        {
            botAvatar->setAnimation(upperAnim = BOTH_DEAD1);
            time( &botTimer1 );
            time( &botTimer2 );
            event = UPDATE;
        }
        else if ( event == UPDATE )
        {
            //respawn in 5 seconds
            time( &botTimer2 );
            if ((botTimer1 + 5) < botTimer2)
                event = EXIT;
        }
        else if ( event == EXIT )
        {
            health = 100;
            state = ATTACK;
            event = ENTER;
        }
        break;
    }
}
```

Add the FSM() method from Listing 5.2 to the AIBot class. This method should be called from the update() method. Because most of the code from previous update methods is now in FSM(), the update() method contains only a call to FSM(). Save, compile, and run the code and watch the bot die and be reborn.

5.3.2 Step Two: Building Complexity into the FSM

Extend the FSM to include the bot states RETREAT and DUCK. Ensure that you add the appropriate animation sequences into the code and update the bot's health. For example, if the bot is retreating, its health could increase, and if it ducks while the player is shooting at it, its health should not be affected.

Because a finite state machine is a graph consisting of nodes and edges, it can be searched. Searching allows an NPC to find its current state in the FSM and determine how it can get from that state to another desired state. The same method is used in programming the navigational functions of an NPC to enhance its movement around an environment from simple, random behavior to more complex goal-orientated behavior. There are many ways to search through a graph of connected nodes, some better than others. Some of these methods are examined in the next section.

5.4 SEARCH METHODS

As you may notice, many concepts in AI can be represented as graphs. So far you have experienced Bayesian networks and finite state machines. Soon you will discover a way of environment navigation that also uses a graph concept. For every graph that exists, methods are needed that allow the programmer to perform searches through the nodes following the connecting edges. Three popular methods of searching a graph are discussed here. To begin we examine a method of NPC navigation called *waypoint traversal*.

5.4.1 Waypoint Pathfinding

Pathfinding is the term used to describe the movement of an object (and in our case, NPCs) in a gaming environment. To be of any real use in a game, the NPCs must be able to move around and explore their environment. In Chapter 3, you learned to navigate an NPC around a simple environment using random direction selection and collision detection of walls.

The movement of an NPC is one of the primary outward behaviors by which a person interacting with the NPC can judge its internal state. As you have already seen, many internal processes are involved in the programming of an NPC, but

when it comes down to it, to judge the behavior of the NPC as being realistic or unrealistic, a human player can use only the outward appearance of the NPC to predict the NPC's internal state. For example, in *The Sims*, meters on the screen indicate the characters' internal state, which is translated into outward behavior, mostly in the characters' movements. If a *Sim* is in a hurry, its movement toward its goal is quickened. In Chapter 2, several methods were examined to move an NPC around inside the Apocalyx environment, including straight line movement between two points and random movement. These methods, however, are less than effective when the NPC must negotiate a complex environment map.

One of the most popular methods for programming navigation, which has been implemented in games such as *Unreal Tournament* and *Quake III*, is waypoint traversal. A waypoint is simply a remembered location on a map. Waypoints are placed in a circuit over the map's surface and are connected by straight-line paths. The paths and waypoints are connected in such a way that an NPC moving along the paths is assured not to collide with any fixed obstacles. An example of a graph of waypoints is illustrated in Figure 5.6. An NPC placed at any waypoint can find its way to another waypoint using the paths and, thus, avoid any collisions.

The waypoint graph can be programmed in a number of ways, including sets, arrays, adjacency tables, and adjacency lists. The best way to program waypoints is by using linked lists because they provide the greatest flexibility—they can be traversed and searched with recursive functions, do not require an initial fixed amount of memory, and can grow and shrink in size as needed. A set of waypoints represented in this way forms a graph. The waypoints are the nodes or vertices of the

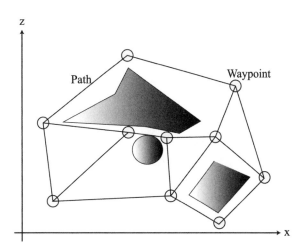

FIGURE 5.6 An example of waypoints positioned around obstacles.

graph, and the paths are the edges. Graphs can be either directed or undirected. In a directed graph the edges can be traversed in only one direction. For an NPC navigating through a graph, a directed path would be one-way only. An undirected graph has edges that can be traversed in any direction. The linked list method we are about to examine allows for directed graphs, meaning an edge that connects nodes A and B can be traveled only from A to B. However, if we want to implement it so that we can travel from B to A, we simply add another edge from B to A. Figure 5.7 illustrates a simple undirected graph and its associated linked list.

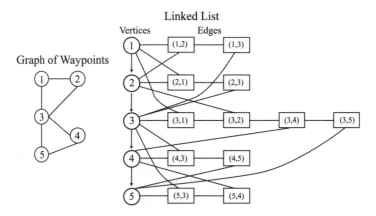

FIGURE 5.7 An undirected graph and linked list.

Because the graph is undirected, the edge from vertex 1 to vertex 2 can be traveled in both directions. In the linked list representation we, therefore, represent this one edge with two edges: one from 1 to 2 and one from 2 to 1. In Figure 5.7, these two edges, represented by rectangles, are shown as (1,2) and (2,1). The declarations for the implementation of a linked list are displayed in Listing 5.3.

LISTING 5.3 The declaration of a linked list

```
typedef struct vertex vertex;
typedef struct edge Edge;

struct vertex
{
    Edge *startEdge;
    vertex *nextVertex;
    float x,y,z;        //coordinates of waypoint
};
```

```
struct edge
{
    vertex *lastVertex;
    Edge *nextEdge;
};

class Graph
{
    public:
        vertex *graphStart;     //first vertex in
        vertex *graph;          //last added vertex in
        Graph();
        ~Graph();
        vertex *AddVertex(float X, float Y, float
        Edge *AddEdge(vertex *startVertex, vertex *lastVertex);
};

Graph::Graph()
{
    graph = (vertex *) 0;
    graphStart = (vertex *) 0;
}

Graph::~Graph()
{
    delete graph;
    delete graphStart;
}

vertex *Graph::AddVertex(float X, float Y, float Z)
{
    if(graph == (vertex *) 0) //this is the first vertex
    {
        graph = (vertex *) malloc(sizeof(vertex));
        graphStart = graph;
    }
    else
    {
        graph->nextvertex = (vertex *) malloc(sizeof(vertex));
        graph = graph->nextVertex;
    }
    graph->x = X;
    graph->y = Y;
    graph->z = Z;
```

```
        graph->edges = (Edge *) 0;
        graph->startEdge = (Edge *) 0;

        return( graph );
}

Edge *Graph::AddEdge(vertex *startVertex, vertex *lastVertex)
{
    if(startVertex->edges == (Edge *) 0)
    //this is the first edge
    {
        startVertex->edges = (Edge *) malloc(sizeof(Edge));
        startVertex->startEdge = startVertex->edges;
    }
    else
    {
        startVertex->edges->nextEdge = (Edge*)malloc(sizeof(Edge));
        startVertex->edges = startVertex->edges->nextEdge;
    }
    startVertex->edges->lastVertex = lastVertex;
    startVertex->edges->nextEdge = (Edge *) 0;

    return startVertex->edges;
}
```

In Listing 5.3, a vertex is declared to include the x-, y-, and z-coordinates of the waypoints. You could also add any other variables you wanted inside the vertex structure if they were pertinent for that vertex. For example, you might like to record the presence of objects, such as medical kits. The AddVertex() method for the Graph class adds a new vertex to the list of existing vertices in the graph. Each vertex is linked to the next by a pointer stored in the nextVertex variable of the vertex structure. This pointer links vertices in a one-dimensional chain and in no way indicates where the edges from one vertex to the other are. The edges are stored in another chain, where one exists for each vertex. An edge is added using the Graph's AddEdge() method. Each edge is added by specifying the start and end vertices.

Implementing a waypoint graph is simply a matter of specifying the location of each waypoint and the edges connecting them. Code that you might use to achieve the graph in Figure 5.7 is shown in Listing 5.4.

LISTING 5.4 The implementation of a waypoint graph for Figure 5.7

```
Graph wayGraph;
vertex *waypoints[5];
```

```
waypoints[0] = wayGraph.AddVertex(0,0,420);
waypoints[1] = wayGraph.AddVertex(210,0,420);
waypoints[2] = wayGraph.AddVertex(0,0,210);
waypoints[3] = wayGraph.AddVertex(210,0,100);
waypoints[4] = wayGraph.AddVertex(0,0,0);

wayGraph.AddEdge(waypoints[0],waypoints[1]);
wayGraph.AddEdge(waypoints[0],waypoints[2]);
wayGraph.AddEdge(waypoints[1],waypoints[0]);
wayGraph.AddEdge(waypoints[1],waypoints[2]);
wayGraph.AddEdge(waypoints[2],waypoints[0]);
wayGraph.AddEdge(waypoints[2],waypoints[1]);
wayGraph.AddEdge(waypoints[2],waypoints[3]);
wayGraph.AddEdge(waypoints[2],waypoints[4]);
wayGraph.AddEdge(waypoints[3],waypoints[2]);
wayGraph.AddEdge(waypoints[3],waypoints[4]);
wayGraph.AddEdge(waypoints[4],waypoints[2]);
wayGraph.AddEdge(waypoints[4],waypoints[3]);
```

When the graph of waypoints has been established, the next thing to determine is how the bot selects and moves between them. If each waypoint is connected to every other waypoint, this process is easy because the problem is reduced to a simple matter of plotting a straight line between the points. The need for edges in this instance becomes superfluous.

In the graph shown in Figure 5.7, an NPC wanting to move from waypoint 2 to waypoint 5 could not simply plot a straight line between the two waypoints because they are not directly connected by an edge. The NPC then has the choice of navigating from waypoint 2 to waypoint 5 with the following sequences: 2, 1, 3, 4, 5 or 2, 3, 5 or 2, 3, 4, 5 or 2, 1, 3, 5 or 2, 1, 2, 3, 4, 5, and so on. In the last sequence shown here, the NPC has moved through waypoint 2 twice. This move is legitimate because the edges allow this. The NPC may even circle through points 2, 1, and 3 several times before moving to 5. So how do you determine the best path from one waypoint to another?

Usually you want an NPC to move from one waypoint to another using the shortest path. The meaning of shortest often refers to the Euclidian distance between points, but not always. In real-time strategy (RTS) games, where maps are divided into grids of differing terrain, the shortest path from one point to another may not be based on the actual distance but on the time. For example, the shortest Euclidean distance from point *A* to point *B* may take the NPC through a boggy swamp. Moving through the swamp may take the NPC twice as long as if it were to go around it. The definition of shortest is, therefore, left up to a matter of *utility*. The term, utility, originates in classical game theory and refers to the preferences of

game players (as defined in Chapter 3). If time is more important to an NPC than distance, the NPC places a higher utility on time, thus avoiding the swamp. The utility values can be represented on a graph as weights on the edges, as shown in Figure 5.8. In this example, to travel from waypoint 2 to 5 directly via 3 cost the bot $6+7=13$ points. Assuming a high number means less desirable, we might attribute these weights with travel time and say this route will take the NPC 13 minutes. Further examination of the graph shows that it will cost only 10 minutes to travel from waypoint 2 to 5 via points 1, 3, and 4.

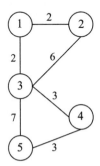

FIGURE 5.8 A graph with edge utilities.

5.4.2 Graph Searches

Many methods are available to find the shortest path from one vertex to another in a graph, including algorithms such as Breadth-First Search, Depth-First Search, Ford's Distance, and Dijkstra's Distance [Gould88].

The Breadth-First Search (BFS) takes the given starting vertex and examines all adjacent vertices. Vertices that are adjacent to a starting vertex are those that are directly connected to the starting vertex by an edge. In turn, from each of the adjacent vertices, the vertices adjacent to these are examined. This process continues until the end vertex is found or the search for adjacent vertices has been exhausted. The algorithm can be written as shown in Listing 5.5.

LISTING 5.5 A Breadth-First Search algorithm

1. Let $i=1$;
2. Label starting vertex as i.
3. Find all unlabeled vertices adjacent to at least one vertex with label i. If there are no adjacent vertices, stop because we have run out of vertices. If the ending vertex is found, stop because we have found a path.

4. Label all vertices found in step 3 with $i+1$.
5. Let $i = i+1$, go to step 3.

This algorithm always finds the shortest path (Euclidean distance) from the start to the end vertices, assuming that each vertex is the same distance apart. For example, in a RTS game in which the environment is represented by a grid of squares of equal size, each square represents a vertex for the purposes of the algorithm. As shown in Figure 5.9, the starting square is labeled with a 1. Radiating out from this square, all adjacent squares are labeled with a 2. All squares adjacent to the 2 squares that are not already labeled with a 1 or a 2 are labeled with a 3. This process continues until the destination square is found. This way of searching can be time consuming because almost all squares in the grid are examined. This algorithm can be modified to take into consideration other costs, such as terrain type and traversal times, in addition to or instead of distance by keeping track of all possible paths to the destination and adding up the costs. The path with the least cost can then be selected.

FIGURE 5.9 The environment map for a RTS with a path found using BFS.

The Depth-First Search (DFS) is simpler than the BFS and, hence, less effective. Instead of radiating out from the starting vertex, this algorithm simply follows one adjacent vertex to the next until it reaches the end of a path. Recursion works well for this algorithm and can be written as shown in Listing 5.6.

LISTING 5.6 A Depth-First Search algorithm

$DFS(a, vertex)$

1. Let $i = a$;
2. Label vertex as i.
3. For each adjacent vertex, **v**, to i, if **v** is labeled skip it, if **v** is the end vertex then stop the search, else if **v** is not labeled run this algorithm with $DFS(a+1, \mathbf{v})$.

An implementation of this algorithm is shown in Figure 5.10. Note that the algorithm does not find the shortest path to the destination, just a path. The success of finding the destination in a reasonable time is left to the luck of which adjacent vertex is selected first. In Figure 5.10, the vertices were selected in a counterclockwise order beginning with the one immediately above the current vertex. If a clockwise order had been chosen, the path would be different. Of course, this algorithm could also be modified to perform an exhaustive search to find all paths to the destination, and by finding the path with a minimum cost the best could be chosen. However, it is an ineffective way of finding the shortest path.

FIGURE 5.10 The environment map for a RTS with path found using DFS.

To complete this examination of graph searching, the efficient A* (pronounced A Star) algorithm is now examined. What makes A* more efficient than BFS or DFS is that instead of blindly picking the next adjacent vertex, the one that looks most promising is chosen. From the starting vertex, the projected cost of all adjacent vertices is calculated and the best vertex is chosen to be the next on the path. From this

next vertex, the same calculations occur again and the next best vertex is chosen. This algorithm ensures that all the best vertices are examined first. If one path of vertices does not work out, the algorithm can return to the next-best in line and continue the search from there.

To determine the cost, f, of a particular vertex, the function shown in Equation 5.1 is used.

$$f = g + h \qquad (5.1)$$

In Equation 5.1, g is the cost of getting to the vertex and h is an estimate of how much more it will cost to get from this vertex to the destination. The value of h is determined by a heuristic function. The term *heuristic* seems to be one of those funny words in AI that is difficult to define. It was defined by Alan Newell in 1963, as performing the opposite function to that of an algorithm. A more current definition of its meaning is given by Russell and Norvig [Russell95] in which they define a heuristic as any technique that can be used to improve the average performance of solving a problem that may not necessarily improve the worst performance. In the case of pathfinding, if h is perfect—that is it can accurately calculate the cost from the current vertex to the destination—then the best path will be found. However, in reality, h is very rarely perfect and can only offer an approximation.

Figure 5.11 shows an example of a pathfinding exercise from one vertex to another. For vertex a, the value of g is 2 (the cost of getting from the start to a) plus the value of h, which in this case is estimated as 6, making the value of f equal to 8. Note the calculation of h is indeed an estimate in this case. There are no direct paths from a to the end vertex. Therefore, the heuristic makes an estimate. An exact value of the cost from a to the end vertex is not possible without further path

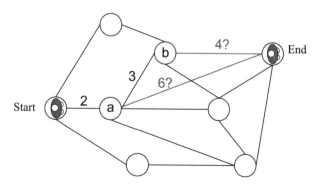

FIGURE 5.11 Pathfinding using the A* algorithm.

searching, which we are trying to avoid. If the next vertex chosen on the search is *b*, the value of *g* will be 5, which is the cost of getting from the start to *b* via *a*, plus a value of *h* being estimated at 4, making *f* equal to 9.

The algorithm works by calculating the value of *f* for each adjacent vertex. Each of these vertices is placed in a list called the open list. Next the vertex with the least value of *f* is taken off the open list (popped) and the adjacent vertices to this have their *f* values calculated. The vertex is then added to the open list, provided the vertex is not already on the open list with a smaller *f* value. The same vertex with different *f* values is entirely possible because there may be more than one path to get to that vertex and, therefore, the costs are different. The previously popped vertex is placed in a closed list. If at any point the destination vertex is examined, the search is stopped. As each vertex is examined it is linked backward to its parent (previously adjacent) vertex. Thus, by the end of the search the destination vertex can be taken and traced backward to the starting vertex to reveal the path. Listing 5.7 displays a method that can be added to the Graph class of Listing 5.6 to achieve an A* search of a graph of waypoints. The code implements the C++ Standard Template Library (STL) to make the open and closed lists easier to handle. Each vertex is placed into a node structure before being placed on a list. The node structure also keeps points to the node's parent and child nodes that form the best path. In this example, the heuristic to determine the shortest (least-cost) path is based on Euclidean distance, demonstrated by the distance method. It can just as easily be modified to estimate other values of cost, such as time.

LISTING 5.7 An A* method for the graph class

```
struct node
{
    node *parent;
    node *child;
    vertex *ptr;
    float f, g, h;
    node(): ptr(0), f(0), g(0), h(0) {}
    ~node() {}
};

typedef vector<node> List;

void Graph::AStar(vertex *start, vertex *end)
{
    node *currentNode = (node *) malloc(sizeof(node));

    List open;
    {
```

```
        currentNode->parent = (node *) 0;
        currentNode->ptr = start;
        //put start node on open list
        currentNode->g = 0;
        currentNode->h = distance(start, end);
        currentNode->f = 0;
        open.push_back(*currentNode);
}

List closed;
Edge *edge;

while (!open.empty())
{
    //get the node off the open list with
    //the lowest f value
    int i = lowestF(open);
    node * thisnode = open.begin() + i;
    currentNode = (node *) malloc(sizeof(node));
    currentNode->parent = thisnode->parent;
    currentNode->ptr = thisnode->ptr;
    //put start node on open list
    currentNode->g = thisnode->g;
    currentNode->h = thisnode->h;
    currentNode->f = thisnode->f;

    open.erase(open.begin() + i);

    if(currentNode->ptr == end)
        break;

    edge = currentNode->ptr->startEdge;

    //for all edges of the vertex
    while(edge)
    {
        node successor;
        successor.parent = currentNode;
        successor.ptr = edge->lastVertex;

        successor.g = currentNode->g +
            distance(successor.ptr, currentNode->ptr);
        successor.h = distance(successor.ptr, end);
        successor.f = (successor.g + successor.h);
```

```
            bool skip = false;
            node *found;
            int f;
            f = findNode(open, successor);

            if(f > —1)
            {
                found = open.begin() + f;
                if(found—>f < successor.f)
                {
                    //skip this successor
                    skip = true;
                }
            }

            f = findNode(closed, successor);
            if (f > —1)
            {
                found = closed.begin() + f;
                if(found—>f < successor.f)
                {
                    //skip this successor
                    skip = true;
                }
            }

            if(!skip)
            {
                open.push_back(successor);
            }

            edge = edge—>nextEdge;
        }
        closed.push_back(*currentNode);
    }

    //at this point the end will be found
    //or search exhausted
    //search will be in reverse order starting with the
    //last currentNode and linked by the parent pointers

    node *lptr = currentNode—>parent;
    currentNode—>child = (node *) 0;
    currentNode—>ptr—>path = (vertex *) 0;
```

```
    while(lptr)
    {
        lptr->child = currentNode;
        lptr->ptr->path = currentNode->ptr;
        lptr = lptr->parent;
        currentNode = currentNode->parent;
    }
}

//return the position number of the given node
//in the given list
int Graph::findNode(List l, node N)
{
    int count = 0;
    for( List::iterator i = l.begin(); i != l.end(); ++i )
    {
        if((*i).ptr == N.ptr)
        {
            return count;
        }
        count++;
    }
    return -1;
}

//return the distance between vertices
//calculated as the addition of the squares of
//the delta coordinates
//no need to square root the return
//value as it is being used as
//a comparison value
float Graph::distance(vertex *a, vertex *b)
{
    float dx = a->x - b->x;
    float dy = a->y - b->y;
    float dz = a->z - b->z;
    float dist = dx*dx + dy*dy + dz*dz;
    return( dist );
}

//return the node with the lowest f value
//in the given list
int Graph::lowestF(List l)
{
    float lowestf = 0;
```

```
        int count = 0;
        int iteratorCount = 0;
        for( List::iterator i = l.begin(); i != l.end(); ++i )
        {
            if( i == l.begin())
            {
                lowestf = (*i).f;
                iteratorCount = count;
            }
            else if( (*i).f < lowestf )
            {
                lowestf = (*i).f;
                iteratorCount = count;
            }
            count++;
        }
        return iteratorCount;
    }
```

The following Day of Reckoning takes the concept of waypoints and the A* algorithm and applies them to the bot's navigational methods implemented in previous exercises.

5.5 DAY OF RECKONING: PATHFINDING WITH WAYPOINTS

For this practical exercise we lay down a number of waypoints on a map and have the bot navigate between randomly selected points using the A* algorithm.

ON THE CD The initial project files for this exercise are located in the Apocalyx/dev/src/ Chapter Five-2 folder. Included with the source are the files *graphs.h* and *graphs.cpp*, which include the code translated from Listings 5.6 and 5.7.

5.5.1 Step One: Defining Waypoints and Adding the Edges

Given the new Graph class, setting up waypoints and defining the edges is a breeze. Once these are set up, the bot can start using the graph to find its way from one point to another. The first thing to do is initialize the graph with the following code placed into the AIBot's initialize() method:

```
path = 0;  //path pointer
//add random waypoints
for(int i = 0; i < NUMWAYPOINTS; i++)
```

```
        waypoints[i] = wayGraph.AddVertex(getrandom(-800,800),
            startBot.y, getrandom(-800,800));

    //add edges from every node to every other node
    for(int i = 0; i < NUMWAYPOINTS; i++)
    {
        for(int j = 0; j < NUMWAYPOINTS; j++)
        {
            if (i != j)
                wayGraph.AddEdge(waypoints[i],waypoints[j]);
        }
    }
    //a BSPVector holding the current goal location
    goalLocation.set(waypoints[0]->x, waypoints[0]->y, waypoints[0]->z);
```

The preceding code initializes the path, adds 10 random waypoints (that is, NUMWAYPOINTS = 10), connects each waypoint to every other waypoint, and then sets the initial goal location to be the first waypoint. Add this code to your bot's class.

5.5.2 Step Two: Randomly Traversing the Waypoints

In most situations you won't want your bot to randomly select a goal location. However, this section shows you how it is done. It could be used as a random wander method to allow the bot to move around the environment in a nondeterministic way. To achieve this random wander we implement a new method, as follows:

```
int lastGoal = 0;
int newgoal = 4;

void AIBot::waypointWander()
{
    BSPVector botPos( botAvatar->getPositionX(),
        botAvatar->getPositionY(),
        botAvatar->getPositionZ() );
    if(isNear(botPos, goalLocation, 10))
    {
        if(!path)   //if no current path - find one
        {
            newgoal = getrandom(0,NUMWAYPOINTS-1);
            wayGraph.AStar(waypoints[lastGoal], waypoints[newgoal]);
            path = waypoints[lastGoal]->path;
            lastGoal = newgoal;
        }
        else
```

```
                    path = path->path;

                if(path)
                {
                    goalLocation.set(path->x, path->y, path->z);
                }
            }
            BSPVector oldVelocity = velocity;

            velocity.set(goalLocation.x - botPos.x, 0,
                goalLocation.z - botPos.z);
            velocity = velocity.normalize();
            botAvatar->rotateStanding(turnXZ(velocity, oldVelocity));

            BSPVector botVel = velocity;
            botVel.x *= speed;
            botVel.z *= speed;
            bsp->slideCollision(botPos,botVel,extent);
            botAvatar->setPosition(botPos.x,botPos.y,botPos.z);
        }
```

The most important parts of this code are the parts shown in bold. Essentially, this code selects a new random waypoint to be the next goal. The A* algorithm is then run to find the shortest path between the bot's current location and the new goal. This process returns a path for the bot to follow. The remainder of the code is dedicated to moving the bot between the waypoints following the given path. This method should be called from the update() method.

Add this method to your bot. Save, compile, and run the program. You should be able to see the bot wandering randomly around the environment between the waypoints.

5.5.3 Step Three: Pathfinding with a Mission

Now that you have the bot randomly traversing the map, you might like to have it find a path between specified waypoints. For example, if we lay down a new graph of waypoints that create a circular running track around the interior of the map, we might like the bot to walk around these. Imagine that it is guarding some valuable treasure in the center of the map, keeping watch by continually marching around it. The first thing to do is determine where the waypoints will be located. To create a track somewhere in the center of the map, we can replace the randomly initialized waypoints and edges in the initialize() method with the following code:

```
    path = 0;
```

```
waypoints[0] = wayGraph.AddVertex(-200, startBot.y, -200);
waypoints[1] = wayGraph.AddVertex(-200, startBot.y, 200);
waypoints[2] = wayGraph.AddVertex(200, startBot.y, 200);
waypoints[3] = wayGraph.AddVertex(200, startBot.y, -200);

wayGraph.AddEdge(waypoints[0],waypoints[1]);
wayGraph.AddEdge(waypoints[1],waypoints[2]);
wayGraph.AddEdge(waypoints[2],waypoints[3]);
wayGraph.AddEdge(waypoints[3],waypoints[0]);

botAvatar->setPosition(waypoints[0]->x, waypoints[0]->y,
    waypoints[0]->z);
goalLocation.set(waypoints[0]->x, waypoints[0]->y,
    waypoints[0]->z);
```

Only four waypoints are in use, so be sure to set NUMWAYPOINTS in *AIBot.h* to 4. Save, compile, and run the code. Without modifying the waypointWander() method, the bot appears to be marching in circles. This occurs because each waypoint is connected in a single sequence going in one direction. No matter which waypoint is randomly selected, the bot has no choice but to travel in the one direction to get to it. However, if we only want the bot to move from the start of the circuit to the end of the circuit, then using the existing waypointWander() method is a bit of an over-kill. It may by chance pick the start and end of the circuit, but it is more likely that it will select other waypoints. Each time a pair of waypoints is selected, the A* algorithm is run. For efficiency's sake we should reduce as much as possible the number of times this algorithm is run. A method, such as the following, can be included:

```
void AIBot::waypointTravel(int start, int end)
{
    BSPVector botPos( botAvatar->getPositionX(),
        botAvatar->getPositionY(),
        botAvatar->getPositionZ() );
    if(isNear(botPos, goalLocation, 10))
    {
        if(!path)   //if no current path - find one
        {
            wayGraph.AStar(waypoints[start],waypoints[end]);
            path = waypoints[start]->path;
        }
        else
            path = path->path;

        if(path)
```

```
            {
                goalLocation.set(path->x, path->y, path->z);
            }
        }
        BSPVector oldVelocity = velocity;
        velocity.set(goalLocation.x - botPos.x, 0,
            goalLocation.z - botPos.z);
        velocity = velocity.normalize();
        botAvatar->rotateStanding(turnXZ(velocity, oldVelocity));
        BSPVector botVel = velocity;
        botVel.x *= speed;
        botVel.z *= speed;
        bsp->slideCollision(botPos,botVel,extent);
        botAvatar->setPosition(botPos.x,botPos.y,botPos.z);
    }
```

The preceding `waypointTravel()` method is mostly the same as the
`waypointWander()` method with one major exception. `waypoint Travel()` can be
used by specifying the start and end waypoints between which you want the bot to
travel. Therefore, A* algorithm is run the first time the method is called and the
path determined. It is not run again until the bot is at its destination and a new start
and end are given. This method, which can be used to move a bot from one loca-
tion to another using the shortest possible path, is very useful if you have a large
map and many waypoints.

Add the `waypointTravel()` method to your bot class and be sure to call it from
the `update()` method as follows:

```
void AIBot::update()
{
    waypointTravel(0,3);
}
```

Save, compile, and run the program and watch the bot march around the circuit.

*For a more complex set of waypoints in an environment with many obstacles, load
the map into the program from this session and determine the coordinates of the
waypoints using the player avatar. Pressing F1 reveals the avatar's current loca-
tion. If you take note of these coordinates, you can build up a useful set of way-
points for a bot in a complex map.*

1. Often NPCs following waypoint paths can get off track. For example, the
 NPC may decide to attack another player, which causes it to move away
 from a waypoint, or the NPC may be bumped by another player, causing it

to diverge from its path. When this situation occurs, the NPC must find its way back to the closest waypoint. The easiest way of doing this is vectoring towards the waypoint that is nearest to the NPC's current location barring any obstacles. Write and implement a method called backonTrack() that determines the NPC's current location, finds the nearest waypoint, and moves the NPC to that waypoint. Test your method using the Apocalyx engine.

2. Create a running race with a number of bots in Apocalyx and have them running around the same circuit. Set the bots' speeds randomly so that some bots travel faster than others. Implement a bump() method that determines if one bot is close to another bot (use the extent property and the bots' locations). As it stands, Apocalyx does not perform collision detection between bots. Therefore, use your bump() method to cause bots to deviate from the track to avoid running into each other. Use the backonTrack() method from Exercise 1 to keep the bumped bots running around the circuit.

5.6 DECISION TREES

The previously examined AI methods used in games programming (finite state machines and waypoint traversal with searching algorithms) are useful in dictating the behavior of an NPC as defined by the programmer. And although extended techniques such as fuzzy state machines provide an element of unpredictability to the NPC's performance, the techniques lack the ability to learn and adapt to their environment. From this point onward, we examine some learning and adaptation AI techniques used to enhance the humanlike abilities of an NPC, beginning with decision trees.

Decision trees are a hierarchical graph that structure complex Boolean functions and use them to reason about some situation. A decision tree is constructed from a set of properties that describe the situation being reasoned about. Each node in the tree represents a single Boolean decision along a path of decision that leads to the terminal or *leaf* nodes of the tree. The leaf nodes represent the overall decision made about a situation. Decision trees are reminiscent of the game trees discussed in Chapter 3.

5.6.1 Constructing a Decision Tree

A decision tree is constructed from a training set of previously made decisions about a situation given the criteria on which the decision was made. Decision trees are used in *Black & White* to determine the behavior of the creature. For example, a

decision tree based on how tasty the creature finds an object is built to determine what it will eat. How tasty it finds an object is gathered from past experience where the creature was made to eat an object by the player or the creature ate the object without any previous knowledge about it.

To illustrate the creation of a decision tree for an NPC, we examine some sample data on decisions made about eating certain items in the environment. The decision we want made is a yes or no about eating, given the characteristics, or *attributes*, about the eating situation. Table 5.2 displays some past eating examples that will be used.

TABLE 5.2 Examples for Making an Eating Decision[a]

Example	Attributes			Eat?
	Hungry	Food	Taste	
1	yes	rock	0	no
2	yes	grass	0	yes
3	yes	tree	2	yes
4	yes	cow	2	yes
5	no	cow	2	yes
6	no	grass	2	yes
7	no	rock	1	no
8	no	tree	0	no
9	yes	tree	0	yes
10	yes	grass	1	yes

[a] The values for the attribute Taste are 0 for awful, 1 for okay, and 2 for tasty.

The examples in Table 5.2 are used to build the decision tree for the NPC; they are not necessarily from the NPC's experiences. The values in the table may be the opinion of the programmer creating the NPC or from a set of real-life data. For instance, in our opinion, examples 4 and 5 imply that a tasty cow should be eaten regardless of whether or not the NPC is hungry, whereas an awful-tasting tree should be eaten only when hungry. Given the attributes of a situation (hungry, food, and taste) a decision tree can be built that reflects whether or not the food in question should be eaten or not. As you can see from the previously listed data, it is not easy to construct a Boolean expression to make a decision about eating. For

example, sometimes it does matter if the NPC is hungry and other times it does not; sometimes it matters if the food is tasty and sometimes it does not.

To construct a decision tree from some given data each attribute must be examined to determine which one is the most influential. To do this we examine which attributes split the final decision most evenly. Table 5.3 is a count of the influences of the attributes over eat.

TABLE 5.3 Attribute Influence over the Final Eat Decision

Attribute	Eat = yes	Eat = no	Total Influences
Hungry			
Yes	5	1	
No	2	2	
Total Exclusive 0s	*0*	*0*	*0*
Food			
Rock	0	2	
Grass	3	0	
Tree	2	1	
Cow	2	0	
Total Exclusive 0s	*1*	*2*	*3*
Taste			
0	2	2	
1	1	1	
2	4	0	
Total Exclusive 0s	*0*	*1*	*1*

To decide which attribute most splits the eat decision in Table 5.3, we must look for examples where an attribute's value definitively determines if Eat is yes or no. For example, in the case of the Food being a Rock, it can be seen that in every instance the Eat decision is no. This means that we could confidently write a Boolean expression such as

```
if food = rock
then eat = no
```

without having to consider any of the other attributes. The attribute with the best split is determined by the total number of exclusive 0s counted in a column. By exclusive, we mean that the value of the attribute must be 0 in one column and greater than 0 in another. If both columns were 0, then the value would have no effect at all over the decision. In this case the attribute with the best decision-making split is Food. This attribute becomes the root node of the decision tree. In the cases of Rock, Grass, and Cow, the final value for Eat is already known and, thus, these values can be used to create instant leaf nodes off the root node, as shown in Figure 5.12. However, in the case of Tree, the decision is unclear because sometimes Eat is yes and sometimes it is no. When this occurs, the decision tree under such a node must be expanded with the next-most-splitting attribute.

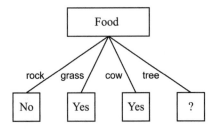

FIGURE 5.12 Partial decision tree for data from Table 5.2.

To find the next-most-splitting attribute to be used in conjunction with Tree, the outcome decisions involving the Tree value are combined with the remaining attributes to give the values shown in Table 5.4.

From the values shown in Table 5.4, the second-best attribute is Hungry. Hungry can now be added to the decision tree under the Tree node to give the graph shown in Figure 5.13. Notice that the yes and no choices for Hungry provide definitive answers for Eat. Therefore, the nodes do not need to be further classified with any other attributes. The decision tree in Figure 5.13 is the complete decision tree for the data from Table 5.2. You could say in this case that the taste of the food is irrelevant.

TABLE 5.4 Attribute Influence over the Final Eat Decision with Food = Tree

Attribute	Eat = yes	Eat = no	Total Influences
Food = Tree and Hungry			
Yes	2	0	
No	0	1	
Total Exclusive 0s	*1*	*1*	2
Food = Tree and Taste			
0	1	1	
1	0	0	
2	1	0	
Total Exclusive 0s	*0*	*1*	*1*

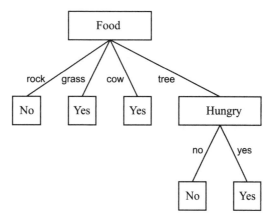

FIGURE 5.13 Complete decision tree for data from Table 5.2.

5.6.2 A Decision Tree Creation Algorithm

A famous algorithm used for creating decision trees from examples (which is used in *Black & White*) is ID3 [Quinlan79]. ID3 uses the concept of *entropy* to decide which attributes to use to split the decision. Entropy is a measure of the uncertainty that exists in the sample examples being used to build the decision tree. Entropy is

calculated as the negation of the sum of the products of the logarithms of the probability, p, of the outcomes, i, and their probability, as shown in Equation 5.2.

$$E = -\sum_{i=1}^{n} p_i \log p_i \qquad (5.2)$$

For example, the data set from the Eat decision (shown in Table 5.2) has two possible outcomes, yes or no. The probability of yes, P_y, is 7/10, and the probability of no, P_n, is 3/10. This would make the entropy of the set, E:

$$\begin{aligned}
E &= -\left(P_y \log P_y + P_n \log P_n\right) \\
&= -\left(\tfrac{7}{10} \log \tfrac{7}{10} + \tfrac{3}{10} \log \tfrac{3}{10}\right) \\
&= -(0.7 \times -0.1549 + 0.3 \times -0.5229) \\
&= 0.2653
\end{aligned}$$

Next, the examples are partitioned into the values, v, for each attribute, a, and the sum of the weighted averages of the entropies for each is found using Equation 5.3.

$$E_a = \sum_{i=1}^{n} \frac{|v_i|}{|v_{count}|} E_v \qquad (5.3)$$

where E_v is the entropy of the value with respect to the outcomes of the set. For example, there are three values of Tree in which two relate to an outcome of yes and one for no. Using this data, the food attribute would equate to:

$$\begin{aligned}
E_{food} &= \tfrac{2}{10} E_{rock} + \tfrac{3}{10} E_{grass} + \tfrac{3}{10} E_{tree} + \tfrac{2}{10} E_{cow} \\
&= \tfrac{2}{10}\left(-\left(\tfrac{2}{2}\log\tfrac{2}{2} + \tfrac{0}{2}\log\tfrac{0}{2}\right)\right) + \\
&\quad \tfrac{3}{10}\left(-\left(\tfrac{3}{3}\log\tfrac{3}{3} + \tfrac{0}{3}\log\tfrac{0}{3}\right)\right) + \\
&\quad \tfrac{3}{10}\left(-\left(\tfrac{2}{3}\log\tfrac{2}{3} + \tfrac{1}{3}\log\tfrac{1}{3}\right)\right) + \\
&\quad \tfrac{2}{10}\left(-\left(\tfrac{2}{2}\log\tfrac{2}{2} + \tfrac{0}{2}\log\tfrac{0}{2}\right)\right) \\
&= 0.0828
\end{aligned}$$

Finally, the *information gain* is calculated for each attribute. This value is the entropy of the example set minus the entropy for the attribute, as shown in Equation 5.4.

$$Gain_a = E - E_a \qquad (5.4)$$

For the Food attribute, the gain equates to $0.2653 - 0.0828 = 0.1825$. This value of course doesn't mean much in isolation; however, the ID3 algorithm calculates the information gain for each of the attributes, then selects the one with the highest gain to use to split the decision.

ON THE CD

Source code written in C for creating a decision tree from a set of examples can be found in the Chapter Five/examples/ID3 folder. Compilation and user instructions are included in the top of the *id3.c* file. Data files are included that contain the example data used for the Eat example.

5.6.3 Advantages and Disadvantages of Decision Trees

Decision trees provide a simple and compact representation of complex Boolean functions. Once constructed, a decision tree can also be decomposed into a set of rules. The beauty of the decision tree is that the Boolean functions are learned from a set of complex data that could take some time by a programmer to deconstruct manually into rules. In addition, a decision tree can be updated as the program runs to incorporate newly learned information that may enhance the NPC's behavior. Unfortunately, each decision tree is unique and has little common structure with other decision trees and is, therefore, not able to be reused in differing decision-making techniques. Because of this, decision trees require more coding, take up more memory, and come at a higher CPU cost than a FSM. In addition, decision trees require large amounts of sample data from which to learn, and if the data contains errors, so will the decision tree. Although FSMs may seem a more efficient means of moving an NPC between states, the NPC is still incapable of learning. Decision-tree-type techniques could hold the key to programming real-time learning and behavior modification in NPCs, such as those programmed into the *Black & White* creatures.

EXERCISE

1. Calculate the information gain for the attributes of Hungry and Taste.
2. Once a decision tree has been constructed, other attribute values can be parsed through the tree to come up with a decision, such as if an NPC were faced with a situation in which it was required to eat a tasty rock when it was hungry. According to the decision tree, the NPC would choose not to eat it because the decision for every rock is always no. Add the following examples to the training set and run it through ID3 to determine the new tree:

 yes, rock, 2, yes
 yes, cow, 0, no

 Explain the new structure of the decision tree.

3. Create an example data set for building a decision tree to determine if an NPC is happy in a particular situation. Use the situation attributes of hungry, tired, bored, clean, and wealthy. Assume the values for each attribute to be simply yes and no. Run the data set through the ID3 algorithm to create a decision tree. How could you use this decision tree in a game? Use *The Sims* as an example.

5.7 EVOLUTIONARY COMPUTING

Evolutionary computing is another AI technique used in the programming of learning. It examines intelligence through environmental adaptation and survival and attempts to simulate the process of natural evolution by implementing concepts such as selection, reproduction, and mutation. In short, it endeavours to computationally replicate the genetic process involved in biological evolution.

Genetics, or the study of heredity, concentrates on the transmission of traits from parents to offspring. It not only examines how physical characteristics such as hair and eye color are passed to the next generation but also observes the transmission of behavioral traits such as temperament and intelligence [Lefton94]. All cells in all living beings, with the exception of some viruses, store these traits in *chromosomes*. Chromosomes are strands of deoxyribonucleic acid (DNA) molecules present in the nuclei of the cells. A chromosome is divided into a number of subparts called *genes*, which are encoded with specific traits, for example, hair color, height, and intellect. Each specific gene (such as that for blood type) is located in the same location on associated chromosomes in other beings of the same species. Small variations in a gene are called *alleles*. An allele favors a gene to create a slight variation of a specific characteristic, for example, in one person a gene that specifies the blood group A may present as an allele for A+ and in another person an allele for A−. Chromosomes come in pairs, and each cell in the human body contains 23 of these pairs (46 chromosomes in total), with the exception of sperm and ova, which contain only half (23). The first 22 pairs of human chromosomes are the same for both males and females; it is the 23rd pair that determines a person's sex. When a sperm and ova meet at conception, each containing half of the parent's chromosomes, a new organism is created. The meeting chromosomes merge to create new pairs. There are 8,388,608 possible recombinations of the 23 pairs of chromosomes with 70,368,744,000,000 gene combinations [Lefton94].

Evolutionary computing simulates the combining of chromosomes through reproduction to produce offspring. Each gene in a digital chromosome represents a binary value or basic functional process. A population is created with anywhere between one hundred and many thousands of individual organisms in which each

individual is represented usually by a single chromosome. The number of genes in the organism depends on its application. The population is put through its paces in a testing environment in which the organism must perform. At the end of the test each organism is evaluated on how well it performed. The level of performance is measured by a fitness test. This test might be based on how fast the organism completed a certain task, how many weapons it has accumulated, or how many human players it has defeated in a game. The test can be whatever the programmer deems is a best judgement of a fit organism. When the test is complete, the failures get killed off and the best organisms remain—just like Darwin's survival of the fittest.

These organism are then bred together to create new organisms, which make up a new second generation population. When breeding is complete, the first generation organisms are discarded and the new generation is put through its paces before being tested and bred. The process continues until an optimal population has been bred.

Several different methods, all of which work according to the previously described process, can be used to achieve evolutionary computing—evolution strategies, genetic programming, and genetic algorithms. Evolution strategies simulate the natural evolution process to solve technical optimization problems. They are designed to replace an engineer's intuition in making random changes in experimental parameters to find the most optimal design. For example, imagine the design for a new aircraft being put through its paces in a wind tunnel. To modify the aerodynamic properties of the aircraft, designers make continuous and often laboriously small changes to the design to find the optimal shape. The designer's task of making changes to the shape of the aircraft can be replaced with an evolution strategy. The idea behind genetic programming is to have computer programs breed better computer programs. In short, a selection of programs is used to solve a problem. The programs that compete the best are bred together to create a new and improved program. The idea behind all evolutionary programming methods is the process of natural selection and evolution. The best way to introduce the processes of evolutionary computing is to examine genetic algorithms. Due to the space restrictions of this text, evolution strategies and genetic programming are not discussed here, but if you are interested in these topics, you are encouraged to read [Negnevitsky02].

5.7.1 Genetic Algorithms

A chromosome in a genetic algorithm is represented by a string of numbers. Each chromosome is divided into a number of genes made up of one or more of the numbers. The numbers are usually binary; however, they need not be restricted to such. An outline of the genetic algorithm process follows, implementing a simple example for illustration purposes.

Step One: Create a Population and Determine Fitness

A genetic algorithm begins by specifying the length of a chromosome and the size of the population. A 4-bit chromosome looks like that shown in Figure 5.14.

FIGURE 5.14 A 4-bit binary string for a digital chromosome.

Next, each individual in the population has its genes (the 1s and 0s) randomly assigned, as shown in Table 5.2. As previously stated, a real population would have many more organisms present; however, in this case we will keep it simple. In this example, let's assume our fitness function is a nonlinear mathematical equation defined by:

$$f(x) = 2x + x^3$$

Given this function, the fitness of each organism can be determined by using the decimal value represented by the binary value stored in the chromosome string. The decimal value is substituted into the fitness function in the place of x. The result is a fitness value, as shown in Table 5.5. Next, the total fitness of the population is found by summing the fitness values of each organism and using that sum to find an individual's fitness ratio. The fitness ratio is the individual's fitness divided by the population's total fitness. The fitness ratios for the organisms in the current example are shown in the last column of Table 5.5.

TABLE 5.5 The Random Assignment of Gene Values in a Small Population

Organism ID	Chromosome	Decimal Value	Fitness	Fitness Ratio (%)
1	0011	2	12	0.6
2	1010	10	1020	49.7
3	1000	8	528	25.7
4	0111	7	357	17.4
5	0101	5	135	6.7

Step Two: The Mating of Chromosomes

A number of methods are available for pairing off chromosomes for mating, including stochastic sampling, (also known as roulette wheel [Davis91]), remainder stochastic sampling, and ranking [Laramee02]. Stochastic sampling takes a roulette wheel approach to selecting mating chromosomes (hence, its other name). Each chromosome is allocated a portion of a circular wheel the size of which represents its fitness ratio (as shown in Figure 5.15).

A chromosome is selected for mating by conceptually spinning the wheel and picking the chromosome on which the wheel stops. This process can be programmed using the organism's fitness ratio as a probability of selection value. Organisms are mated until the new generation population is the same size as the old population. There is no reason why one organism cannot be selected a number of times. Remainder stochastic sampling determines if an organism is selected for mating based on the ratio of its fitness and the average population fitness. In the population from Table 5.5, the average fitness is 204, Organism 1's ratio is 0.06, and Organism 3's is 2.59. An organism is mated only if its ratio is greater than 1. If it is greater than 1, the organism is mated a number of times equal to the whole number part of the ratio. In this case, that would allow Organism 3 to mate 2 times. Finally, ranking mating, which is probably the simplest method, orders the organisms in descending order of their fitness. Organisms near the top of the order are chosen for breeding more times than ones lower down. A cut-off point may even be applied where poorly performing organisms are culled from the population.

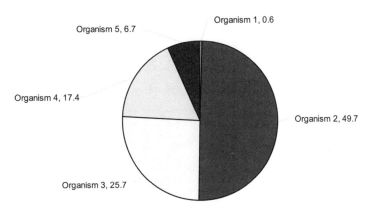

FIGURE 5.15 Stochastic sampling roulette wheel.

No hard and fast rules exist for selecting a mating strategy. In [Laramee02] a new population is produced by cloning the top fittest 20 percent (this means copying the old organisms into the new population), 70 percent are mated according to their ranking, and 10 percent are newly created organisms with random gene values.

So how is the chromosome of an offspring determined? When organisms are mated, the chromosomes of the parents influence the chromosome of the child. This way, the fittest parents should pass on the cause of their fitness to the child, though this is not always the case. Sometimes the best parents can produce useless offspring and vice versa (Yes, we are still talking about genetic programming!), though, any badly created offspring are phased out in future fitness tests. When mated, the chromosomes of the parents undergo a process called crossover. This process takes identical-sized segments from each parent and swaps them to create two new chromosomes, which are allocated to two new organisms. The crossover segment is chosen through the generation of two random numbers that represent the start and end gene locations of the crossover. For example, if Organism 2 and Organism 4 were chosen to mate and the crossover segment was from location 2 to 3, then the offspring's chromosomes would be 1110 and 0011, as shown in Figure 5.16.

Often a mating results in clones of the parents. For example, if Organisms 2 and 3 were crossed over for the segment between 2 and 3 (the middle two genes), the result would be two children, one each a clone of a parent. Crossover can also be achieved through coin tossing. In this case, each of the genes in the parents' chromosomes is subject to a coin toss. If heads comes up, the first parent's gene is added to the offspring's chromosome; if tails comes up, the gene is from the other.

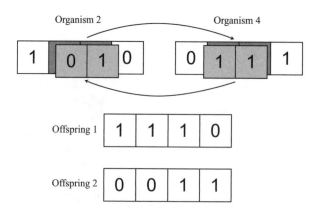

FIGURE 5.16 The crossover mating of two organisms and the resulting chromosomes.

In nature a rare event occurs in breeding called mutation. Here, an apparent random gene change occurs. This change may lead to improved fitness or, unfortunately, a dramatically handicapped offspring. In evolutionary computing, mutation can reintroduce possibly advantageous gene sequences that may have been lost through population culling. Mutation can be achieved by introducing new randomly generated chromosomes into the population or by taking new offspring and randomly flipping a gene or two. For example, an organism with a chromosome 0101 could be mutated by flipping the third gene, which would result in 0111.

Step Three: Introducing the New Population

The final step in a genetic algorithm is to replace the old population with the new one. It is important that the new population is the same size as the old one so they can be processed in the same way. When the new population is in place, it is treated as the old one was and put through its paces, then tested for fitness.

The process is a cycle that continues creating and testing new populations until the fitness values converge at an optimal value. You can tell when this has occurred because the fitness values will change little from population to population. Just how optimal the fitness value is is determined by the fitness evaluation function. In the case of the mathematical formulae used for the example given here, it is not possible to improve on the fitness function because, in a sense, it is perfect. However, when working with a more complex scenario with NPCs in a dynamic environment, the evaluation function may not be as clear-cut, and some experimentation may be needed to find the best balance.

5.7.2 Advantages and Disadvantages of Evolutionary Computing

Evolutionary computing methods, including genetic algorithms, are robust search methods useful in making sense of complex environments and finding near optimal solutions to nonlinear problems. In a complex environment where an NPC has many options available to it, coupled with nondeterministic interactions with players, evolutionary algorithms can be used to evolve a better-performing NPC. Unfortunately, optimizing performance requires many evolutionary cycles, which makes the learning process time consuming and unsuitable for many game environments. Coding and development of fitness functions is also resource intensive. However, genetic algorithms are an ideal solution where these limitations are not a problem and the inherited behavior of parent NPCs are used as the primary focus of game play involving breeding NPCs, such as in *Creatures* and *Nooks and Crannies*. They can also be used to enhance the performance of a respawned NPC, which is able to learn from its mistakes in game play and to come back better and stronger than before each time it is killed.

5.8 DAY OF RECKONING: INTRODUCING A GENETIC ALGORITHM FOR NPC BEHAVIOR

In this practical exercise you create an evolving population of NPCs in Apocalyx. The NPCs implement the AIBot class and include a new property called chromosome, which is an array of four floating values. Notice that we will use floating point values for the genes instead of the previously examined binary values. The floating point values in chromosome relate to the bot's motivation to complete a certain goal. Each bot has four goals: ATTACK, WANDER, BEFRIEND, and REST. The objective is to use a genetic algorithm to evolve bots that can stay alive for the longest without being too passive (that is, resting all the time).

ON THE CD

The project file for this practical is in the Apocalyx/prj/Chapter Five-3 folder.

5.8.1 Step One: Preparing the Environment

To prepare the *vh.cpp* code for running a genetic algorithm, first, the one or two bots used in previous implementations must be changed into an array of bots. Add the following private properties to the MainScene class:

```
AIBot bots[MAXBOTS];
int simRuns;
```

You must add two constants to the top of the file that can easily be changed to modify the number of bots and the length of each population run, as follows:

```
#define MAXBOTS 150
#define MAXSIMS 2000
```

TIP

If you don't think your computer's processor can handle 150 bots, consider reducing this to, say, 10 just to get the program working.

The creation of the bots can then be achieved in a for loop at the bottom of the MainScene::initialize() method with the following code. This code replaces any code for the creation of individual bots. Notice the bot's initialize() method has an extra argument added to the end, which allows for the bot to obtain its own numerical identification number initially representing its position within the bot array.

```
for(int i = 0; i < MAXBOTS; i++)
{
    char botname[15];
```

```
            sprintf(botname,"Bot %d", i);
            bots[i].botAvatar = zip.getBot("koollight/koollight.mdl",true);
            bots[i].initialize(bsp, botname, bots, MAXBOTS, i);
            glWin.getWorld().addObject(bots[i].botAvatar);
    }
```

Save, compile, and run the program. The game should initialize with 150 (or whatever number you choose) bots randomly scattered around the map.

5.8.2 Step Two: Updating the Bots

The only other change that must be made to the *vh.cpp* file is to modify the update() method to run the genetic algorithm and perform the mating process. This new code goes at the beginning of the MainScene::update() method and is shown in bold in Listing 5.8.

LISTING 5.8 A partial listing of the new MainScene::update() method

```
int stateCount[NUMSTATES] = {0,0,0,0,0,0};
int MainScene::update(GLWin& glWin)
{
    GLCamera& camera = glWin.getCamera();
    float timeStep = GLWin::getTimeStep();

    //PART A
    if(simRuns < MAXSIMS)
    {
        for(int i = 0; i < MAXBOTS; i++)
        {
            bots[i].update();
            stateCount[bots[i].state]++;
        }
    }
    else
    {
        //PART B
        double averageHealth = 0;
        double averageCycles = 0;
        double averageExchanges = 0;
        for(int i = 0; i < MAXBOTS; i++)
        {
            averageHealth += bots[i].health;
            averageCycles += bots[i].cycles;
            averageExchanges += bots[i].healthExchanges;
```

```
    }
    averageHealth /= MAXBOTS;
    averageCycles /= MAXBOTS;
    averageExchanges /= MAXBOTS;

    //PART C
    //breed bots using alive cycles as a fitness test
    qsort( bots, MAXBOTS, sizeof( AIBot ), RankBots );

    //PART D
    //Crossover top best
    for( int i = 0; i < MAXBOTS/2; i += 2 )
    {
        //cross over chromosomes
        for( int j = 0; j < NUMSTATES - 2; j++ )
        {
            if( rand() % 2 == 0 )
            {
                double tmp = bots[i].chromosome[j];
                bots[i].chromosome[j] = bots[i + 1].chromosome[j];
                bots[i + 1].chromosome[j] = tmp;
            }
        }
    }

    //PART E
    //Mutate the rest
    for( int i = MAXBOTS/2 + 1; i < MAXBOTS; i++ )
    {
        for( int j = 0; j < NUMSTATES - 2; j++ )
        {
            bots[i].chromosome[j] = getrandom(0,100)/100.0;
        }
    }

    //PART F
    for(int i = 0; i < MAXBOTS; i++)
    {
        bots[i].initialize();
    }

    simRuns = 0;
}

simRuns++;
```

```
if(avatar->getUpper().getStoppedAnimation() == TORSO_ATTACK)
    avatar->setUpperAnimation(TORSO_STAND);

//Weapon Shooting Animation
if(glWin.isLeftButtonPressed() &&
    (avatar->getUpperAnimation() != TORSO_ATTACK))
    ...
```

The parts of Listing 5.8 and an explanation of each section of code follows:

Part A: The first part of Listing 5.8 runs a simulation for a population of bots until the program has looped MAXSIM times. Each time, the bots' update() methods are called and an accumulation of the bots' states is taken.

Part B: If a simulation run is finished, the next part calculates the run's statistics, which include the average of the bots' health, the average update cycles that each bot experienced, and the average number of times the bots were able to gain health rewards. Although not specifically coded here, these values could be written to a log file for examination when the program has finished.

Part C: The next part of the code takes the bot array and sorts it according to a fitness function, which is specified by supplying a pointer to the fitness function in the qsort() function. In this case, the function is called RankBots() and should be included in the *vh.cpp* code as follows:

```
int RankBots(const void * bot1, const void * bot2 )
{
    AIBot * b1 = ( AIBot * ) bot1;
    AIBot * b2 = ( AIBot * ) bot2;

    if( (b1->health + b1->cycles*10 + b1->healthExchanges * 15) >
            (b2->health + b2->cycles*10 + b2->healthExchanges * 15) )
        return -1;
    else
        return 1;
}
```

The RankBots() function is used by qsort() to specify how the bot in the array should be ordered. In this case, when RankBots() returns 1, qsort() swaps the bots it is comparing. In this case the fitness function is:

$$f = \text{health} + \text{alive cycles} \times 10 + \text{times health gained} \times 15;$$

Note that the fitness function can be whatever you want it to be. In this case, the number of times a bot was able to gain health is rated higher than its health or the cycles for which it was alive.

Part D: When the bots have been ranked in descending order based on their fitness, the top half of the bots are bred with each other, with the chromosome crossover function based on a coin-tossing process.

Part E: Because part D replaced only half of the population, the next part creates random mutations and adds them to the population to make up the numbers.

Part F: Finally, the new population is initialized, and the simulation run begins again.

When you have made these modifications to the game environment you can begin changing the code for the AIBot class.

5.8.3 Step Three: Constructing the Bots' DNA

The bots' DNA is represented by a new property in the AIBot class called chromo-some, which is declared thus

```
float chromosome[NUMSTATES - 2];
```

as a public property, where NUMSTATES is a constant value set to 6 to represent the number of states in which the bot can be. These states are enumerated as follows:

```
enum botState
{
    ATTACK, WANDER, BEFRIEND, REST, PURSUE, DEAD
};
```

In addition to the chromosome array, a few other properties are needed to keep track of the bots' statistics. These properties will be used later in determining bot fitness. They are:

```
int cycles;
int healthExchanges;
```

When these properties are added together, their sum is the number of game cycles the bot has survived (the number of times the bot's update() method has been called) and the number of times the bot has been able to accumulate health. Finally, an integer property called botId has been added so a bot can keep track of

itself and the ID of other bots. The value is generated in the *vh.cpp* code when the bot array is created and passed to the bot via its `initialize()` method. You must modify the existing `initialize()` method in *AIBot.cpp* to accept this value.

A bot can accumulate health in three ways. First, it can attack another bot. If the other bot dies, then the attacker is rewarded with 20 health points. Second, a bot can approach another bot and befriend it. When this occurs, the befriended bot shares some of its health with the approaching bot. Finally, a bot can accumulate a small amount of health by resting.

Before we examine the new `update()` method for the bot, note that some changes must occur to the bot's `initialize()` method. The following lines should be added to initialize the bot's new properties and fill its `chromosome` array with random values between 0 and 1:

```
cycles = 0;
healthExchanges = 0;
botId = id;
botsArray = bots;
numBots = maxbots;

//initialize chromosomes
for(int i = 0; i < NUMSTATES - 2; i++)
{
    chromosome[i] = getrandom(0,100)/100.0;
}
```

In addition to updating the existing `initialize()` method, an overloaded one is added to reset the bots at the beginning of each new generation, as follows:

```
int AIBot::initialize()
{
    botAvatar->move(getrandom(MAPXMIN,MAPXMAX), 0,
        getrandom(MAPZMIN,MAPZMAX));
    health = MAXHEALTH;
    state = WANDER;
    cycles = 0;
    healthExchanges = 0;
    return 1;
}
```

The bot is initially relocated within the map. Here the boundaries of the map have been made into constants (that is, `MAPXMIN`, `MAPXMAX`, and so on). The values you assign these constants depends on the dimensions of the map. Next, the bot's `health` is set to the maximum, its `state` to `WANDER`, and other statistics set to 0.

5.8.4 Step Four: Implementing a New `update()` Method to Make the Bot Behave

Now for the new update method. The code, shown in Listing 5.9, once again has been divided into parts to aid the explanation.

LISTING 5.9 The new `update()` method for a genetic algorithm bot

```
void AIBot::update()
{

    //PART A
    //if health below 0 then you are dead
    if (health <= 0)
    {
        state = DEAD;
        if( upperAnim != BOTH_DEATH1 && upperAnim != BOTH_DEAD1)
            botAvatar->setAnimation(upperAnim = BOTH_DEATH1);
        else if( upperAnim == BOTH_DEATH1)
            botAvatar->setAnimation(upperAnim = BOTH_DEAD1);
        return;
    }

    cycles++;

    if(health > MAXHEALTH)
        health = MAXHEALTH;

    //PART B
    state = pickGoal();
    int nearBot = whoNear(10.0);

    if (nearBot == -1 && (state == ATTACK || state == BEFRIEND) )
    {
        nearBot = whoNear(1000.0);
        if(nearBot != -1)
            state = PURSUE;
        else
            state = WANDER;
    }

    //PART C
    if (state == REST)
    {
        health += 0.01;
        if(lowerAnim != LEGS_IDLECR )
```

```
                            botAvatar->setLowerAnimation(lowerAnim = LEGS_IDLECR);

        return;
    }
    else if (state == ATTACK)
    {
        healthExchanges++;
        bots[nearBot].health -= getrandom(0,10);
        health -= getrandom(0,5); //get damaged

        if(bots[nearBot].health <= 0) //reward with health
            health += 20;

        if(lowerAnim != LEGS_IDLE )
            botAvatar->setLowerAnimation(lowerAnim = LEGS_IDLE);
        if(upperAnim != TORSO_ATTACK )
            botAvatar->setUpperAnimation(upperAnim = TORSO_ATTACK);
        return;
    }
    else if (state == BEFRIEND)
    {
        healthExchanges++;
        bots[nearBot].health -= 5;
        //other bot share's its health
        health += 5;
        if(lowerAnim != LEGS_IDLE )
            botAvatar->setLowerAnimation(lowerAnim = LEGS_IDLE);
        if(upperAnim != TORSO_STAND )
            botAvatar->setUpperAnimation(upperAnim = TORSO_STAND);
    }

    //PART D
    if(lowerAnim != LEGS_WALK )
        botAvatar->setLowerAnimation(lowerAnim = LEGS_WALK);

    BSPVector botPos( botAvatar->getPositionX(),
        botAvatar->getPositionY(),
        botAvatar->getPositionZ() );
    BSPVector oldVelocity = velocity;

    //PART E
    //wander
    if(state == WANDER)
        wander();
    else if (state == PURSUE)
```

```
            pursue(nearBot);

        health -= 0.01;

        //PART F
        velocity = velocity.normalize();
        botAvatar->rotateStanding(turnXZ(velocity, oldVelocity));

        BSPVector botVel = velocity;
        botVel.x *= speed;
        botVel.z *= speed;
        bsp->slideCollision(botPos,botVel,extent);
        botAvatar->setPosition(botPos.x,botPos.y,botPos.z);
    }
```

The code in the update() method makes the bot act. By now you should be familiar with lines of animation code, so these are not explained here. The code is broken up into the following parts:

Part A: This part tests for the death of the bot. If the bot is dead it should just lie on the ground and not do anything. If it is not dead, this call of the update() method is counted with the cycles property. Finally, the bot's health is made equal to the maximum health value if it has exceeded it, which ensures the bot's health cannot skyrocket.

Part B: The next part introduces new logic not found in the preceding practical exercises in other chapters. First, the bot determines in which state it wants to be. The state also represents its goal. The pickGoal() method determines a value for each of the possible states in which the bot could be. It then multiplies these values by the associated gene in the bot's chromosome. The value for each goal could be interpreted as the bot's desire to achieve that goal, with the values in the bot's chromosome representing its preferences for each goal. The values for each goal are inspired from the game matrices of Chapter 2, in which the goals are made more desirable based on the bot's health. How a goal is finally ranked depends both on its value and the bot's preference. The goal with the highest ranking is returned to be the bot's next state. The code for the pickGoal() and associated goal valuing methods follow. Note that the multipliers used in each goal method are purely arbitrary and can be changed in your own program as you see fit to make one goal appear more important than another.

```
float AIBot::attackGoal()
{
    return health * 15.0;
```

```
}

float AIBot::wanderGoal()
{
    return (MAXHEALTH - health) * 5;
}

float AIBot::befriendGoal()
{
    return (MAXHEALTH - health) * 2.0;
}

float AIBot::restGoal()
{
    return (MAXHEALTH - health) * 1.2;
}

botState AIBot::pickGoal()
{
    int best;
    float favorite[NUMSTATES - 2];
    favorite[0] = attackGoal() * chromosome[0];
    favorite[1] = wanderGoal() * chromosome[1];
    favorite[2] = befriendGoal() * chromosome[2];
    favorite[3] = restGoal() * chromosome[3];

    best = 0;
    for(int i = 1; i < NUMSTATES - 2; i++)
    {
        if(favorite[i-1] < favorite[i])
            best = i;
    }

    return (botState) best;
}
```

After the bot's new state has been determined, the bot picks another bot that is close to it using the whoNear() method, defined as follows:

```
int AIBot::whoNear(float distance)
{
    BSPVector botPos( botAvatar->getPositionX(),
        botAvatar->getPositionY(),
        botAvatar->getPositionZ() );
```

```
for(int i = 0; i < numBots; i++)
{
    if(botId != i && bots[i].getBotState() != DEAD)
    {
        BSPVector otherBotPos(
            bots[i].botAvatar->getPositionX(),
            bots[i].botAvatar->getPositionY(),
            bots[i].botAvatar->getPositionZ()
        );

        if(isNear(botPos,otherBotPos, distance) )
            return i;
    }
}
return -1;
}
```

If the bot is not near enough to another bot (in this case, within 10 units) and the bot wants to ATTACK or BEFRIEND the other bot, the bot's state changes to PURSUE. If the bot can see another bot (within 1,000 units), the bot follows the movements of the other bot; otherwise, it sets its state to WANDER.

Part C: The third part processes the bot's state. If the bot is in the REST state, its health is incremented by a small amount. If the bot's state is ATTACK, its opponent's health is reduced by a random value between 0 and 10, and the bot's own health is reduced by a random value between 0 and 5. If the bot manages to kill its opponent, it is rewarded with 20 health points. If the bot has selected to BEFRIEND another bot, the BEFRIEND-ed bot gives 5 of its health points to its new friend.

Part D: This section will be familiar, because it hasn't changed from previous AIBot classes. It simply obtains and stores the bot's current location in the map.

Part E: If the running of the code has reached this part, the bot is in a state of either WANDER or PURSUE. If the bot's state is set to WANDER, the wander() method implemented in the simple fighting game of Chapter 2 is called. Otherwise, the bot's pursue() method is called. This again is based on code from Chapter 2 and determines the bot's current location with respect to the bot that it has decided to follow. The code for the pursue() method follows:

```
void AIBot::pursue(int botId)
{
    velocity.set(bots[botId].botAvatar->getPositionX() -
        botAvatar->getPositionX(), 0 ,
        bots[botId].botAvatar->getPositionZ() -
```

```
                    botAvatar->getPositionZ());
        }
```

Part F: The last section of the code updates the bot's location on the map.

Compile your code and watch the bots perform.

5.8.5 Step Five: Optimization

If you keep track of the population statistics, after many populations you will see the values become optimal, meaning they do not increase or decrease much with each new generation. To determine when this occurs, run the program for a certain number of generations and record the statistics in a file. When a leveling out of values occurs, say, for the average health of the population, then the genetic algorithm has found the optimal population. As an example, the population outlined in the preceding code was used and the average health for each population recorded. When plotted over 53 generations, the average health can be seen to increase dramatically at first and then level off to oscillate around 59 percent, as shown in Figure 5.17.

As you can see in Figure 5.17, the average health of the population increases spectacularly over the first five generations. After this, a small rise occurs until finally the average health settles in the region of 55 to 65 percent. To achieve better results, a better breeding process could be considered. When the breeding process of the preceding program was modified to replace the mutated half of the population with clones of the crossover half, the optimal average health range rose to 75 to 85 percent.

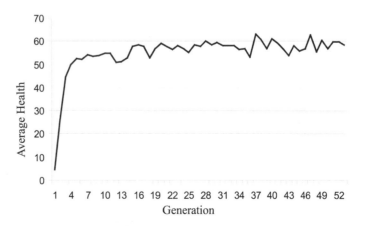

FIGURE 5.17 Average health versus population for a genetic algorithm.

Genetic algorithms are useful for evolving behavior preferences in NPCs. In the preceding practical session, a genetic algorithm was used to breed a population of NPCs that lived longer and obtained a higher average health. The fitness function in this case was quite simple. However, there is no reason the programmer could not make it as complex as he wants. For example, in [Laramee02] the fitness function evaluates a troll's ability to attack knights, capture sheep, and stay alive in a fantasy game. A genetic algorithm could also be implemented to evolve behaviors with respect to the way that a human player plays a game. That way, the NPCs would be programmed to respond to the user's behaviors. If a human player always took the same route to get from location *A* to location *B*, enemies that successfully attacked the player on the route could be deemed the fittest, and a population would evolve to hang around the player's route.

Another AI technique inspired by the processes of nature are neural networks. Just as genetic algorithms attempt to improve the performance of a computer program using biologically inspired practices, neural networks attempt to simulate brain physiology. Both techniques create systems that can adjust themselves to a particular environment without programmer intervention. The subject of neural networks is presented in the next section.

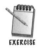

EXERCISE

1. Modify the breeding procedure of your genetic algorithm program and remove the mutations by replacing them with clones of the first half of the population. How does this change affect the population's average health? What is the maximum average health value you could expect?
2. In attempting to optimize a population, why would you adjust the breeding process and not the goal values and the loss of health values incurred during bot interaction?
3. Introduce a new species into your program—this addition requires another bot class. Have the species interact with each other and evolve. Instead of having the AIBots attack each other, have them attack the other species instead. Examine the change in each species' average health over a number of generations. What do you observe? Do the species evolve to be as good as one another, or does one end up dominating?
4. Write a finite state machine for the bots to replace the code in the update() method in the genetic algorithm exercise.

5.9 NEURAL NETWORKS

The inspiration for the artificial neural network structure comes from the very organ that provides us with our intelligence—the organic brain. The brain comprises

more than 100 billion nerve cells called neurons. Neurons are found throughout the body's nervous system. They act as a medium through which the electrical and chemical signals that carry information throughout our bodies function. The neurons you are most familiar with are the ones that exist in the peripheral nervous system and are bundled together to form nerves. These neurons carry external signals to the brain. If you were to grab a sword by the blade, the nerves in your partially severed fingers would relay information up the network of neurons in your arm to your spinal cord and then to your brain. This signal would tell your brain to take your hand off the sharp edge of the sword before any more damage was done.

The typical neuron is composed of three parts: a cell body, an axon (with axon terminals), and dendrites. The dendrites receive signals from neighboring neurons and carry them to the cell body. The cell body transforms the signals, then passes them onto the axon, which relays the signal to the next neuron through the axon terminals. The neurons do not physically touch each other—they are separated by microscopically small gaps called *synapses*. The signal from one neuron to another hurtles across the gap in the form of an electrochemical substance called a neurotransmitter. Figure 5.18 illustrates the components of a neuron.

The whole process of message transmission through the network of neurons, that is, the nervous system, is similar to electrical circuitry. Neurons are not always active and involved in message sending. In a resting state, a neuron is negatively charged on the inside and positively charged on the outside. The difference in the internal and external electrical charge of the neuron is called *polarization*. A neuron

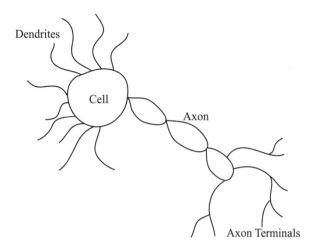

FIGURE 5.18 The basic structure of a neuron.

becomes excited, or *activated*, when some kind of stimulation, either a message from a neighboring neuron or external sensations, is picked up by a sensory organ, for example, the skin. At a particular point when the neuron is stimulated beyond its *threshold*, the neuron becomes depolarized. Until a depolarized threshold value is reached nothing happens. Once depolarized, the neuron emits an electrical current, or *spike discharge*. This electrical current moves down the axon and initiates the release of neurotransmitters, which move across the synapse and attach themselves to the dendrites of the receiving neuron, thus relaying the message. This electrochemical process for message relaying around a biological nervous system is the inspiration for the artificial neural network (ANN).

An ANN consists of nodes called *neurodes*, or *artificial neurons* (more commonly just referred to as neurons), organized in a network. A single neuron has a number of inputs (x_1 to x_n) with associated weights (w_1 to w_n), a method for processing the input, N, and an output, y. An example of a basic neuron with two inputs is shown in Figure 5.19.

Before the neuron can process the input, each value of x is multiplied by its associated value of w, then added with the other input values. The result is called the input activation, N. The formula is shown in Equation 5.5:

$$N = \sum_{i=1}^{n} X_i w_i \qquad\qquad (5.5)$$

where n is the number of input values to the neuron. For the neuron in Figure 5.19, the value of N could be determined using the previous equation, equating to:

$$N = X_1 w_1 + X_2 w_2$$

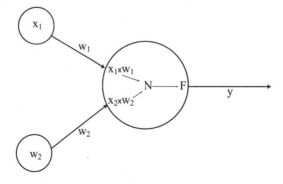

FIGURE 5.19 A single neuron with two inputs.

For example, if the values for the inputs and weights were $x_1 = 1$, $x_2 = 0$, $w_1 = 0.3$, and $w_2 = 0.2$, then the activation value for the neuron would be $1 \times 0.3 + 0 \times 0.2 = 0.3$. Following this summation, the input activation value is processed within the neuron using a predetermined function called the *activation function*, F, the output of which is the value for y. The actual function used by the neuron is determined by the application for the ANN. The four common activation functions are the step, sign, linear, and sigmoid functions. These functions are illustrated in Figure 5.20.

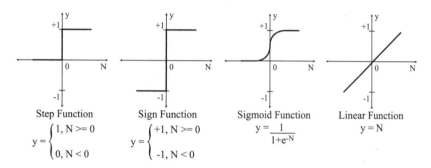

Step Function
$$y = \begin{cases} 1, & N >= 0 \\ 0, & N < 0 \end{cases}$$

Sign Function
$$y = \begin{cases} +1, & N >= 0 \\ -1, & N < 0 \end{cases}$$

Sigmoid Function
$$y = \frac{1}{1 + e^{-N}}$$

Linear Function
$$y = N$$

FIGURE 5.20 Four common neuron activation functions.

The step and sign activation functions are usually used in applications that require classification and pattern recognition. The step function sets y to a value of 1 if N is greater than or equal to 0; otherwise, y is set to 0. In the case of the last example where N equated to 0.3, y, using the step function, would be set to 0. The sign function is similar to the step function, except the output is set to +1 or −1. If N is greater than or equal to 0, y becomes +1; otherwise, it is −1. When you apply the sign function to the value of $N = 0.3$, y becomes −1. The step and sign activation functions can also have their decision constant changed from 0 to a *threshold* value. For example, in the step function, y is set to 1 if $N \geq 0$. Zero may not be appropriate for the values you are working with, and, therefore, this value could be modified by setting y to 1 if $N \geq \theta$. The form of the step function would become as follows:

$$y = \begin{cases} 1, & N \geq \theta \\ 0, & N < \theta \end{cases}$$

The sign function could also be changed appropriately to include a threshold value. If the value of N was 0.3 and the threshold was 0.2, using the step function, y would become 1.

The sigmoid function takes a value of N, which can be anywhere between positive and negative infinity, and reduces it to a value between 0 and 1. Sigmoid functions are often used in ANN that require *back-propagation* (a technique that will be examined shortly). The value of N is substituted into the equation shown in Figure 5.20, where e is a mathematical constant equaling approximately 2.7183, to obtain a value for y. Given $N = 0.3$, y would equal approximately 0.6. The sigmoid function is also used to output values when 0 and 1 do not suffice. For example, the *Minesweeper* tanks discussed in [AIJunkie03] use a neural network with two outputs to control the speeds of the tanks' left and right tracks to move them around the environment. The sigmoid function is used to obtain a value that can be applied to modify the speed of each track. In this example a simple 1 or 0 would not cut it. The final function shown in Figure 5.20 is the linear function. This function gives y the same value as N; therefore, when $N = 0.3$, so does y. Neurons using a linear activation function are mostly used in linear approximation problems.

In short, a neuron can learn by modifying its weights until the desired output is achieved. Given the input values, the neuron begins with randomly assigned weight values. The value of N is calculated and passed through the activation function to determine the value of y. The value of y is then examined and compared to some desired result. The difference between y and the desired result gives an error value that is used to adjust the values of the weights. The input values are then run through the neuron again with the new values of the weights. A new value for y is obtained that is again compared with the desired result and an error calculated. The error is again used to modify the weight values. This cyclical process continues until the desired output is reached or until it is deemed the neuron will never come up with the right output. The process of continually testing the output and updating the weights is called *training*. The training process can best be described as an algorithm, shown in Listing 5.10 (in the next section), which includes sample code at each algorithm step.

5.9.1 The Perceptron

The simplest ANN that can be created is one with just a single neuron. In fact, it is not really a network because the neuron is not connected to other neurons. The neuron does, however, take inputs and converts these to an output value. Such a neuron was dubbed a *perceptron* by AI researcher Rosenblatt [Rosenblatt58]. A perceptron looks like that shown in Figure 5.19. Can such a simple processor be trained to learn anything? The answer is yes. A perceptron can be trained to perform the basic logical operations of OR, AND, and XOR using the algorithm described in Listing 5.10. The error associated with the perceptron's training is calculated using Equation 5.6:

$$e = O_d - y \tag{5.6}$$

where O_d is the desired output and e is the error. This error is not simply added onto the weights but is applied using the *perceptron learning rule* [Rosenblatt60]. This rule is given as Equation 5.7:

$$w_{i,\text{new}} = w_{i,\text{old}} + \alpha \times x_i \times e \tag{5.7}$$

where α is the *learning rate*, which has a positive value less than one. (Note that the learning rate is set once for the entire neural network.)

LISTING 5.10 The Training of a neuron with example code[a]

1. Initialization
 a. Set the input and output values as desired.

   ```
   int x1 = 1, x2 = 0, output = 1;
   ```

 b. Set the values of the weights to random values (between −0.5 and 0.5).

   ```
   float   w1 = (rand()%11−5)/10.0,
           w2 = (rand()%11−5)/10.0;
   ```

 c. Set the value of the threshold value, if there is one, between −0.5 and 0.5.

   ```
   float threshold = 0.2;
   ```

 d. Set the value of the learning rate (a positive value less than 1).

   ```
   float alpha = 0.1;
   ```

2. Activation
 a. Multiply each input value by its associated weight.

   ```
   a = x1*w1; b = x2*w2;
   ```

 b. Add together all the values calculated in Step 2.a and subtract the threshold to obtain a value for N.

   ```
   N = a + b − threshold;
   ```

 c. Use the activation function on N to calculate y.

```
if (N >= 0) y = 1; else y = 0; //step
```

3. Training
 a. Compare *y* with the desired output to obtain the error value.

    ```
    error = output - y;
    ```

 b. If the error is sufficiently small and training appears complete, end the cycle.
 c. Otherwise, adjust the weights using the error value.

    ```
    w1 = w1 + alpha*x1[i]*error;
    w2 = w2 + alpha*x2[i]*error;
    ```

4. Cycle
 a. Return to Step 2 using the new weights.

[a] The sample code in this listing is meant as a guide only and illustrates the use of two input values, two weights, and the step function, whereas a neuron could have many more inputs and weights and use different activation functions.

The best way to illustrate a perceptron is to give a proper working example. The code in Listing 5.11 follows the algorithm in Listing 5.10 to produce a perceptron capable of learning the logical operator OR. Although you could feed the inputs and desired outputs to the perceptron as it is running, the code listing has them hard-coded for simplicity.

LISTING 5.11 A perceptron learning the OR operation

```
int main()
{
    int x1[4] = {0,0,1,1},    //input one
        x2[4] = {0,1,0,1},    //input two
        o[4] = {0,1,1,1},     //desired output
        y;                    //actual output
    float w1, w2, error;      //weights and error
    float threshold = 0.2, alpha = 0.1, N;

    w1 = (rand()%11-5)/10.0;
    //set weights randomly [-0.5,0.5]
    w2 = (rand()%11-5)/10.0;
```

```
for (int p = 0; p < 8; p++)        //epoch loop
{
    for(int i = 0; i < 4; i++)     //training set loop
    {
        N = x1[i]*w1 + x2[i]*w2 — threshold;
        if (N >= 0) y = 1; else y = 0;
        error = o[i] — y;
        w1 = w1 + alpha*x1[i]*error;
        w2 = w2 + alpha*x2[i]*error;
    }
}
}
```

Four training sets are provided as arrays x1, x2, and o. Each relative cell in the arrays represents an OR operation. For example, x1[0] OR x2[0] = o[0]. Each set is fed into the perceptron one at a time, hence, the for loop shown in bold in Listing 5.11. The sets are fed through a total of eight times each by the outer for loop with the variable p. Each of the p loops is referred to as an *epoch*. This perceptron has eight epochs. Of course, you could have more or fewer. In this case, we know the perceptron has learned the OR operation within eight epochs, hence, its use. You could also monitor the error values until they are consistently 0 over a smaller number of epochs. The results of this perceptron's learning process are shown in Table 5.6, where the values of the variables are recorded.

In the first epoch, the first training values are $(0,0,0)$, representing x1, x2, and o, respectively, with weights of −0.10 and 0.00. The perceptron's output is 0, which in this instance is correct. Therefore, the error is 0 and the adjusted weights remain the same. The next training values are $(0,1,1)$ and the perceptron outputs a value of $y = 0$, which is incorrect. Therefore, the error is set to the difference between the desired output, o, and the actual output, y, giving error = 1. The error is used to adjust the weights, using Equation 5.7, to −0.10 and 0.10. These new weights are then used with the next set of training inputs and the process continues. As shown in Table 5.6, by Epoch 5 the perceptron has learned the OR operation, from where no more errors occur.

TABLE 5.6 Example of Perceptron Learning of the Logical OR Operation

	x1	x2	o	Initial				Adjusted	
				w1	w2	y	e	w1	w2
Epoch 1	0	0	0	−0.10	0.00	0	0.00	−0.10	0.00
	0	1	1	−0.10	0.00	0	1.00	−0.10	0.10
	1	0	1	−0.10	0.10	0	1.00	0.00	0.10
	1	1	1	0.00	0.10	0	1.00	0.10	0.20
Epoch 2	0	0	0	0.10	0.20	0	0.00	0.10	0.20
	0	1	1	0.10	0.20	0	1.00	0.10	0.30
	1	0	1	0.10	0.30	0	1.00	0.20	0.30
	1	1	1	0.20	0.30	1	0.00	0.20	0.30
Epoch 3	0	0	0	0.20	0.30	0	0.00	0.20	0.30
	0	1	1	0.20	0.30	0	1.00	0.20	0.40
	1	0	1	0.20	0.40	0	1.00	0.30	0.40
	1	1	1	0.30	0.40	1	0.00	0.30	0.40
Epoch 4	0	0	0	0.30	0.40	0	0.00	0.30	0.40
	0	1	1	0.30	0.40	1	0.00	0.30	0.40
	1	0	1	0.30	0.40	0	1.00	0.40	0.40
	1	1	1	0.40	0.40	1	0.00	0.40	0.40
Epoch 5	0	0	0	0.40	0.40	0	0.00	0.40	0.40
	0	1	1	0.40	0.40	1	0.00	0.40	0.40
	1	0	1	0.40	0.40	1	0.00	0.40	0.40
	1	1	1	0.40	0.40	1	0.00	0.40	0.40
Epoch 6	0	0	0	0.40	0.40	0	0.00	0.40	0.40
	0	1	1	0.40	0.40	1	0.00	0.40	0.40
	1	0	1	0.40	0.40	1	0.00	0.40	0.40
	1	1	1	0.40	0.40	1	0.00	0.40	0.40
Epoch 7	0	0	0	0.40	0.40	0	0.00	0.40	0.40
	0	1	1	0.40	0.40	1	0.00	0.40	0.40
	1	0	1	0.40	0.40	1	0.00	0.40	0.40
	1	1	1	0.40	0.40	1	0.00	0.40	0.40
Epoch 8	0	0	0	0.40	0.40	0	0.00	0.40	0.40
	0	1	1	0.40	0.40	1	0.00	0.40	0.40
	1	0	1	0.40	0.40	1	0.00	0.40	0.40
	1	1	1	0.40	0.40	1	0.00	0.40	0.40

EXERCISE

1. Use the code in Listing 5.11 to program your own perceptron. Modify the values in the desired output array to train the AND operation. You also must include print statements to view the values of the variables, as in Table 5.6. How many epochs does it take for the perceptron to learn AND?
2. Modify the perceptron from Exercise 1 to learn the XOR operation. Compare the number of epochs needed against the OR and AND operations.
3. Modify the perceptron from Exercise 1 to learn the NOR and NAND operations. What do you observe?

Unfortunately the single-neuron perceptron is limited to learning the XOR, AND, and OR operations. You should have discovered this in the previous set of exercises. Why this is so would take up the contents of another book and is not covered here. If you are interested in finding out, see [Minsky88]. To solve the problem of limited processing, numerous neurons can be connected into a network structure (hence, the term *neural network*).

5.9.2 Multilayer Artificial Neural Networks

A multilayer ANN, which is more or less what people are referring to when they mention just ANNs without reference to multiple layers, is a network of neurons organized into an input layer, output layer, and any number of middle or hidden layers. The input layer accepts the input values and rarely does any processing. The input values are passed from the input layer to the middle layers, where the usual weightings and activation functions are applied. The outputs from the middle layers become the inputs to the output layer, where the final results are produced. Because the middle layers are essentially hidden, their output and weightings are not observed. A typical multilayer ANN is illustrated in Figure 5.21. This type of ANN is called *forward feeding* because the values travel through the network in one direction, from the input to the output. It is also considered to be *fully connected* because each neuron is connected to every other neuron. For example, each neuron on one hidden layer sends its output to each neuron on the next layer. Each neuron in a back-propagation network uses the sigmoid activation function.

An ANN can have many hidden layers containing any number of neurons. Commercial ANNs usually have one or two hidden layers, with each layer containing anywhere between 10 and 100 neurons. Some experimental neural networks can have five or six layers (including input and output) with millions of neurons. The most practical and least computationally expensive ANNs simply have an input, output, and one hidden layer. In selecting the number of neurons for a hidden layer, a good place to start is with twice the number of inputs [Champandard02].

Weights are updated in a multilayered ANN through a process called back-propagation. Essentially, when the inputs have made their way through the ANN to

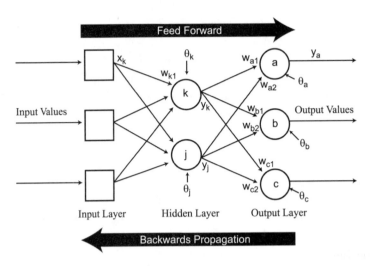

FIGURE 5.21　A multilayer neural network.

the output layer and output values are obtained, errors are calculated for the neurons in the output layer in the same way as for a single-neuron perceptron. The errors are then fed backward through the ANN to update the weights of neurons in the hidden layers. The error signal for a neuron in the output layer is calculated using Equation 5.8:

$$e_a = O_{d,a} - y_a \qquad (5.8)$$

where $O_{d,a}$ is the desired output from neuron a (as shown in Figure 5.21) and y_a is the actual output from neuron a. The output from neuron a is the sum of the input values multiplied by their weights minus the threshold value run through the sigmoid function, as shown in Equation 5.9, where all values are shown in Figure 5.21. Of course, if there were more inputs and associated weights, Equation 5.9 would be expanded to include these.

$$y_a = \text{sigmoid}\left(y_k w_{a1} + y_j w_{a2} - \theta_a\right) \qquad (5.9)$$

Now, it is not as simple as before to update the neuron's weights using just the error value. Because the ANN is multilayered, it contains many errors that must be spread throughout the network to update all weights. For this, we use what is called an *error gradient*. The error gradient for neuron a, δ_a, is calculated as the derivative of the activation function (in this case sigmoid) multiplied by the neuron's output error. This formula is shown as Equation 5.10.

$$\delta_a = \frac{\delta\left(\dfrac{1}{1+e^{-\left(y_k w_{a1}+y_j w_{a2}-\theta_a\right)}}\right)}{\delta\left(y_k w_{a1}+y_j w_{a2}-\theta_a\right)} e_a \tag{5.10}$$

If the word *derivative* makes you cringe, then Equation 5.10 may have you ready to close this book. However, rather than ask you to expand out Equation 5.10, we give it to you as Equation 5.11.

$$\delta_a = y_a\left(1-y_a\right)e_a \tag{5.11}$$

Now, isn't this more to your liking? The error gradient for neuron *a* can now easily be calculated by just knowing the neuron's output and associated error. Too easy! Finally, to modify the weights of an output neuron, each weight is updated by the value of α (the learning rate; some positive value less than one) multiplied by the input affected by the weight and the error gradient, as shown in Equation 5.12. All weights for output layer neurons can be updated in the same way.

$$w_{a1_new} = w_{a1} + \alpha \times y_k \times \delta_a \tag{5.12}$$

Because outputs from neurons in the hidden layers are fed forward, some blame for any errors incurred in the output layer must influence the hidden layer weight updates. For example, neuron *k* (as shown in Figure 5.21) feeds its output, y_k, to neurons *a*, *b*, and *c*. Each of *a*, *b*, and *c* incurs an error and error gradient, which was partially affected by the value of y_k. The error gradient from *a*, *b*, and *c* is, therefore, fed backward through the associated weight to neuron *k*. These values are used in the calculation of neuron *k*'s error gradient, shown in Equation 5.13.

$$\delta_k = y_k(1-y_k)(\delta_a w_{a1} + \delta_b w_{b1} + \delta_c w_{c1}) \tag{5.13}$$

Having calculated the error gradient for a hidden layer neuron, such as *k*, the weights of the neuron can be adjusted using Equation 5.14, which is similar to Equation 5.11. Note that this time, the input that is affected by the weight is now the first input into the ANN, because the ANN input goes directly into this one hidden layer. If there were other hidden layers, this value would be substituted with whatever value was the input for this weight.

$$w_{k1_new} = w_{k1} + \alpha \times x_k \times \delta_k \tag{5.14}$$

Each neuron in the ANN also has a threshold value. This threshold acts as another kind of weight and is updated in the same way. However, a threshold does

not have an input value to use in the calculation and, therefore, a fixed input value is used, such as −1. The updating of a threshold value is shown in Equation 5.15.

$$threshold_{k1_new} = w_{k1} + \alpha \times -1 \times \delta_k \tag{5.15}$$

The complete algorithm for training a multilayer back-propagation ANN is given in Listing 5.12.

LISTING 5.12 A training algorithm for a multilayer back-propagation ANN

1. Initialization
 a. Set the input and desired output values.
 b. Randomly assign values to all weights and thresholds in the range $(-2.4/n, +2.4/n)$, where n is the number of inputs to the neuron for which the values are being assigned [Haykin94].
2. Activation
 a. Multiply each neuron's input value by its associated weight.

   ```
   a = x1*w1; b = x2*w2;
   ```

 b. Add together all the values calculated in Step 2.a and subtract the threshold to obtain a value for N.

   ```
   N = a + b - threshold;
   ```

 c. Use the activation function on N to calculate y.

   ```
   sigmoid(N);
   ```

 d. Forward-feed neuron output to all neurons in next layer.
3. Training
 a. Starting with the output layer, calculate the values for the errors and error gradient.
 b. Update the output layer weights and thresholds.
 c. Back-propagate the error gradients to neurons in preceding hidden layer.
 d. Calculate the error gradients and update weights and thresholds in the current hidden layer.
 e. Continue back-propagating error gradients to preceding layers until the input layer is reached.
4. Cycle
 a. Return to Step 2 and repeat cycle until the error is satisfactorily small.

5.9.3 Advantages and Disadvantages of Neural Networks

Genetic algorithms and neural networks are capable of producing erratic and un-predictable results. Although they are an excellent means of programming learning in a dynamic environment, they are not usually used in released games. They may be used during the development stage to develop suitable behaviors for NPCs. If, however, they are allowed to continue learning in the hands of the game player, the results may be less than desirable. As was illustrated in the section on genetic algo-rithms, they are great for finding the optimal types of behavior in an environment in which it might take some time for the programmer to discover the correct pa-rameters. For this reason these types of techniques can be used in development to tweak the parameters, and these parameters can be transferred into a more reliable AI method, such as FSM or rules in the final product.

5.10 DAY OF RECKONING: PROGRAMMING A MULTILAYER BACK-PROPAGATION ARTIFICIAL NEURAL NETWORK

In this practical exercise, you create your own multilayer ANN with back-propagation training. The program is going to be structured from three classes: one for a neuron, one for a layer, and one for the neural network. The program uses the C standard template library to make life easier when dealing with dynamic arrays (vectors).

5.10.1 Step One: Coding the Neural Network Class and Associates

The include file for the ANN, which contains the class declarations, is shown in Listing 5.13. This code declares a neuron, layer, and neuralNet class. Besides a con-structor method, a neuron has a number of inputs, a threshold, an output, an error gradient, and two arrays—one to hold the weights and one to hold the inputs. A layer contains a constructor, the number of neurons in the layer, and an array for holding the neurons. Finally, the neuralNet class stores the total number of inputs, the total number of outputs, the number of hidden layers, a value for the learning rate (alpha), and an array of its layers.

LISTING 5.13 Program code for *NeuralNet.h*

```
#define getrandomFloat(min, max) ((rand())/(RAND_MAX + max) - \
        (rand())/(RAND_MAX + min))

#include <vector>
using namespace std;
```

```
class neuron
{
    public:
        neuron(int nInputs);
        int numInputs;
        double threshold;
        double output;
        double errorGradient;
        vector<double> weights;
        vector<double> inputs;
};

class layer
{
    public:
        layer(int nNeurons, int numNeuronInputs);
        int numNeurons;
        vector<neuron> neurons;
};

class neuralNet
{
    private:
        int numInputs;
        int numOutputs;
        int numHidden;
        int numNPerHidden;
        double alpha;   //learning rate
        vector<layer>  layers;
    public:
        neuralNet(int nInputs, int nOutputs, int nHidden,
            int nNeuronsPerHidden, double learningR);
        void initialize();
        vector<double> go(vector<double> &inputvalues,
            vector<double> &desiredOutput);
        void updateWeights(vector<double> &outputvalues,
            vector<double> &desiredOutput);
        void printWeights(FILE *output);
        int step(double activation);
        int sign(double activation);
        double sigmoid(double activation);
        double linear(double activation);
};
```

Next, each of the class's methods should be written. The first method is the constructor for the `neuron`. The constructor accepts the number of inputs as an argument and populates the weight array with random values, as follows:

```
neuron::neuron(int nInputs)
{
    double weightRange = 2.4/nInputs;

    threshold = getrandomFloat(-weightRange,weightRange);
    numInputs = nInputs;

    for(int i = 0; i < nInputs; i++)
    {
        weights.push_back(getrandomFloat(-weightRange,weightRange));
    }
}
```

The layer constructor simply accepts the number of neurons to be created for the layer and the number of inputs for each neuron. (Note that each neuron in a layer has the same number of inputs.) The constructor creates each neuron by calling the neuron constructor method and adds the neuron to the layers neuron array, as follows:

```
layer::layer(int nNeurons, int numNeuronInputs)
{
    numNeurons = nNeurons;
    for(int i = 0; i < nNeurons; i++)
    {
        neurons.push_back(neuron(numNeuronInputs));
    }
}
```

The constructor for the `neuralNet` accepts as arguments the number of inputs, the number of outputs, the number of hidden layers, the number of neurons in each hidden layer, and the learning rate. Each of these values is assigned to a `neuralNet` property. Following this, the neural network is initialized, which creates each layer, which in turn creates its own array of neurons. The `neuralNet`'s layers are placed in an array. The code for this constructor follows:

```
neuralNet::neuralNet(int nInputs, int nOutputs,
    int nHidden, int nNeuronsPerHidden,
    double learningRate)
{
```

```
numInputs = nInputs;
numOutputs = nOutputs;
numHidden = nHidden;
numNPerHidden = nNeuronsPerHidden;
alpha = learningRate;

if(numHidden > 0)
{
    //first hidden layer accepts
    //the inputs and therefore the
    //number of inputs is the same as for the ANN
    layers.push_back(layer(numNPerHidden, numInputs));

    for(int i=0; i < numHidden-1; i++)
    {
        //remaining hidden layers will
        //accept an input from
        //each neuron in preceding layer
        //therefore the number of inputs
        //to each layer is
        //equal to the number of neurons
        //in the preceding layer -
        //note:: each hidden layer
        //has the same number of neurons
        layers.push_back(layer(numNPerHidden, numNPerHidden));
    }

    //add the output layer with the number of inputs
    //to each neuron equal to the number
    //of neurons in the preceding hidden layer
    layers.push_back(layer(numOutputs, numNPerHidden));
}
else
{
    //if there are no hidden layers then the number of
    //inputs to the output will be
    //equal to the inputs to the ANN
    layers.push_back(layer(numOutputs, numInputs));
}
}
```

The next method to be included in the neuralNet class is the go() method. This method processes the forward feedback of the input values. Both sets of values are accepted by the method as arrays. The actual output from the neural network is

returned by the method as an array. Because the ANN is fully connected, every neuron in the first layer receives each of the inputs. For example, if the `inputValues` array has three values in it, then each neuron receives three values and, in turn, has three associated weights. The `outputValues` array stores outputs from each layer. As one layer is processed, the outputs from that layer go into the `outputValues` array. As the code moves to the next layer, the output values of the last layer become the input values for the new layer, hence, the `inputs` array is populated with values from `outputValues`, then `outputValues` is emptied and ready for a new lot of outputs from the new layer. The code follows:

```
vector<double> neuralNet::go(vector<double> &inputValues,
    vector<double> &desiredOutput)
{
    vector<double> inputs;
    vector<double> outputValues;
    int currInput = 0;

    if(inputValues.size() != numInputs)
    {
        return outputValues;
    }

    inputs = inputValues;

    for(int i = 0; i < numHidden + 1; i++)
    {
        if(i > 0)        //set inputs for this layer to
                         //the outputs from the last
        {
            inputs = outputValues;
        }
        outputValues.clear();

        for(int j = 0; j < layers[i].numNeurons; j++)
        {
            double N = 0;

            layers[i].neurons[j].inputs.clear();

            for(int k = 0; k < numInputs; k++)
            {
                layers[i].neurons[j].inputs.push_back(inputs[currInput]);
                N += layers[i].neurons[j].weights[k] * inputs[currInput];
                currInput++;
```

```
            }
            N -= layers[i].neurons[j].threshold;
            double t = sigmoid(N);
            layers[i].neurons[j].output = sigmoid(N);
            outputValues.push_back(layers[i].neurons[j].output);
            currInput = 0;
        }
    }

    updateWeights(outputValues, desiredOutput);
    return outputValues;
}
```

Before returning the calculated output values back to the calling program, the
go() method calls the updateWeights() method, which performs the back-
propagation of the error gradients and updates all the weights in the network. The
updateWeights() method works through the layers in reverse order, starting at the
output layer, and implements the back-propagation process as described earlier in
this chapter, as follows:

```
void neuralNet::updateWeights(vector<double> &outputvalues,
    vector<double> &desiredOutput)
{
    double error;

    for(int i = numHidden; i >= 0; i—)
        //for each layer back propagate
    {
        for(int j = 0; j < layers[i].numNeurons; j++)
            //for each neuron
        {
            if( i == numHidden )     //output layer
            {
                error = desiredOutput[j] — outputValues[j];
                layers[i].neurons[j].errorGradient =
                    outputValues[j] * (1—outputValues[j]) * error;
            }
            else
            {
                layers[i].neurons[j].errorGradient =
                    layers[i].neurons[j].output *
                    (1—layers[i].neurons[j].output);

                //put the sum of the
```

```
                    //next layers error gradients
                    //x the output
                    double errorGradSum = 0;
                    for(int p = 0; p<layers[i+1].numNeurons; p++)
                    {
                        errorGradSum += layers[i+1].neurons[p].errorGradient *
                            layers[i+1].neurons[p].weights[j];
                    }
                    layers[i].neurons[j].errorGradient *= errorGradSum;
                }
                for(int k=0; k< layers[i].neurons[j].numInputs; k++)
                    //for each weight
                {
                    if ( i == numHidden ) //output layer
                    {
                        layers[i].neurons[j].weights[k] +=
                            alpha * layers[i].neurons[j].inputs[k]
                            * layers[i].neurons[j].errorGradient;
                    }
                    else
                    {
                        layers[i].neurons[j].weights[k] +=
                            alpha * layers[i].neurons[j].inputs[k]
                            * layers[i].neurons[j].errorGradient;
                    }
                }
                layers[i].neurons[j].threshold += alpha * −1 *
                    layers[i].neurons[j].errorGradient;
            }
        }
    }
```

The complete code for the `neuralNet` class is in the Apocalyx/dev/src/ ON THE CD Chapter Five-4 folder.

5.10.2 Step Two: Up and Running

So now you have this multilayered back-propagating ANN, but what can you do with it? Before you go jumping head-first into navigational control or pattern and voice recognition, the best thing to do is test your ANN to see if it actually works. The simplest multilayer ANN is probably that to work out the XOR operation. Yes, this sounds very dull, but it illustrates the training and learning of an ANN with inputs and layers. The ANN to work out the XOR operation contains three layers: one input, one hidden, and one output. Although the input layer isn't really con-

sidered in the code, we include it in the discussion for completeness. The ANN has two inputs (x_1 and x_2) and one output (O_d), and is illustrated in Figure 5.22. The hidden layer has two neurons.

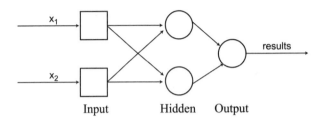

FIGURE 5.22 A three-layered network for solving the XOR operation.

The first thing to do is start a new file called *neuralNetTest.cpp*. This file must include *neuralNet.h* and be compiled with *neuralNet.cpp*. The program to test the neural network is very short and must include only a main function, as follows:

```
int main(int argc, char* argv[])
{
    vector<double> in, out, results;
    neuralNet n(2, 1, 1, 2, 0.1);
}
```

This main function declares three arrays: one to hold the input values, one to hold the desired output values, and one to hold the returned results. Next, the neural network is declared. The arguments to the neuralNet constructor, in order, specify two inputs, one output, one hidden layer, two neurons in the hidden layer, and a learning rate of 0.1. The neural network, n, is now ready to accept some input. However, before we continue, you should know what that input is. Because we are training the network to perform the XOR function, we must train it with data that represents that function, such as the truth table for XOR, shown in Table 5.7.

The values in Table 5.7 constitute a *training set* with four training values. Each training value is fed into the network one at a time. To run the first value, you should populate the in array with 1 and 1 and the out array with 0, as follows:

```
in.push_back(1.0);
in.push_back(1.0);
out.push_back(0.0);
```

TABLE 5.7 The Truth Table for the Logical XOR Operation

Inputs		Outputs
x_1	x_2	O_d
1	1	0
1	0	1
0	1	1
0	0	0

You can place this code after the declaration of n in the main function. Next, the first training session begins by calling the neural network's go() method, as follows:

```
results = n.go(in, out);
```

At this point, the results array contains the output from the neural network after one training iteration. You can print the contents of results using the following code:

```
printf("Result: %lf\n", results[0]);
```

The neural network is calculating only one output value; therefore, we only need to see what is in the first location of the results array. Save, compile, and run your program. If all went well, your output looks like the following line:

```
Result: 0.454897
```

If you get a different number, it is because either the ANN weights are assigned randomly and your computer has different weights than the ones used in this example, or you have a bug in your code. Let's assume the first for now. The result from the first test run of the ANN is the output from the output layer. This result is used to calculate the error value. In this case the desired output was a 0, and, therefore, the error would be $e = 0 - 0.454897 = -0.454897$. This value would have been used to calculate the error gradient that would have been back-propagated through the network to update the weights. What we would assume is that as the same training values were run through the neural network again and again, the result would get closer to the desired output each time. If you place a loop in your code around the neural network's go() method and print the result each time, you should see the

result getting closer to 0 with each iteration. You might include a loop like the following:

```
for(int i = 0; i < 10; i++)
{
    results = n.go(in, out);
    printf("Result: %lf\n",results[0]);
}
```

This loop gives you results similar to the following:

```
Result: 0.454897
Result: 0.450629
Result: 0.446415
Result: 0.442255
Result: 0.438150
Result: 0.434099
Result: 0.430102
Result: 0.426160
Result: 0.422271
Result: 0.418436
```

As you can see, the results are getting smaller each time, albeit the difference is very small. However, if you continued to loop, eventually the result would reach the desired value of 0 or get *close enough*. But, how close is *close enough*? Because the algorithm written for this neural network is attempting to minimize the error, we must run the training sets through the neural network until we are satisfied that the network has *converged*. This means the errors produced by the network are sufficiently small. The measurement used to determine if the network has converged is the sum of the squared errors. Therefore, for one run with each of the values in the training set (in this case, it would be four lots of values), each error is squared and added together. If the sum equates to a satisfactorily small value, let's say 0.001, then we can finish the training. You can implement the following piece of code into your program to run the entire training set through the neural network until convergence:

```
while(sumSquareError > 0.001)
{
    sumSquareError = 0;
    in.clear();
    out.clear();
    in.push_back(1.0);
    in.push_back(1.0);
```

```
        out.push_back(0.0);
        results = n.go(in, out);

        sumSquareError += pow(results[0] - out[0],2);

        in.clear();
        out.clear();
        in.push_back(1.0);
        in.push_back(0.0);
        out.push_back(1.0);
        results = n.go(in, out);

        sumSquareError += pow(results[0] - out[0],2);

        in.clear();
        out.clear();
        in.push_back(0.0);
        in.push_back(1.0);
        out.push_back(1.0);
        results = n.go(in, out);

        sumSquareError += pow(results[0] - out[0],2);

        in.clear();
        out.clear();
        in.push_back(0.0);
        in.push_back(0.0);
        out.push_back(0.0);
        results = n.go(in, out);

        sumSquareError += pow(results[0] - out[0],2);
    }
```

At this point the neural network is trained and you can test it using the go()
method on any of the training values. The results should be very close to being per-
fect.

EXERCISE

1. Run the neural network developed in this section with the training set from
 Table 5.7. How many iterations does it take to converge? After conver-
 gence, have the program print a truth table for XOR where the results from
 the neural network are displayed, rather than the ideal results. The output
 should look something like this:

x1	x2	result
1	1	0.014181
1	0	0.984968
0	1	0.981993
0	0	0.015770

2. The program you have just developed calculates and sets up the neural network with the correct weights to allow it to act as an XOR processor. However, when the program finishes running, all the weights are lost and the network must be trained again. Write a new method for the neuralNet class called storeWeights() that accepts as an argument a filename and stores the weights in the file.

3. Write a new method for the neuralNet class called retrieveWeights() that accepts as an argument a filename, retrieves the weights from the file, and assigns them to their correct neurons within the neural network.

4. Write two new methods for the neuralNet class, the first called storeNetwork(), which accepts a filename and writes all pertinent information about the network into that file including the number of inputs, the number of outputs, the number of hidden layers, the number of neurons per hidden layer, the learning rate, and the weight values. The second method is a new constructor that constructs the neural network given the name of the file the data was stored to in the storeNetwork() method.

This practical exercise introduced the programming and training of neural networks. An application of neural networks specific to the programming of NPCs is examined in Chapter 7 with respect to creating emotional behavior in NPCs.

5.11 SUMMARY

In this chapter we began by examining the use of a common AI technique in NPC programming (finite state machines) and discussed some enhancements (FuSM and PSM) to state machines that allow them to generate unpredictable behaviors more in line with humanlike performance. Following this, NPC movement was discussed in relation to navigating efficiently around complex environments from one goal location to another using the A* algorithm. Both FSMs and the A* algorithm are tried and true AI techniques that have been implemented as standard in many NPCs for some time.

The second half of the chapter concentrated on the complex AI techniques capable of programming learning and adaptation into NPCs. The topics covered were decision trees, evolutionary computing, and neural networks. These techniques can

be used in programming the behaviors of NPCs in complex environments where the programmer may not be aware of the optimal parameters that could be set. For example, in the genetic programming example, NPCs who were evolved could stay alive the longest in a particular environment. As an environment grows and the interactions between NPCs become complex, it is difficult to guess what the NPC's best preferences or actions will be. Although genetic programming and neural network techniques are used in game production, often they are not allowed to continue learning once the game has been released to the public because further evolution may create an NPC with erratic behavior. However, as more is learned about these techniques and ways to control their behavior, it is hoped that continuously learning NPCs will be unleashed on game players where the NPCs can further evolve through player interaction.

In the next chapter we examine the topic of NPC program structuring by discussing differing architectures used to emulate differing degrees of humanlike behavior and study where the techniques discussed in this chapter fit into the holistic view of an NPC's program.

REFERENCES

[AIJunkie03] AIJunkie, 2003, *Neural Networks in Plain English*, available online at *www.aijunkie.com/nnt1.html*, July 2003.

[Champandard02] Champandard, A. J., 2002, The Dark Art of Neural Networks, in *AI Game Programming Wisdom*, Rabin, S. (ed), Charles River Media, Hingham, pp. 641–51.

[Davis91] Davis, L., 1991, *The Handbook on Genetic Algorithms*, van Nostrand Reinhold, New York.

[Gould88] Gould, R., 1988, *Graph Theory*, Benjamin/Cummings Publishing Inc., Menlo Park.

[Haykin94] Haykin, S. 1994, *Neural Networks: A Comprehensive Foundation.* MacMillan College Publishing Company.

[Laramee02] Laramee, F. D., 2002, Genetic Algorithms: Evolving the Perfect Troll, *AI Programming Wisdom*, Rabin, S. (ed), Charles River Media, Hingham.

[Lefton94] Lefton, L. A., 1994, *Psychology*, Allyn and Bacon, Needham Heights.

[Minsky88] Minsky, M. and Papert, S., 1988, *Perceptrons—Expanded Edition*, MIT Press.

[Negnevitsky02] Negnevitsky, M., 2002, *Artificial Intelligence: A Guide to Intelligent Systems*, Pearson Education Limited, Harlow.

[Quinlan79] Quinlan, J. R., 1979, Discovering rules from large collections of examples: a case study, in Michie, D. (ed), *Expert Systems in the Microelectronic Age*, Edinburgh University Press, Edinburgh, Scotland.

[Rabin02] Rabin, S., 2002, Implementing a State Machine Language, in *AI Game Programming Wisdom*, (ed) Rabin, Charles River Media, Hingham.

[Rosenblatt58] Rosenblatt, F., 1958, The Perceptron: A Probabilistic Model for Information Storage and Organization in the Brain, *Psychological Review*, vol. 65, pp. 386–408.

[Rosenblatt60] Rosenblatt, F., 1960, Perceptron Simulation Experiments, *Proceedings of the Institute of Radio Engineers*, vol. 48, pp. 301–09.

[Russell95] Russell, S., and Norvig, P., 1995, *Artificial Intelligence: A Modern Approach*, Prentice Hall, Upper Saddle River.

6 Structuring an Intelligent Non-Player Character

In This Chapter

- Fundamental intelligent agent architectures
- Practical development of reactive, triggering, goal-based, and utility-based agents for game play
- Hybrid agents developed to emulate humanlike cognition and behavior applied to the development of NPCs

6.1 INTRODUCTION

Traditional games, such as *Chess*, *Solitaire*, and *Go*, lend themselves well to solutions provided with many established AI techniques, especially those based in searching. Today's computer games, however, are much more complex and present the player with a dynamic, simulated environment. This same environment is also the world in which the NPC lives and must survive. In Chapters 4 and 5, we examined numerous AI and knowledge representation techniques that can be used to program an NPC's cognitive abilities. These abilities are just one small part of the entire structure for a computer-generated and -controlled character. Integrating the *mental* component with other controlling mechanisms requires a conceptual structure that defines the NPC as a whole. In the realm of AI, such a structured artificial being is known as an *agent*.

The term *agent* has been popular in the computing domain since the mid-1990s. The term also has been associated more and more with computer games programming. With all the excitement into agent research and the ever-increasing presence of agents in gaming, the defining characteristics that separate agents from simple computer programs are frequently blurred. The earliest documented use of a simulation game is from the Roman Empire. Soldiers would simulate combat fight-

ing by practicing sword strokes on the trunks of trees. This practice evolved into practicing on wooden mannequins. Although disfigured and affected by its environment, the mannequin could not be considered an agent. This concept also holds true for computer games. Data structures that have been programmed into a game cannot be considered an agent when they are simply acted upon and do not react to their environment. Therefore, before examining the use of agents in computer games, we should agree upon a definition, because without a consensus, the term, as we fear, begins to lose all meaning and becomes indistinguishable from the term *program*.

The definition of an agent has inspired much controversy. However, one characteristic that is universally accepted is that of *autonomy*. Other characteristics of agents have differing importance in different domains. For example, AI researchers agree that *learning* would be a key characteristic of agents. However, as pointed out by Woolridge [Woolridge02], the clients of an air-traffic controller agent would be dismayed by the prospect that their agent might modify its behavior when run. To cater to the majority of application domains, Woolridge provides the general definition of an agent to be a computerized system existing autonomously in an environment with the ability to act on the environment to meet its goals. Further to this, Franklin and Grasser [Franklin96] add another characteristic that is fundamental in games—sensing and acting on a *temporal* scale. This characteristic means the agent possesses information about its past and present and can extrapolate its future states. Franklin and Grasser also suggest that being classified as an agent is fundamentally associated with the environment—change the environment and the agent may no longer be an agent. For example, an air-traffic controller agent placed in an environment devoid of air traffic is no longer an agent.

Programs and software agents are distinguished by two criteria: One, an agent's output or outward behavior affects what it senses in the future; and two, an agent demonstrates *temporal continuity*, by which we mean that over time it continues to function. It does not perform one task, shut down, and require reactivation to perform the task again.

An artificial agent is an entity that perceives its environment through sensors for the purpose of achieving prompt and sufficiently detailed orientation within the environment. It references the relevant aspects of that environment on the basis of jointly explicit, relatively restricted, stereotyped, and insufficient information. Then, through non-deterministic interaction, the agent achieves high precision in behaving to act upon that environment for its own purpose.

If the behavior of an agent is determined by its own experience and beliefs, it must be able to learn through interactions with its environment and, therefore, adapt its behavior to suit new situations. This would suggest that if the properties of the environment changed, the agent should be able to cope. In environments that are predictable and certain, where the complete state of the environment is known

(accessible), the future state of the environment is determined by past and current states (deterministic), the state of the environment does not change independently (static), and the environment has a finite set of observations and actions (discrete), such characteristics of an agent are not required. For example, the game of chess has an environment that is accessible, deterministic, static, and discrete. Is a chess program, therefore, not an agent? Not necessarily. If the program were written such that it could gather knowledge about playing the game from its past performance and observations of its opponent, then it would be classified as a chess-playing agent. However, chess software that personifies its human programmer and contains only the knowledge given to it by the programmer and, therefore, cannot adapt and create its own strategies, is simply a program.

6.2 GAME ENVIRONMENTS

The characteristics of the game environment have much to do with the type of agent that can successfully function within it. A game environment can be classified within five criteria: *accessibility, determinability, intermittence, changeability,* and *continuity.*

The accessibility of an environment is the extent to which players (both NPC and human) have access to the environment state. At one end of the scale an environment can be fully accessible, which means a player can acquire all available information about the environment. For example, *Chess* is an accessible game environment because both players can see the entire board and have knowledge of all the possible moves. Although an opponent's next move may not be known, this does not impact the accessibility of the environment because the opponent's cognitive processes are not considered a part of it until they affect its state. On the other end of the scale, an environment can be inaccessible. An RTS game is inaccessible at the beginning if the map is totally hidden until the player uncovers the terrain as he moves about. There is much controversy about the accessibility of an environment to the NPC and its ability to cheat. Because an NPC is essentially part of the game program, it can have access to the internal workings and status of the environment. Often it is more efficient and computationally wise to create a cheating NPC rather than create elaborate AI systems that allow it to read the environment. At the risk of entering this debate, a trade-off between the NPC's abilities and cheating must be reached to create the best NPC for a particular game. If the human player cannot determine whether an NPC is cheating, does it really matter?

The determinability of an environment refers to a player's ability to predict the next state of the environment, given the current state. A deterministic environment is one in which the player can be certain of how the environment will change in the

future. In a FPS game, if the player chooses to fire his weapon, he knows that after he presses the appropriate button, the weapon will fire. In a nondeterministic environment, there is an element of uncertainty as to what will happen next. Games that involve dice rolling, such as *Dungeons and Dragons*, are nondeterministic, because the player cannot be sure what the result of the dice toss will be and how the environment will change. NPCs that exist in a deterministic environment are much easier to program because each future state of the environment can be catered to in the form of many rules in the knowledge base that cover the full range of possible interactions.

Intermittence refers to the episodic nature of an environment. An episodic environment is one in which the player does not need to plan ahead because his interactions occur in mutually exclusive installments, where actions in one installment do not affect others. It is actually quite difficult to think of a game that is episodic because it wouldn't be a game if the present did not affect the future, where some kind of planning is involved. Can you think of any? In a nonepisodic environment, the actions of the player at any time will affect the quality of his game playing in the future. For example, a bad move in an RTS that causes the loss of many valuable units affects how the player continues to play.

The changeability of an environment is defined by its static or dynamic characteristic. A static environment does not change when the player is deliberating. For example, in a strategy game in which each player takes turns, such as *Warlords*, the state of the environment remains the same while the player decides what to do next. On the other hand, a dynamic environment can change regardless of what the player is doing. For example, in *Quake III Arena*, other players and bots do not stand around while a player makes up his mind about what to do. Developing an NPC to deal with a dynamic environment is a complex task because it must plan its actions but also take into consideration the changing environment while it is planning. Therefore, by the time a plan has been formulated, it may be obsolete.

The final characteristic of an environment is its continuity. A continuous environment is one in which the range of actions and environment states can change through a range of continuous values. For example, *Project Gotham* provides a continuous environment because the speed and position of cars on the track are defined by continuous values. On the other hand, an environment may be discrete when it has a finite number of player actions and environment states. *Poker*, for example, is a discrete game.

As you might expect, the most complex type of environment to develop an NPC for would be one which is inaccessible, nonepisodic, dynamic, and continuous. Unfortunately for the games programmer, most modern-day computer game environments can be defined as such. What is the allure of these games? They attempt to replicate the unpredictable and cognitively challenging real world. These environments excite and challenge the human player, whose cognitive abilities are

honed by the real world, but they can be a nightmare for the NPC programmer (so what if they have to cheat a little?), especially when only five to 10 percent of CPU time is available for the AI processes within a game.

EXERCISE

1. Make of list of 10 of your favorite computer games. Classify each of them with respect to accessibility, determinability, intermittence, changeability, and continuity.
2. Discuss which characteristics of a computer game environment could be compromised in allure if NPC cheating is allowed.

6.3 AGENT ARCHITECTURES

Over the years many and varied designs for agents have been created in the AI community. Many build on the fundamental concepts of providing agents with autonomy, social abilities, reactivity, and pro-activeness, conceptualized using human-specific models [Woolridge95]. Agents are created for a plethora of applications. In developing an agent to act as a gaming NPC, we are particularly interested in designing a structure suitable for supporting humanlike behavior. An *architecture* is simply a name given to the blue prints of an agent, which visually represents the components or modules and the connections between them. According to Travis [Travis00], an architecture for an NPC should:

- be highly reusable, with emphasis on human performance and characteristics
- incorporate sophisticated AI mechanisms for selecting and controlling actions
- emphasize human limitations and temporal constraints
- be able to turn off human attributes not relevant to the current gaming application

In addition to these traits, the architecture for an NPC should consider the tasks that are repeatedly executed during game play. We refer to the recurring tasks—perception, inference, selection, and behavior—as the NPC's *intelligence loop*. Perception is the means by which the NPC reads the state of its environment, interprets it, and adds it to its knowledge base. Inference, as discussed in Chapter 4, refers to the method of processing newly acquired rules and facts to make deductions. Selection is the technique used to decide the NPC's next move. Behavior is the outward performance generated as a result of the three preceding tasks.

In the next sections we examine several agent architectures and examine their use in NPC creation.

6.3.1 Reactive Agents

The simplest agent architecture is the *reactive* (sometimes called *reflex*) agent. These types of agents work on the most primal principle of human cognition—*stimulus-response theory*. Initially a conjecture proposed by the Behaviorist school of psychology [Watson28], stimulus-response theory attempts to explain all human behavior as a series of perceived stimulus followed by a behavioral response. The theory also includes a reinforcing stimulus that reinforces the behavior and is the reason for the response.

Being as simple as it is, the reactive agent architecture makes no promise of modeling the entire mind of a human; rather, it attempts to represent quick-thinking instinctual behaviors. For example, when confronted by a large, fast-moving object you instinctually attempt to get out of its way, even if you later find out it was just a beach ball. The reactive agent architecture emulates the thought processes that seem to be habitual and do not require deep and reflective thought.

We define the reactive agent architecture (and all following architectures) in modules devoted to the agent task of perception, inference, selection, and behavior, as shown in Figure 6.1. The perception module attempts to sense the environment, and any stimuli are converted into percepts, which are in line with the agent's ontology. The percepts are fed into the inference module, which performs a rule-matching operation to update the knowledge base and determine the agent's next action. The selection module orders the actions produced by the inference module. The actions are then performed in sequence by the behavior module. In traditional AI, a reactive agent isn't as complicated because it does not include a selection module, and the first rule matched by the inference module is used as the next action.

For example, consider a reactive agent in a simple simulated environment. Let's assume the agent is guarding an area of the environment, and the knowledge base contains the following rule:

Rule: *if hear(noise) then action(activate_alarm)*

This rule explicitly declares how the agent will behave in response to detecting certain stimuli. In this case, the agent receives external stimulus in the form of a noise and uses this information to decide what its own state of action should be. If the agent hears a noise it sounds the alarm.

The intelligence loop for a reactive agent begins, as all intelligence loops do, with the perception module. Here, the external stimuli are sensed by the agent and converted into percepts. A percept is the internal representation the agent uses to symbolize what it has sensed and is defined in terms of the ontology. An example of human perception that denotes this process is the act of seeing and identifying an

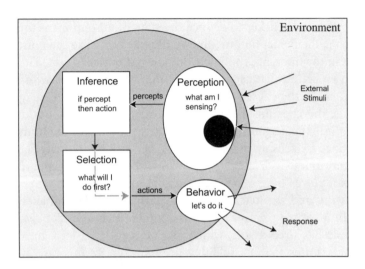

FIGURE 6.1 A reactive agent architecture.

object. Let's say three people see a four-legged furry creature with a wagging tail and some other familiar characteristics. The first person, who is English, converts the stimuli to the percept *dog*. The second person, who is German, converts the stimuli to the percept *hund*. Finally, the third person, who happens to be a two-year-old, has never seen such a creature before and may convert the stimuli to the percept *cow*. In the case of the first two people, who have obviously seen a dog before, they associate the visual representation of the dog with their vocabulary. In the case of the two-year-old, the percept is taken from previous percepts he has encountered and his vocabulary. In his world, a cow may be the closest thing that matches the description of the new creature, and, therefore, without being corrected, it is assigned that percept.

In the case of the agent, what the perception module senses must be converted into a suitable fact that can be asserted in the knowledge base. In this example, the only fact that causes a rule to fire is sound. If the opponent makes a sound, the fact

$$hear(noise)$$

could be asserted into the knowledge base, which would cause the rule to fire. How the perception module comes up with the fact depends on its programming. The agent might consider a noise to be heard if the opponent is moving and a specified distance away. The agent could ascertain this by accessing the internal states of the opponent. This behavior could be viewed as cheating because the agent hasn't detected a noise from the environment but rather by reading the mind of its opponent. Many games allow this type of access to other agent's properties because it is

far easier and quicker to deduce the state of an opponent this way. If this were not allowed, the perception module would have to sense the noise another way, and the rules in the inference module would have to cater to suit. The opponent would perform an action that caused a noise that was registered with the environment. The agent could then access this state to hear the noise. When agents are playing other agents, the cheating method may be a more efficient option; however, when the agent is playing against a human player, the state of the human player must be determined by sensing other attributes, because the human player does not explicitly set and unset his avatar's properties as he plays the game. For example, should a human player have good intensions in approaching the agent, the agent is not to know this and would still sound the alarm if the player makes a noise.

In a simple reactive agent, the intelligence loop concludes after the inference module has fired a rule, which can be translated into an action by the behavior module. Often the first rule that fires is taken. In this case, if the rule has fired, the fact *action(activate_alarm)* is instantiated. This rule is used by the behavior module to determine the outward appearance and actions of the agent and relies primarily on coordinating the agent's location within the environment, its animation sequences, and sounds.

Reactive agents react very quickly. The drawbacks, however, are that the programmer must foresee every possible environmental state and game event to create rules that will allow the agent to respond to them; the more complex the environment the larger the knowledge base; and they are incapable of long-term reasoning.

6.3.2 Triggering Agents

A triggering agent architecture is shown in Figure 6.2. A triggering agent is essentially the same as a reactive agent, the difference being that the triggering agent includes internal stimuli. The internal stimuli are taken from the agent's own characteristics. In other words, the agent is aware of the state it is in.

A rule for such an agent might look as follows:

Rule: *if hear(noise) and state(awake) then action(activate_alarm)*

where the agent uses information about its state to decide whether to sound the alarm when it hears a noise. By incorporating internal stimuli, a triggering agent can have past events influence its current behavior. For example, whether the agent is awake is an accumulative account of the agent's past. As the game runs, the agent may get sleepier with time until at some stage it falls asleep. If it is asleep, it is less likely to hear any noise made in the environment.

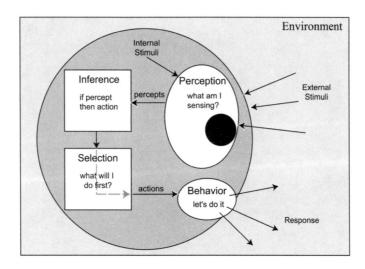

FIGURE 6.2 A triggering agent architecture.

Because a triggering agent uses the same intelligence loop, rule and fact knowledge base, and inferencing structure as a reactive agent, it, too, can make very fast decisions. Unfortunately, the triggering agent also succumbs to the same reactive agent drawbacks. The rules are hard-coded, and the more complex the environment the larger the knowledge base.

6.3.3 Goal-Based Agents

A goal-based agent architecture incorporates a set of preferred states that define the agent's goals and desires. Whereas a reactive agent has a direct association between a stimulus and a response, a goal-based agent must decide how a stimulus affects its own wants and desires and associated actions. This decision adds an extra reasoning step to the inference module. For example, the rules might present as follows:

Rule 1: *if hear(noise) then goal(alert_others)*
Rule 2: *if goal(alert_others) then goal(activate_alarm)*
Rule 3: *if goal(alert_others) then goal(use_radio)*
Rule 4: *if goal(activate_alarm) then plan(locate_alarm, move_to_alarm, sound_alarm)*
Rule 5: *if goal(use_radio) then plan(pick_up_radio, set_frequency, call_for_help)*
Rule 6: *if plan(x, y, z) then action(x), action(y), action(z)*
Rule 7: *if hear(alarm) then ¬goal(activate_alarm)*

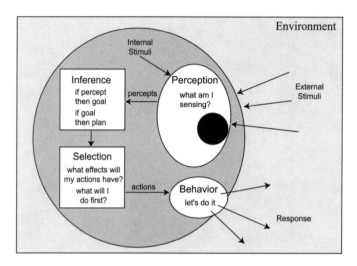

FIGURE 6.3 A goal-based agent architecture.

In this example, if the agent's current goal is *alert_others*, Rule 1 will have fired, providing it with a set of subgoals to execute (*activate_alarm* or *use_radio*), which in turn activate Rules 4 and 5. These rules demonstrate the fundamental difference between a reactive agent and a goal-based agent: the ability to execute a plan. While the agent is executing the plan in Rule 4, its goal always remains *activate_alarm*. When the action *sound_alarm* has been performed, the perception module notices a change in the environment state and, thus, updates the fact in the inference module using Rule 7. If for some reason the alarm was faulty and did not sound, the *activate_alarm* and, in turn, the *alert_others* and *use_radio* goals would still be active. In this case a second plan is available to the agent for attempting to satisfy the *alert_others* goal. A goal-based architecture is illustrated in Figure 6.3.

Both internal and external stimuli are used to motivate the agent, that is, to *trigger* a goal. An agent may have many goals but will not be working toward achieving them all at the same time. Many lie dormant until needed. As we have seen, the agent may have a number of plans that it could execute to satisfy a goal. To *obtain_health*, the agent might have the plans *use_medical_kit* and *drink_adrenalin*. Through the selection process the agent can decide which plan to execute. The goals and associated plans and actions can be represented in a goal hierarchy [Baillie02]. At the very top level in the hierarchy the goal is declared. This is then decomposed into a set of partially ordered subgoals that represent a plan. At the very bottom of the hierarchy the decomposed subgoals represent actions that can be translated by the behavior module into the agent's outward performance. A sample goal hierarchy for the *alert_others* goal is shown in Figure 6.4.

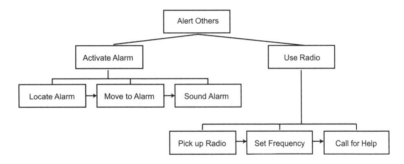

FIGURE 6.4 The goal hierarchy for *alert_others*.

The goal hierarchy in Figure 6.4 gives two plans for satisfying the *alert_others* goal. Having identified them, the agent would select one of the plans to execute. A pure goal-based agent has no means of assessing which plan is better and, therefore, usually uses the first calculated plan. If the first plan cannot be completed (for example, the agent cannot locate the alarm), the next plan can be initiated. When *alert_others* is triggered, the subgoals *activate_alarm* and *use_radio* are also triggered, which in this case are mutually exclusive. Therefore, when one of the subgoals has been satisfied, both can be removed from the agent's goal list. In turn, *alert_others* will be considered satisfied and also removed. In addition, subgoals can be mutually inclusive. If this is the case, each subgoal must be satisfied before the parent goal is complete.

The advantage of the goal-based agent over the reactive and triggering agents is its ability to plan and replan. In addition, when more plans become available for satisfying an existing goal, they can easily be added to the knowledge base without extensive reprogramming. The only drawback with a goal-based agent is its inability to identify which plans are better than others for satisfying the same goals. A goal-based agent is also proactive. Instead of *waiting* for something to happen, it *causes* something to happen.

6.3.4 Utility-Based Agents

A utility-based agent introduces the concept of utility (as discussed in Chapter 3 in the section about games theory) to the goal-based agent architecture. As was made evident in the previous section, a pure goal-based agent has no preference over which plans it is executing. First, an agent may have many active goals. How does the agent decide which goal it should currently be working toward? In an ordinary goal-based agent, this decision is made on a first-come-first-served basis. However, what happens if a more important goal arises? In normal human behavior, we would predict that the current goal would have to be placed on the back burner while the more important goal took precedence. A utility-based agent can achieve

this by placing a utility value on the goal. This utility value can be anything that could classify one goal as more important than another goal and can change over time (such as safety, profitability, urgency, and so on). For example, in the simple fighting game from Chapter 3, the NPC's health was used as a utility value. When health was high, the NPC preferred to attack, and when health was low, the NPC preferred to retreat. The utility value can also be applied to the agent's actions. In the previous section, an agent could satisfy the *alert_others* goal by executing the plan of actions for *activate_alarm* or *use_radio*. Rather than picking the first available plan to execute, a utility-based agent can select the more preferential plan. For example, the alarm might be further away than the radio; therefore, the agent can place a higher preference on using the radio to call for help.

Because utility is used as a selection method among goals and actions, the utility values are used by the agent's selection module to order the goals and actions from most important to least important. Utility, as we have seen in the NPC's health example, can also be based on the agent's state, and, therefore, the internal stimuli are needed by the selection module during the decision-making process. The architecture for a utility-based agent is displayed in Figure 6.5.

As a goal-based or utility agent's goal hierarchy becomes more complex, the computational time needed to devise a plan becomes longer. When the inference and selection module, which perform the planning, are called from the agent's update() method, they can run until complete, thus the longer the planning

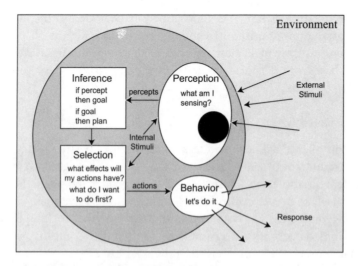

FIGURE 6.5 A utility-based agent architecture.

process the longer the update()method is held up before continuing to the next game loop. In high-speed, dynamic environments, this type of processing is less than desirable. By the time an agent devises a plan, the environment could have changed considerably and the plan may no longer be relevant. What is needed is an agent architecture that can integrate spontaneous decision making with goal planning, such that the agent always has a plan available within a limited amount of processing time. In other words, we want to place a processing time limit on the inference and selection modules.

6.3.5 Anytime Agents

An agent that places limitations on internal processes and has a plan ready at all times is known as an anytime agent [Nareyek02]. In the update() method for such an agent, a time limitation is placed on the inference and selection modules that keeps their processing within acceptable time limits. The architecture for an anytime agent is illustrated in Figure 6.6.

The key to the success of the anytime agent is that it always has a plan on hand, no matter how much processing the inference and selection modules have achieved in the allotted time. This limited processing can also be advantageous because the agent may not have to compute an entire plan that may at some later time become irrelevant. For example, if the agent were to satisfy the goal *activate_alarm* in the

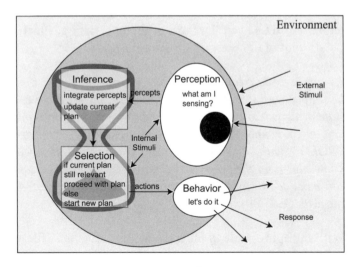

FIGURE 6.6 An anytime agent architecture.

first update, it may have time to compute only the first step, *locate_alarm*. Having carried out this action, the agent may perceive from the environment that the alarm has already been sounded. Therefore, it can abandon the *activate_alarm* goal without having wasted its time computing the rest of the plan. Although it is unlikely that a simple plan such as this would not be computed within one intelligence loop, it is used here to illustrate the concept.

6.4 DAY OF RECKONING: IMPLEMENTING AN INTELLIGENCE LOOP

In this practical exercise you learn how to turn a conceptualized agent architecture into a working NPC. The NPC that you create uses PROLOG for the agent's knowledge base.

ON THE CD

The initial project file for this exercise is located in the /Apocalyx/prj/Chapter Six-1 folder. After compiling the project for the first time, you will see an NPC marching back and forth diagonally across the map.

The first type of NPC that we create is a simple reactive agent. The NPC marches back and forth across the map between two waypoints, as if patrolling an area. When the player's gun is fired (by right-clicking), a noise is registered with the environment and picked up by the NPC. On hearing a noise, the NPC runs to the alarm and turns it on.

6.4.1 Step One: Creating the Knowledge Base

As mentioned previously, the NPC's knowledge base is constructed in PROLOG. Therefore, PROLOG handles most of the inferencing, which means that you won't have to do a lot of unnecessary programming.

NOTE

As you begin to create this bot, you will probably start thinking, "This could have been done with if-then statements," which, in fact, is true. In addition, the if-then statements would probably involve a lot less programming. However, we assume you already know how to do that. Therefore, by learning how to integrate PROLOG with a C/C++ program, you can see the benefits of separating the knowledge from the program. When the bot has been created more rules and facts can be added to the knowledge base without having to reprogram and recompile the actual C/C++ code.

With the appropriate *.h* file included in the *AIBot.h* file and a variable pointing to the PROLOG engine already included, your first step in setting up the knowledge base is to initialize it in the AIBot::initialize() method, as follows:

```
//set environment variable to installation
//directory of SWI-PROLOG
putenv("SWI_HOME_DIR=d:\\PROLOG\\");
//Initialize the SWI-PROLOG Engine
plEngine.initialize("d:\\PROLOG\\");
//load the rules and facts
loadPL("kb.pl");
```

The code shown in bold is where your code might differ. These parts should indicate the directory into which you installed SWI-Prolog in Chapter 4. The loadPL() function loads the PROLOG code from a file (in this case *kb.pl*) into the PROLOG engine and compiles it ready for use. Ensure that your PROLOG code file is in the same directory as your program code; otherwise, you must specify the absolute path. The initial contents of *kb.pl* should be:

```
:- dynamic (action/1).
:- dynamic (hear/1).

action(patrol) :-
    not(hear(noise)).

action(activate_alarm) :-
    hear(noise),
    not(hear(alarm)).
```

The initial rules specify that if the bot cannot hear a noise, its action should be to patrol. If the bot hears a noise and the alarm has not already been turned on, the alarm should be activated.

ON THE CD

All necessary *include* and *library* files pertinent to integrating SWI-Prolog with your program are located in the /Apocalyx/dev/src/SWI-Prolog folder. The extra *DLL* files are included in the working directory for your program. Links to the appropriate files already exist in the initial project for this exercise.

At this point you can save and compile your program successfully. It won't have changed the behavior of the bot; however, you will know that you have the knowledge base set up correctly.

TIP

When you start modifying the rules and facts in the PROLOG code file, any compilation errors made by the PROLOG engine will not be evident from within your C/C++ program. If you are unsure about your PROLOG code, try opening it in the SWI-Prolog interface. You can interact with it in the interface using the same methods taught in Chapter 4.

6.4.2 Step Two: Creating an Intelligence Loop

The intelligence loop consists of four modules: perception, inference, selection, and behavior. For each of these modules we create a separate method within the AIBot class and call them from AIBot::update(). The perception() method accepts a vector of the environment's states. The data type for States is defined in *vh.h*, and the vector is initialized in *vh.cpp*. Basically, the vector is an array of strings where each string specifies an environmental state. In this case, during the course of the program the vector might contain the following:

```
hear(noise)
switch(alarm)
```

The perception() method loops through this vector and asserts the environment states into the knowledge base using the assertPL() function defined in *../SWI-Prolog/prolog.h*. When new facts are asserted into the knowledge base, the PROLOG engine processes them as it would if you were typing them into the SWI-Prolog interface and fires any appropriate rules. For example, if the fact hear(noise) is asserted, the second rule in the *kb.pl* file is activated and action(activate_alarm) is instantiated. The code for perception() follows:

```
void AIBot::perception(States l)
{
    //assert environment states
    for( States::iterator i = l.begin(); i != l.end(); ++i )
    {
        assertPL((*i).data());
    }
}
```

The inference() method queries the knowledge base for rules in the format action(X). For this simple reactive agent, the first action found is used. For example, if the knowledge base contained:

```
action(patrol).
action(eat).
action(activate_alarm).
```

the inference() method would set the action to "patrol." The code for this method follows:

```
void AIBot::inference(char *action)
{
```

```
int arity = 1;
PlTermv t(arity);
PlQuery q("action",t);

if(q.next_solution())
{
    strcpy(action,(char *) t[0]);
}
}
```

In the preceding code, the variable `arity` refers to the number of terms inside a predicate. For example, `action(patrol)` contains one term (patrol), and `parent(tom, joe)` contains two terms (tom and joe). The `PlQuery` class creates a query, which in this case is the same as typing `action(X)` at the SWI-Prolog console. The variable `t` is an array, `arity` in size, holding the returned terms. `action(patrol)` `t[0]` contains "patrol." If the query were about parents and the fact `parent(jenny, bill)` existed, `t[0]` would be "jenny" and `t[1]` would be "bill." `q.next_solution()` runs the query. It returns true while there are more matching predicates and false when there are none. In this example, all actions could be found by placing `q.next_solution()` inside a `while` loop. However, because we are only interested in the first action found, an `if` loop has been used.

The `arity` set in `inference()` must match the number of terms inside the brackets of the predicate. Otherwise, your program returns an error when trying to run the query. Therefore, if you change the predicate of the query, be sure to check the setting of the arity. You also find a reference to arity in the PROLOG code file. At the top of kb.pl where the dynamic facts are declared, note the arity for each is included after a "/".

The selection method is not implemented in a simple reactive agent and, therefore, can be left empty for the time being, as follows:

```
void AIBot::selection()
{
    //nothing to see here
}
```

The method that processes the bot's actions into animations and movement around the environment is the `behavior()` method. For this example, the bot has two available actions: *patrol* and *activate_alarm*. While the bot is patrolling it should move back and forth between waypoints 0 and 1. The bot's speed is set to a casual 1, and the bot's leg animation is set to LEGS_WALK. When the bot's action turns to *acti-*

vate_alarm, the bot's behavior is to run to the location of the alarm, which has been set to be waypoint 2. When complete, the method returns a string representing the action taken by the bot. The behavior() method can be coded as follows:

```
string AIBot::behavior(char *action)
{
    if(!strcmp(action,"patrol"))
    {
        speed = 1.0;
        if(lowerAnim != LEGS_WALK)
            botAvatar->setLowerAnimation(lowerAnim = LEGS_WALK);
        if(currentWP == 0)
            waypointTravel(0,1);
        else
            waypointTravel(1,0);
    }
    else if(!strcmp(action,"activate_alarm"))
    {
        speed = 4.0;
        if(lowerAnim != LEGS_RUN)
            botAvatar->setLowerAnimation(lowerAnim = LEGS_RUN);
        waypointTravel(currentWP,2);
        if(currentWP == 2)
            return("switch(alarm)");
    }

    return "";
}
```

You may also notice a new property of the AIBot class used in behavior()—currentWP. currentWP is set to the waypoint through which the bot last passed. This method makes it is easier to keep track of where the bot is with respect to waypoints, rather than having to compare its physical location with all waypoints to determine its location each time you need to move it from one point to another.

Finally, each of the preceding methods that define the intelligence loop are called in order in the bot's update() method, as follows:

```
string AIBot::update(States env)
{
    perception(env);
    inference(action);
    selection();
    return(behavior(action));
}
```

This new `update()` method is passed to the vector of environment states from its call in `MainScene::update()` and returns the action string created by the `behavior()` method.

At this point you can save, compile, and run your code. The bot should continue to behave as before, patrolling the map. In the next step, the `hear(noise)` state is added to the environment, which causes the bot to activate the alarm.

6.4.3 Step Three: Handling Environment States

As previously mentioned the environment keeps track of its states in a vector called `envStates`, which is accessed by the bot. In this example, we allow the environment to record a sound occurring when the player shoots. The following code is from the `MainScene::update()` in *vh.h* where the bold line is to be added.

```
//Weapon Shooting Animation
if(glWin.isLeftButtonPressed() &&
    (avatar->getUpperAnimation() != TORSO_ATTACK))
{
    avatar->setUpperAnimation(TORSO_ATTACK);
    M3Reference linkTransform;
    if(avatar->getLinkTransform("tag_weapon",linkTransform))
    {
        shotEmitter->set(linkTransform);
        shotEmitter->moveSide(1*SCENE_SCALE);
        shotEmitter->setVisible(true);
        shotEmitter->reset();
    }
    envStates.push_back("hear(noise)");
}
```

To keep things uniform, the environment state is added as a PROLOG fact, which makes it simple for the bot's perception module to assert facts from the `envStates` vector directly into the knowledge base. After adding this line to the existing *vh.cpp* code, save, compile, and run. This time when you right-click to fire, the bot starts running to the far corner of the map where the alarm is located. Notice that it doesn't go directly there but travels via the existing waypoints. Remember, the waypoints allow the bot to avoid obstacles; and although there are none in the sample environment, the alarm could actually be down a hall and around a corner, which would make waypoint traversal imperative.

Finally, to spice up the program a little we add an actual alarm. In the previous section the `behavior()` method and, in turn, the `update()` method returns the string

"switch(alarm)" when the bot makes it to the alarm location. We add this string to the environmental states vector. Simply replace:

```
bot1.update(envStates);
```

in `MainScene::update()` with:

```
string s = bot1.update(envStates);
if(s != "")
    envStates.push_back(s);
```

We can now have the environment examine its own state vector to determine how it should be changed. Before we can add a sound we must define and initialize the appropriate properties. Sound in Apocalyx is controlled by the freely available sound API called Fmod. (see *www.fmod.org*.) All the links and hooks are already set up in the project for you. Be sure to include *fmod.dll* with your executable file. First, create the private properties, as follows:

```
FMSample    *alarm;
FMSound     *alarmSound;
```

in `class MainScene: public Scene`. Next, initialize the sound with the following:

```
alarm = zip.getSoundSample("alarm.wav");
alarm->setLooping(true);
alarm->setVolume(255);
```

in `MainScene::Initialize()`. As you can see, the sound file is taken from same Zip file that contains the bot models. The Zip file included with this project includes the file *alarm.wav*, which concludes the sound initialization. All that is left to do is activate the sound.

To compile Apocalyx with the appropriate links you must set up your compiler to include the preprocessor directive USE_SOUND. To do this in Visual C++, click Project > Properties from the menu, click C/C++ and type USE_SOUND into the text box marked Preprocessor Definitions.

Because other environmental states may affect the sounds or look of the environment, it is a good idea to include a new method that processes the environment states vector and adjusts the environment accordingly. Such a method can be written as follows:

```
void MainScene::processStates()
{
    int i;
    if( (i = findState(envStates,"switch(alarm)")) != -1)
    {
        alarmSound = alarm->createSound();
        alarmSound->play(255);

        //remove switch_alarm from environment states
        envStates.erase(envStates.begin() + i);

        //add alarm noise
        envStates.push_back("hear(alarm)");
    }
}
```

This new method can be called as the last line in `MainScene::update()`. Save, compile, and run the program. Now when your avatar shoots, the bot will run to the far corner and activate the alarm, which you should be able to hear.

EXERCISE

1. Add a shooting noise to accompany the clicking of the right mouse button.
2. When the bot activates the alarm, it remains in the far corner of the map. Have the bot chase the player's avatar after it has activated the alarm.
3. Have the alarm turn off if the player's avatar moves to the alarm location. When the alarm is off, have the bot resume its patrol until the player shoots again.

6.4.4 Step Four: Upgrading to a Triggering Agent

To create a triggering agent the agent must read its own internal states and add these as facts to the knowledge base. For this example, create the following property for the `AIBot` class and initialize it to 1.0 in the `initialize()` method:

```
float alertness;
```

As the bot patrols we want its alertness to diminish to a point where it needs to rest. To do this we simply decrease the value of `alertness` with each update while it is patrolling. When the alertness falls to 0, the bot must rest. While it is resting or asleep, the value of `alertness` will increase until it is considered to be awake again. We can do this in the `behavior()` method as follows:

```
string AIBot::behavior(char *action)
{
```

```
if(!strcmp(action,"rest"))
{
    speed = 0;
    if(upperAnim != BOTH_DEAD2)  //sleep
    {
        botAvatar->setAnimation(upperAnim = BOTH_DEAD2);
        lowerAnim = LEGS_IDLE;
    }

    alertness+= 0.001;
    return "";
}

if(upperAnim != TORSO_STAND)
    botAvatar->setUpperAnimation(upperAnim = TORSO_STAND);

if(!strcmp(action,"patrol"))
{
    speed = alertness;
    if(lowerAnim != LEGS_WALK)
        botAvatar->setLowerAnimation(lowerAnim = LEGS_WALK);

    if(currentWP == 0)
        waypointTravel(0,1);
    else
        waypointTravel(1,0);

    alertness-=0.001;
}
...
```

The bot's speed is set to the same value as its alertness. This setting makes the bot appear to slow down as it becomes tired. To change the rate of increase and decrease in alertness, change the incremental and decremental values in the preceding code to the desired values. In this case, we have the rate set to fast so the effects can be seen quickly when the program is run. When it receives an action to rest from the knowledge base, the bot will lie down while its alertness value is increased. But where does the rest action come from? It should be inferred by the inference() method. Therefore, the rules in the knowledge base must be updated to include a rest action. Modify the *kb.pl* file as follows:

```
:- dynamic (action/1).
:- dynamic (hear/1).
```

```
action(patrol) :-
   not(hear(noise)),
   state(awake).

action(activate_alarm) :-
   hear(noise),
   not(hear(alarm)),
   state(awake).

action(rest) :-
   not(state(awake)).
```

Next, the bot must perceive that it is tired to control the state(awake) fact in the knowledge base. In the perception() method add extra code to process the bot's internal states, as follows:

```
//assert internal states
if (alertness <= 0)            //sleep
    retractPL("state(awake)");
else if (alertness > 0.9)      //wake up when refreshed
    assertPL("state(awake)");
```

At this point, save, compile, and run the program. You will notice the bot starting out on its patrol, and its speed will rapidly decrease until it lies down to rest. After a short period of rejuvenation, the bot will jump up and resume its patrol. If you shoot while the bot is patrolling, you will notice the bot responds by running for the alarm as it previously did. However, if you wait until it is resting and shoot, the bot will not respond instantly because of the following rule:

```
action(activate_alarm) :-
   hear(noise),
   not(hear(alarm)),
   state(awake).
```

that insists the bot be awake to activate the alarm. What you will also notice is that if you shoot while the bot is asleep, once it awakes, it will immediately run for the alarm. The reason being that the hear(noise) fact is still in the knowledge base and will activate the preceding rule when the bot awakes. This, however, is not very realistic because the hear(noise) fact should exist only for a short while and then be removed from the environment states. We could add the fact for one update cycle, but doing so creates a problem. The bot's update() method is called before the shooting is processed in MainScene::update(). If the hear(noise) fact is removed from the environment state at the beginning of the next update, the bot will never

perceive the fact. Second, if the bot is allowed to perceive the fact and it is then removed from the environment state, the fact still exists in the bot's knowledge base and somehow must be removed without the bot processing it.

To prevent rules being added to the knowledge base when the bot is ignoring percepts (such as when it is asleep), we could skip the perception module when the bot is not awake. Although this process would work for this example, there might be more specific states when the bot will ignore some facts and accept others. Therefore, we should program the knowledge base with rules that know when to accept facts. Rather than explicitly assert new facts into the knowledge base, we create a rule in the knowledge base that decides when to accept facts, as follows:

```
ignoreAssert(Fact) :-
    state(awake),
    assert(Fact).
```

This rule can be called as a process from within the perception() method by replacing the existing code with:

```
void AIBot::perception(States l)
{
    //assert environment states
    char callString[SMALLBUF];
    for( States::iterator i = l.begin(); i != l.end(); ++i )
    {
        sprintf(callString,"ignoreAssert(%s)", (*i).stateStr.data());
        callPL(callString);
    }

    //assert internal states
    if (alertness <= 0)             //sleep
        retractPL("state(awake)");
    else if (alertness > 0.9)       //wake up when refreshed
        assertPL("state(awake)");
}
```

The callPL() function works to enter a command directly into the knowledge base in the same way that go() was called in the PROLOG example in Section 4.3.4. Once submitted to the knowledge base, the ignoreAssert rule fires with the given fact. Because a process can consist of any number of statements separated by a comma, the inference engine works its way down the list. If it ever hits a statement that equates to false, the process ends. In this example, if state(awake) is false, then the given fact is not asserted. Therefore, ignoreAssert only asserts rules when the bot is awake. You could also write more elaborate rules that accept percepts in some

cases and not in others. For example, when the bot is asleep it might be able to hear percepts but not see them.

In the previous code you can see the data structure for envStates has changed with the code (*i).stateStr.data(). The original way of representing environment states as a single string is inadequate for explaining how long a state should persist. In the case of hear(alarm), the state should persist until the alarm is deactivated; however, for the hear(noise) state, it should persist only for a few update cycles. This way the player can shoot while the bot is asleep and when the bot awakes it will be none the wiser. The new data structure for the envStates is:

```
struct state
{
    string stateStr;
    int length;
    state(string str, int len):stateStr(str), length(len){}
    ~state() {}
};
```

where

```
typedef vector<state> States;
```

These changes should be made in *vh.h*. Next, because envStates has changed you must update parts of the code where it is referenced and processed because it no longer contains simple strings. In MainScene::update() the following changes must be made:

```
...
state s(bot1.update(envStates),-1);
if(s.stateStr != "")
    envStates.push_back(s);

if(avatar->getUpper().getStoppedAnimation() == TORSO_ATTACK)
    avatar->setUpperAnimation(TORSO_STAND);

//Weapon Shooting Animation
if(glWin.isLeftButtonPressed() &&
    (avatar->getUpperAnimation() != TORSO_ATTACK))
{
    avatar->setUpperAnimation(TORSO_ATTACK);
    M3Reference linkTransform;
    if(avatar->getLinkTransform("tag_weapon", linkTransform))
    {
```

```
            shotEmitter->set(linkTransform);
            shotEmitter->moveSide(1*SCENE_SCALE);
            shotEmitter->setVisible(true);
            shotEmitter->reset();
        }
        state n("hear(noise)",3);
        envStates.push_back(n);
    }
    ...
```

In the preceding code a length of −1 for the state's length indicates the state is persistent or always considered to be true until some other active interaction, such as the alarm being on. A length greater than 0 indicates the number of update loops the state for which it should exist before being removed from the envState vector. Each time MainScene::processStates() runs, it can now determine if a nonpersistent state is ready to be removed. This determination is achieved with the following code inserted at the beginning of the method:

```
//update temporally dynamic states
for( States::iterator j = envStates.begin(); j != envStates.end(); ++j )
{
    if( (*j).length > 0 )
        (*j).length—;
    else if ( (*j).length == 0 )
    {
        envStates.erase(j);
        j—;
    }
}
```

With this new code implemented you can save, compile, and run the program. Notice the bot now ignores your avatar's shooting when it is asleep, and when it awakes it does not run straight for the alarm.

6.4.5 Step Five: Upgrading to a Goal-Based Agent

The previous two bots were purely reactive in the sense that they perceived a state from the environment and reacted to it. The reactive bot responded straight away and the triggering bot responded only when it was awake. A goal-based bot should display a deeper level of intelligence, consisting of multiple goals with multiple plans made up of multiple actions in the form of a goal hierarchy. The structure of the goal hierarchy is programmed into the knowledge base.

When a goal-based bot queries the knowledge base for actions to perform, instead of receiving just one action, the bot should be prepared to receive a list of actions. To handle these, we create a vector to hold them. In *vh.h* the vector should be defined and declared as follows:

```
struct act
{
    string actionStr;
    act(string str):actionStr(str){}
    ~act() {}
};

typedef vector<act> Actions;
```

and

```
Actions actions;
```

is added as a new private property to the AIBot class. For now an act consists of only a describing string. Later we will add other variables. Next, we add a new method to help search through the actions vector to locate a given action:

```
int AIBot::findAction(string N)
{
    int count = 0;
    for( Actions::iterator i = actions.begin(); i != actions.end(); ++i )
    {
        if(!N.compare((*i).actionStr))
        {
            return count;
        }
        count++;
    }
    return -1;
}
```

The actions vector is populated by the inference method using the existing query. The if statement that returned the first action from a query is now converted into a while statement to return all actions returned by a query. Each action is inserted into the actions vector. Replace the existing if statement in inference() with:

```
actions.clear();        //empty actions vector
```

```
while(q.next_solution())
{
    strcpy(action,(char *) t[0]);
    if( findAction(action) == -1 ) //if action doesn't exist
    {
        act a(action);
        actions.push_back(a);
    }
}
```

Now that the bot is set up to handle multiple actions, the goal hierarchy can be coded in the knowledge base. Modify *kb.pl* to code the goal hierarchy shown in Figure 6.4 with the following:

```
:- dynamic (goal/1).
:- dynamic (plan/1).
:- dynamic (action/1).
:- dynamic (finished/1).
:- dynamic (hear/1).

%patrol goal ─────────────────
goal(patrol) :-
    not(hear(noise)),
    state(awake).

plan(patrol) :-
    goal(patrol).

action(patrol) :-
    plan(patrol).

%call for backup goal ─────────────────
goal(alert_others) :-
    hear(noise),
    not(hear(alarm)),
    not(finished(alert_others)),
    state(awake).

plan(use_radio) :-
    goal(alert_others).

action(pick_up_radio) :-
    plan(use_radio).
```

```
action(set_frequency) :-
    plan(use_radio),
    finished(pick_up_radio).

action(alert_others) :-
    plan(use_radio),
    finished(set_frequency).

plan(activate_alarm) :-
    goal(alert_others),
    not(finished(switch_alarm)).

action(locate_alarm) :-
    plan(activate_alarm),
    not(finished(locate_alarm)).

action(travel_to_alarm) :-
    plan(activate_alarm),
    finished(locate_alarm),
    not(finished(travel_to_alarm)).

action(switch_alarm) :-
    plan(activate_alarm),
    finished(travel_to_alarm),
    not(finished(switch_alarm)).

%rest goal ――――――――――
goal(rest) :-
    not(state(awake)).

plan(rest) :-
    goal(rest).

action(rest) :-
    plan(rest).

%insert facts only if awake ――――――――――
ignoreAssert(Fact) :-
    state(awake),
    retractall(Fact),
    assert(Fact).
```

With these rules, when the fact hear(noise) is added to the knowledge base and the bot is awake, the goal alert_others is instantiated. This in turn activates the

plans `use_radio` and `activate_alarm`. Each plan has three associated actions. Notice the actions fire in order as each is completed by including the fact `finished(X)` with preceding actions. Doing this ensures the actions are executed in order and only after the preceding action has been completed. To process these new rules the `behavior()` method should be updated to:

```
string AIBot::behavior()
{
    bool success = false;
    string envEvent = "";  //environment state change

    Actions::iterator i = actions.begin();
    string action;

    //keep looking until an action is successful
    //or action choices run out
    while( !success && i != actions.end())
    {
        action = (*i).actionStr;

        if(action == "rest")
        {
            speed = 0;
            if(upperAnim != BOTH_DEAD2)   //sleep
            {
                botAvatar->setAnimation(upperAnim = BOTH_DEAD2);
                lowerAnim = LEGS_IDLE;
            }
            alertness+= 0.001;
        }

        if(upperAnim != TORSO_STAND)
            botAvatar->setUpperAnimation(upperAnim = TORSO_STAND);

        if(action == "patrol")
        {
            speed = alertness;
            if(lowerAnim != LEGS_WALK)
                botAvatar->setLowerAnimation(lowerAnim = LEGS_WALK);

            if(currentWP == 0)
                waypointTravel(0,1);
            else
                waypointTravel(1,0);
```

```
                alertness-=0.001;
            }
            else if(action == "pick_up_radio")
            {
                success = false;
            }
            else if(action == "locate_alarm")
            {
                goalWP = 2;
                //set goal waypoint to alarm location

                assertPL("finished(locate_alarm)");
                success = true;
            }
            else if(action == "travel_to_alarm")
            {
                speed = 4.0;
                if(lowerAnim != LEGS_RUN)
                    botAvatar->setLowerAnimation(lowerAnim = LEGS_RUN);

                waypointTravel(currentWP, goalWP);
                if(currentWP == goalWP)
                    assertPL("finished(travel_to_alarm)");

                success = true;
            }
            else if(action == "switch_alarm")
            {
                envEvent = "switch(alarm)";
                assertPL("finished(switch_alarm)");
                success = true;
            }
            i++;    //get next action from vector
        }
        return envEvent;
    }
```

The new behavior module needs a behavior associated with each action that could be returned by the knowledge base. If a matching behavior is not found, the current code causes the bot to do nothing. (In this case it just walks on the spot.) The actions are taken from the actions vector in FIFO (first in first out) order. If the bot is successful at matching and performing a behavior with the given action, a successful flag is set to true, which halts the while loop and allows the program to

return to the main game loop. If an action is not successful, the next action is taken from the `actions` vector and processed. The `while` loop continues attempting actions from the vector until either one is successful or it runs out of actions. In this case, when the goal `alert_others` is activated, the actions, `pick_up_radio` and `locate_alarm` are added to `actions`. On the first loop, the behavior module tries to process `pick_up_radio` because it is first in `actions`. In the preceding code for `behavior()` we have purposely made the action `pick_up_radio` fail. This failure could signify that the bot does not know how to perform `pick_up_radio`, the bot dropped the radio, or something else occurred that caused the action to fail. When any action in a plan fails and stops the bot from proceeding to the next action in the plan, a new plan must be selected. At this point, the `while` loop grabs the next action in `actions`: `locate_alarm`. The behavior module can deal with this, and, therefore, the bot executes this action and asserts `finished(locate_alarm)` into the knowledge base, which then allows the action `travel_to_alarm` to be added to `actions` in the next `update` loop. When the `activate_alarm` plan has been completed, the environment makes the alarm sound, which causes `hear(alarm)` to be added to the bot's knowledge base during the next perception. The `alert_others` goal is removed from the list of facts because `hear(alarm)` must be false for the goal to be active. This, in turn, removes all plans and associated actions.

The beauty of representing plans as a sequence of individual actions is that once an action and the associated behavior code has been written, new plans that include existing actions can be easily created without a lot of reprogramming. For example, if a plan needed to be written that had the bot communicating the location of the alarm to another player via the radio, the plan could include the already-existing actions `pick_up_radio`, `locate_alarm`, and `set_frequency`. Therefore, if a complete list of behaviors is defined that uses the bot's set of animations, it could be incorporated into many plans. When a new plan is needed, it needs only to be added to the knowledge base—the C/C++ code can remain untouched. You could say the PROLOG code acts as a simple scripting language for the game engine.

EXERCISE

1. In the preceding example, when the bot activates the alarm it continues running on the spot at the alarm location. This occurs because the `hear(noise)` fact is still instantiated in the knowledge base and prevents the `patrol` goal from firing. Devise a method for removing the `hear(noise)` fact from the knowledge base, given that it is not a persistent environment state.

2. Complete the code in the behavior module to handle the plan `use_radio`. If you are feeling creative you might have a radio tuning and message relay sound play as each action is executed.

6.4.6 Step Six: Upgrading to a Utility-Based Agent

In the preceding section the bot could have two plans from which to select, in which case it would select from the actions vector using a FIFO method. However, the first action in the vector may not be a part of the *best* plan the bot could have chosen. How *best* is defined depends on the situation. When the bot is low in health, the best plan for a goal might be the one that raises its health the most or prevents it from getting any lower. If the bot needed to purchase something and it was low on money, the best plan would be the one that costs the least, or if the bot is in a hurry, the best plan would be the fastest one to complete. On the other hand, a goal can be assigned a utility value that informs the bot of the most important or urgent goal to work toward satisfying. For example, patrolling might be a very important goal, but as the bot is patrolling it could become hungrier and hungrier. At some point the desire to satisfy an eat goal may become more urgent than patrolling, and the bot might leave its post to find a snack. Whatever the measure used, it allows the bot to place a preference on a goal, plan, or action and is known as a utility value.

To modify the goal-based bot to become a utility bot, we must place a utility value of each goal, plan, and action. To do this, rewrite the knowledge base as follows:

```
:- dynamic (goal/2).
:- dynamic (plan/2).
:- dynamic (action/2).
:- dynamic (state/2).

state(working,0.5).

%eat goal ————————————————
goal(eat,X) :-
    state(hungry,X).

plan(eat,X) :-
    goal(eat,X).

action(eat,X) :-
    plan(eat,X).

%wash goal ————————————————
goal(wash,X) :-
    state(dirty,X).

plan(wash,X) :-
```

```
    goal(wash,X).

action(wash,X) :-
    plan(wash,X).

%patrol goal ─────────────────
goal(patrol,X) :-
    state(working,X).

plan(patrol,X) :-
    goal(patrol,X).

action(patrol,X) :-
    plan(patrol,X).

%rest goal ──────────────────
goal(rest,X) :-
    state(awake,X).

plan(rest,X) :-
    goal(rest,X).

action(rest,X) :-
    plan(rest,X).

%insert facts only if awake ─────────────────
ignoreAssert(Fact) :-
    state(awake,X),
    retractall(Fact),
    assert(Fact).
```

Notice the state, goal, plan, and action facts now have an arity of 2, where the second value represents a utility value. An example of this can be seen at the top of the knowledge base in the line state(working,0.5). In this case we assume values of utility between 0 and 1, where the closer the value is to 0 the more urgent the associated goal. The preceding knowledge base is simplistic compared to the previous ones. We keep it like this to demonstrate the use of utility with goal triggering. However, you could add more complex plans and actions as you see fit.

Now we add some new internal states to the agent: *alertness* (as before), *hunger*, and *hygiene*. These states can be added as float properties to the AIBot class. In the AIBot::initialize() method they can be set as:

```
alertness = 1.0;
hunger = 1.0;
```

```
hygiene = 1.0;
```

where we assume a value of 1 means that each of the states is satisfied. For example, a value of 1 for hygiene means the bot is clean and does not require a bath.

Next, the perception module should be modified to update the goal utilities in the knowledge base. The code should remove any existing facts with utilities and replace them with new ones. Previously, a fact such as state(awake) was added and removed as needed. Now the state fact will always exist, but the utility value will change. For example, one moment it might be state(awake, 0.56) and the next it might be state(awake,0.13). Because the utility values for these facts are different, they could both exist in the knowledge base at the same time. However, this situation could get confusing because we would not be able to determine which utility value is relevant. By implementing situation calculus, we can define a fact with a time factor, such as state(awake,0.13, 12:30pm), and then find the latest fact to determine the current bot state. Doing so would also allow us to reason about the bot's past states. However, in this example it greatly complicates things and is not necessary. The perception() method should therefore be updated to:

```
void AIBot::perception(States l)
{
    //assert environment states
    char callString[SMALLBUF];
    for( States::iterator i = l.begin(); i != l.end(); ++i )
    {
        sprintf(callString,"ignoreAssert(%s)", (*i).stateStr.data());
        callPL(callString);
    }

    //assert internal states
    char internalState[SMALLBUF] = "";
    sprintf(internalState,"state(awake,%f)", alertness);
    callPL("retractall(state(awake,X))");
    assertPL(internalState);

    sprintf(internalState,"state(hungry,%f)", hunger);
    callPL("retractall(state(hungry,X))");
    assertPL(internalState);

    sprintf(internalState,"state(dirty,%f)", hygiene);
    callPL("retractall(state(dirty,X))");
    assertPL(internalState);
}
```

Because the arity of the facts has been changed from 1 to 2, the `inference()` method must be updated, setting `arity` to 2 and processing 2 values in the `t` array. Inside the `while` loop, update the creation of the action and the vector placement to:

```
act a(action, atof((char *) t[1]));
actions.push_back(a);
```

where act is now defined in *AIBot.h* to be:

```
struct act
{
    string actionStr;
    float utility;
    act(string str, float u):actionStr(str), utility(u) {}
    ~act() {}
};
```

With the introduction of utility into the application, the selection module is now necessary to define the order in which actions should be performed, based on which goals are the most important. The ordering is easily achieved by using the `sort()` function on the actions vector. In this case, the ordering is achieved with a new function called `RankActions()`, which orders the actions in ascending order of the utility, placing the actions with the lowest utility values (more urgent goals) at the top. The `selection()` method now reads:

```
bool RankActions ( act elem1, act elem2 )
{
    return elem1.utility < elem2.utility;
}

void AIBot::selection()
{
    sort( actions.begin(), actions.end(), RankActions );
}
```

Finally, the behavior module should be updated to handle the new actions. Most of the code is similar to its previous state, with new lines inserted to increment and decrement the internal state values of the bot:

```
string AIBot::behavior()
{
    bool success = false;
```

```
            string envEvent = "";  //environment state change

            Actions::iterator i = actions.begin();

            //keep looking until an action is
            //successful or action choices run out
            while( !success && i != actions.end())
            {
                actionStr = (*i).actionStr;

                if(actionStr == "rest")
                {
                    speed = 0;
                    if(upperAnim != BOTH_DEAD2)   //sleep
                    {
                        botAvatar->setAnimation(upperAnim = BOTH_DEAD2);
                        lowerAnim = LEGS_IDLE;
                    }

                    alertness+= 0.01;
                    hunger-=0.00005;
                    hygiene-=0.00001;

                    success = true;
                }

                if(upperAnim != TORSO_STAND)
                    botAvatar->setUpperAnimation(upperAnim = TORSO_STAND);

                if(actionStr == "eat")
                {
                    speed = 4.0; //hurry to food
                    goalWP = 0;//location of food

                    if(currentWP == goalWP)
                    {
                        if(lowerAnim != LEGS_IDLE)
                            botAvatar->setLowerAnimation(lowerAnim = LEGS_IDLE);
                        hunger+=0.05;
                    }
                    else
                    {
                        waypointTravel(currentWP, goalWP);
                        if(lowerAnim != LEGS_RUN)
                            botAvatar->setLowerAnimation(lowerAnim = LEGS_RUN);
```

```
        hunger-=0.00005;
    }

    alertness-= 0.0002;
    hygiene-=0.0001;

    success = true;
}
else if(actionStr == "patrol")
{
    speed = alertness;
    if(lowerAnim != LEGS_WALK)
        botAvatar->setLowerAnimation(lowerAnim = LEGS_WALK);

    if(currentWP == 0)
        waypointTravel(0,1);
    else
        waypointTravel(1,0);

    alertness-= 0.0002;
    hunger-=0.00003;
    hygiene-=0.0001;

    success = true;
}
else if(actionStr == "wash")
{
    speed = 3.0;    //hurry to wash
    goalWP = 2;     //location of shower

    if(currentWP == goalWP)
    {
        if(lowerAnim != LEGS_IDLE)
            botAvatar->setLowerAnimation(lowerAnim = LEGS_IDLE);
        hygiene+=0.02;
    }
    else
    {
        waypointTravel(currentWP, goalWP);
        if(lowerAnim != LEGS_RUN)
            botAvatar->setLowerAnimation(lowerAnim = LEGS_RUN);
        hygiene-=0.0005;
    }

    alertness-= 0.0002;
```

```
            hunger-=0.00001;

            success = true;
        }

        i++; //get next action from vector
    }

    return envEvent;
}
```

In the preceding code, the increments and decrements for the internal states are purely arbitrary and can be changed as you see fit. At this point you may want to update the getBotDetails() method to report the current values for alertness, hunger, and hygiene. Updating these values allows you to see them changing by pressing F1 when the program is running. Save, compile, and run your program. You can see the bot patrolling the environment until it becomes tired, hungry, or dirty, at which time the bot's goals change and it takes up a different action.

There is an obvious problem with the current program. First, because the cutoff points for comparing goals are discrete, once a goal becomes more important than another goal, the current goal is abandoned. This may seem reasonable in principle, but it creates a problem where the bot can get stuck moving from one goal to another in quick succession. For example, let's say the bot's utility for patrol is 0.5 and the utility for eat is 0.6. In this case, the bot would be patrolling. When the utility for eat falls below 0.5, eating becomes more important and the bot will concentrate on the appropriate action. However, as the bot eats, its hunger level increases. After, say, one game loop the bot's hunger goes up to 0.6 again, making eating less of a priority than patrolling. The bot now begins patrolling again. If after another game loop the hunger falls below 0.5, eating will again be the priority. Can you see how the bot gets stuck between two goals without actually completing either? Ideally, what we want is for the bot to begin eating and for its hunger to increase to 1.0 before another goal is activated. This problem can be fixed by implementing a finite state machine and dictating the amount of time a bot should spend on an action. Alternatively, fuzzy logic could be integrated to define where the boundaries of the utility values lie that make one goal more important than another. Solving this problem is left as an exercise for you.

In this section we have examined the practical application of some basic bot architectures. As previously mentioned, the way in which the bot performs inferencing in a real-time game environment may have to be limited. The limitations can be achieved by implementing anytime programming. Because the utility-based bot in this section selects only one action from a plan at a time, it is limiting the way in which it accesses the steps of the plan and, therefore, will always have an action

available to it in the `actions` vector. Although not strictly a form of anytime planning, the code efficiently allows for action selection. The only problem that may occur could be when the `actions` vector is full of actions that are not achievable. To alleviate this, actions that are not achievable could be disallowed from being placed in the `actions` vector.

In the next section, several agent architectures and how they have been applied to create NPCs with anytime planning are discussed.

1. Not only goals can have utility values—plans and actions can as well. Consider a goal such as eat that might be satisfied by two individual plans: `cook_food` and `buy_food`. Let's say the bot prefers to cook its own food. How could you implement utility so it favors not only a goal but also a plan? Test your theory using your utility-based bot.

2. Building on Exercise 1, actions for plans may also have utility values. Consider the plan in Figure 6.7. Unlike previously examined plans, this plan has two paths to completion.

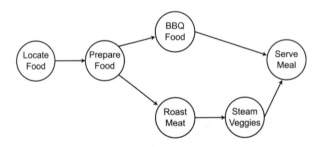

FIGURE 6.7 A plan with two paths to completion.

One subplan is to BBQ the food and the second is to roast it. Although the actions *Locate Food*, *Prepare Food*, and *Serve Meal* must be performed in order to complete the plan, *BBQ Food*, *Roast Meat*, and *Steam Veggies* do not. The plan could be written in first-order logic as:

```
Cook(Food) → Locate(Food) ∧
    Prepare(Food) ∧
    Serve(Meal) ∧
    (BBQ(Food) ∨
    (Roast(Meat) ∧ Steam(Veggies)) )
```

Devise a method for storing utility values with the actions such that one subplan is preferred over the other. Test your method using your bot. Next, attempt to use the bot's HUNGER state to determine which subplan it will follow. If the bot is extremely hungry it may prefer the plan containing *BBQ Food* because it is quicker. If the bot is not particularly hungry make it prefer the roasting option.

6.5 SPECIFIC GAME-PLAYING AGENT ARCHITECTURES

Over the years a number of researchers and game developers have come up with some interesting and complex agent architectures dedicated to solving problems faced by NPCs. Most of these architectures are known as *hybrid architectures* because they combine the qualities of reactive, triggering, goal-based, and utility-based agent architectures. Several of the architectures, some designed for specific tasks, and others general purpose, are briefly examined in this section. Due to the exhaustive number of architectures that exist, the discussion is restricted to a small selection of popular architectures to give you an overview of the research work being performed in this domain.

6.5.1 Soar: An Architecture of Human Cognition

Around 1980, Allen Newell (one of the founders of the AI field) and two of his students, John Laird and Paul Rosenbloom, began work on the Soar architecture to bring together partial theories of human cognition from fields such as psychology, anthropology, AI, and linguistics to create a *unified theory of cognition* (UTC) [Lehman96]. A UTC can be thought of as a complete theory of the way in which humans think by borrowing partially developed concepts from other research domains. The Soar architecture concentrates on six characteristics of human cognition [Newell90]. These characteristics suggest that human cognition is:

Goal-oriented: Human thought and behavior is not randomly occurring. Each of us has a particular set of goals. Our motivation to achieve these goals is determined by the urgency in which we work to achieve them. To achieve our goals, as illustrated in the goal hierarchy in a previous section, the planning process is goal-based, which suggests a goal-orientated train of human thought such that any cognition is ultimately aimed at achieving some goal.

A reflection of a complex environment: As we have discussed, the environment in which we live is inaccessible, nonepisodic, dynamic, and continuous. To operate in such a world our thought processes must deal with incomplete,

inconsistent, incorrect, and inaccessible information. Luckily, we manage to function just fine.

Based on significant quantities of knowledge: Most human acts seem to be performed without thinking. We usually call these kinds of behavior instinctual. However, if you think about daily activities that you perform without much cognitive effort, you may be amazed at how much knowledge is needed to complete them. For example, consider driving a car. The simple act of changing gears occurs without effort. However, imagine the processes taking place. Not only do you need to be attuned to when a gear change is necessary, but you also need to know how and where to move the gear stick, how to position your hand, wrist, and arm—all while depressing the clutch, trying to maintain your speed and watch the road.

Uses symbols and abstractions: Symbols and abstractions allow us to extrapolate appropriate behaviors and thoughts in new situations based on past experiences. It is a process by which we create stereotypes that categorize entities and situations we have experienced. For example, your car is represented internally as a car percept or symbol. When you see another car you can immediately recognize it as a car based on certain characteristics. These symbols allow you to abstract new situations such as driving other cars. Although you may never have driven any other car but your own, the experiences with your car and the stereotypical driving processes you know allow you to get into another car and start driving.

Is flexible and determined by environmental conditions: Ever heard the phrase "best laid plans gone astray"? This phrase refers to the fact that even the best thought-out plans can be hampered at any moment. Our cognitive process allows for such events and provides us with the faculties to plan and replan on the fly. Consider driving to work or university. Each day you take the same route because it is the quickest or most scenic. One day there is a bad accident on your route and you are required to change your route. The diversion occurs in the middle of your plan for getting to your destination because the environmental conditions have changed. However, you still manage to get to where you are going because you are able to replan your route as you drive.

A continual process of learning from dynamic environmental conditions and experiences: All of the past examples of human cognition don't come naturally. Although we are born with numerous intuitions, many tasks that seem instinctual were once unknown and required learning and practice (for example, driving a car or speaking in a particular language). As our environment changes we need to adjust our thinking and behaviors to suit. This adjustment requires the effort of learning to modify our behaviors to new situations and to achieve new goals.

The Soar architecture, illustrated in Figure 6.8, is based on a utility-based architecture. The agent's goals are generated in the working memory through perceptions from the outside world or internal stimuli generated by the long-term memory. The long-term memory is a set of production rules that defines the agent's knowledge. The values stored in the working memory are used to trigger the rules in the long-term memory. This process works in a similar way to the goal-based agents created in Section 6.4.5, where the program sends states to the PROLOG knowledge base and awaits triggered actions. Working memory also contains a list of operators that describe how one goal state can be transformed into another. These operators act as state transition functions. As with the goal-based agent, a Soar agent also has a set of dependencies that determine when and in what order rules can be fired. New production rules can be learned through a process called *chunking*. The process of chunking converts goal-based problem solving into production rules and inserts them into the long-term memory. Last, but not least, like a utility-based agent, a Soar agent has a list of preferences that it can use to order its goals and the associated actions.

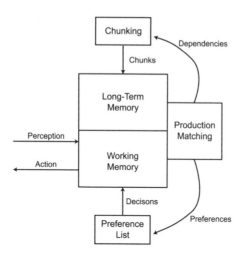

FIGURE 6.8 The Soar agent architecture.

Although the Soar architecture was not designed initially as a conceptual map for building an NPC, it has been used to create a bot that plays the death match version of *Quake II*. The Soar Quakebot [Laird00a] attempts to provide a human player with an adversary that has the same strengths and weaknesses as another human player. The knowledge required for playing a game of *Quake II* is written as production rules and stored in the bot's long-term memory. As the bot plays the

game it builds up an internal representation of the game map and the location of objects such as weapons, armor, and health. The Soar Quakebot discussed in [Laird00b] has 100 operators and 715 rules.

6.5.2 H-CogAff: A Real-Time Goal Orientated Humanlike Agent Architecture

The H-CogAff architecture, created by the Cognition and Affect Project at the University of Birmingham, is a three layered architecture designed to conceptualize a schematic theory of human information processing [Sloman01]. The H-CogAff architecture is illustrated in Figure 6.9.

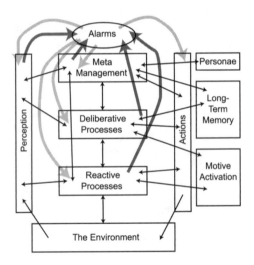

FIGURE 6.9 The H-CogAff agent architecture, adapted from [Sloman01].

As can be seen in Figure 6.9, data is freely distributed between the layers of the architecture, which allows for the monitoring of the timeliness of the agent's decisions with respect to the speed at which the environment changes. A purely reactive alarm system allows for quick decisions to be made when extra processing time is unavailable. As such, it implements concepts used in anytime agent architectures. The reactive layer works as a pure reactive agent that processes internal and external stimuli and produces fast and crude responses. The deliberative layer supports a more goal-based orientation to reasoning about its actions by making decisions based on how they will affect the agent and the agent's environment. The meta-management layer provides self-reflection and self-monitoring of internal states.

This layer provides mechanisms that allow the agent to evaluate how it is acting and give it the opportunity to change its own thinking. The personae module describing the agent's personality can be programmed to create differing behavior in agents (such as passive or aggressive). All of the layers and alarms operate concurrently, meaning that no layer ever has total control over the agent's decision making and associated actions but allows for the agent to operate and react quickly in a dynamic environment.

In considering using the H-CofAff agent as the basis for an NPC, we must consider how it will react in a dynamic real-time game environment. First, we want the NPC to be proactive in that it will decide to hunt down its opponent rather than wait around to be shot first. Second, the NPC must be able to react to changes in its environment within limited processing time while considering how its actions will affect itself, other players, and the environment. The basic element to providing this type of processing is planning. It is proposed within the H-CogAff architecture to modify the way in which information is structured within the NPC for faster access when reasoning about planning [Hawes00]. One proposed method is to structure available information as plan waypoints. These waypoints work in a conceptually similar manner to navigation waypoints, where efficient search algorithms, such as A*, could be used to generate plans in a reasonable time. Each node of the plan would represent an action through which the agent must pass to complete the plan and satisfy an associated goal. By structuring plans in this way, the agent need process only small sections of the plan at any time, which speeds the planning process and also reduces the amount of generated future actions that may become invalid as the environment changes.

6.5.3 The EXCALIBUR Project

The objective of the EXCALIBUR project is to develop a generic agent architecture for the building of autonomous agents that can operate in a complex computer game environment [Nareyek02]. The EXCALIBUR architecture concentrates on anytime planning and the associated considerations of generating such plans in a game-specific environment. These considerations include:

Temporal scheduling: In generating a plan, the process must consider how the environment and the NPC's state changes with time. For example, the duration of an action should be considered when determining the validity of a plan with respect to the rate of change in the environment.

Environmental resources: Most games, in particular FPS games, contain resources such as health, weapons, armor, food, and tools. NPCs (and human players) have an objective to be motivated to obtain these resources for their

use. The location of these resources and the NPC's desire to obtain them should be integral in any planning process.

Incomplete knowledge: As we have pointed out many times before, a complex game environment is inaccessible, which means that an NPC has incomplete knowledge of its states. Initially, plans must be devised that consider what the agent does and does not know. These plans, however, must be flexible enough to be updated as new information comes to light.

Domain-Specific knowledge: Although generic planning systems can be easily developed, once in production it is desirable to be able to apply them to differing game domains. The ability to integrate such a planning system with a game-specific ontology can make or break a successful planning algorithm.

The planning process for the EXCALIBUR architecture is illustrated in Figure 6.10. In brief, an agent constructs a plan within a limited amount of processing time and outputs the agent's actions. On each iteration, the data sensed from the environment is used to adjust the current plan to suit the agent's current situation. Once the plan has been completed, it undergoes a repair process that applies constraints to the devised plan to improve is efficiency and potential outcomes.

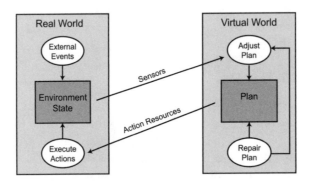

FIGURE 6.10 The EXCALIBUR planning process, adapted from [Nareyek02].

6.5.4 being-in-the-world: An Agent Architecture of MUDs

being-in-the-world is an agent architecture designed to survive within a multiuser dungeon (MUD) environment. The survival of this agent means that it must be able to navigate the dungeon; avoid hazards such as hunger, thirst, and hostile NPCs and human players; collect resources such as gold; purchase equipment; and gain experience to become a worthy adversary.

being-in-the-world is a two-level hybrid agent architecture that consists of a reasoning module called *Descartes* and a real-time coping module called *Heidegger*. Both modules run in parallel and communicate through a queue of goals and the environment ontology. Structuring the architecture in this way allows it to be applied to MUD environments in which it should be able to develop runtime strategies and achieve timely inferencing.

The Descartes module is the architecture's planning layer. Given a set of production rules that describe the environment, from high-level goals to low-level goals, the module, using the current world state, can devise a plan of low-level goals to be completed. These plans are communicated to the Heidegger module, which forms the plans into concrete actions.

The Heidegger module is responsible for the agent's perception and behavior. States sensed from the MUD are integrated by this module into the agent's knowledge base, which is then reasoned by the Descartes module to formulate plans. The Heidegger module also includes a reactive component that allows the agent to make fast stimulus-response behavior to allow it to cope with any immediate dangers that should be dealt with in a shorter time than it takes for the inferencing of the Descartes module.

6.6 SUMMARY

An agent architecture is used to conceptually map the structure for an agent. Five such fundamental architectures are available: reactive, trigger, goal-based, utility-based, and anytime. Most architecture designers for NPCs have come to realize the majority of gaming environments require at least goal-orientated behavior and cognition from these gaming agents and have built a variety of hybrid architectures that include goal-based directives. In addition to goal orientation, another concern is the lack of computational processing resources available to NPCs and how this affects the amount of time an NPC has to reason about its environment and plan its next move. This limitation has caused the development of anytime planning, which has been implemented in several gaming agent architectures to improve efficiency and ensure the NPC always has a plan to follow, regardless of processing time.

This chapter has presented but a few of the plethora of agent architectures that have been developed. On examining just the ones included here, you should realize that many fundamental principles of agent design are repeated from one architecture to the next. Many of the differences occur because of the particular domain for which the architectures have been designed. In addition, differing theories of human cognition also affect the way in which an architecture is designed and implemented. No matter what the background and theory behind a particular design, it

will be the outward behavior and interactivity with an NPC built from such architectures that ultimately evaluates its effectiveness and believability.

REFERENCES

[Baillie02] Baillie, P., 2002, *The Synthesis of Emotions in Artificial Intelligences*, Ph. D., University of Southern Queensland, Toowoomba.

[Franklin96] Franklin, S. & Graesser, A., 1996, Is it an Agent or Just a Program: A Taxonomy for Autonomous Agents, in *Intelligent Agents III: Agent Theories, Architectures and Languages*, Springer-Verlag, Berlin, vol. 1193, pp. 21–35.

[Hawes00] Hawes, N., 2000, Real-Time Goal-Orientated Behavior for Computer Game Agents, in *Proceedings of Game-On 2002*, 1st International Conference on Intelligent Games and Simulation, pp. 71–75.

[Koestler67] Koestler, A., 1967, *The Ghost in the Machine*, Penguin Books Ltd., London.

[Laird00a] Laird, J. E., 2000, It Knows What You're Going to Do: Adding Anticipation to a Quakebot, AAAI 2000 Spring Symposium Series: Artificial Intelligence and Interactive Entertainment, March 2000: AAAI Technical Report SS-00-02, pp. 41–50.

[Laird00b] Laird, J. E. & Duchi, J. C., 2000, Creating Humanlike Synthetic Characters with Multiple Skill Levels: A Case Study using the Soar Quakebot in *Proceedings of AAAI Fall Symposium on Simulating Human Agents*, November 2000, North Falmouth, Massachusetts, pp. 75–79.

[Lehman96] Lehman, J. F., Laird, J. E., & Rosenbloom, P. 1996, A Gentle Introduction to Soar: An Architecture for Human Cognition, in S. Sternberg & D. Scarborough (egs), *Invitation to Cognitive Science*, Volume 4, Cambridge, MA., MIT Press.

[Nareyek02] Nareyek, A., 2002, Intelligent Agents for Computer Games, in Marshland, T. A., & Frank, I. (eds), *Computers and Games*, Second International Conference, CG 2002, Springer LNCS 2063, 414–22.

[Newell90] Newell, A. 1990. *Unified Theories of Cognition*. Cambridge, Massachusetts: Harvard

[Sloman01] Sloman, A., 2001, Varieties of Affect and the CogAff Architec-
 ture Schema, in C. Johnson (ed), *Proceedings of Symposium on
 Emotion, Cognition, and Affective Computing AISB'01 Conven-
 tion*, York, March 2001, pp. 39–48.

[Travis00] Travis, M. F., Bear, H. G., Hyatt, G., Reber, P. & Tauber, J.,
 2000, Towards more humanlike computer opponents, in *Pro-
 ceedings of AAAI Spring Symposium, Artificial Intelligence and
 Interactive Entertainment*, March 2000, Palo Alto, California,
 pp. 22–26.

[Watson28] Watson, J. B., 1928, *Behaviorism*. London.

[Woolridge95] Woolridge, M. and Jennings, N. R., 1995, Intelligent Agents:
 Theory and Practise, in *The Knowledge Engineering Review*,
 University Press, vol. 10 no. 2 pp. 115–52.

[Woolridge02] Woolridge, M., 2002, *An Introduction to Multiagent Systems*,
 Wiley, 2002.

7 Creating Believable Non-Player Characters

In This Chapter

- Artificial and human intelligence
- Perception of intelligence and believability
- Social behaviors and interactions for an NPC
- Models of emotion for use with NPCs
- Natural language conversation with NPCs

7.1 INTRODUCTION

For a computer character to reach the status of *intelligent*, most people place expectations on the character above and beyond those they would use to consider another person as intelligent. According to the definition of AI, all people are intelligent because it is the way in which we think and behave that AI researchers are trying to replicate in machines. However, people classify others as unintelligent and even stupid, although they meet AI's standards of intelligence. The simplest explanation for this confusion is that when people assess each others' intelligence they are not in fact assessing intelligence from the perspective of generalistic human cognitive abilities, but rather they are making an assessment of aptitude.

In 1950, a mathematician by the name of Alan Turing devised a test (later to be known as the *Turing Test*) in which an artificial device is interrogated by means of a natural language exchange to establish intelligence in the artificial device. The human interrogator does not know if he is interacting with a machine or another person. The test can also be conducted under similar conditions in an Internet chat room where participants cannot see each other. They can interact only using a textual message repartee. If after a series of cognitive tasks the interrogator believes he is interacting with another human being, the machine passes the test. To achieve such a level of deception the computer must possess skills in natural language processing, storage of previously acquired information, answering questions, drawing

conclusions, adapting to new situations, and extrapolating information. Turing's original test avoids physical contact between both participants, because physical embodiment is not a prerequisite for intelligence. However, with advances in technology and further thinking, the Turing Test has been updated to become the *Total Turing Test*. Mechanical participants in this test, though still not in physical contact with the interrogator, must also possess the abilities of visual recognition and object manipulation and relocation.

In 1991, some 40 years after Turing proposed his test, the test was first implemented by Dr. Hugh Loebner. He pledged $100,000 to the first entrant that could pass the test. Although small prizes have been given out to the most "humanlike" computer, no one has achieved the 50 percent success for which Turing aimed. For more information on the Loebner prize visit *www.loebner.net/Prizef/loebner-prize.html*.

So where does intelligence fit in with NPCs? Well, actually, not in the way that you might think. Whereas AI researchers are trying to replicate functions of the human brain within a machine using constructs that parallel our biological ones (neural networks, genetic algorithms, and so on), NPC programmers work as artists attempting to give the *illusion* of intelligence by whatever means possible. And it is not exactly the formal definition of intelligence they are trying to recreate, but rather a character that is *believable*.

This chapter begins by establishing the difference between actual intelligence and perceived intelligence, which leads to a discussion at the heart of NPC creation—making the character believable. The chapter talks about the characteristics of a believable NPC and illustrates the use of social interactions, emotion synthesis, and natural language conversations as tools toward creating such an artificial creature.

7.2 PERCEIVED INTELLIGENCE

Chapter 6 examined the realm of what AI calls *intelligent agents*. More than attempting to make the agents act in an intelligent manner, AI attempts to model intelligence using theories on human cognition and integrating appropriate concepts into agent architectures. However, when it comes to computer games, it is not the complicated underlying structure of an NPC that ensures its success as being intelligent, but rather the human player's perception of the NPC's intelligence [Isbister95].

In assessing the intelligence of an agent, an AI researcher considers the way in which the agent has been constructed and the underlying theories implemented. Whether these are neural networks, genetic algorithms, or production rules, the

definition of intelligence in the AI field can be categorized as 1) machines that think like humans; 2) machines that act like humans; 3) machines that think rationally; and, 4) machines that act rationally [Russell95].

Although a definition of intelligence from the psychological perspective differs among research fields, the most widely accepted definition is that intelligence is the cumulative capacity of a person to act decisively, to think rationally, and to deal appropriately with the environment [Wechsler58]. Encompassing this definition are many theories of intelligence [Lefton94], including:

Piaget's Theory: Intelligence is a reflection of a person's ability to adapt to his environment and the way in which he does.

Wechsler's Theory: Intelligence is more than simple mathematical and problem-solving abilities. It is a generic ability to deal with one's environment.

Factor Theories: Statistical analysis on the results of verbal comprehension, spelling, reading, and other tests reveal factors of intelligence.

Jensen's Two-Level Theory: Testing can reveal intelligence functioning on one's associative and cognitive abilities.

Gardner and Hatch's Theory: The seven types of intelligence are logical-mathematical, linguistic, musical, spatial, bodily-kinesthetic, interpersonal, and intrapersonal.

Not knowing the theories and constructs used in the AI and psychological domains, the average person cannot assess the intelligence of another with these complex underlying characteristic in mind. However, he manages to gauge another's intelligence. Humorously, McNemar [McNemar64] suggested that intelligent people identify intelligence as being the thing that the other person lacks.

Humor aside, a number of researchers decided to find out exactly how the average Joe perceives intelligence.

According to Isbister [Isbister95], perceived intelligence is assessed in four categories: appearance, language cues, actions and behaviors, and group membership. Using these categories higher intelligence is associated with:

- physical attractiveness, fashionable dressing, and hair style
- clear, articulate, and fluent speech
- logical reasoning, accurate information interpretation, common sense, and planning ahead
- admittal of mistakes, social conscience, empathy, honesty, and environmental interest
- stereotypes and status

The projections of intelligence we place on other humans and, indeed, physical beings can also be placed on NPCs. Indeed, Isbister found that *interface agents* (or what we would call an avatar) are assessed for intelligence based on the agent's 1) physical appearance; 2) use of language; 3) behavior; and, 4) social skills. Therefore, if we are going to develop an NPC that we want to be perceived as intelligent, we must consider these four characteristics independent of any underlying complex AI programming.

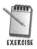

EXERCISE

1. In considering the design for an intelligent NPC, give some examples of how you would implement each of the four criteria.
2. How would the four criteria for intelligent NPCs differ in practice for the development of a scientist character and a bodyguard character?

7.3 SUSPENSION OF DISBELIEF

In the previous section we discussed the issue pertaining to the perception of intelligence in humans and agents. However, much of the research relates to what is considered *highly intelligent*. For example, Sternberg [Sternberg86] found that verbal cues such as clear, fluent, and articulated speech were perceived as intelligent. But how is a person perceived if they cannot speak in this way? Does this mean the person is unintelligent? The domain of AI would argue he is not. Simply being human is enough to imply intelligence. (And other creatures, such as, say, Labrador retrievers, would be argued by the Blind Society to possess intelligence although they obviously cannot speak clearly, fluently and articulately.) If an NPC were created with incomprehensible speech, it might be perceived as stupid. But isn't stupid just a level of intelligence? There seems to be an obvious incongruity between the perception of intelligence and the perception of being human. And if we consider other living beings to possess levels of intelligence, we could widen this category to the perception of being real.

Obviously NPCs are not real in the sense that they are truly alive—though researchers in the domain of A-Life might disagree—but virtual. The first step in the perception of these characters as real starts with the human player. Without a willingness to accept the realness of an NPC, the illusion of the game will fail. Samuel Coleridge recognized this relationship between the reader and literature in 1817, coining the phrase "willing suspension of disbelief" [Coleridge17]. Suspending your disbelief does not mean that you believe everything you see or read but that you don't disbelieve it. It is the ability to keep an open mind about subject matter that may not seem entirely plausible in order to be immersed in the fiction. For example, it is an essential ingredient in science fiction films and television, such as *Star*

Trek, where unusual-looking aliens, techno-babble, and space travel require a degree of imaginary participation on behalf of the audience to be successful. Gene Roddenberry, the creator of *Star Trek*, once commented to Marvin Minsky, one of the founders of AI, that it was "too dangerous" to insert even just a little *real* science into the storylines [Stork97]. This quote reinforces the idea that it is believability and not reality that is required to suspend the viewer's disbelief and that this belief is a conscious decision made by the viewer. This also suggests that what one person can tolerate to not disbelieve another may not. Therefore, when creating a believable NPC, the audience must be considered. For example, children easily accept their *Tamagotchi* is truly alive and must be fed in order to survive, whereas parents may consider them no more intelligent or alive than a digital watch.

Zeltzer [Zeltzer92] proposes a model by which the dimensions of suspension of disbelief can be measured by introducing three crucial properties of a virtual environment: autonomy (the objects and agents must act on their own accord); interaction (the object and agents should be modifiable and interrelate with the human user); and presence (the objects and agents be immersed in the environment and thus be able to sense the environment, affect the environment, and appear within the environment). Zeltzer's model, known as the AIP cube, is illustrated in Figure 7.1.

In one corner of the cube fall environments that do not possess autonomy, presence, and interaction. Such an environment might be a simple batch program for processing bank records. At the other extreme lies an environment in which the

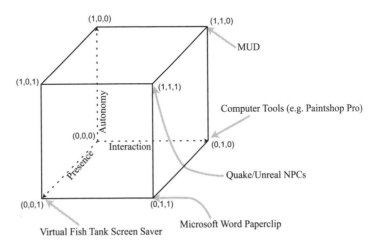

FIGURE 7.1 Zeltzer's AIP (autonomous, interaction, and presence) cube for a virtual environment. Adapted from [Zeltzer92].

agents are autonomous, interactive, and present. For example, *Quake/Unreal* bots possess all three qualities. They can wander around the environment of their own free will, attacking players and picking up armor, weapons, and health. The human player can interact with the bots by playing on their team or by shooting at them. They appear to exist within the environment by conforming to the structure of the environment and its laws of physics. *Tamagotchi* also fits this bill. It autonomously decides on what state it is in and what it needs. It is interactive in that you can feed and pet it. It has a presence in the real world as a handheld plastic device with an LCD screen, or it is the creature that *lives* within.

Systems do not need to possess each of the dimensions to achieve a suspension of disbelief. Take a virtual fish tank screen saver. The fish are not interactive and, after some observation, are not autonomous; however, the level of graphical detail and the way in which the fish move do meet the criteria for presence. Another example is that of digital animation films. With high levels of graphic detail, accurate movements, and real voices, the characters have real presence and easily achieve suspension of disbelief in the audience because they are drawn into the digital environment and experience empathy towards the characters. In the movie *Final Fantasy*, when the male lead character (Gray Edwards) dies in the arms of the heroine (Dr Aki Ross) a viewer might catch himself intently watching the dead character's body looking for a sign of a fake death, such as a nostril twitch or an eyelid movement, as he might in death scenes involving real actors. Of course, the digital character isn't going to flinch an inch, but because the viewer behaves toward the movie as he would one with human actors, the animators can be assured they have successfully achieved the suspension of disbelief.

Until the day when virtual environments are like that of *Star Trek's* famous Holodeck, in which the holographic world cannot be distinguished from the real world, imagination on the behalf of the integrator will always be necessary. And it is the power of human imagination that made games such as the text-based adventure *Zork* so successful. The game text prompted an imaginary world to be constructed in the mind's eye of the player. Therefore, certain parameters of the game could be constructed as the player saw fit and enhanced their belief of the environment because it was one they had created themselves. Nowadays, however, with detailed graphics and sound, much of the imaginative process has been taken away from the player. Rather than asking players to create a world in which they would believe, they are now being asked to believe in the world created by the game developers, programmers, and graphic designers (much like the Holodeck). Rosenberg [Rosenberg95] suggests that it can no longer be referred to as a *willing* suspension of disbelief but a *coercive* suspension of disbelief where the player is forced to believe in what he is interacting with.

To truly create an NPC with believable autonomy, interaction, and presence we must focus on the development of the NPC's mind because it is the essence of be-

havior that needs to be captured. Although graphics and sound have advanced at a phenomenal rate, the field of AI and autonomous agents is far behind. A digitally animated character in a movie has the advantage that its actions are predetermined and drawn by the animators. NPCs in a dynamic gaming environment are not. Therefore, to program an autonomous believable agent we must examine the requirements for such a being. According to Loyall [Loyall95], the requirements for believability in an artificial being are personality, emotion, self-motivation, change, social relationships, and the illusion of life.

7.3.1 Personality

The personality of a believable agent is about the character's unique and specific traits as related to their behavior, cognitive processes, and emotional expression. Part of the personality can be achieved through the viewer's imagination and use of stereotyping. As we examined in Chapter 2, the outward appearance of a character can give the viewer certain expectations about how it should act. For example, Leisure Suit Larry would be expected to act sleazy and sex-crazed. To achieve thorough suspension of disbelief, the character's behaviors and thoughts should match the perceived stereotype.

To create a convincing personality the creator must know the character before creating its program. One way of achieving this is to specify the character in the *tridimensions* of physiology, sociology, and psychology [Egri60]. Often writers have complete portfolios of their characters, including pictures and detailed backgrounds. Although the audience may never learn all this information about the character, the writer's intimate relationship with his character is reflected in the character's personality. This detailed background can help keep the character's personae consistent throughout the work.

7.3.2 Emotion

Emotion is a fundamental requirement of believability. It is expressed through the character's outward appearance and behaviors and used internally for perception, reasoning, and decision making [Baillie02]. In simple animated characters for film, the internal processes do not exist, and the emotions portrayed are dictated by the script. In an NPC, however, emotion must be a dynamic process. In recent years, many new agent architectures focusing on emotion have been created to conceptualize the internal processing of emotion and examine how it influences the agent's behavior. Emotional agents are discussed in depth later in this chapter. The emotional expressions and behaviors of an NPC must be in line with its personality.

7.3.3 Self-Motivation

Self-motivation is just another word for goal-orientated behavior. We examined how this essential property of an autonomous agent can be programmed into an NPC in Chapter 6. Characters that are simply reactive do not portray any depth of thought behind their actions. A game player can easily predict how a reactive NPC will respond to their interactions. Players develop a deeper respect and interest toward NPCs when they realize the NPCs are acting on their own accord, attempting to satisfy their own goals, and not just responding to an internal stimuli [Loyall97]. What an NPC is motivated to do must be in line with its personality.

7.3.4 Change

Over the long time periods in which we interact with other people, we notice many changes in them. Not only do they change physically, but their attitudes and behaviors also change. Most often these changes are in line with their personality. Sometimes they are not. When one of our friends acts out in left field we are often taken aback and our perception of him is modified. We often account such an unexpected change to a side of their personality with which we were not familiar. However, unanticipated change in artificial characters is not so easily accepted due to the relative short amount of time we spend interacting with them and our stereotypical view of their personality. When an NPC acts out of character, it destroys the suspension of disbelief.

Although unpredictable change in characters is not desirable, some change is necessary to make the characters more believable. For example, consider a character that likes dogs. If the character were attacked by a dog, we would expect it to be afraid of dogs and even dislike them from that point onward. This type of change is necessary for us to believe the character has presence in its environment and is affected by it. Change can be orchestrated by the programmer, but anticipating all types of interaction and affect could be an exhaustive list of production rules. Machine learning could be employed as long as the generated changes were carefully monitored. As we have previously discussed, although game developers may use neural networks and genetic algorithms in the creation of their programs, they are usually not allowed to run riot after game release because these AI mechanisms could produce unexpected behaviors in the characters.

7.3.5 Social Relationships

The way in which we interact with other people and how other people relate with each other gives us insight into their deeper beliefs, personality, and behavior. The allure of most reality television shows is in observing how others behave toward each other. These voyeuristic experiences create strong emotional responses and

attachments to these people whom we have never met. When we notice that artificial characters have relationships with other characters and ourselves as the player, it makes them more believable. Again, it adds to their personality depth and gives the impression the characters have feelings that can be affected by others.

7.3.6 Illusion of Life

In addition to the preceding characteristics of a believable agent is the broad category of *illusion of life*, which encompasses features of agents examined throughout this book. This category includes the believable agent having:

- goals, a plan to achieve its goals, and the ability to multitask
- a stimulus-response behavior to deal with quick environmental changes
- a sense of how its environment is changing around it and the ability to update its plans appropriately
- physical and mental restrictions placed on it so it does not appear to exist outside the laws of the environment's physics (not just the world as we know it—fantastical environments should also have restrictions governing characters' physical movements) and does not have complete knowledge of the environment
- a social context in which it is located in a social environment with other characters, such as a cafe or shopping mall, and cultural beliefs and behaviors

7.3.7 Social Interaction

Much of the believability of an NPC comes from its interactions with the player and other NPCs. When these interactions fall along the lines of social human behavior, the player's ability to accept the situation as real increases. Everyday human behavior is *social*. By this we mean that individuals are constantly influenced by the feelings, thoughts, and behaviors of others. The study of these influences and their reactions is known as social psychology. Social psychology involves three major concepts: attitudes, social cognition, and social influence [Lefton94].

Although attitude has no clear definition, popular consensus among social psychologists is that the term refers to the general enduring disposition to feel positively or negatively toward an object, person, or issue. By using a relevant collection of a person's attitudes, it is possible to closely predict the behavior of that person where the same set of attitudes is applied. This behavior can be viewed as consisting of the following four key elements:

- the action being performed
- the target or targets that are the object of the action

- the context of the action, for example, where it is being performed
- the temporal alignment of the action, for example, the time of day or month

Attitudes can be formed through *classical conditioning* (by which continued positive or negative experiences reinforce beliefs), *operant conditioning* (by which conditioning is performed by an individual attempting to persuade others that his beliefs are correct), or *observational learning* (by which beliefs are formed by observing and mimicking influential individuals). Attitude formation is used in games as a mechanism for learning. Classical conditioning is used in the game of *Petz* in which the player can respond positively or negatively toward the digital pet to mold its behavior. If the pet performs an act that the player perceives is good, the player can reward the pet with a pat or some food, which allows the pet to believe its actions are good and should be repeated. A *Black & White* player provides observational learning to a creature through the observation and mimicking of the player's behaviors. The creature watches the actions of the player and chooses whether to mimic them. At the moment the creature mimics a desired behavior, the player has the opportunity to use classical conditioning to reinforce the behavior.

Social cognition is the process by which individuals attempt to make sense of their environment, other individuals, and situations by analyzing them and forming conclusions. An individual can form an impression of another's internal states and beliefs by observing his appearance and behavior. This process is called *impression formation*. Impression formation begins as nonverbal communication through facial expressions, body language, physical contact, and eye contact. Next, a person's motives and intentions are deduced by his behavior. Finally, a person's view of himself is used to reason about others in which parallels are formed between his own beliefs and behaviors and projected onto others to make sense of others' beliefs and behaviors.

The third major concept in social psychology, social influence, identifies the way in which people's beliefs and behaviors are influenced by those of others. This concept include issues such as *conformity*, where people are strongly affected by influential individuals, peer groups, and family, and *obedience*, where one person agrees to comply with orders given by another.

Finally, *social interaction* is the means by which we are able to form attitudes, use social cognition, and exert and experience social influences. It shapes who we are as individuals and determines how we behave around different people, whether or not we succumb to pressure, and how we form stereotypes and prejudices.

Throughout this book, we have already examined many ways in which we can create NPCs with the characteristics mentioned in this section. For example, presence can be achieved through the modeling of the character and creating animations that conform to the laws of physics, such as where the character's center of gravity is situated with respect to the character's movements, and employing way-

point navigation and collision detection. The remainder of this chapter examines some extra issues pertaining to believable agents, in particular; those of the social interactions pertaining to emotions and communication.

7.4 EMOTIONS

Emotion presents itself as a inconcise term in many of the domains that boast an understanding of the topic, ranging from neurology [Fellous99], [Pert97] and psychology [Smith00] to artificial intelligence [Picard97]. The reason may be that the term is used to describe a large range of cognitive and physiological states in sentient beings. Emotions are often referred to in the broad sense, to describe not only familiar feelings such as *happiness* and *sadness* but also biological motivational urges such as *hunger* and *thirst* [Pert97]. Koestler [Koestler67] summed up this general view, defining emotions as mental statuses supplemented with strong feelings generated by physiological changes.

The degree of difficulty plaguing this subject matter is that a person rarely experiences a *pure* emotion. For example, feelings of *hunger* may be accompanied by feelings of *frustration*. However, there is a logical intuitive difference in defining *hunger* as an emotion and *frustration* as an emotion. Another general definition of emotion given by Lefton [Lefton94] defines emotion as a prejudiced feeling accompanying physiological change that through cognitive interpretation changes a person's behavior.

The use of emotions in computing devices is encompassed within the field of *Affective Computing*. This domain examines the effect that emotions have on human intelligence and endeavors to use this effect to further enhance the field of AI. In this domain much work is being done to develop artificial intelligence capable of identifying, processing, and synthesizing emotions. Emotions are being used in believable agents to produce a number of desirable effects, including outward emotional expression, goal setting, and decision making. The following sections divide the use of emotion into the five distinct categories of emotional behavior, fast primary emotions, emotional experience, body-mind interactions, and cognitively generated emotions.

7.4.1 Emotional Behavior

The area of emotional behavior refers to systems that display outward emotions. This does not necessarily mean the system has the means to internally process emotional responses as humans do but is nonetheless capable of appearing emotional. A robotic device that seemingly displays emotional behavior is that of W. Grey Walter's tortoise [Penrose89], which was capable of autonomous motion and had the

ability to plug itself into a power socket to recharge its batteries. Although a simple decision-making algorithm was obviously deployed to cause this, the tortoise still exhibited *emotional behavior*.

Another example of the display of emotions is the well-known boot-up sequence smiley face on the Apple® Macintosh® computer. Although it is very simple, the user could infer whether the computer is in a *happy* state or not. Though logically it is not, some human users without in-depth thought about the computer's emotional state might gain a feeling of well being from the machine.

A more complex example of a computer-generated display of emotions is that developed by Haptek [Kaehms99]. The company has developed a series of three-dimensional animated characters capable of accepting scripts of text and converting them into speech. Besides this ability, the characters also possess the ability to express emotion using voice inflections and facial expressions, when explicitly programmed. These characters are an example of the computer being able to convey a more complex emotional state to the user while not having autonomously generated that state.

The next stage in emotion-machine integration is to program the machine with the capacity to generate these emotional behaviors independently. In fact, in the case of W. Grey Walter's tortoise, this machine was programmed with the ability to recognize depletion in power and to act on it. This action is synonymous with human *hunger* and fits into the next category of fast primary emotions.

1. In Section 2.4.5, we discussed six outwardly expressed emotions that could unambiguously be identified by an observer. What were they?
2. List five examples of NPCs that express emotion without having been generated by any obvious internal process.

EXERCISE

7.4.2 Fast Primary Emotions

The brain, in response to stimuli that evoke a survival mechanism, generates fast primary emotions. (This is the emotional substance in the stimulus-response theory.) One such application of fast primary emotions in an NPC would be to implement survival mechanisms with which it could quickly react to protect itself. This could include such things as getting out of the way of moving objects, ducking, heightening its perceptual sensors, or renewing its health.

Another subset of these primary emotions is drives or motivational urges. Many affective systems implement motivational mechanisms in unison with goal-orientated belief systems. These systems work by generating internal motivations that activate the goals of the artificial agent. The ideas behind these systems are essentially the same: A timing mechanism or change in state of the agent generates an urge that, in turn, triggers a goal. Balkenius [Balkenius95] identified several categories of motivational drives that he believes play an important role in cognitive proc-

esses and uses these in the simulation of animal behavior. The homeostatic drive, or the drive that is generated by a violation of homeostasis, includes, for example, not only *hunger* and *thirst,* but also the responses to heat and cold. The noxious drive considers the signals from noxious stimuli and includes the sensation of *pain.* Cyclical drives, which vary with the time of day or the year, are generated by an oscillator influenced by external stimuli, such as the length of the day, odors, or the amount of light in the environment. These drives include *tiredness* and *wakefulness,* the *sexual* drives of most animals, and migratory drives. The default drive influences the animal when no external cue is present to command the animal to do something else. The exploratory drive is similar to the default drive in that it tries to activate behavior when the animal has nothing else to do. Finally, the anticipatory drive is internally generated but does not relate to any present need of the animal. This drive can influence any other drive, and its purpose is to simulate a drive, typically a homeostatic one, which is not present. An obvious use of such drive mechanisms in NPCs is evident in *The Sims.* Each *Sim* is programmed as a series of states whose values are affected over time. For example, each *Sim* has a tiredness state represented as a series of values on a gauge. Over time the value for tiredness increases to a certain point at which the *Sim* seeks rest to replenish the value on the gauge.

One or more of these drives have been implemented in a number of affective agent systems, such as El-Nasr's PETEEI [El-Nasr98], Balkenius's simulated artificial creatures [Balkenius95], Padham and Taylor's Dog World agents [Padgham97], Canamero's Abbotts [Canamero97], and Fido [Baillie02]. In all cases the drives are programmed into the agent as a number of gauges and cyclical mechanisms. The cyclical mechanisms update the drive gauges, and when a threshold value on a gauge is reached a goal is triggered. For example, an agent may have a *hunger* gauge that is cyclically updated to simulate *hunger* increasing over time. At a predetermined threshold value on the *hunger* gauge, a goal to seek food is activated.

These types of primary emotions are easily simulated, and methods for implementing them in artificial beings are quite elementary. In Section 6.4.6, we programmed a utility-based bot with such gauges represented by the properties alertness, hunger, and hygiene. The next stage in the implementation of such mechanisms in AI is that of generating appropriate internal state changes within a machine and having that machine understand, react, and learn from them. This capability is called emotional experience.

EXERCISE

1. Fast primary emotions are easily integrated into reactive agents. Why?
2. List five examples of primary emotions that would be beneficial to include in an NPC's design.
3. List each of Balkenius's motivational drives and explain how each is evident in the behavior of an NPC from *The Sims.*

7.4.3 Emotional Experience

An emotional experience is the ability of a machine to have an awareness of its emotional state. This awareness may be accompanied by changing physiological states (an example in humans being an increased heartbeat) and may be generated by internal subjective feelings. These internal feelings, or *gut feelings*, are very difficult to implement in computers due to the fact that in humans they are produced biochemically. Goal-orientated agents are constructed from motivation mechanisms that cause the machine to appear as though it *wants* and *cares*, when in fact it has only been programmed to give the superficial appearance of these humanistic traits.

Sloman [Sloman01] does not speculate on whether machines may one day have conscious feelings but provides an informative architecture for a humanlike agent that can emulate the process of emotional experience. He conjectures that the information-processing capabilities of humans make use of three different architectural layers of the H-CofAff agent discussed in Section 6.5.2. The reactive layer takes care of the fast primary emotions, the deliberative layer deals with higher emotional states and the creation and execution of plans, and the meta-management layer oversees the improvement of the processes stemming from the other two layers. It is the final meta-management layer that gives the agent the ability to become aware of its emotional experiences, to identify them, and to learn from them.

EXERCISE

1. Think of a situation that causes a strong emotional experience, such as being confronted with a savage dog on the street. Explain why you think the emotion is experienced. How does the emotional experience affect your future behaviors?
2. Discuss how emotional experience could be implemented in an NPC for the purpose of learning.
3. List five emotional experiences that might enhance the game play of an NPC in a FPS. Discuss how they would benefit the NPC's performance.

7.4.4 Body-Mind Interactions

Body-Mind interactions refer to an emotion's ability to influence the body's state and, in turn, the body's state influencing the emotion. Canamero [Canamero97] describes an AI system in which emotional state changes cause changes to a system of synthetic hormones. In addition, changes to the states of these hormones also influence the emotional state of the artificial beings. The emotionally influenced beings, called the *Abbotts*, inhabit a two-dimensional world with another race of unemotional beings called the *Enemies*. The Abbotts' behavior is determined by motivational and emotional mechanisms that correspond to internal state changes

within the agent. These internal states (constructed from synthetic hormones) represent the agent's physiological state. The agents can choose to attack, withdraw, drink, eat, play, and rest. Each behavior has an effect on the agent's internal state, which may trigger a motivation that will cause a different behavior.

7.4.5 Cognitively Generated Emotions

Cognitively generated emotions may be explained as the emotions that follow primary emotions. They are the emotions generated on appraisal of a stimulus. Groups of theorists, known as cognitive appraisal theorists, have attempted to explain different emotional reactions by categorizing emotions by evaluating the situations from which the emotions arose. The long-term interest in the classification of emotional experiences was traditionally defined in only two dimensions: *pleasantness* and *arousal*. However, these appraisal dimensions were found to be inadequate in classifying the range of human emotional states, and newer models arose using more complex appraisal dimensions. One such model, by Ortony, Clore and Collins (OCC) [Ortony88], examines the valenced reaction (a positive or negative response) to one of three elements: the consequences of an event, the actions of the agent, and the aspects of objects. The model assesses the human reaction to these elements as being pleasing, displeasing, approving, disproving, liking, or disliking. An illustration of the model is shown in Figure 7.2.

The Oz project [Bates92] is the effort of researchers at Carnegie Mellon University. The primary focus of their work has been in the development of agents capable of generating emotions and moods for the purposes of believable characters. Their broad architecture, called *Tok*, incorporates a number of subsystems, one of which, *Em*, is primarily for the generation of emotions. In the *Em* architecture, emotions are structured hierarchically and categorized as either positive or negative in nature. The emotions are generated in the goal-orientated agents when a goal is completed. The intensity of the emotion is calculated from the importance of the goal. Although based on the OCC model, *Em* differs slightly in that its likelihood of success or failure, rather than an appraisal of the event to which it relates, determines the importance of the goal. The inspiration for this research has been to build a set of tools that can be used by creative artists to build believable artificial characters and scenarios for dramatic purposes. Artists have the ability to create new characters and situations by manipulating, by hand, the hard-coded cognitive and behavioral mechanisms of *Em*. Today, this type of reasoning is the most frequent way of generating emotions in artificial intelligences through cognitive reasoning.

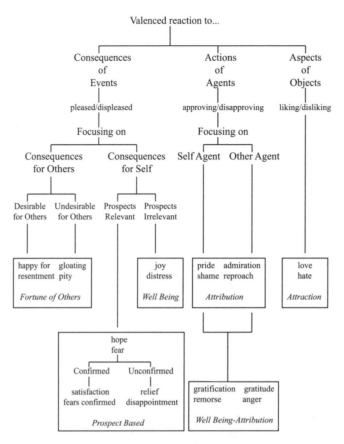

FIGURE 7.2 The OCC cognitive structure of emotion [Ortony88]. Reprinted with the permission of Cambridge University Press.

7.4.6 Affective Agent Architectures

In recent times, a number of architectures have been designed to produce artificial agents capable of expressing and processing emotions. These models cover a wide range of affective phenomena and differ broadly among implementations. A complete examination of these architectures would constitute a publication in its own right, so a comprehensive review of these models does not appear here. Having said this, the current architectural designs, their application, and evaluation provide essential research information that should be considered in the development of any emotional NPC. This section provides a brief yet expansive overview of several current models and ideas circulating in the Affective Computing research domain.

Blumberg's Silas T Dog

An artificial agent that uses primary emotions to motivate behavior is Blumberg's architecture for *Silas T Dog* [Blumberg96]. The architecture illustrated in Figure 7.3 is an autonomous, animated virtual dog, consisting of three layers: the Behavior System layer, the Motor Controller layer, and the Geometry layer. The Motor Controller and Geometry layers perform the necessary tasks to represent the agent as a virtual computer character in a virtual three-dimensional world and control its movements. The Behavior system controls the agent's intelligent behaviors.

The Behavior System is a network consisting of independent, goal-orientated entities called *Behaviors*. *Behaviors* are grouped into mutually inhibiting groups called Behavior Groups, which are organized into a loose hierarchical structure. The goal of a *Behavior* can range from very general (for example, "reduce hunger") to very specific (for example, "chew food"). Before the agent can exhibit a given behavior, the *Behavior* entity must evaluate its relevance given external stimuli and internal motivations. External stimuli are passed from the Sensory System (which senses the external world) through the Behavior's Releasing Mechanism. The Releasing Mechanism filters the sensory input for relevance toward the *Behavior* entity. Motivations and goals are represented by Internal Variables. The *Behavior* entity combines the values from the Releasing Mechanism and Internal Variables to determine the Behavior's Level of Interest. This Level of Interest is used to model the strength of a particular Behavior.

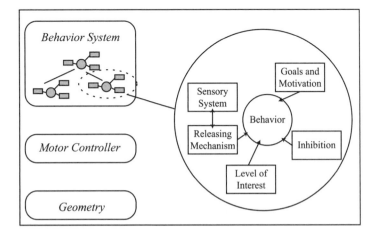

FIGURE 7.3 The architecture for *Silas T Dog*, adapted from [Blumberg96].

The process of the Behavior System begins by examining the Behavior Group at the top of the system's Behavior Group Hierarchy. *Behavior* entities within this group compete for control of the agent. The winning *Behavior* entity is decided by examining the Releasing Mechanism, Internal Variables, and Level of Interest of each *Behavior*. This *Behavior* entity is then said to become active. If the active *Behavior* is linked to a child Behavior Group in the hierarchy, the process of competing begins again on a more specific level. This process continues until the most specific form of a *Behavior* is identified (that is, the bottom level of the hierarchy is reached). The chosen *Behavior* entity then communicates with the Motor Controller layer to create the outward behavior of the agent. This architecture provides a means of managing goal-orientation and motivational mechanisms controlled by lower-level emotions, such as *fear* and *hunger*.

PETEEI (A PET with Evolving Emotional Intelligence)

The PETEEI architecture [El-Nasr98] has three major components: an emotional process model, a cognitive process model, and a learning process model. The architecture has been used to build an agent with the behaviors of a pet dog. A PETEEI agent operates by perceiving data in the form of an event occurrence. On receipt of this external stimulus the agent's emotional model evaluates the event's desirability and expectation and proceeds to activate an emotion and produce an appropriate emotional behavior. The emotion is decayed linearly using a constant decay-rate function. Each emotion is triggered according to predefined rules based on the OCC model. Behaviors are then selected using a set of predefined production rules. For example, *if **anger is high** and **event is food-dish-was-taken-way** then **behavior is bark-at-user***. Besides reacting to external stimuli, a PETEEI agent also generates internal stimuli in the form of motivations. These motivations include states such as *hunger, fatigue, thirst,* and *pain*. These states are stored as individual variables and updated linearly using measures such as time.

Emotion-Based Control (EBC) Framework for Autonomous Agent

Velasquez's Emotion-based Control (EBC) Framework [Velasquez99], as shown in Figure 7.4, integrates emotional processing with other agent systems that control perception, attention, motivation, behavior, and motor skills in a robotic agent. In an EBC agent, the Perceptual System accepts external stimuli from the outside world. This data is provided to the Emotion Generation System and the Behavior System. Both systems also receive data from the Drive System. The Emotion Generation System determines the emotional significance of incoming stimuli and ensures that future behavior and perception are affected accordingly.

The EBC framework is based on the neurobiological premise of *affect programs*. Affect programs relate to preprogrammed brain systems that generate and coordinate stereotypical behavior in biological agents.

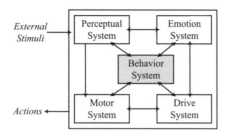

FIGURE 7.4 The EBC framework for autonomous agents, adapted from [Velasquez99].

The EBC framework has six different types of affect programs generated by the Emotion Generation System, which correspond to different primary emotions: *fear, anger, sorrow, happiness, disgust,* and *surprise*. Each affect program activates its own series of circuitry in an EBC robot, which causes it to behave in a preprogrammed manner. For example, the *fear* affect program can cause the robot to exhibit cowering and retreating behavior. Each affect program is programmed with a temporal decay function that controls the time for which the affect program is in operation once activated. Although not fully explored, the EBC framework could also be used to generate behaviors relating to higher-order emotions, such as *guilt*. For example, by implementing a system of emotion blending, the affect programs for *fear* and *joy* could be activated simultaneously to produce the emotional behavior for *guilt*.

The Emotionally Motivated Artificial Intelligence

The Emotionally Motivated Artificial Intelligence (EMAI) architecture [Baillie02] (shown in Figure 7.5) is a complex set of mechanisms that process emotions for their use in decision-making and reasoning. Two types of emotion mechanisms are integrated in the EMAI architecture. The first mechanism emulates fast primary emotions, known as motivational drives, in the EMAI. These drives are classified according to their source, pleasure rating, and strength and are used to initiate outward behaviors. They can include concepts such as hunger, fatigue, arousal, hygiene, and so on. The strength of the drives changes with time and, at particular threshold levels, triggers goals that when successfully achieved appease the drives. The drives are represented by a set of internal state registers located within the motivational drive generator.

The second type of emotion implemented in the EMAI architecture is secondary emotion, which includes the familiar higher-level emotions such as happiness, anger, sorrow, guilt, and boredom. Secondary emotions are represented as values in the affective space. The affective space is a six-dimensional space defined by six

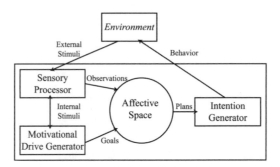

FIGURE 7.5 The EMAI agent architecture.

appraisal dimensions. The affective space, based on the psychological model of Smith and Ellsworth [Smith85], defines 15 emotions (happiness, sadness, anger, boredom, challenge, hope, fear, interest, contempt, disgust, frustration, surprise, pride, shame, and guilt) with respect to the dimensions of pleasantness, responsibility, effort, certainty, attention, and control. The dimensions of the affective space form a coordinate system in which they can be used to assess the emotional reaction the agent has to a situation, object, another agent, or any other entity in its environment. The affective space is also used to associate emotions with all stimuli both internal and external.

The sensory processor of the agent is where high-level observation takes place. This information is filtered through the affective space before it is used by the agent to generate outward behavior (determined by the intention generator). All information perceived by the agent is influenced by the agent's emotional state.

In the next section Smith and Ellsworth's model, used in the Affective Space of the EMAI architecture, is used to program an emotion-synthesizing neural network.

7.5 DAY OF RECKONING: CREATING AN EMOTIONAL NPC

In this practical exercise we build a neural network for processing emotional states. Because there are six distinguishable emotions [Elkman72] suitable for use in a NPC, as mentioned in Section 2.4.5, we will build a neural network based on the one developed in Section 5.9 which will output one of six emotional states based on a series of appraisals. If you are feeling a little rusty on the theory and application of neural networks, be sure to review Chapter 5 before continuing with this exercise. The appraisals we use are based on Smith and Ellsworth's study [Smith85] used to develop the Affective Space in the agent of Baillie [Baillie02].

ON THE CD
The initial project and code for this exercise are located in the Apoca-lyx/prj/Chapter Seven-1 folder.

7.5.1 Step One: Building an Appraisal Model

An appraisal model of emotion is one based on the cognitive assessment of a set of known characteristics about the entity to which the emotion will be attributed. An example of this would be to appraise something as being pleasant or unpleasant. For example, if you find yourself in a pleasant situation, you will be happy; if you find yourself in an unpleasant situation, you will be sad. Cognitive appraisal models developed by psychologists consider more than just pleasantness to assess an emotional state. The Smith and Ellsworth appraisal model considers 15 different emotions appraised by 6 appraisal dimensions (one of which is pleasantness). A subset of this model, which includes the six emotions in which we are interested is displayed in Table 7.1.

The values in Table 7.1 were obtained by surveying people about their emotional experiences and asking them to rate the appraisals. In the model, the values range between −1.5 and +1.5. For example, for the pleasantness dimension −1.5 means very pleasant and +1.5 means very unpleasant. By examining Table 7.1, you can see that the people surveyed attribute the emotion happiness with a very pleasant appraisal.

Using the values from Table 7.1, we can construct a set of training data for the neural network as follows:

TABLE 7.1 A Subset of the Smith and Ellsworth Emotion Appraisal Model[a]

Emotion	Pleasantness	Responsibility	Certainty	Attention	Effort	Control
Happiness	−1.46	0.09	−0.46	0.15	−0.33	−0.21
Sadness	0.87	−0.36	0	−0.21	−0.14	1.51
Anger	0.85	−0.94	−0.29	0.12	0.53	−0.96
Fear	0.44	−0.17	0.73	0.03	0.63	0.59
Disgust	0.38	−0.5	−0.39	−0.96	0.06	−0.19
Surprise	−1.35	−0.97	0.73	0.4	−0.66	0.15

[a] Each appraisal is rated on a scale between −1.5 and +1.5. The appraisals of pleasantness and certainty are inverted in the model. A value of −1.5 for each appraisal would represent very pleasant, very low responsibility, high certainty, low attention, low effort, and low control.

```
typedef struct
{
    char name[25];
    float appraisals[6];
} emotions;

emotions em[6] = {
    "Happiness", -1.46, 0.09,-0.46,0.15,-0.33,-0.21,
    "Sadness", 0.87,-0.36,0,-0.21,-0.14,1.51,
    "Anger", 0.85, -0.94,-0.29,0.12,0.53,-0.96,
    "Fear",0.44,-0.17,0.73,0.03,0.63,0.59,
    "Disgust",0.38,-0.5,-0.39,-0.96,0.06,-0.19,
    "Surprise",-1.35,-0.97,0.73,0.4,-0.66,0.15 };
```

Include these values as globals at the top of *emotions.cpp*. To run this data through the neural network training process we must pass each emotion's appraisal values through and specify the answer. In this example, we want the neural network to output a binary code that represents each emotional state, as shown in Table 7.2.

The neural network accepts the values for each of the six appraisal dimensions using an associated input node and outputs each digit of the emotion binary representation as a separate node. Therefore, the neural network should have six input nodes, one hidden layer, seven nodes in the hidden layer, and six output nodes. The number of appropriate layers and nodes is discussed in Section 5.8.2, in which it is suggested you use twice as many nodes in the hidden layer as there are inputs. However, we have found that seven is sufficient for this example. (Because no hard and fast rules exist about the number of layers and nodes, feel free to experiment with as many as you like. Be aware, however, that the more layers and nodes you use, the larger the memory requirement, processing, and training time.)

TABLE 7.2 Binary Representation of Emotional States Used as Results for Neural Network

Emotion	Binary Representation
Happiness	100000
Sadness	010000
Anger	001000
Fear	000100
Disgust	000010
Surprise	000001

The neural network can be created in the `main()` function as:

```
neuralNet n(6, 6, 1, 7, 0.1);
```

where the arguments represent inputs, outputs, number of hidden layers, nodes in the hidden layers, and the alpha training value, respectively. Once declared and initialized, the network can be run through training using the least-squared error method to determine when sufficient training has been achieved. The following code can be placed in `main()` after neural network creation:

```
double sumSquareError = 1;
//training using Smith and Ellsworth
//Emotion Appraisal Data
while(sumSquareError > 0.001)
{
    sumSquareError = 0;

    for(int i = 0; i <= 5; i++)
    {
        in.clear();
        out.clear();

        //appraisal values as inputs
        for(int j = 0; j <= 5; j++)
        {
            in.push_back(em[i].appraisals[j]);
        }

        //emotion binaries as desired outputs
        for(int k = 0; k <= 5; k++)
        {
            if(k == i)
                out.push_back(1.0);
            else
                out.push_back(0.0);
        }

        //train the network
        results = n.go(in, out, 1);
        sumSquareError += pow(results[0] - out[0],2);
    }
}
```

In the preceding code, the neural network's training values are run through the network by calling the network's go() method. The go() method accepts the input and output values, as well as a Boolean value, to inform the network whether it should be in training mode. In this case we have set the value to 1 to ensure the network's weights are trained. Later you may just want to use the network and not have it learn any bad habits from erroneous data entry. In this case, the Boolean value should be set to 0.

After the training, include some code to run each of the training examples through the network once and record the results in a log file:

```
for(int i = 0; i <= 5; i++)
{
    fprintf(logfile,"\n%s ", em[i].name);
    in.clear();
    out.clear();
    for(int j = 0; j <= 5; j++)
    {
        in.push_back(em[i].appraisals[j]);
        fprintf(logfile," %f ", em[i].appraisals[j]);
    }
    for(int k = 0; k <= 5; k++)
    {
        if(k == i)
            out.push_back(1.0);
        else
            out.push_back(0.0);
    }
    results = n.go(in, out, 0);
    fprintf(logfile,"\nResults: ");
    for(int r = 0; r <=5; r++)
        fprintf(logfile," %f ", results[r]);
}
```

When you have completed adding this code to the existing project file, save, compile, and run. The neural network will take a little time to train, so be patient. This is another time to consider adding save and retrieve methods to your neural network (see Exercises 2 and 3 in Section 5.9) so that you do not have to train the network each time it is run. We printed the weights and training results into a file called *neuralnet.log*. When the program has finished running you can examine the results in this log file. You can expect some small errors in the neural network's results—instead of getting 1,0,0,0,0,0 for happiness, you may get something more like 0.979550, 0.002749 0.000023, 0.007271, 0.010615, 0.007426. The result depends on how accurate you want the neural network to be.

7.5.2 Step Two: Using the Network to Synthesize Emotions

To have the neural network synthesize (calculate) an emotional state, you must feed it values for each of the appraisal dimensions. These values can be between -1.5 and +1.5 because this was the range we used for training. The value obtained from the neural network on parsing of these appraisals points to one of the six emotional states. Rather than using numerical values let's use a concrete example. An NPC is about to fight an opponent to protect its village. On appraisal of the situation (using our dimensions), the NPC calculates the situation to be highly unpleasant, a great responsibility, have a moderately uncertain outcome, require its full attention, require a great deal of effort, and be a situation over which it has little control. This could translate into values for each dimension as (1.4, 1.5, 0.8, 1.5, 1.4, −1.1) or something similar, depending on how you assess the NPC's appraisal.

These values can be parsed through the network with code similar to that used for training as follows:

```
float attitudes[6] = {1.4, 1.5, 0.8, 1.5, 1.4, −1.1};
in.clear();
out.clear();
for(int j = 0; j <= 5; j++)
{
    in.push_back(attitudes[j]);
}
//get results but don't train
results = n.go(in, out, 0);
printf("\nResults: ");
for(int r = 0; r <=5; r++)
    printf(" %f ", results[r]);
```

When run through our neural network, the results for these input values gave:

```
Results:0.258508 0.004834 0.011271 0.996339 0.000001 0.002100
```

Naturally, these results don't perfectly match one of the emotions binary representations. However, we can analyze the results and determine which of the six values is most dominant, then assign an emotion. The previous results best match the binary representation for *fear* because the fourth result is closest to 1 and the binary representation for fear is 000100. Therefore, in this situation we would say that our NPC is feeling fear.

When synthesized, emotions can be used for determining the behaviors of the NPC. For example, if an NPC were facing a fight with the appraisals given in our example, it might prefer to turn and flee rather than stay and fight because it might be too scared. Emotions can also be used to make decisions between seemingly

equivalent choices. Say, for example, the NPC is experiencing hunger. It might have the choice of eating an apple or eating a doughnut. The appraisal of each situation might reveal that the NPC would be happy if it ate the doughnut and disgusted if it ate the apple, in which case, we can assume the NPC will do what makes it feel the best and eat the doughnut. On the other hand, if only apples were available, the NPC might have to eat the apple or starve. Therefore, after eating the apple the NPC's emotion may turn to disgust. Can you see how appraisals can be used to predict how you might feel if you did something in contrast to how you would actually feel after you did it?

EXERCISE

1. Complete your program in the previous section by having it assess the given results and print out the textual representation of the calculated emotion. For example, instead of (0.258508 0.004834 0.011271 0.996339 0.000001 0.002100), have the program print out "fear."
2. Consider a scenario in which a starving NPC must cross a stinky swamp just to eat some rotten fruit in order to survive. Assign values for each of the dimensions used in this section and run them through your neural network to synthesize an emotion.
3. The appraisal dimensions used in this section are but one set of appraisals used in a particular emotion model. Can you think of other appraisals (characteristics) about a situation that could be used to create a new model?
4. Another emotion-synthesizing neural network that could be constructed is one that assesses the NPC's interaction with the player to generate an emotional reaction in the NPC. What types of appraisals could you use in such a network? Given these appraisals, come up with a training set of values and test your network's ability to produce reasonable emotions for differing social interactions.

7.6 CONVERSATION

One of the allures of multiplayer games is knowing you are playing against other humans. Some researchers suggest the attraction of such games is not the skill or intelligence of their human counterpart, but rather the knowledge that their opponents are real beings capable of emotional reactions [Zubek02]. Because the avatars in multiplayer games are all alike in physical structure, with a limited set of animations and restricted, if any, facial expressions, it is difficult on this level to tell if the player is human or bot. The majority of social interactions that takes place in

games, which reveals the true nature of the intelligence behind the avatars, are communicated through natural language conversation.

And there lies the problem. Communicating with natural language is a breeze for humans, but for the NPC, it is entirely a different kettle of fish. Why do you think we use structured languages to program computers? Communicating successfully with natural language (whether spoken or written) requires that both parties (the sender and the receiver) share a common set of symbols and grammars that define the language, share a common context for the communication, and exhibit some signs of rationality (a common trait of intelligence) [Russell95]. Although this form of communication works well using structured languages such a C++ or PROLOG, it isn't as easy with complex natural languages such as English, Chinese, and French. Although these languages contain a finite set of symbols and a definable grammar, people do not always adhere to the rules, and what might mean one thing in one context could mean something completely different in another. In the next section, we examine the communication process and identify areas where complications arise when communicating with NPCs (and computers in general).

7.6.1 The Act of Communicating

Eight steps are involved in communication [Russell95]. We examine each of these with respect to communicating with an NPC using natural language.

Intention: Communication is first initiated when someone decides to speak. (We will assume speak and speech refer to both verbal speech and written text, as would be the case in a chat room.) Intention is tightly related to an individual's goals, and, therefore, the speaker must assume he has something worth communicating and that the hearer will be interested in receiving the communication. In a FPS game, an NPC on the opposing team may not be interested in communicating with the player; it may just be trying to kill him. On the other hand, an NPC on the same team as the player could receive essential advice from the player about strategies or the state of the environment.

Generation: Generation is the act of verbalizing the intended information and structuring it according to the rules of the language. It is the process whereby the information in the head of the sender is formed into coherent sentences ready for transmittal. For an NPC this means taking the knowledge that needs to be communicated from its knowledge base and structuring it in a way that the receiver will understand. For NPCs communicating with like NPCs, it is possible for them to directly access the knowledge bases of each other and transfer information in the knowledge base format. However, to communicate with a human player, the NPC must create coherent sentences in the language of the player.

Synthesis: Speech synthesis is nothing new. Humans can achieve this by passing air over their vocal chords. For computers, however, it requires complex mathematical equations and programming. We do not examine the technical aspects of speech synthesis here. Some NPCs such as those in *Unreal Tournament* communicate their intentions to the human players in the format of canned sound files, prerecorded by actors. These sound files relate to a limited number of situations, and after a short amount of playing time, the human player learns what the communications are so they become less believable. These types of communications are not generated from the knowledge base of the NPC and, therefore, communicate no useful information. If an NPC were to communicate their location to the other players, it would have to establish its location from its knowledge base and construct an appropriate sentence, for example, "I am in grid 2, 4," or with more inference, "I am behind you." The sentence could then be communicated to the player in the form of on-screen text or using a text-to-speech engine. Although canned sound files could be recorded to convey this information, the recordings would have to take into consideration every possible location of the NPC, which could be an exhaustive list. Text-to-speech technology allows far more flexibility for types and formats of communicated information.

Perception: As we have already established, perception is the process of receiving some stimuli and converting it into a known internal representation. The perception of speech is a process by which the spoken words are recovered from the communication. As with speech synthesis, computer perception of the spoken word is also a complex set of algorithms and is not discussed here. To implement speech perception within an NPC, speech recognition engines could be integrated with the program. These engines attempt to convert the spoken word into text, which can then be interpreted by the NPC. A far simpler method is to communicate directly using text.

Analysis: The process of analysis takes the perceived text and deconstructs it into its primary elements. Deconstructing the text involves using knowledge about the language to extract parts pertaining to nouns, verbs, and so on. This process is called *parsing*.

Interpretation: Interpretation extracts the meaning of the communication and converts it into a format compliant with the receiver's internal percepts. For an NPC, this means converting the text into knowledge that could be inserted into its knowledge base. If the knowledge base were a series of logical rules written in PROLOG, the interpretation of the text would be converted into PROLOG. This type of conversion is called *semantic interpretation*. Often speech can have more than one interpretation. This type of communication is called *ambiguous*. For example, the spoken sentence, "She is hot," could be interpreted to mean

"The woman is a real babe" or "The woman has a high temperature." Further interpretation that adds another dimension to the speech is called *pragmatic interpretation*. Pragmatic interpretation adds context to the communication with the addition of the situation in which the correspondence was made. For example, "on the beach" or "in the hospital."

Disambiguation: This process works by attempting to remove any ambiguities from the communication to assess the exact meaning. In the previous example, when the context of "in the hospital" is taken into consideration, the communication would *probably* be interpreted to mean "The woman has a high temperature." However, we use the word *probably* here because the communication could have been between two medical students commenting on the physical features of their patient. So although it might be possible to remove some ambiguities by selecting the most feasible interpretation, it does not mean the sentence will always be correct. The same problem exists when humans communicate with each other.

Incorporation: After the communication has been received and processed, it is added to the NPC's knowledge base and incorporated with its other knowledge. This process may fire new rules and cause the NPC to reevaluate its current goals, plans, and actions.

One of the more difficult parts of the communication act is parsing of the given text and breaking it down into its elementary parts ready for interpretation. This process requires extensive knowledge of the language's grammar. Although a complete elucidation of this process would require another book, we provide a brief overview in the next section.

7.6.2 Language Generation and Parsing

Natural language is a complex set of symbols representing characters, words, and punctuation structured according to specific rules called a grammar. In reality, most natural languages are misused due to incorrectly spelled words, colloquial and colorful words, and erroneously constructed sentences. Analysis of the *real* use of the English language, for example, would cause quite a few headaches and blow out the page limit for this book; therefore, we examine a more formal and limited version of English to illustrate the parsing process. The syntax we use to represent the language is first-order logic.

A simple sentence, S, can be considered as the addition of a noun phrase, NP, and a verb phrase, VP, as follows:

$$S \rightarrow NP\ VP$$

For example, the sentence "I am behind you" is constructed from *NP* = "*I*" and *VP* = "*am behind you.*" A more complex sentence can be created through the joining of two sentences using a conjunctive keyword (and, or, however, and so on):

$S \rightarrow S$ **and** S	*I am behind you and I am hungry.*
$S \rightarrow S$ **or** S	*I am behind you or you are an illusion.*
$S \rightarrow S$ **however** S	*I am behind you however I need to move elsewhere.*

A noun phrase can be constructed from:

- a single noun: Schreckle, Medical Kit, Armor
- a single pronoun: I, me, you, they
- one or more digits: 3, 85, 214
- the composition of an article and another **noun**: the **cat**, a **Quakebot**
- the composition of a noun phrase, a **preposition** (to, in, on, behind) and another noun phrase: the cat **in** the hat, a bot **behind** the door
- the composition of a noun phrase, "**that**," and a VERB PHRASE: the bot **that** IS BEHIND YOU, the cat **that** SMELLS

A verb phrase can be created from:

- a single verb: eat, shoot, move
- multiple verbs: is shooting
- a verb phrase and a **noun phrase**: eat **the apple**, shoot **an opponent**
- a verb phrase and another **verb** or an **adverb**: is **shooting**, go **willingly**
- a verb phrase, a **preposition**, and a NOUN PHRASE: turn **to** FACE THE PLAYER, is shooting **near** THE DUNGEON
- a verb phrase and an adverb: is shooting nearby, find the treasure here

A sentence is easily constructed using a grammar such as the one defined here and a list of nouns, verbs, articles, and more. To illustrate this we have written a short PROLOG program that generates sentences, shown in Listing 7.1.

LISTING 7.1 A PROLOG sentence-generation program

```
sentence(List1, End) :-
    noun_phrase(List1, List2),
    verb_phrase(List2, End).
verb_phrase(List1, End) :-
    verb(List1, List2),
    noun_phrase(List2, End).
noun_phrase(List1, End) :-
```

```
    article(List1, List2),
    noun(List2, End).

article([a|End], End).
article([the|End], End).
noun([bot|End], End).
noun([player|End], End).
verb([shoots|End], End).
verb([protects|End], End).
```

The grammar programmed in Listing 7.1 is just a small subset of the preceding grammar, but it aids in the illustration. In this example, a sentence is created and placed in a PROLOG list (see Appendix E). Because a sentence generated from Listing 7.1 is in the form of a list of concatenated words, a legitimate sentence would be [a, bot, shoots, the, player] or [*the, player, protects, a, bot*]. When we use the code in Listing 7.1 with SWI-Prolog the query:

```
? sentence(A,[]).
```

produces results such as

```
A = [a, bot, shoots, a, bot];
A = [a, bot, shoots, a, player];
A = [a, bot, shoots, the, bot];
A = [a, bot, shoots, the, player];
A = [a, bot, protects, a, bot];
...
```

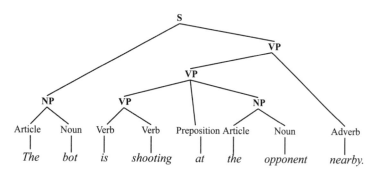

FIGURE 7.6 Sentence parsing.

until every possible combination of words that conforms to the structure of a sentence has been exhausted. Notice the query defined End as an empty list. By making a small modification to the code, it can also be used to parse a sentence and break it down to identify single words.

The process of parsing a sentence is a bottom-up process. Each word is classified and then used to form noun phrases and verb phrases. The process continues until a sentence has been defined. This technique is illustrated in Figure 7.6.

The PROLOG code to parse a simple sentence using the same grammar from Listing 7.1 is shown in Listing 7.2.

LISTING 7.2 Sentence parsing in PROLOG

```
sentence(sentence(NP,VP), List1, End) :-
    noun_phrase(NP, List1, List2),
    verb_phrase(VP, List2, End).
verb_phrase(verb_phrase(Verb, NP), List1, End) :-
    verb(Verb, List1, List2),
    noun_phrase(NP, List2, End).
noun_phrase(noun_phrase(Article, Noun), List1, End) :-
    article(Article, List1, List2),
    noun(Noun, List2, End).

article(article(a),[a|End], End).
article(article(the),[the|End], End).
noun(noun(bot),[bot|End], End).
noun(noun(player),[player|End], End).
verb(verb(shoots),[shoots|End], End).
verb(verb(protects),[protects|End], End).
```

In Listing 7.2, the rules and facts have been modified to include facts about the words. For example, an *a* in a sentence is defined by the predicate article. If we query these rules with:

```
? sentence(ParseTree, [a, bot, shoots, the, player], []).
```

the result is:

```
ParseTree = sentence(noun_phrase(article(a), noun(bot)),
verb_phrase(verb(shoots), noun_phrase(article(the),
noun(player))))
```

where it can be seen that each word has been identified.

While we are exploring language using PROLOG, let's examine one final process, that of interpreting the sentence and adding its meaning into the knowledge base. Hold onto your hat—this gets a little complex. First, we must define what *meaning* means to the knowledge base. Consider the sentence, "a bot shoots a player." Given to an NPC, we want the NPC to know there exists some bot, x, that shoots at some player, y. In first-order logic, this would be written as:

$$\exists x, y \; avatar(x) \wedge shoots(x, y)$$

This sentence could be written in PROLOG as:

```
exists(x, and(avatar(x), shoots(x,y)).
```

But how do we get from the English sentence to a PROLOG statement? Most of the work has already been done during the parsing exercise. All we must do is make a few modifications to what it means to be a noun, article, and verb. The general form of the `exists` statement is:

```
exists(x, and(property, assertion))
```

where x is some entity, `property` tells us something about x, and `assertion` is some statement about x. In the current example, `property` is `avatar(bot)` and `assertion` is `shoots(bot, player)`, but assertion could just as easily be `protects(bot, player)`, depending on the given sentence. A given word in a sentence can only have a property if it is a noun and an assertion if it is a verb. The *exists* predicate can be applied when an article is encountered that introduces a particular noun with the words *a* and *the* and a verb phrase follows the noun. Knowing this, the PROLOG code can be modified to that shown in Listing 7.3. The code that instantiates the meaning of the sentence is shown in bold.

LISTING 7.3 Integrating the meaning of a sentence into the knowledge base[a]

```
sentence(sentence(NP,VP), Meaning, List1, End) :-
    noun_phrase(NP, X, Assn, Meaning, List1, List2),
    verb_phrase(VP, X, Y, Assn, List2, End).
verb_phrase(verb_phrase(Verb, NP), X, Y, Assn, List1, End) :-
    verb(Verb, X, Y, Assn, List1, List2),
    noun_phrase(NP, X, Assn, Meaning, List2, End).
noun_phrase(noun_phrase(Article, Noun), X, Assn, Meaning, List1, End) :-
    article(Article, X, Prop, Assn, Meaning, List1, List2),
    noun(Noun, X, Prop, List2, End).
```

```
article(article(a), X, Prop, Assn,
    exists(X, and(Prop, Assn)), [a|End], End).
article(article(the), X, Prop, Assn,
    exists(X, and(Prop, Assn)), [the|End], End).
noun(noun(bot), X, avatar(X), [bot|End], End).
noun(noun(player),X, avatar(X), [player|End], End).
verb(verb(shoots), X, Y, shoots(X, Y), [shoots|End], End).
verb(verb(protexts), X, Y, protects(X, Y), [protects|End], End).

exists(X, and(Property,Assertion)).
```

[a] Note some lines of this code have been wrapped onto the next line to fit on the page. When writing this as PROLOG code, *do not* wrap the lines.

Given this new code, when we query the knowledge base with:

```
? sentence(ParseTree, Meaning, [a, bot, shoots, a, player],[]).
```

the results display the parse tree (as before), and now the meaning is displayed, as follows:

```
ParseTree = sentence(noun_phrase(article(a), noun(bot)),
verb_phrase(verb(shoots),
noun_phrase(article(a), noun(player))))

Meaning = exists(_G632, and(avatar(_G632), shoots(_G632, _G648)))
```

These examples of producing, parsing, and interpreting natural language have been very simplistic. However, they give you a good foundation by which to continue your exploration of the concepts in processing natural language using PROLOG. When you have mastered it in the SWI-Prolog interface, you can then use your skills at interfacing the PROLOG knowledge base with Apocalyx to create a natural-language-processing NPC.

EXERCISE

1. Modify the PROLOG code in Listing 7.1 to represent a more complete grammar as outlined earlier in this section.
2. Extend the number of words in the knowledge base to better represent information about a virtual environment and a multiplayer game.
3. Modify the PROLOG code into a program that accepts a sentence from the user and processes it. If the sentence does not conform to the grammar, have the program print out an error message.

4. One of the areas of research in producing believable NPCs in online multi-player environments is to have them shout abuse at their opponents. Integrate your natural language PROLOG knowledge base with Apocalyx and have the bot hurl random and varied insults at the player by displaying the language as text on the screen.

7.6.3 Faking Natural Language Processing

Some researchers in the natural language processing field may be insulted by the heading of this section, especially if they see their particular domain discussed here. However, at the risk of offending others, what we discuss in this section is how an NPC can produce natural language that appears to the human player as though it has been thought about by the NPC, but it is just a facade. Although some processing is performed by the program to produce the language, the language is in no way internally processed for meaning and integrated into any knowledge base. This is a legitimate way of producing language in an NPC because it requires much less processing and memory usage than the mechanisms discussed in the previous section. This is the smoke-and-mirrors way of producing natural language generation in an NPC.

A Counter-Strike Chat Bot

The first method, which we have already discussed, occurs in many FPS games, such as *Unreal Tournament*, in which bots can access and play prerecorded sound files. These files are limited, and the bot's language becomes predictable to a player after a short amount of interaction. This predictability quickly becomes tiresome, and players are fully aware the bot is just a bot and not another human player. This type of communication is one-directional and the players do not have the opportunity to respond to the bot (and know they will be heard) as they do with other humans.

Taking this type of communication one step further, researchers at Northwestern University have been experimenting with online multiplayer environments in which the bots can communicate with players in a realistic manner and respond to other players' comments [Zubek02]. The experiments take place in the FPS *Counter-Strike*, in which players (both human and bot) converse using on-screen text messages. To have the bot produce believable messages the researchers concluded that such messages were:

- disconnected in that topic changes are quite frequent and it is easy to forget who is talking to whom and what the topic is
- multithreaded, and a single person can be involved in more than one thread

- less than perfect use of grammar, frequent spelling mistakes, and *awful* language
- conforming to known stereotypical personalities

The bots can keep track of the context of conversations, recording the attitude they have about each player and keeping responses relevant, in context, and in language appropriate to the way that they feel about the intended message recipient. The bot creates messages by processing incoming messages from other players and keeping track of significant game events. Incoming messages are pattern-matched to find an appropriate response using an *ELIZA* module.

ELIZA

The ELIZA module used in the *Counter-Strike* bots is an augmented version of the ELIZA program first conceived in 1966 by Joseph Weizenbaum. ELIZA was written as a tool for examining natural language communication between man and machine [Weizenbaum66]. It works by analyzing inputted text for keywords and generating appropriate textual responses. A typical conversation between a human and ELIZA follows:

```
ELIZA:  Hello, I am Eliza.
Human:  Hello
ELIZA:  How are you today?
            What would you like to talk about?
Human:  My friends
ELIZA:  Tell me more…
Human:  They don't like me.
ELIZA:  Can you elaborate on that?
Human:  They don't call me.
ELIZA:  I'm not sure I understand you fully.
Human:  I leave them messages, but they don't call back.
ELIZA:  Oh dear, can you elucidate your thoughts further?
Human:  Maybe I am being paranoid.
ELIZA:  Do you believe it is normal to be paranoid?
Human:  I don't think I like you.
ELIZA:  Do you wish to be able to like me?
```

At the heart of the program lies a set of decomposition and assembly rules. The decomposition rules work in a manner similar to parsing. A sentence is taken and broken down into elementary parts. However, unlike parsing, decomposed elements may consist of more than one word. A decomposition rule takes the form of

(* you * me)

where the given text is analyzed for the keywords *you* and *me*. The * denotes matching of any number of other words in the same way that regular expression-matching works. For example, given the text "I think you don't like me," using the given rule, decomposition forms the elements:

1) I think 2) you 3) don't like 4) me

Besides using a *, a decomposition rule can also attempt to match exact numbers of words such as:

(1 you 2 me)

In this case, given the previous sentence the rule would fail because there is more than one word before *you*. There may exist any number of decomposition rules for the same keywords. If a sentence does not match a decomposition rule, a default response is generated. When a match is found, an assembly rule is applied to create the response. An assembly rule that might be used with the preceding sentence follows:

(Are you sure you think I 3 you?)

where the *3* in the previous line is replaced by the third decomposition element from the sentence. In this example, the response sentence would be:

*Are you sure you think **I don't like** you?*

Markov Model Language Learning

Another type of natural language processing and learning application is based on statistics and probability theory. One of the simplest ways of analyzing the essence of a language is called a second-order Markov model [Hutchens02]. The model scrutinizes the order in which words occur in a sentence and determines the probability that a word will follow a sequence of others. Recall the probability theory from Chapter 4 that represents the probability that event A will occur if event B has already occurred, written as:

$$P(A|B)$$

The same concept can be used to determine the probability that a word in a sentence will follow a sequence of others. For example, the probability that the word *hat* will follow the sequence *"the cat in the"* can be written as:

$$P(hat \,|\, the \; cat \; in \; the)$$

If the value of this probability was 1, we would be able to, with certainty, conclude on hearing the words "*the cat in the*" that the next word would be "*hat.*" Now assume you have written a program to work out the probabilities of word sequences. Let's say the program reads the lines:

the cat in the hat
the cat in the house
the cat in the box

It would set the following probabilities:

$$P(hat \mid the\ cat\ in\ the) = 0.333$$
$$P(house \mid the\ cat\ in\ the) = 0.333$$
$$P(box \mid the\ cat\ in\ the) = 0.333$$

Now we turn our idea around and ask the program to generate a sentence in natural language using the probabilities that it knows about word order. We could expect that one third of the time it would generate "*the cat in the hat,*" another third of the time it would generate "*the cat in the house,*" and yet another third of the time it would say "*the cat in the box.*" As we give the program more and more sentences to learn, its vocabulary will grow.

A simple implementation of such a program could determine the probability that just one word follows another, for example:

$$P(the \mid on)$$

The program would have to keep track of each word read and the number of times a particular word has followed it. It could then use these statistics to regurgitate its own sentences. The code for this program is listed in Listing 7.4.

LISTING 7.4 A statistical language-learning program

```
#include <stdio.h>
#include <stdlib.h>
#include <time.h>
#include <string>
#include <vector>
#include <stack>

using namespace std;

//Part A
```

```
struct word
{
    string theWord;
    string nextWord;
    int count;
    int total;
    word(string str1, string str2, int c, int t):
        theWord(str1), nextWord(str2), count(c), total(t){}
    ~word() {}
};

typedef vector<word> dictionary;

//Part B
string getNext(string N, dictionary d)
{
    //probability of using this word
    int prob = rand() % 100;
    int accumprob = 0;
    for( dictionary::iterator i = d.begin(); i != d.end(); ++i )
    {
        if(!N.compare((*i).theWord))
        {
            accumprob += (((*i).count/(float) (*i).total) * 100);
            if( prob < accumprob)
                return (*i).nextWord;
        }
    }
    return "";
}

//Part C
int updateWordCount(string w, string n, dictionary *d)
{
    int count = 0;
    int totalWords = 0;
    for( dictionary::iterator i = d->begin(); i != d->end(); ++i )
    {
        if(!w.compare((*i).theWord) && !n.compare((*i).nextWord))
        {
            (*i).count++;
            count++;
        }

        if(!w.compare((*i).theWord))
```

```
                    totalWords+=(*i).count;
        }

        for( dictionary::iterator i = d->begin(); i != d->end(); ++i )
        {
            if(!w.compare((*i).theWord))
                (*i).total = totalWords;
        }

        return count;
}

//Part D
int main()
{
    char str1[256] = "", str2[256] = "";
    dictionary mydict;
    FILE *file;

    if( (file=fopen("markov.txt","r")) == (FILE *) NULL)
    return 2;

    while(!feof(file))
    {
        fscanf(file,"%s",str1);
        if(updateWordCount(str2, str1, &mydict) == 0)
            //word not found
        {
            word newword1(str2, str1, 1, 1);
            mydict.push_back(newword1);
        }
        strcpy(str2, str1);
    }

    srand(time(NULL));
    dictionary::iterator dtemp;

    do
    {
        //start somewhere in the list
        dtemp = mydict.begin() + rand()% mydict.size();
        string next = (* dtemp).theWord;
        do
        {
            fprintf(stdout,"%s ",
```

```
            strupr(_strdup(next.c_str()))));
            next = getNext(next, mydict);
        } while (((int)next.find(".")) == -1);
        fprintf(stdout,"%s ",
        strupr(_strdup(next.c_str()))));

        fprintf(stdout, "\n\nPress Any Key or q to quit.\n\n");
    }
    while(getchar() != 'q');
    return 0;
}
```

The code in Listing 7.4 is divided into parts that are now explained.

Part A: The code works by reading through a file of text and recording the frequency of sequences of every two words in a dictionary vector. The first part of the code sets up an array to store the read word (theWord), along with the word that follows it (nextWord), and the number of times this sequence has been encountered (count). The total variable stores the total number of times the first word has been encountered. The probability that nextWord follows theWord is rendered as:

$$P(nextWord \mid theWord) = count/total$$

Part B: The getNext() function is used when generating a sentence to determine the most probable word to succeed the last word used in a sentence. For example, if the current sentence were "*the cat on the*" and

$$P(cat \mid the) = 0.5$$
$$P(hat \mid the) = 0.3$$
$$P(box \mid the) = 0.2$$

then the sentence is most likely to be "*the cat on the cat.*" However, every time the next word is to be determined, a random-number generator determines a probability that is used to pick the next word from the list such that the word succession probabilities remain true over the course of many generated sentences.

Part C: The updateWordCount() function takes a word and the following word and updates their counts for count and total in the dictionary array.

Part D: The main() function in the code sets up the dictionary by reading through a text file and calling the updateWordCount() function. This function re-

turns 0 if the word was not found in the dictionary, and the `main()` function adds it and initializes its counts. The remainder of `main()` operates within a loop, continually generating sentences using the `getNext()` function. The end of the sentence is denoted by the finding of a full stop in the word. Note, any punctuation in the text is read in as part of a word. The program continues generating sentences until the user types a q.

The program in Listing 7.4 is not very sophisticated, but it does illustrate the use of statistical learning for natural language generation. The program was run and allowed to read in the text from the first section in this chapter. Although many of the sentences are nonsensical, some are amusing and most strangely conform to a loose version of English grammar. Here are some examples:

THE REALM OF VERBAL COMPREHENSION, SPELLING, READING AND TO DEAL EFFECTIVELY WITH THE AVERAGE PERSON CANNOT ASSESS THE MOST WIDELY ACCEPTED DEFINITION IS MORE THAN ATTEMPTING TO DEAL EFFECTIVELY WITH THE COMPLICATED UNDERLYING CHARACTERISTC IN WHICH IT IS A PERSON'S ABILITY TO MODEL INTELLIGENCE FUNCTIONING ON NPCS.

DRESSING AND BEHAVIORS AND PROBLEM-SOLVING ABILITIES.

RESEARCHERS DECIDED TO GAUGE ANOTHER'S INTELLIGENCE.

CAPACITY OF THE PSYCHOLOGICAL PERSPECTIVE DIFFERS AMONG RESEARCH FIELDS.

HUMOR ASIDE, A REFLECTION OF INTELLIGENCE IS MORE THAN ATTEMPTING TO ACT LIKE HUMANS.

Many of the sentences created by the program border on the edge of what would be considered reasonable grammar, but the clarity produced by analyzing just the sequence of every two words is remarkable.

A more sophisticated form of this language-learning method was used in the creation of an online artificial conversationalist called MegaHAL [Hutchens98]. MegaHAL statistically analyzes sentences input by users and attempts to respond to them using keywords from their input. They keywords are used as points for starting the creation of a sentence with the remainder of the sentence generated before and after the keyword. More information and the source code for MegaHAL is available at *http://megahal.sourgeforge.net/*.

Learning and generating natural language is a complex task and is the topic of much ongoing research. This section has only scratched the surface of the domain in an attempt to provide you with an introduction to the topic and a platform from which to begin further research.

7.7 DAY OF RECKONING: COMMUNICATION WITH YOUR NPC

In this practical exercise, you learn how to have a console open in the Apocalyx environment and use it for text communication with a bot.

ON THE CD
The initial project files for this practical can be found in the Apocalyx/prj/Chapter Seven-2 folder. To compile the files with the console and language mechanisms you must use the USE_CONSOLE and USE_LANGUAGE preprocessor commands. Compile and run the program. To open the console, in which you can freely enter text, press F3.

7.7.1 Step One: Natural Language Deciphering

Because we want the bot to respond to natural language, the bot must be enabled with the correct grammar. We will use rules similar to those used in ELIZA. The knowledge base that comes with this initial project is the one that was used in Section 6.4. The rules that must be added are:

```
match([],L,L).
match([X|L1],L2,[X|L3]) :-
    match(L1,L2,L3).

rule(X,[here,i,am]) :-
    chat(X,S),
    match([where],[are,you],S).

speak(X,S) :-
    rule(X,S),
    not(respondedTo(X)).
```

When `rule` fires, it causes `speak` to fire. `speak` is the fact sought by the AIBot class to determine if the bot should say something. These rules work by having `rule` fire when `chat` is perceived by the bot. A `chat` fact is entered into the environmental states vector when the player types text in the console. Let's say the player types:

where are you

When the environment processes its states (we examine this shortly), it adds the string:

```
chat(1, [where,are,you])
```

to its states vector (envStates). Why does a chat state look like this? Recall that PROLOG processes sentences as a list of words. Therefore, any sentence typed by the player should be converted into list form. Next, the chat state also includes a numeral, in this case 1. The numeral assigns a unique ID to the chat event. This ID is used by the bot to keep track of which communications it has answered. For example, if the player types *where are you* and the bot responds with *here I am*, the bot knows that it has responded to the first instance of *where are you* and that it need not respond again. When the player types *where are you* again, a new ID is assigned to the sentence, and the bot knows this is a different chat message from the previous one and that it should respond. The chat ID is generated sequentially by the program.

When a chat fact is received by the knowledge base, a rule cannot fire until the match fact has been found to be true. In brief, the match rule, at the very top of the newly inserted code, tries to match a chat fact with a known sentence, in this case *where are you*. The match works using difference lists and recursion to test each part of the given sentence against a known sentence. In this case, when the match rule first fires, it looks like the following line:

```
match([where], [are, you], [where, are, you])
```

On the first recursive call the rule takes off the first word in the chat sentence that matches the first argument, leaving the rule as:

```
match([], [are, you], [are, you])
```

When the first argument denotes an empty list ([]), as above, the rule makes a final comparison between the second argument and what remains of the sentence. If they are the same, match is assumed to be true. This then causes rule to be true. All that remains is for the speak rule to fire for the bot to respond to the player. For speak to fire, after a matched message from the player, the bot must not have previously responded to the same text message with the same ID, x. After the bot responds to the given message, its code inserts a respondedTo(1) fact into the knowledge base to prevent the bot from responding more than once to a message.

We are not dealing with uppercase letters or punctuation because it will just complicate things. As you enhance this work, you can explore the problems and solutions associated with including them.

7.7.2 Step Two: Capturing Player Communications

For any of the preceding rules to fire, the knowledge base must receive the message typed at the console. The console code contained in the *Apocalyx/dev/src/Apocalyx/glconsole.cpp* and *glconsole.h* files is set up so that any message typed by the player is placed in a string array called messages. The following code, which should be inserted at the end of MainScene::processStates() in *vh.cpp*, takes the strings from messages and inserts them into envStates as an environmental state in the format required to fire a rule in the knowledge base. We also assume text messages to be in the same category as sounds made in the environment. They are not persistent environmental states and should be removed from envStates after several game update loops. Therefore, if the bot is asleep, it may miss the textual message.

```
//process console messages
GLConsole &console = GLConsole::get();
char messageStr[SMALLBUF];
for( vector<string>::iterator j = console.messages.begin();
    j != console.messages.end(); ++j )
{
    //format string into a list i.e.
    //put commas where the spaces are.
    for(string::iterator t = (*j).begin(); t != (*j).end(); t++)
    {
        if((*t) == ' ') (*t) = ',';
    }

    sprintf(messageStr,"chat(%d,[%s])",chatid,(*j).c_str());

    //add message for 2 updates
    state message(messageStr, 2);
    envStates.push_back(message);
    chatid++;
}
console.messages.clear();
```

When the console messages have been entered into envStates, messages is cleared. These are the only changes that must occur to the *vh.cpp* code.

7.7.3 Step Three: Hearing the Player

Hearing what the player has said is a simple matter of modifying the bot's inference module to watch for the firing of a speak rule. The perception module already takes the environmental states from envStates and enters them into the knowledge base. Therefore, it is unnecessary to make any changes to it. The code to extract speak facts is the same as that for extracting actions, so:

```
arity = 2;
PlTermv t1(arity);
PlQuery q1("speak",t1);
int speechId;
char retractChat[SMALLBUF];

while(q1.next_solution())
{
    speechId = atoi((char *) t1[0]);
    GLConsole &console = GLConsole::get();

    console.println((char *) t1[1]);
    console.printPrompt();

    sprintf(retractChat,"respondedTo(%d)", speechId);
        assertPL(retractChat);
}
```

can be added to the end of the inference() method to access any of these facts if they exist. In the code, because a speak fact is found, the associated response message is printed to the console. Following this, the respondedTo fact is inserted into the knowledge base to ensure the bot does not respond to the same instance of the message again. However, note that the bot does retain a *memory* of all messages received and all those to which it has responded, which could prove useful in future conversations.

At this point, save, compile, and run the code. Press F3 to initiate the console and type *where are you*. After you press Enter, the bot responds with *here I am*.

7.7.4 Step Four: Expanding the Bot's Vocabulary

What has been achieved in the previous sections is nothing but simply matching the inputted text exactly with a stored sentence in the knowledge base. This process is fairly trivial. However, what if we want to deal with more ambiguous sentences, such as:

where in the world are you

or

where the heck are you

The keywords in this message are still *where, are,* and *you*; however, this time extra words have been inserted, and you cannot be sure how many extra words might exist. An exact string match no longer works, but in both cases, we may still want the response to be the same (*here I am*). The astute reader may be thinking we need to apply some kind of wildcard in the string to match any number of ambiguous words—that is correct. A new rule can be added to the knowledge base to deal with these types of messages, therefore:

```
rule(X,[here,i,am, too]) :-
    chat(X,S),
    match([where|_],[are,you],S).
```

In PROLOG a "_" is an anonymous variable that can be matched to anything. In this case we are using it to match a list of words. That list might be empty, have one word, two words, or even more. The bot's response has been slightly modified so you can be sure which rule has fired when this is run (if you leave the existing rule where it is). This time when you run the program you will notice the bot responds to any message starting with *where* and ending with *are you*, regardless of the number of words inserted between them.

In this section, did you notice how easy it was to modify the bot's vocabulary without having to modify the C++ code and recompile? You can add many more rules to the bot's knowledge base and have it deal with all kinds of chat messages and not have to recode or recompile.

For some more enlightening speech rules check out *eliza.pl* in the Chapter Seven folder.

1. Create a new rule that accepts and responds to the following messages:

 ■ *are you hungry*
 ■ *how hungry are you*
 ■ *where are you going*
 ■ *what are you doing*

 If you want the bot to respond with exact coordinates of its location or its degree of hunger, you may have to perform extra processing on the text in the `inference()` module before writing the message to the console.

2. Modify the rules and the bot's code so that it can accept commands from the player and act (through animation) appropriately:

 ■ *walk to location X, Y* (where *X* and *Y* would be map coordinates)
 ■ *run to location X, Y*
 ■ *lie down*
 ■ *lie down at location X, Y*

7.8 SUMMARY

Believability is in the eye of the beholder; it is up to the game developers to predict the expectations of their players to create an NPC capable of suspending disbelief. As game graphics and sounds improve, the task actually becomes much more difficult because the player is asked to believe in what they are seeing. In the example of pure text-based games, such as *Zork*, the character visualization was performed in the player's imagination. Therefore, the player could create the characters to his own specifications, making them more believable to each individual. Nowadays, the way a character looks and moves is dictated to the player, and little is left to the imagination.

Mutliplayer games introduce another dimension in that an obviously computer-generated avatar can be controlled by a human player. A player can anticipate how the other player is feeling, determine what the player's goals are, and form alliances and carry on conversations using natural language. It is the type of challenge that can be experienced while playing against another human that programmers want to recreate in an NPC. This goal requires the NPC to be believable to the extent where it might possibly be able to pass the Turing Test.

As has been examined in this chapter, the believability of an NPC is highly correlated with its social behaviors and its ability to interact with a human player in the same way as another human. We have discussed the issues and practical applications of emotion synthesis and natural language conversation in an attempt to inspire you into this domain and examine the issue beyond the conventional AI necessary for advancing the programming techniques used in NPC programs.

REFERENCES

[Baillie02] Baillie, P., 2002, *The Synthesis of Emotions in Artificial Intelligences*, Ph.D., University of Southern Queensland.

[Balkenius95] Balkenius, C. 1995, *Natural Intelligence in Artificial Creatures*, Lund University Cognitive Studies, Lund.

[Bates92] Bates, J., Loyall, A.B. & Reilly, W.S. 1992, "An Architecture for Action, Emotion, and Social Behavior," in *Proceedings of Artificial Social Systems: Fourth European Workshop on Modeling Autonomous Agents in a Multi-Agent World*, Pittsburg, 1994, Springer-Verlag, Germany, pp. 55–68.

[Blumber96] Blumberg, B.M., P.M. Todd and Maes, P., 1996, "No Bad Dogs: Ethological Lessons for Learning in Hamsterdam," in *From Animals to Animats 4: Proceedings of the Fourth International Conference on Simulation of Adaptive Behavior*, Cape Cod, MIT Press/Bradford Books, Cambridge, pp. 295–304.

[Bullock87] Bullock, D., 1987, Socializing the theory of intellectual development, in M. Chapman & R.A. Dixson (eds), Meaning and the growth of understanding: Wittgenstein's significance for developmental psychology, Springer-Verlag, Berlin.

[Canamero97] Canamero, D. 1997, "Modeling Motivations and Emotions as a Basis for Intelligent Behavior," in *Proceedings of the First International Conference on Autonomous Agents, New York*, 1997, ACM Press, New York, pp. 148–55.

[Coleridge17] Coleridge, S. T., 1817, Biographia Literaria; or Biographical Sketches of my Literary Life and Opinions, vol. 1, London: Rest Renner, 23, Paternoster Row.

[Egri60] Egri, L., 1960, *The Art of Dramatic Writing; Its Basis in the Creative Interpretation of Human Motives*, Simon and Schuster.

[Elkman72] Ekman P., Friesen W.V., Ellsworth P. *Emotion in the Human Face*, Pergamon Press, 1972.

[El-Nasr98] El-Nasr, M. S. 1998, *Modeling Emotion Dynamics in Intelligent Agents*, M.Sc. Dissertation, American University in Cairo.

[Fellous99] Fellous, J. 1999, "The Neuromodulatory Basis of Emotion," *The Neuroscientist*, SAGE Science Press, Thousand Oaks, vol. 5, no. 5, pp. 283–94.

[Hutchens02] Hutchens, J. & Barnes, J., 2002, Practical Natural Language Learning, in S. Rabin (ed) *AI Game Programming Wisdom*, Charles River Media, Hingham.

[Hutchens98] Hutchens, J., 1998, Introducing MegaHAL, NeMLaP/CoNLL *Workshop on Human Computer Conversation*, Association for Computational Linguistics.

[Isbister95] Isbister, K., 1995, Perceived Intelligence and the Design of Computer Characters, *Masters Thesis*, Stanford University.

[Kaehms99] Kaehms, B. 1999, Putting a (Sometimes) Pretty Face on the Web, *WebTechniques*, CMP Media, Issue: September 1999, available online at *www.newarchitectmag.com/archives/1999/09/newsnotes/*.

[Koestler67] Koestler, A. 1967, *The Ghost in the Machine*, Penguin Books Ltd., London.

[Lefton94] Lefton, L. A. 1994, *Psychology: Fifth Edition*, Allyn and Bacon, Boston.

[Loyall97] Loyall, B., 1997, *Believable Agents*, Ph.D. Carnegie Mellon University.

[McNemar64] McNemar, Q., 1964, Lost: Our Intelligence. Why?, *American Psychologist*, vol. 19, pp. 871–82.

[Ortony88] Ortony, A., Clore, G.L. & Collins, A., 1988, *The Cognitive Structure of Emotions.* Cambridge University Press, Cambridge.

[Padgham97] Padgham, L. & Taylor, G., 1997, "A System for Modeling Agents having Emotion and Personality," *Lecture Notes in Artificial Intelligence*, Springer-Verlag. vol.12, no. 9, pp. 59–71.

[Penrose89] Penrose, R., 1989, *The Emperor's New Mind*, Oxford University Press, New York.

[Pert97] Pert, C. B., 1997, *Molecules of Emotion*, Simon and Schuster, New York.

[Picard97] Picard, R., 1997, *Affective Computing*, The MIT Press, London.

[Rosenberg95] Rosenberg, S., 1995, The New Video Game Philosophers: Did someone say "Suspension of Disbelief?," *Digital Culture*, May 1995, available online at *www.wordyard.com/dmz/digicult/disbelief-5-17-95.html*, Available March 2003.

[Russel95] Russell, S., and Norvig, P., 1995, *Artificial Intelligence: A Mordern Approach*, Prentice Hall, Upper Saddle River.

[Sloman01] Sloman, A., 2001, "Beyond Shallow Models of Emotion," *Cognitive Processing*, Pabst Science Publishers, Lengerich, vol. 2, no. 1, pp. 177–98.

[Smith00] Smith, C. A. & Kirby, L.D. (eds.), 2000, *Consequences Require Antecedents: Towards a Process Model of Emotion Elicitation. Feeling and Thinking: The role of affect in social cognition*, Cambridge University Press, London.

[Smith85] Smith, C. A. & Ellsworth, P.C., 1985, Attitudes and Social Cognition, in *Journal of Personality and Social Psychology*, American Psychologists Association, Washington, vol. 48, no. 4, pp. 813–38.

[Sternberg86] Sternberg, R. J., 1986, Inside Intelligence, *American Scientist*, vol. 74, pp. 137–43.

[Stork97] Stork, D., 1997, *Scientist on the Set: An Interview with Marvin Minsky, in D. Stork (ed) HAL's Legacy: 2001's Computer as Dream and Reality, MIT, pp. 15–31.*

[Velasquez99] Velasquez 1999, "From Affect Programs to Higher Cognitive Emotions: An Emotion-Based Control Approach," in *Proceedings of Workshop on Emotion-Based Agent Architectures*, Seattle, USA, pp. 10–15.

[Wechsler58] Wechsler, D., 1958, *The Measurement and Appraisal of Adult Intelligence*: 4th Edition, Williams and Wilkins, Baltimore.

[Weizenbaum66] Weizenbaum, J., 1966, Computational Linguistics, *Communications of the ACM*, vol. 9, no. 1, pp. 36–45.

[Zeltzer92] Zeltzer, D., 1992, Autonomy, Interaction and Presence, *Presence: Teleoperators and Virtual Environments*, vol. 1, no. 1, pp. 109–112.

[Zubek02] Zubek, R. & Khoo, A., 2002, Making the Human Care: On Building Engaging Bots, *Proceedings of the 2002 AAAI Spring Symposium on Artificial Intelligences and Interactive Entertainment.* Palo Alto, California, pp. 103–08.

Appendix

A About the CD-ROM

This CD-ROM contains files to assist you in creating models for NPCs, creating 3D game environments, and programming 3D games. Three primary types of folders are present: one for each chapter, one for additional shareware software, and one for the Apocalyx 3D game engine code. The content of these folders follows. Please also refer to the system requirements contained in this document to ensure that your system meets these requirements.

The code and programs listed on the CD-ROM are referred to throughout the book. When the book prompts you to install and use the software, full instructions are given for its operation. Again, be sure that you have all the necessary hardware and software to run these files.

Image Files: All the images from the book.

Chapter Files: Throughout the book, sample code, images, and exercise data are referenced. These files are included in the associated chapter folder.

Shareware: The practical contents of the book have been designed to use software freely available for download from the Internet. For your convenience, this software is included on the CD-ROM. All software is for the Windows operating system. An Internet search may reveal versions for other operating systems. The programs included are:

Milkshape: A 3D modeling and animation package.

Netica: An API for programming in Bayesian networks.

SWI-Prolog: A PROLOG programming environment and APIs for the creation of PROLOG knowledge bases for C/C++ programs. Distributed under the GPL.

Apocalyx 3D game engine: This game engine is provided as open source C/C++ code and is used throughout the book to create a 3D gaming environment and for practical applications of the concepts presented in the text.

SYSTEM REQUIREMENTS

Windows Intel® Pentium® processor (required); Pentium III, Pentium IV, or multiprocessor system recommended. Windows 98 (32MB RAM), WIN XP (64MB RAM), or higher (or its equivalent); 500 MB+ of available hard disk space; sound card (recommended); 16-bit video card (required); 24-bit or greater video display card (recommended).

This appendix contains many of the answers to the exercises presented throughout the book. Some of the answers have been omitted because they are subjective, based on personal experience, listed in the text, or related to specific programming tasks.

CHAPTER 3

Section 3.2.3 Games of Strategy: The Prisoner's Dilemma

1.

		Player 2	
		C	D
Player 1	C	1, 1	1, 4
	D	4, 1	3, 3

In this game each prisoner wants the worst for the other, regardless of the consequences for themselves. If both players withhold information (C), the payoff is small because the other is not punished. If the both confess (D), they both go to jail. If only one confesses, then the other goes to jail, which provides the best payoff for the one who confesses because he goes free. The maximin solution is at (D, D), creating the situation where both players go to prison. This constitutes a Nash equilibrium because neither player can do better by selecting C when the other sticks with D.

2. There is no Nash equilibrium. The mixed strategy probabilities follow:

		Boy		
		Look for Work	**Play Computer Games**	*p*
Girl	**Support Boyfriend**	(2,3)	(−1,3)	0.25
	Don't Support	(−1,1)	(0,0)	0.75
	p	1.00	0.00	

The mixed strategy for this game suggests the boyfriend should look for work while the girlfriend selects to support the boy with probability 0.25 and not support him with probability 0.75.

3.

		Mordred		
		Camlann	**Camelot**	*p*
Arthur	**Camlann**	0	50	2/3
	Camelot	100	0	1/3
	p	1/3	2/3	

CHAPTER 4

Section 4.2.1 Propositional Logic

1.

A	B	B ∧ ¬A	B ∧ ¬A ∨ ¬B
True	True	False	False
True	False	False	True
False	True	True	True
False	False	False	True

2.

A	B	$(A \vee B) \wedge \neg (A \wedge B)$	$(A \wedge \neg B) \vee (\neg A \wedge B)$
True	True	False	False
True	False	True	True
False	True	True	True
False	False	False	False

3. a. Contradiction
 b. Contradiction
 c. Tautology
 d. Tautology
 e. Contradiction
 f. Tautology

4. $(\neg P \wedge (Q \vee R)) \vee ((\neg P \vee \neg Q) \wedge (\neg P \vee R))$
 $\equiv (\neg P \wedge (Q \vee R)) \vee (\neg (P \wedge Q) \wedge \neg (P \wedge \neg R))$ (de Morgan)
 $\equiv (\neg P \wedge (Q \vee R)) \vee \neg ((P \wedge Q) \vee (P \wedge \neg R))$ (de Morgan)
 $\equiv \neg (P \vee \neg (Q \vee R)) \vee \neg (P \wedge (Q \vee \neg R))$ (de Morgan)
 $\equiv \neg ((P \vee \neg (Q \vee R)) \wedge (P \wedge (Q \vee \neg R)))$ (de Morgan)

5. Show that $M_{2,1}$ is true.

$1_{1,1}$
$1_{1,2}$
$1_{2,2}$
$1_{1,1} \rightarrow M_{1,2} \otimes M_{2,1} \otimes M_{2,2}$
$1_{1,2} \rightarrow M_{1,1} \otimes M_{2,1} \otimes M_{2,2}$
$1_{2,2} \rightarrow M_{1,1} \otimes M_{1,2} \otimes M_{2,1}$

$1_{1,1}$
$1_{1,2}$
$1_{2,2}$
$M_{1,2} \otimes M_{2,1} \otimes M_{2,2}$
$M_{1,1} \otimes M_{2,1} \otimes M_{2,2}$
$M_{1,1} \otimes M_{1,2} \otimes M_{2,1}$

$1_{1,1}$
$1_{1,2}$
$1_{2,2}$

$$M_{1,2} \otimes M_{2,1} \otimes M_{2,2}$$
$$\equiv \left(M_{1,2} \vee M_{2,1} \vee M_{2,2} \right) \wedge \neg \left(M_{1,2} \wedge M_{2,1} \right) \wedge \neg \left(M_{1,2} \wedge M_{2,2} \right) \wedge \neg \left(M_{2,1} \wedge M_{2,2} \right)$$
$$M_{1,1} \otimes M_{2,1} \otimes M_{2,2}$$
$$\equiv \left(M_{1,1} \vee M_{2,1} \vee M_{2,2} \right) \wedge \neg \left(M_{1,1} \wedge M_{2,1} \right) \wedge \neg \left(M_{1,1} \wedge M_{2,2} \right) \wedge \neg \left(M_{2,1} \wedge M_{2,2} \right)$$
$$M_{1,1} \otimes M_{1,2} \otimes M_{2,1}$$
$$\equiv \left(M_{1,1} \vee M_{1,2} \vee M_{2,1} \right) \wedge \neg \left(M_{1,1} \wedge M_{1,2} \right) \wedge \neg \left(M_{1,1} \wedge M_{2,1} \right) \wedge \neg \left(M_{1,2} \wedge M_{2,1} \right)$$

$$1_{1,1}$$
$$1_{1,2}$$
$$1_{2,2}$$
$$\left(M_{1,2} \vee M_{2,1} \vee M_{2,2} \right) \wedge \neg \left(M_{1,2} \wedge M_{2,1} \right) \wedge \neg \left(M_{1,2} \wedge M_{2,2} \right) \wedge \neg \left(M_{2,1} \wedge M_{2,2} \right)$$
$$\left(M_{1,1} \vee M_{2,1} \vee M_{2,2} \right) \wedge \neg \left(M_{1,1} \wedge M_{2,1} \right) \wedge \neg \left(M_{1,1} \wedge M_{2,2} \right) \wedge \neg \left(M_{2,1} \wedge M_{2,2} \right)$$
$$\left(M_{1,1} \vee M_{1,2} \vee M_{2,1} \right) \wedge \neg \left(M_{1,1} \wedge M_{1,2} \right) \wedge \neg \left(M_{1,1} \wedge M_{2,1} \right) \wedge \neg \left(M_{1,2} \wedge M_{2,1} \right)$$

$$1_{1,1}$$
$$1_{1,2}$$
$$1_{2,2}$$
$$\left(M_{1,2} \vee M_{2,1} \vee M_{2,2} \right)$$
$$\neg \left(M_{1,2} \wedge M_{2,1} \right)$$
$$\neg \left(M_{1,2} \wedge M_{2,2} \right)$$
$$\neg \left(M_{2,1} \wedge M_{2,2} \right)$$
$$\left(M_{1,1} \vee M_{2,1} \vee M_{2,2} \right)$$
$$\neg \left(M_{1,1} \wedge M_{2,1} \right)$$
$$\neg \left(M_{1,1} \wedge M_{2,2} \right)$$
$$\neg \left(M_{2,1} \wedge M_{2,2} \right)$$
$$\left(M_{1,1} \vee M_{1,2} \vee M_{2,1} \right)$$
$$\neg \left(M_{1,1} \wedge M_{1,2} \right)$$
$$\neg \left(M_{1,1} \wedge M_{2,1} \right)$$
$$\neg \left(M_{1,2} \wedge M_{2,1} \right)$$

$$1_{1,1}$$
$$1_{1,2}$$
$$1_{2,2}$$
$$\left(M_{1,2} \vee M_{2,1} \vee M_{2,2} \right) \wedge \left(M_{1,1} \vee M_{2,1} \vee M_{2,2} \right) \wedge \left(M_{1,1} \vee M_{1,2} \vee M_{2,1} \right)$$
$$\neg \left(M_{1,2} \wedge M_{2,1} \right)$$
$$\neg \left(M_{1,2} \wedge M_{2,2} \right)$$
$$\neg \left(M_{2,1} \wedge M_{2,2} \right)$$
$$\neg \left(M_{1,1} \wedge M_{2,1} \right)$$
$$\neg \left(M_{1,1} \wedge M_{2,2} \right)$$
$$\neg \left(M_{2,1} \wedge M_{2,2} \right)$$

$$\neg\left(M_{1,1} \wedge M_{1,2}\right)$$
$$\neg\left(M_{1,1} \wedge M_{2,1}\right)$$
$$\neg\left(M_{1,2} \wedge M_{2,1}\right)$$

$$1_{1,1}$$
$$1_{1,2}$$
$$1_{2,2}$$
$$M_{2,1} \vee \left(M_{1,1} \wedge M_{2,2} \wedge M_{1,2}\right)$$
$$\neg M_{1,2} \vee \neg M_{2,1}$$
$$\neg M_{1,2} \vee \neg M_{2,2}$$
$$\neg M_{2,1} \vee \neg M_{2,2}$$
$$\neg M_{1,1} \vee \neg M_{2,1}$$
$$\neg M_{1,1} \vee \neg M_{2,2}$$
$$\neg M_{2,1} \vee \neg M_{2,2}$$
$$\neg M_{1,1} \vee \neg M_{1,2}$$
$$\neg M_{1,1} \vee \neg M_{2,1}$$
$$\neg M_{1,2} \vee \neg M_{2,1}$$

$$1_{1,1}$$
$$1_{1,2}$$
$$1_{2,2}$$
$$M_{2,1} \vee \left(M_{1,1} \wedge M_{2,2} \wedge M_{1,2}\right)$$
$$\neg M_{1,2} \vee \neg M_{2,1}$$
$$\neg M_{2,1} \vee \neg M_{2,2}$$
$$\neg M_{1,1} \vee \neg M_{2,1}$$
$$\neg M_{2,1} \vee \neg M_{2,2}$$
$$\neg M_{1,1} \vee \neg M_{2,1}$$
$$\neg M_{1,2} \vee \neg M_{2,1}$$
$$\neg\left(M_{1,1} \wedge M_{2,2} \wedge M_{1,2}\right)$$

$$1_{1,1}$$
$$1_{1,2}$$
$$1_{2,2}$$
$$M_{2,1}$$
$$\neg M_{1,2}$$
$$\neg M_{2,2}$$
$$\neg M_{1,1}$$

Section 4.2.2 First-Order Logic

1. a. $\forall x, t_1, t_2 \; Prince(x) \wedge Time(t_1) \wedge After(t_2, t_1) \rightarrow King(x) \wedge Time(t_2)$
 b. $\forall x \, \exists y \; Princess(x) \wedge Frog(y) \wedge Kiss(x, y) \rightarrow Prince(x)$
 c. $\forall x \; Green(x) \wedge \neg Easy(x)$

Section 4.3 Day of Reckoning: Practice with PROLOG

1.

```
troll(X) :-
    parent(Y,X),
    parent(Z,X),
    troll(Y),
    troll(Z),
    not(Y==Z).

half-troll(X) :-
    parent(Y,X),
    parent(Z,X),
    troll(Y),
    not(elf(Z)),
    not(Y==Z).

process(race) :-
    setof(X, human(X), HUMANS),
    setof(Y, elf(Y), ELVES),
    setof(Z, half_elf(Z), HALF_ELVES),
    setof(T, troll(T), TROLLS),
    nl, write_ln('-- MEMBERS OF RACE --'),
    write('Humans: '), write(HUMANS), nl,
    write('Elves: '), write(ELVES), nl,
    write('Half Elves'), write(HALF_ELVES),
    write('Trolls: '), write(TROLLS), nl, nl.
```

2.

```
faster(X, Y) :-
    elf(X),
    human(Y).

faster(X, Y) :-
    human(X),
    troll(Y).

process(beat_troll) :-
    setof(X, faster(X, Troll), BEATTROLL),
    troll(Troll),
    write('Can beat Troll: '), write(BEATTROLL), nl, nl.
```

Section 4.4 Bayesian Networks

1.

| $p(B)$ | $p(F)$ | $p(G)$ | $p(E\,|\,[B,F,G])$ | $p(E)$ | $\flat(E)$ |
|--------|--------|--------|---------------------|--------|------------|
| T=0.009 | T=0.005 | T=1 | 0.0005 | 0.0000000225 | 0.00000 |
| T=0.009 | T=0.005 | F=0 | 0.05 | 0 | 0 |
| T=0.009 | F=0.995 | T=1 | 0.01 | 0.00008955 | 0.00292 |
| T=0.009 | F=0.995 | F=0 | 0.1 | 0 | 0 |
| F=0.991 | T=0.005 | T=1 | 0.2 | 0.000991 | 0.03232 |
| F=0.991 | T=0.005 | F=0 | 0.25 | 0 | 0 |
| F=0.991 | F=0.995 | T=1 | 0.03 | 0.02958135 | 0.96476 |
| F=0.991 | F=0.995 | F=0 | 0.001 | 0 | 0 |

If the grid has gone down, the most likely explanation is that it was this event alone that caused the electricity failure.

CHAPTER 5

Section 5.2 FSM Extensions

1.

	In Range	Out of Range	Injured
FIRE BOMB (F)	D	REST	RETREAT
SWORD-O-VENOM (S)	D	REST	RETREAT
DUCK (D)	F	REST	RETREAT
RETREAT (R)	D	REST	RETREAT
REST	S	REST	RETREAT

Section 5.6 Decision Trees

1. $Gain_{Hungry} = 0.0479$

 $Gain_{Taste} = 0.0253$

2. food
 rock-hungry
 y-taste
 0-n

```
        1-?
        2-y
    n-n
  grass-y
  tree-hungry
        y-y
        n-n
  cow-y
```

The new data doesn't change the decision made about cows; however, it does mean that in order to decide on eating a rock, the taste must now be considered. The "?" next to a rock with taste 1 means there is not enough information in the data to make a decision about these types of rocks.

3.

HUNGRY	TIRED	BORED	CLEAN	WEALTHY	HAPPY?
yes	yes	yes	yes	yes	no
yes	yes	yes	no	no	no
no	no	no	yes	yes	yes
no	yes	no	yes	yes	yes
yes	no	no	yes	yes	yes
yes	yes	no	no	no	no
yes	yes	no	yes	yes	yes
no	no	yes	no	no	no
etc...					

A Crash Course in Vector Mathematics

A s a geometrical object, a vector is a line that has a length and a direction (denoted by an arrow). It can be used to represent measurements such as displacement, velocity, and acceleration. You can think of a vector as a change in location of coordinates, with the values of the vector representing the amounts of coordinate change. An example of a vector is given in Figure C.1.

In Figure C.1, the vector, **v**, is the displacement from **P** to **Q**. It can be thought of as a set of coordinate instructions where the first value is a change in the *x*-direction and the second is a change in the *y*-direction. For example, if we are located at point **P** and we traverse **v**, we end up at **Q**. The value of **v** can be calculated by subtracting the coordinates of the start location from the coordinates of the end location. This formula is shown in Equation C.1.

$$\mathbf{v} = \mathbf{Q} - \mathbf{P} \qquad\qquad (C.1)$$

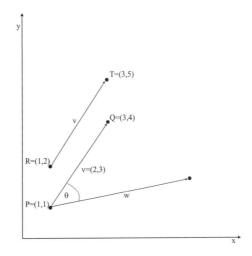

FIGURE C.1 The graphical representation of a vector.

In the example shown in Figure C.1, \mathbf{v} can be calculated as $\langle Q_x - P_x, Q_y - P_y \rangle = \langle 3-1, 4-1 \rangle = \langle 2, 3 \rangle$. If the vector from \mathbf{Q} to \mathbf{P} were required, the calculation would be reversed, thus, $\langle P_x - Q_x, P_y - Q_y \rangle = \langle 1-3, 1-4 \rangle = \langle -2, -3 \rangle$. The resulting value makes sense because the magnitude of the vector from \mathbf{P} to \mathbf{Q} is the same as that from \mathbf{Q} to \mathbf{P}; however, the direction of travel is different and, therefore, you have negative values.

A vector does not specify a fixed starting location. It can start and end anywhere, depending on its application. If, for example, there was a point $\mathbf{R} = \langle 1, 2 \rangle$, vector, \mathbf{v}, could be added to this point as directions to a new point, \mathbf{T}. To determine the location of \mathbf{T}, simply add \mathbf{R} and \mathbf{v}, as shown in Equation C.2.

$$\mathbf{T} = \mathbf{R} + \mathbf{v} \tag{C.2}$$

In this case, the location of \mathbf{T} would be $\langle R_x + v_x, R_y + v_y \rangle = \langle 1+2, 2+3 \rangle = \langle 3, 5 \rangle$.

Often it is useful to know the length of a vector. The length of vector, \mathbf{v}, in the previous example would tell us the distance between points \mathbf{P} and \mathbf{Q} or \mathbf{R} and \mathbf{T}. The length of a vector, denoted $\|\mathbf{v}\|$, is found using Pythagoras' Theorem, shown in Equation C.3.

$$\|\mathbf{v}\| = \sqrt{v_x^2 + v_y^2} \tag{C.3}$$

Here, the length of \mathbf{v} is $\sqrt{2^2 + 3^2} \approx 3.6$.

Sometimes it is necessary to scale a vector so that it has a unity length. Therefore, the length of the vector is equal to 1. The process of scaling the length is called normalizing, and the resultant vector, which still points in the same direction, is called a unit vector. To find the normalized form of a vector, denoted $\hat{\mathbf{v}}$, Equation C.4 is used.

$$\hat{\mathbf{v}} = \frac{\mathbf{v}}{\|\mathbf{v}\|} \tag{C.4}$$

The equation divides the original vector by its length to calculate the unit vector. The unit vector for \mathbf{v} from the previous example would be $\hat{\mathbf{v}} = \langle 2/3.6, 3/3.6 \rangle = \langle 0.556, 0.833 \rangle$, where each coordinate (x and y) is divided by the vector's length. If you were to calculate the length of the unit vector using Equation C.3, you would find it would equal 1 (excusing any rounding errors).

Two further important calculations can be performed with vectors: the dot product and the cross product. The use of these in computer graphics and games programming will become overwhelmingly clear later in this appendix. Among other things, the dot product can be used to calculate the angle between two vectors, and the cross product can be used to calculate direction.

The dot product is calculated by taking two vectors, **v** and **w**, and multiplying their respective coordinates together, then adding them. The dot product results in a single value. It can be calculated using Equation C.5.

$$\mathbf{v} \cdot \mathbf{w} = v_x w_x + v_y w_y \tag{C.5}$$

Given the vectors $\mathbf{v} = \langle 2, 3 \rangle$ and $\mathbf{w} = \langle 5, 1 \rangle$, the dot product will be $2 \cdot 5 + 3 \cdot 1 = 13$. But what does this mean? The most useful application of the dot product is working out the angle between two vectors. In a moment we will work out the actual value of the angle, but for now, by just knowing the value of the dot product you can determine how the vectors sit with relation to each other. If the dot product is greater than 0, the vectors are less than 90° apart, if the dot product equals 0, then they are at right angles (perpendicular), and if the dot product is less than 0, then they are more than 90° apart.

To determine the exact angle between two vectors, for example, θ in Figure C.1, the arccosine of the dot product of the unit vectors is found (see Equation C.5). This value is the angle between the vectors. See [Hill01] for a derivation if desired.

$$\theta = \cos^{-1} (\hat{\mathbf{v}} \cdot \hat{\mathbf{w}}) \tag{C.6}$$

Now imagine that you are standing at point **P** (in Figure C.1) and facing in the direction of **v**. How far should you turn (on the spot) to be facing in the direction of **w**? It's as easy as using Equation C.6 . . . or is it? Let's find out. Given the previous values for **v** and **w**, the value of θ will be $\cos^{-1}(\langle 0.556, 0.833 \rangle \cdot \langle 0.980, 0.196 \rangle) = \cos^{-1} 0.708 = 44.9°$. So the angle between **v** and **w** is about 45°. Therefore, if you were to turn around 45°, you would be facing in the direction of **w**. This, however, is not necessarily true. If you were asked to turn around 45°, which way would you go? Clockwise or counterclockwise? In computer graphics, a positive value for an angle always indicates a counterclockwise turn. A counterclockwise turn in this case would have you facing away from **w**. When calculating the angle between vectors using the dot product, the angle is always positive. Therefore, you need another method to determine the turn direction. This is where the cross product comes into play.

The cross product of two vectors results in another vector. The resulting vector is perpendicular to both the initial vectors. This would sound odd working in two dimensions because obviously a vector at right angles to two vectors in two dimensions would have to come right out of the page. For this reason, the cross product is defined only for three dimensions. The formula to work out the cross product is a little obtuse and requires further knowledge of vector mathematics, but we will try to make it as painless as possible here.

The cross product of two vectors, **v** and **w**, denoted **v** × **w**, is shown in Equation C.7.

$$\mathbf{v} \times \mathbf{w} = \left(v_y w_z - v_z w_y \right)\langle 1,0,0 \rangle + \left(v_z w_x - v_x w_z \right)\langle 0,1,0 \rangle + \left(v_x w_y - v_y w_x \right)\langle 0,0,1 \rangle \quad \text{(C.7)}$$

The equation is defined in terms of the standard unit vectors. See [Hill01] for derivation if desired. These vectors are three unit-length vectors orientated in the directions of the x-, y- and z-axes (see Figure C.2). If you examine Equation C.7 you will notice there are three parts added together. The first part determines the value of the x-coordinate of the vector because the unit vector $\langle 1,0,0 \rangle$ has a value only for the x-coordinate. The same occurs in the other two parts for the y- and z-coordinates.

To find the cross product of two 2D vectors, the vectors first must be converted into three-dimensional coordinates. This process is as easy as adding another coordinate value of 0 to denote that the vectors do not have a value in the z-direction. For example, $\mathbf{v} = \langle 2,3 \rangle$ becomes $\mathbf{v} = \langle 2,3,0 \rangle$ and $\mathbf{w} = \langle 5,1 \rangle$ becomes $\mathbf{w} = \langle 5,1,0 \rangle$. The value of $\mathbf{v} \times \mathbf{w}$ would equate to

$$(3 \cdot 0 - 0 \cdot 1)\langle 1,0,0 \rangle + (0 \cdot 5 - 2 \cdot 0)\langle 0,1,0 \rangle + (2 \cdot 1 - 3 \cdot 5)\langle 0,0,1 \rangle$$
$$= 0\langle 1,0,0 \rangle + 0\langle 0,1,0 \rangle + (-13)\langle 0,0,1 \rangle$$
$$= \langle 0,0,0 \rangle + \langle 0,0,0 \rangle + \langle 0,0,-13 \rangle$$
$$= \langle 0,0,-13 \rangle.$$

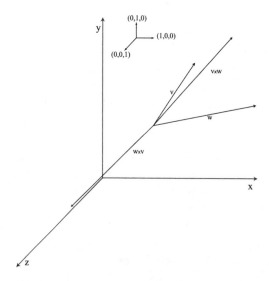

FIGURE C.2 Unit vectors and resulting cross product vectors.

It doesn't appear to be the resulting vector because it is shown in Figure 2.18 at right angles to both **v** and **w** and is seven units long in the z-direction. An interesting thing to note about the cross product is that if the order of the equation is reversed, the resulting vector is different. **w**×**v** would equal ⟨0,0,13⟩ (check this out!), which is a vector the same length as the one produced by **v**×**w**, but it travels in the exact opposite direction (see Figure C.2). This differs from the calculation of the dot product, which yields the same answer no matter what the order of the vectors. So how does this help us determine the direction in which to turn?

If we start facing in the direction of **v** and want to turn to face **w**, we can calculate **v**×**w**. If we examine Figure C.2, it is plain to see that **w** would be on our right, and, therefore, it would require a clockwise turn. This fact is not obvious to a virtual human who has only the vector coordinates. We know from the previous example that a clockwise turn between two vectors produces a cross product result with a negative z-value. The opposite is true for an counterclockwise turn. Therefore, we can say that if z is positive, it means an counterclockwise turn, and if z is negative, a clockwise turn.

This concludes our crash course on vector mathematics.

REFERENCES

[Hill01] Hill, J.S., *Computer Graphics Using OpenGL*, Prentice Hall, Upper Saddle River, 2001.

D Creating a BSP Map for Apocalyx

T he 3D game engine Apocalyx uses binary space partitioning (BSP) maps to represent the 3D gaming environment. It uses the same format that has been implemented in *Quake III Arena*. Therefore, the same tools used to create *Quake III* maps can be used to create maps for Apocalyx. To create your own BSP maps you will need:

Q3Radiant: a 3D map editor available from *www.qeradiant.com*

Quake III Arena Full Licensed Version or Demo Version: available from *www.idsoftware.com/games/quake/quake3-gold*

A graphics program: for creating textures; programs include Paintshop® Pro and Adobe® Photoshop®

Pakscape: a utility for compressing maps and textures for creating *.pk3* files; available at *http://files.filefront.com/10707*

STEP ONE: INSTALLING THE SOFTWARE TOOLS

Download a version of *Q3Radiant* from the Internet and install it on your computer along with a full or demo version of *Quake III Arena*. *Q3Radiant* uses the *Quake III* games engine; therefore, it will not run with *Quake*.

STEP TWO: CREATING TEXTURES FOR THE ENVIRONMENT

A map is simply a wireframe mesh. To make it look solid, textures must be pasted onto the mesh surface. You should create your own textures using the paint program of your choice. Most map textures are 256×256 pixels. The texture files should be saved as Baseline (not Progressive Scan) JPEG files. You might want to create three textures: one for the floor, one for the walls, and one for the ceiling.

Create a new directory within your Quake3/baseq3/textures directory called tuto-rial. If the textures directory does not exist, you must create this first. Save your JPEG texture files into this new directory.

STEP THREE: ORIENTATION OF THE Q3RADIANT EDITOR

The *Q3Radiant* editor has a number of windows that display the various parts of your map, as shown in Figure D.1. Immediately below the button menu that resides along the top of the editor is a series of windows. The left window is called the Z window. This window is essentially a height bar that allows you to set the height of the objects you have created. The window to the right of the Z window is the XY Top View window. It provides an aerial shot of your map. The window in the upper right is the 3D View window, which allows you to view your map as it will appear in Apocalyx (or *Quake III*) and to set textures. The window immediately under the 3D View window is the texture window. When you load some textures for pasting into your environment, they appear in this window. You can select from loaded textures and place them on the desired surface (such as the wall or floor).

FIGURE D.1 The *Q3Radiant* editor.

FIGURE D.2 Creating a simple room.

STEP FOUR: CREATING A ROOM

To create a new map click File > New Map from the menu. To create a simple room, click in the XY Top View window at the grid location (256, −256) and drag the mouse out to (−256, 256). This action creates a red square in the window. You can see that an image has appeared in the 3D View. This image is a 3D representation of the square that was just drawn, which is currently flat like a floor. The 3D representation also has the words "SHADER NOT FOUND" written on it. These words mean that the surface does not yet have a texture assigned to it. In the Z window a blue rectangle with a prism extruding from it also appears. The view after creating the square is shown in Figure D.2.

To give your room some height, place the mouse in the Z window just above the upper red line of the blue rectangle and drag the mouse upward. You can see the height of the blue rectangle changes. This will be the height of your room. Drag the room up to a height of 256. When the height of the room has changed, the 3D representation seems to disappear—you haven't actually created a room but a solid $256 \times 256 \times 256$ cube. What you can see in the 3D View is a view of the inside of the cube. Because the cube is currently solid, you can't actually see anything. To create a room out of the cube, you must hollow it out.

On the button menu bar click the *hollow* button, which looks like a red square with a dotted red square inside it. The cube is hollowed out to create a room. All window views are modified, and you should now be able to see inside the room in the 3D View window. The arrow keys on your keyboard enable you to move around within the 3D View. To deselect the room and its surfaces, press Esc.

Because *Q3Radiant* has proven to be somewhat unstable, it is a good idea to save your work frequently. Click File > Save As from the menu and save your map as *tutorial.map* in the Quake3/baseq3/maps directory.

STEP FIVE: ADDING TEXTURES

To add textures to the surfaces of the room click Textures > Tutorial from the menu. The textures in the tutorial directory that you created earlier appear in the texture viewing window. The Textures drop-down menu obtains the texture list based on the folders placed in the Quake3/baseq3/textures folder. You cannot add a new texture folder when *Q3Radiant* is running. If you wish to do so, save the current map, exit *Q3Radiant*, create the new textures folder, restart *Q3Radiant*, and reload the map. The new texture folder appears under the Textures menu. If the textures do not appear or have the words "SHADER NOT FOUND" displayed, this means the textures are in the wrong format. Make sure they are in Baseline JPEG format. The textures already listed under the Textures menu are Id Software copyrighted. You can use them for your own purposes; however, they are not distributable with games you create with Apocalyx. Therefore, you should create your own textures or use copyright-free textures.

To paste a texture onto a surface, press Shift and select a wall or the floor or ceiling in the 3D View. The surface turns red, indicating it is selected. You can select more than one surface at a time by clicking repeatedly on other surfaces of the map. To deselect just one surface, press Shift and click the surface again. When all the surfaces you want to texture with the same image have been selected, click the desired texture from the texture viewing window. In the 3D View you can see the texture pasted onto the selected surface. To change to another texture, just select the surface again and select a different texture.

When your room is textured to your specifications, remember to save the map.

STEP SIX: ADDING LIGHTING TO THE ENVIRONMENT

Lighting is an important part of your map. Without it, it will be nearly impossible to see where you are going when playing the map in Apocalyx because the scene will

be very dark. To add a light, in the XY View window, right-click to open the Easy Entity shortcut menu. This menu provides a list of entities that can be added to a map. To add a light, select light from the menu. You are asked to enter an intensity value. The default value will do for now. In the XY View window you see a small red square with a cross appear. If you move around in the 3D View window you can see a small gray box on the floor in the location where you placed the light. These objects represent the light in the *Q3Radiant* editor. The light does not appear as a gray box when you play the map in Apocalyx.

The only problem with the newly created light is that it is on the floor—we would prefer it on the ceiling. (Of course you can put lights wherever you like.) To lift the light up, make sure it is still selected—it should appear as if drawn in red in the XY View window. If it is not selected you can select it in the same way as you selected surfaces. Press Shift and click the light. You can do this in either the XY View or 3D window. To change the height of the light you need to change to another view window that displays the z-axis. To do this click View > Layout > XZ from the menu or cycle through the views by clicking the button in the toolbar with XYZ written on it. You are now looking at a side view of your room. The selected light appears on the ground. Drag the light up toward the ceiling. In the 3D View you can see the light is no longer on the floor. To deselect the light, press Esc.

You can add as many lights to the map as you want. One light in a map this size isn't ideal, so add a few more before moving on to the next section.

STEP SEVEN: ADDING A PLAYER START LOCATION

To place the players in the correct location within the map when it is loaded by Apocalyx, you must identify a starting location for the players. This location ensures that players are not loaded outside of the map or halfway up a wall. To add a player start location, right-click inside the XY View window to open the Easy Entity shortcut menu. From this menu click info > info_player_start. A red dotted box appears. The procedure for placing this box in the desired location is the same as that for moving the lights. Cycle through the view windows and move the player start box to the desired location.

STEP EIGHT: COMPILING THE MAP

Before a map can be used by Apocalyx it must be compiled into BSP format. To compile the map click Bsp > bsp_FastVis from the menu. A DOS window opens

while the map is compiled. If you have completed everything correctly, you get no compilation errors.

When you have satisfactorily completed and compiled the map, close *Q3Radiant*.

STEP NINE: CREATING A .PK3 FILE

The .pk3 file format is a zipped file containing the BSP map and the textures. These files in the *Quake* environment have a .pk3 extension; however, as long as the file is in the correct format, it doesn't matter what it is called. The file format can be opened and created with *WinZip* or *PakScape*.

To create a new .pk3 file in *Pakscape*, first make sure you have downloaded the program, then click File > New from the menu. The window looks like that shown in Figure D.3.

To add a new map and textures to the .pk3 file, open Windows Explorer and drag the Quake3\baseq3\maps and Quake3\baseq3\textures folders into PakScape, as shown in Figure D.4.

To save the .pk3 file, click File > Save As from the PakScape menu, set the file type as *Quake 3* Pak, and save the file as *tutepak.pk3*. The map is now ready to be loaded into an Apocalyx game. For more details on this process see Chapter 1.

FIGURE D.3 *Pakscape.*

FIGURE D.4 Creating the .pk3 file.

Appendix

E | A Brief PROLOG Primer

This appendix has been written as an introduction to the artificial intelligence programming language PROLOG. It is in no way complete because the full syntax and functional specifications of PROLOG are quite extensive. The information contained in this appendix is provided as a guide for learning the basic elements of PROLOG and providing a firm foundation in the language for use in creating the knowledge bases of the NPCs explored in this book.

ON THE CD

A freeware PROLOG compiler called SWI-Prolog is provided in the Software/ Prolog folder. Install the software on your computer by running the program *w32pl5210.exe* found in this folder. The software is run from the program *plwin.exe*, which is stored in the bin directory of the software's installation.

FACTS, RULES, AND RELATIONS

PROLOG is well suited to programming information about entities and the relationships that exist between them. An entity is an object that exists within an environment. It is represented in PROLOG with a symbolic name in lowercase text. For example, let's consider a fantasy game environment in which a wizard named Merlin exists. In PROLOG this entity is represented as:

```
merlin
```

Entities, however, do not exist in PROLOG by themselves. They are declared by the relationships that exist between them and other entities. Let's consider the case where the wizard Merlin is the advisor of King Arthur. This relationship would be written in PROLOG as:

```
advisor(merlin, arthur).
```

The previous line of code is read *Merlin is an advisor of Arthur*. If we also wanted to add the relationship stating that *Lancelot is an advisor of Arthur*, we would add the code:

```
advisor(lancelot, arthur).
```

Each of the preceding entries of PROLOG code are known as *clauses*, and they represent *facts* in the knowledge base where they are stored. For example, it is a fact that Merlin and Lancelot are advisors to Arthur.

The number of entities contained in the brackets of a relationship is known as the relationship's arity. In the previous two examples, the relationship advisor has an arity of two. When a relationship has been specified once with a particular arity, another cannot exist within PROLOG with the same name and a different arity. For example:

```
advisor(merlin, lancelot, arthur).
```

is illegal and would cause a compilation error. Relationships are not restricted to arities of only two. For example, the relationship

```
defeated(arthur, mordred, monday, camelot).
```

may state that Arthur defeated Mordred in a fight that took place on Monday in Camelot. The defeated relationship in this case has an arity of four.

All relationships, entities, and facts are written in lowercase text in PROLOG. Uppercase letters are reserved for variables. Also take notice of the full stop at the end of each line of PROLOG. This punctuation is like the use of the semicolon in C/C++ and indicates the end of a line of code or the end of a query.

Besides stating facts in PROLOG using relationships, we can also state rules. A rule is a conditional statement that insists if one fact is true then another is also. Let's say we want to state a military ranking of personnel in King Arthur's army. King Arthur would ultimately be the chief and commander. Assuming he has two battalions; the Knights of the Round Table (KORT) and the Archers, each knight and each archer would be under the direct command of their battalion leader, who is under the command of Arthur, as shown by the hierarchy in Figure E.1.

Each individual in Arthur's army can be added to PROLOG by stating facts about their assignments such as:

```
kort(lancelot).
kort(galahad).
kort(pelleas).
kort(degore).
```

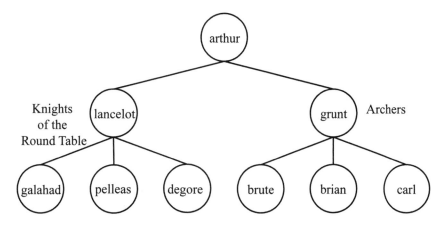

FIGURE E.1 The ranking hierarchy of King Arthur's army. (No claims about the historical accuracy of this diagram are being made. It is purely for illustration purposes.)

```
archer(grunt).
archer(brute).
archer(brian).
archer(carl).
```

We would also like to be able to state, depending on their assignment, who is in charge of whom. In the case of the knights, Lancelot is in charge. We can state this as the following relationship:

```
commander(galahad, lancelot).
```

taken to infer that *Galahad's commander is Lancelot.* Such a relationship would have to be added for each of the knights. If there were only three knights, typing all the relationships is simple; however, if there were 100 knights, it would not be as trivial. Instead of writing 100 relationships for commander, we can simply add a rule that states that all knights are commanded by Lancelot, thus:

```
commander(lancelot, X) :- knight(X).
```

This rule automatically creates a commander relationship for each knight that exists where X is a variable taking on the knight's name. A rule is said to *fire* when the facts on the right side of the ":–" are true. If no knight facts are in the knowledge base, the preceding rule does not fire and there are no commander facts. A rule can also contain more than one fact on the right side. When it does, each of the right-side

facts must be true for the rule to fire. The facts separated by a comma in the rule, are as follows:

```
commander(lancelot, X) :-
    knight(X),
    not(X,arthur).
```

In this rule we are ensuring that Lancelot is the commander of all knights except Arthur.

The symbolic names used for the facts, rules, and relationships such as merlin, arthur, and advisor are left to the discretion of the programmer.

QUERYING THE KNOWLEDGE BASE

Querying the knowledge base allows us to check our own logic in the creation of the PROLOG facts and rules as well as obtain information about the knowledge held within. For use with the SWI-Prolog software, PROLOG clauses are written in a text file and loaded into the program. Consider a text file called *camelot.pl* containing the following clauses:

```
commander(lancelot, X) :- knight(X), not(X == arthur).
commander(grunt, X) :- archer(X).
knight(galahad).
archer(brute).
archer(carl).
```

The program is loaded and compiled in SWI-Prolog when you click File > Consult from the menu and locate *camelot.pl*. The program is immediately compiled and messages about the success of the compilation, such as:

```
% d:/prolog/demo/camelot.pl compiled 0.00 sec, 1,172 bytes
```

are printed in the SWI-Prolog window, as shown in Figure E.2.

To ask the knowledge base if Brute is an archer, we can type the query:

```
archer(brute).
```

FIGURE E.2 The SWI-Prolog command window with example queries.
© 1990–2003 University of Amsterdam.

In the program file, this line would be a clause stating a fact; however, when typed into the SWI-Prolog console it becomes a query. If the fact archer(brute) exists in the knowledge base, the software responds with yes; otherwise, no, as shown in Figure E.2. We can also ask the knowledge base to tell us about all the archers that it knows. To create such a query, a variable is used in place of the archers' names, thus:

```
archer(X).
```

PROLOG responds with a list of facts matching the query one line at a time. At the end of each line, the user can type semicolon to get the next matching fact. When no more matching facts are available, the response is no, as shown in Figure E.2.

Because we have included a rule that states that all archers are under the command of Brute, the inclusion of archer facts should have made this rule fire. Although we did not specifically add any commander facts into *camelot.pl*, they now exist in the knowledge base. We could assume that because there are two archer facts there should also be two associated commander facts. Likewise, because there is only one knight fact, there should be only one associated commander fact. To check this, we type the following query:

```
commander(X,Y).
```

to which PROLOG responds:

```
X = lancelot
Y = galahad ;
```

```
X = grunt
Y = brute ;

X = grunt
Y = carl ;

No
```

If you only wanted a report on all individuals whom Grunt was commander of, you could replace the x variable with his name, thus:

```
commander(grunt,Y).
```

At this point, you may want to add more archers or knights to the knowledge base. The process of doing this through the PROLOG console is called *asserting*. To assert a new fact about an archer, you would type:

```
assert(archer(jonathan)).
```

To this, SWI-Prolog will respond with the error:

```
ERROR: No permission to modify static_procedure `archer/1'
```

This is a fail-safe mechanism that stops facts and rules from being modified and added in the PROLOG program after it has been compiled. Each relationship in a SWI-Prolog program is considered static unless clearly defined as dynamic. To define a relationship as dynamic it must be declared at the top of the program as follows:

```
:- dynamic (archer/1).
```

where the number following the relationship name denotes the arity. Having added this line to the top of the *camelot.pl* file and reloading it, the preceding assert statement is allowed. After it has been added, a query of the archers now gives the results:

```
X = brute ;
X = carl ;
X = jonathan ;
No
```

You would also assume the associated commander rule to have been fired in which
`commander(grunt, jonathan)` should be true, thus:

```
commander(grunt,jonathan).
Yes
```

Facts can also be removed from the knowledge base. This ability is useful be-
cause the environment might change and, therefore, the facts may become incor-
rect. Let's assume that the archer Jonathan dies in combat and no longer exists. We
can remove the fact using retract:

```
retract(archer(jonathan)).
```

A query for all the archers reveals that Jonathan is no longer an archer. In addition,
because the rule that fired the `commander(grunt,jonathan)` fact is no longer true, this
fact is automatically removed from the knowledge base.

 When a rule has fired, it does not mean it will not fire again. It will fire each time
the right side facts are true. This also works in reverse, where a rule can become un-
fired when facts that were once true become false, and, thus, facts added previously
by the rule are removed.

PROLOG PROGRAMS

So far we have written rules and facts using relationships to create a knowledge base
in PROLOG. Unlike conventional programming, these clauses are not procedurally
executable. PROLOG does, however, provide the means of running a program by
executing PROLOG commands, which can add, modify, and delete rules and facts.

As with other programming languages PROLOG can define data objects. The
most basic types of data in PROLOG are *numbers*, *atoms*, and *variables*. Numbers
are obvious (`1`, `4`, `98`); atoms are strings of characters in lowercase text (`merlin`,
`arthur`, `carl`), and variables are character strings starting with an uppercase letter
or underscore (`X`, `Name`, `_x12`) used to store changing values. PROLOG can also be
used to define *structures*, which are data objects containing mixed information, for
example, `journey(brisbane, sydney, 11:30pm)`. A structure when coded in
PROLOG also represents a fact.

In the previous section we examined how rules are fired when facts are consid-
ered true. Expanding on this, rules can also be fired when *conditions* are true. The
conditions can be created through matching data objects. For example, we may
want a rule to fire if one data object is equal to another. Variables in the object can

be used to match anything. For example, journey(perth, darwin, X) and journey(
C1, C2, 1:34am) match, whereas journey(perth, darwin, X) and journey(
melbourne, C2, 1:34am) don't. To perform a matching test the '=' operator is used:

```
journey(perth, darwin, X) = journey(C1, C2, 1:34am)
```

To negate a match, the not function can be used:

```
not(journey(perth, darwin, X) = journey(C1, C2, 1:34am))
```

Given this, we can now write complex rules such as:

```
victorious(X) :-
    defeated(X, Y, Location),
    not(X = Y).
```

In this case, if the fact defeated(arthur, mordred, camelot) is asserted into the
knowledge base, the rule fires and adds the fact victorious(arthur) to the knowl-
edge base. However, if the fact defeated(mordred, mordred, camelot) is asserted,
the rule does not fire because the rule requires the first and second parameters of
the fact to be different. Remember, a comma in PROLOG is the same as a logical
AND, thus both facts on the right side must be true for the rule to fire.

Finally, a forward-executing program can be written in PROLOG where the left
side of the rule is called from the command line and each of the facts and com-
mands on the right side of the rule are executed in order until one that is false oc-
curs. Consider the new code for *camelot.pl*:

```
:- dynamic (archer/1).
:- dynamic (knight/1).
:- dynamic (defeated/3).

commander(lancelot, X) :- knight(X), not(X == arthur).
commander(grunt, X) :- archer(X).
knight(galahad).
knight(mordred).
archer(brute).
archer(carl).

go:-
    assert(defeated(arthur,mordred,camelot)),
    assert(defeated(mordred, mordred, london)),
    retract(knight(mordred)).
```

When this code is compiled by PROLOG, any facts are asserted and the appropriate rules are fired. Therefore, we would assume that a query about the knights would return the names of Galahad and Mordred. Because no facts to fire the go rule exist, there should be no defeated facts and knight(mordred) will not have been retracted. The go rule can explicitly be fired by entering its name at the command line. When executed, we would assume there to be two defeated facts and Mordred removed from being a knight. This action is illustrated in the following command line session:

```
?-
% d:/prolog/demo/camelot.pl compiled 0.00 sec, 1,760 bytes
?- knight(X).

X = galahad ;

X = mordred ;

No
?- defeated(X,Y,Z).

No
?- go.

Yes
?- knight(X).

X = galahad ;

No
?- defeated(X,Y,Z).

X = arthur
Y = mordred
Z = camelot ;

X = mordred
Y = mordred
Z = london ;

No
```

LISTS AND OPERATORS

A set of data can be constructed in PROLOG using a *list*. A list is denoted by a series of atoms, structures, or variables enclosed in square brackets, such as `[lancelot, galahad, pelleas, degore, mordred]`. A list has two parts: the head and tail. The head of the preceding list is `lancelot` and the tail is `[galahad, pelleas, degore, mordred]`. A list can be constructed with the special function:

```
.(Head, Tail).
```

and thus the previous list can be created with:

```
.(lancelot, [galahad, pelleas, degore, mordred]).
```

or:

```
.(lancelot,.(galahad,.(pelleas,.(degore,.mordred,[])))).
```

where the latter uses nested calls to the function to add each member and `[]` denotes an empty list or, in this case, the tail that exists after the names. Another notation that can be used to write a list is a vertical bar. This character is used to segregate parts of the list. For example, our list can also be written as:

```
[lancelot | [galahad, pelleas, degore, mordred]].
```

or:

```
[lancelot, galahad | [pelleas, degore, mordred]].
```

or:

```
[lancelot, galahad, pelleas, degore, mordred | []].
```

A list in PROLOG can be denoted as `[a, b, c, . . .]` or as the difference between two lists. For example, the list `[a, b, b]` is equivalent to `[a, b, b, c, d] - [c, d]`, or as more commonly written `[a, b, b | c, d], [c, d]`. At first this might seem a very obtuse way of defining a list. Why define a list as the list itself plus some miscellaneous items minus the same miscellaneous items? It is because of the way PROLOG concatenates lists. Normally, to add two lists together, PROLOG must loop to the end of the first list and then append the second list. This process becomes inefficient if the first list is really long. Therefore, by using this representa-

tion called *difference lists*, the miscellaneous items actually inform PROLOG where the end of the list is. It can then go directly to the end of the list and add the second list. Note that another legitimate format of a difference list is to represent the end miscellaneous items as an empty list. For example, [a, b, c] = [a, b, c|[]], []. Difference lists are commonly used in functions that operate on lists.

Two functions that are useful with lists are the membership function and the concatenation function. The first function determines if a given object is part of a list, and the second joins the two lists together. PROLOG does not have specific functions to perform these; therefore, we must write our own clauses to achieve the desired processes. The membership function must examine the head and the tail of the list for the occurrence of a given object. Therefore, we first test if the object is the same as the head (remember the head is just one object), or whether the object appears in the tail. The function is achieved with two clauses:

```
member( X, [X|Tail]).
member( X, [Head|Tail]) :- member(X, Tail).
```

The first clause equates to true if x is the head of the list (that is, the first element). The second clause recursively calls the member, each time removing the head and checking if x matches the new head.

The following is a listing of the trace of the membership function being tested. The first run asks if Grunt is a member of the Knights list and the second asks if Degore is a member. As you can see, the function keeps stripping the head off the list and attempting to match the given name with the remaining head until it matches or until the list is empty.

```
?-trace.

Yes
[trace]?-member(grunt,[lancelot,galahad,pelleas,degore,mordred]).

Call:(7)member(grunt,[lancelot,galahad,pelleas,degore,mordred])?creep
Call:(8)member(grunt,[galahad,pelleas,degore,mordred])?creep
Call:(9)member(grunt,[pelleas,degore,mordred])?creep
Call:(10)member(grunt,[degore,mordred])?creep
Call:(11)member(grunt,[mordred])?creep
Call:(12)member(grunt,[])?creep
Fail:(12)member(grunt,[])?creep
Fail:(11)member(grunt,[mordred])?creep
Fail:(10)member(grunt,[degore,mordred])?creep
Fail:(9)member(grunt,[pelleas,degore,mordred])?creep
Fail:(8)member(grunt,[galahad,pelleas,degore,mordred])?creep
Fail:(7)member(grunt,[lancelot,galahad,pelleas,degore,mordred])?creep
```

No

[debug]?—trace.

Yes
[trace]?—member(degore,[lancelot,galahad,pelleas,degore,mordred]).

Call:(7)member(degore,[lancelot,galahad,pelleas,degore,mordred])?creep
Call:(8)member(degore,[galahad,pelleas,degore,mordred])?creep
Call:(9)member(degore,[pelleas,degore,mordred])?creep
Call:(10)member(degore,[degore,mordred])?creep
Exit:(10)member(degore,[degore,mordred])?creep
Exit:(9)member(degore,[pelleas,degore,mordred])?creep
Exit:(8)member(degore,[galahad,pelleas,degore,mordred])?creep
Exit:(7)member(degore,[lancelot,galahad,pelleas,degore,mordred])?creep

Yes

The concatenation function is written in a similar manner to the membership function, using two clauses. The first checks to see if the given lists have already been concatenated, and the second appends one list to the end of the other by recursively removing the head:

```
concat([], List, List).
concat([X|List1],List2,[X|List3]) :-
    concat(List1,List2,List3).
```

A trace of these clauses in action follows where the result of the concatenation of the lists is placed in the variable NewList:

```
[trace]?—concat([lancelot,galahad],[grunt,carl],NewList).
Call:(7)concat([lancelot,galahad],[grunt,carl],_G653)?creep
Call:(8)concat([galahad],[grunt,carl],_G716)?creep
Call:(9)concat([],[grunt,carl],_G719)?creep
Exit:(9)concat([],[grunt,carl],[grunt,carl])?creep
Exit:(8)concat([galahad],[grunt,carl],[galahad,grunt,carl])?creep
Exit:(7)concat([lancelot,galahad],[grunt,carl],[lancelot,galahad,grunt,carl])?creep

NewList=[lancelot,galahad,grunt,carl]
```

Arithmetic can be performed in PROLOG using the familiar operators of + (addition), – (subtraction), * (multiplication), / (division), **(power), // (integer

division), and mod (modulo). To invoke arithmetic, instead of using the contemporary equals sign, as used in other programming languages to assign values to variables, the keyword is is used. A sample of some arithmetic being performed on the PROLOG command line follows:

```
?- X = 1 + 2.
X = 1+2
Yes

?- X is 1 + 2.
X = 3

?- X is 7 * 4, Y is 10 / 5, Z is 203 mod 10.
X = 28
Y = 2
Z = 3
```

INPUT AND OUTPUT

A PROLOG program can prompt the user to input a value and then use the value during processing. The functions for printing a prompt to the screen are write() or write_ln(), and the function for reading user input is read(). For example, a program that recursively reads in the name of King Arthur's knights and asserts a new knight fact for each might look as follows:

```
:- dynamic (knight/1).

go:-
    write_ln('Enter the name of a knight: '),
    read(Name),
    process(Name),
    go.

process(stop) :-
    setof(X, knight(X), KNIGHTS),
    nl, write('The knights are: '), write(KNIGHTS), nl,
    abort.

process(Name) :-
    assert(knight(Name)).
```

In the preceding program, an `nl` is the command to print a new line to the console, and the function `setoff()` creates a list of all the knight facts. Notice that the go function calls itself at the end of the list of commands, which causes the program to loop. The program is finally aborted when the user types `stop` as a knight's name before which the list of names is printed. Interaction with this program follows:

```
?- go.
Enter the name of a knight:
|: lancelot.
Enter the name of a knight:
|: mordred.
Enter the name of a knight:
|: galahad.
Enter the name of a knight:
|: pelleas.
Enter the name of a knight:
|: stop.

The knights are: [galahad, lancelot, mordred, pelleas]
```

SUMMARY

The information contained in this appendix is but a brief introduction to the PROLOG programming language and is meant to serve as a guide to only the most basic PROLOG programming and to assist you in creating knowledge bases for the Apocalyx NPCs developed in this book. For a full elucidation, you are encouraged to study a textbook devoted to the topic of PROLOG, such as Bratko, I., 2001, *PROLOG: Programming for Artificial Intelligence. Third Edition*, Addison-Wesley, Harrow, or the reference guide supplied with the SWI-Prolog software.

Index